Chesapeake Bay

River *of* Redemption

ANACOSTIA
WATERFRONT TRUST

*This book was made possible with support from the Anacostia
Waterfront Trust. Its publication in 2018 is in observance of The Year
of the Anacostia and in celebration of the Captain John Smith
Chesapeake National Historic Trail, named for the first European
explorer to see the river.*

RIVER BOOKS
Sponsored by

THE MEADOWS CENTER
FOR WATER AND THE ENVIRONMENT
TEXAS STATE UNIVERSITY

Andrew Sansom, General Editor

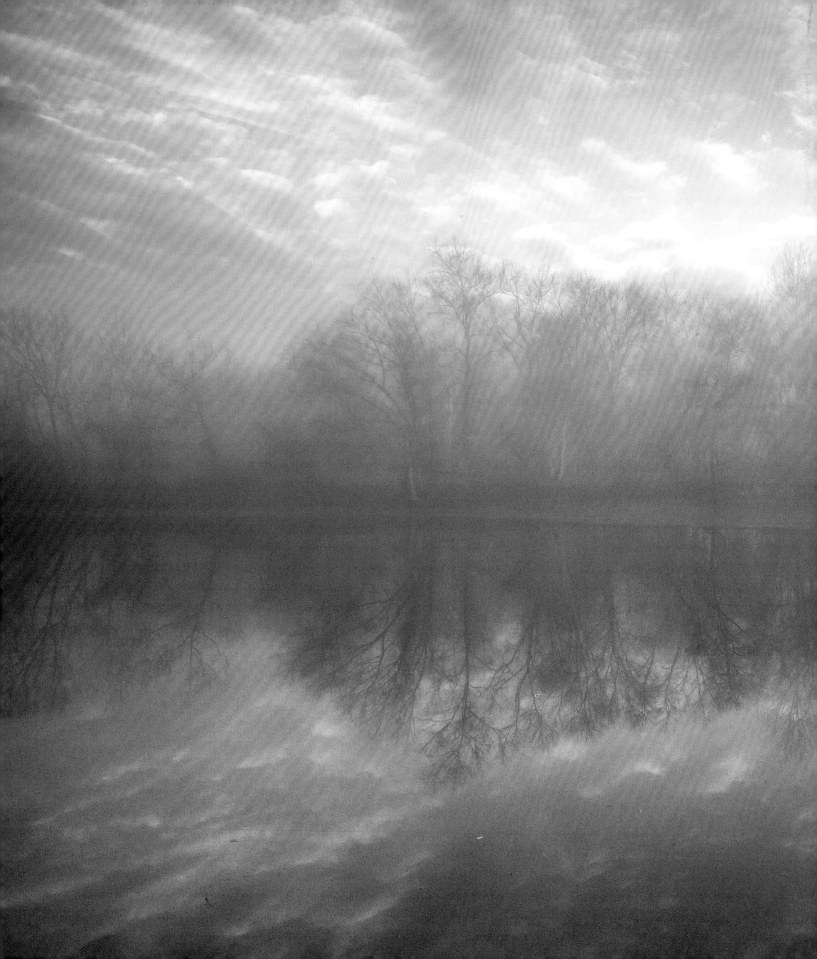

River
of
Redemption

Almanac of Life on the Anacostia

KRISTA SCHLYER

TEXAS A&M UNIVERSITY PRESS COLLEGE STATION

This paper meets the requirements
of ANSI/NISO Z39.48–1992 (Permanence of Paper).
Binding materials have been chosen for durability.
Manufactured in China

Library of Congress Cataloging-in-Publication Data

Names: Schlyer, Krista, 1971– author, photographer.
Title: River of redemption : almanac of life on the Anacostia /
Krista Schlyer.
Other titles: River books (Series)
Description: First edition. | College Station : Texas A&M University Press,
[2018] | Series: River books | Includes bibliographical references and
index. | Includes bibliographical references and index.
Identifiers: LCCN 2018018130| ISBN 9781623496920 (book/cloth : alk. paper) |
ISBN 1623496926 (book/cloth : alk. paper) | ISBN 9781623496937 (e-book)
Subjects: LCSH: Stream ecology--Anacostia River Watershed (Md. and
Washington, DC) | Stream conservation--Anacostia River Watershed (Md.
and Washington, DC) | Anacostia River Watershed (Md. and Washington,
DC)--Pictorial works. | LCGFT: Almanacs.
Classification: LCC QH105.W18 S35 2018 | DDC 577.6/409753--dc23
LC record available at https://lccn.loc.gov/2018018130

Anacostia Watershed map courtesy of Cooper Thomas.

A list of titles in this series is available at the end of the book.

∿

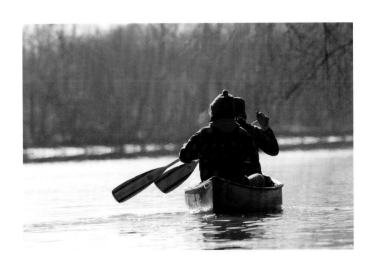

Contents

Foreword

My wife Nona and I moved as newlyweds to Washington, DC, in 1969 believing that the source of all good efforts to improve American society and the country's rich natural heritage was in the nation's capital. Indeed, as a young intern with the National Recreation and Park Association, then located across the street from the White House, I remember being exhilarated by the electric atmosphere in the city, particularly during the Vietnam War and the early days of the modern environmental movement.

And yet, as stimulating as the daily bombardment of events and information was to a fledgling idealist from Texas like me, and as thrilled as we were to be in the midst of it, I remember being absolutely shocked that the capital city of the greatest nation on Earth allowed some of its most historic neighborhoods and lovely natural resources to become so ignored and abused that they had become among the most unsafe and unhealthy environs in America.

Surely, the most heartbreaking of these was the neighborhood in southeastern Washington, DC, known as Anacostia, named after the Nacotchtank, the Native Algonquian people who lived in the area. In the early seventeenth century, Captain John Smith described the Anacostia River Valley as possessing an abundance of forests, game, and fishing grounds. Two centuries later, Frederick Douglass, perhaps the most celebrated abolitionist in our history, broke race barriers to become one of the first African Americans to buy a home in Anacostia, essentially in the shadow of the Capitol Building.

Against that backdrop, this historic and once beautiful community has had among the highest poverty and unemployment rates in the country and accounted for more than half the city's homicides in 2004 and 2005. Meanwhile, the Anacostia River is one of the most polluted in America.

In this twenty-fifth volume of our River Books series, author and pho-

tographer Krista Schlyer illuminates the moving and discouraging story
of the unspeakable treatment of this national treasure through the years
while at the same time just as eloquently describing a river that has some-
how not lost its soul. Schlyer's compelling photos and near poetic prose
illustrate all too unmistakably how devastating the neglect of a commu-
nity and its environment can be, but they also show the restoration efforts
underway that serve as a beacon of hope to those concerned about other
watercourses across the country, such as the Flint River in Michigan, the
San Jacinto in Texas, and more.

It's been many years since Nona and I raised our children in
Washington, but Krista Schlyer moves me to return and be inspired by the
Anacostia's resurrection.

—Andrew Sansom
General Editor, River Books

Acknowledgments

Many hundreds of people have played an important part in the making of this book, most without knowing the part they played. The idea began in a discussion with Shannon Davies, director of Texas A&M University Press, six years ago, and the book was ultimately shepherded through the editorial process by Stacy Eisenstark and Patricia Clabaugh. I am thankful to them and the entire team at TAMU Press for the support and hard work that helped make this idea a reality.

Bill Updike stands always as the rock-solid foundation of my work, and *River of Redemption* is no exception. I am, as ever, more grateful than I can express.

My editing process was aided greatly by two essential readers, Jeff Seltzer and Teresa Martin, both of whom work for the health of the Anacostia and have been ongoing inspirations to me for years as I documented and worked to understand the river community. Their critiques of the manuscript have made it a better book.

Many keystone members of the Anacostia River watershed have aided in the making of this book by allowing me to join them during their work on the river, never hesitating to accommodate me and my camera on forays into the Anacostia world. Ariel Trahan and Brenda Richardson are two bright stars illuminating the river world, and both have welcomed me on many occasions. Jorge Bogantes Montero, Dan Rauch, Stephen Reiling, Josh Burch, Lee Cain, and Brent Bolin have shared much of their time and knowledge of the watershed with me over the years. Dennis Chestnut has given of his time and his long memory of this landscape, which were invaluable to the book.

River of Redemption is a component of *The Anacostia Project*, a long-term documentary endeavor I began in 2010. Since that time the project has had the support of foundations, organizations, individuals, and government agencies that have helped me sustain this work. My earliest sup-

porters were the International League of Conservation Photographers, Puffin Foundation, the Prince George's County Department of Environment, Prince George's Arts Council, and Gateway Development Corporation. More recently, I have received generous and much-needed support from the North American Nature Photography Association, DC Department of Energy and Environment, Anacostia Waterfront Trust, Doug Siglin, and David Epley. I am deeply grateful to all those who have supported this project.

Finally, I thank those who have modeled what it looks like to be a vital component member of the Anacostia River watershed. I have over the course of writing this book encountered many who have lived in this watershed as sources of solar radiance; as the tallest of red oaks sharing their energies with the forest at large; as quiet eastern elliptios filtering the water to make it healthier for all but receiving no honors for their efforts. Some I have named; many I have not. They are John Burroughs and Rachel Carson, the Anacostia Watershed Society, Anacostia Riverkeeper, the staff at the DC Department of Energy and Environment, and Montgomery and Prince George's County departments of environment; Clean Water Action, Groundwork Anacostia, the Alice Ferguson Foundation, the Anacostia Waterfront Trust, and Trash Free Maryland; the Earth Conservation Corps, Smithsonian Anacostia Community Museum, and many, many more. None of these did it for recognition; they did it for community; they did it for home. They have given and continue to give everything they can to help us see a different future for ourselves as component members of the Anacostia and Earth. For their lives to be honored as they should, they should not be viewed as heroes, though they are. Rather, they should be seen as models to emulate. We cannot rely on heroes to bring us home to our river—we must become those heroes ourselves; we must set our own feet on the path they have created and follow them home. I can only hope, in the pages of this book, I have stepped decisively on that path.

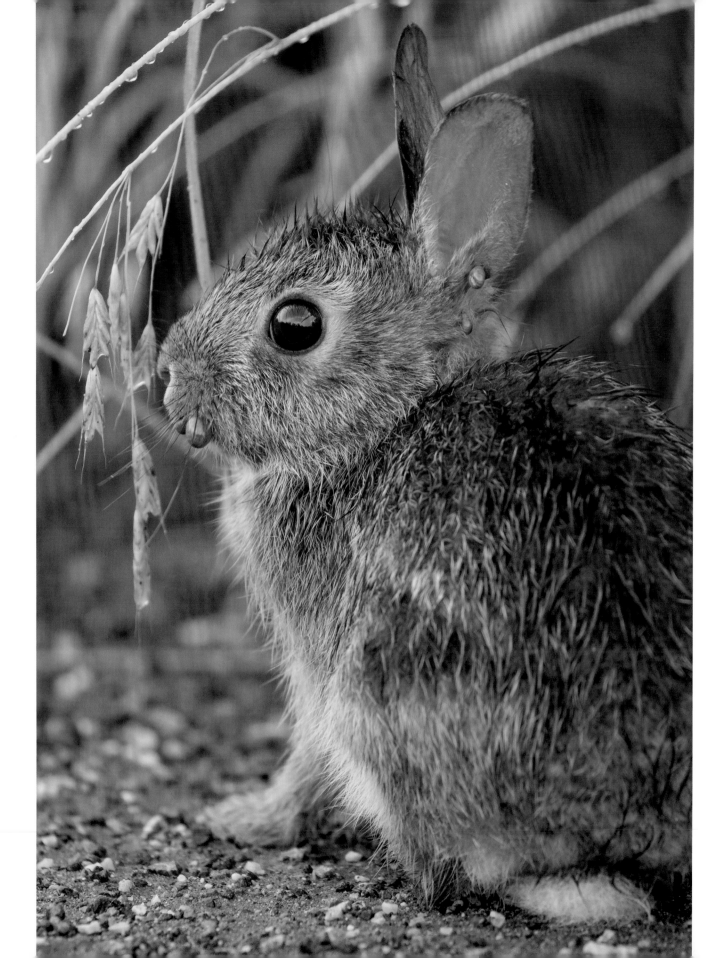

Introduction

Remembering

One recent July morning I walked a trail along the eastern bend of the Anacostia River near the boundary of Maryland and the District of Columbia, meandering through cool lowland forest into bright open meadow and back again to the protective shade of the summer watershed. For miles the river was out of view but present all the same, its ancient existence felt in the smell of the mild morning breeze, in the sight of solitary tufts of river fog clinging to the land, in the taste of the earthy humid air.

Not a single human soul appeared on the trail, and the garrulous Washington, DC, world was as quiet as it can ever be. Within this gentle urban space, baby cottontail rabbits nibbled grasses, too absorbed in their breakfast and not yet wary enough of hawk, fox, and human to flee as I approached. I knelt within a few feet of one guileless babe—so close I could see the morning dew haloing the fine hairs of her velvet ears. I noted her mother, or other rabbit caretaker, farther up the trail within an easy hop of sheltering tall grasses. She sat as still as a bunny statue, casting fretful eyes at the hapless little rube who continued to nibble despite the very real danger of being scooped up by me and snuggled. I resisted the urge and moved on, not wanting to add too much extra stress to rabbit rearing.

Farther up the trail, a box turtle sporting a mesmerizing shell patterned with cryptic archaic pictographs sat in the center of the path, basking in the day's early warmth. This small but significantly more sensible Anacostia resident eyed me warily. As I tried to approach, he fled the turtle way: slowly, and into his shell.

I continued on into the slumbering city silence until I chanced on a shaded grove filled with the sweet song of cardinal, wren, bunting, and robin, alongside chittering choruses of cicadas chanting their summer

love sonnets. This symphony of voices, like an echo out of a distant era, whispered notions of a forgotten world and way of being. They spoke of need, of fear, of desire, and of babes not yet born; they spoke of home. They had been singing their lives into the fabric of this river landscape for thousands of years before *Homo sapiens* knew this place existed, before we as a species existed. And each song, crafted and learned over eons of Anacostia life, through winged generation after winged generation, offered a tender entreaty: *remember*.

I spun round and round, looking for the voices in the dense growth of summer, straining my eyes to match sound with singer. Cicada, ever ethereal, remained utterly incorporeal, perfectly concealed against the bark beneath the verdant river canopy. Birds appeared only as streaks of cobalt-blue, russet-orange, and cherry-red, flashing back and forth across the trail and into the deep shadow of trees. These rainbow sprites and invisible chanting clerics left me swirling in the mystery of Anacostia. In these dog days, at humid dawn, this place can feel like a lucid dream of an almost-paradise.

But dreams are as intangible as cicada song and prone to disappear as unceremoniously as an August morning fog. When I reached the river, the airy dream dissolved in the glare off grimy plastic bottles, toys, take-out containers and other trash, and pollution scrubbed from city streets

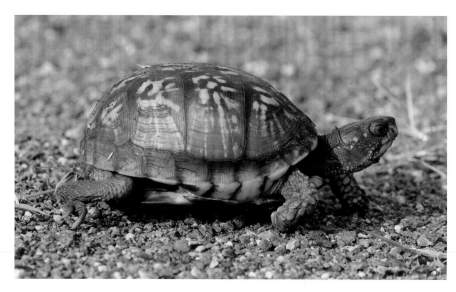

by an overnight summer storm. Flushed through street drains and down inundated creeks, the garbage had gathered on the river and formed enormous oily flotillas that idled on the water. It was slack tide, so the flotillas lounged about as indolent waste islands, waiting for low tide to carry them downriver on their journey to the Potomac and Chesapeake Bay. I stopped for a moment under the Route 50 Bridge to watch the stalled waste procession.

The bridge groaned and rattled under the impatient weight of car and truck traffic, screaming along in pre-rush hour fashion, many of the drivers likely unaware that they passed over the Anacostia. Thousands pass over every morning—I wonder how many know the role this river played in building this city and nation or the dear price the Anacostia paid for it.

Beneath the bridge the amber-gold morning sun reflected off the river onto concrete uprights adorned by graffiti. I had seen the graffiti before. Scrawled here by the Catholic University rowing team, it read: "The efforts of all who row here make this river hallowed." It seemed a fight song for a training field, having little to do with the storied Anacostia. But this particular morning the sun's shimmering reflection off the river struck the underside of the bridge just right so that it projected a geometric highlight on the words *make this river hallowed.*

The message arrested me, and I stood there staring at the bridge for

a long while—long enough for the sun's angle and intensity to shift, long enough for the rising July heat to urge me onward. For days afterward I thought about the illuminated graffiti scrawl, considering it in the context of the Anacostia, and all the while a persistent question dogged me: *How can you consecrate what is already sacred?*

Looking back at the venerable history of this watershed, which predates our own pages in any Earth story by billions of years, you can read the epic saga of a river landscape that felt the scorch of molten rock and the floods of melting glaciers; that was inundated by an inland sea and became home to some of the very first sparks of life on Earth; that felt the soft blanketing of Jurassic fog and the angry bite of Pleistocene wind. The Anacostia landscape supported the crushing feet of the *Astrodon*; its waterways extinguished the thirst of the fierce *Dryptosaurus*; and as the eons flowed ever onward, it saw nearly all of dinosaur-kind extinguished—only our feathered rainbow sprites remain to sing the memory of their long-gone glory. This watershed gentled into a land of lush forests and wetlands where bison and mammoth grazed and where wolves hunted; and the Anacostia, with open arms, offered life to a tribe of Algonquin people for thousands of years.

No, we cannot make the Anacostia sacred; we can only learn to understand, or remember, that it is.

I have worked since 2010 to document the river with my camera, to research its history, understand its realities, and know its residents, both wild and humankind. I have pondered how to tell its story, how to reconnect people to our watershed ecosystem by showing what I have seen—a great well of ecological sorrow and a great wellspring of resilience and opportunity. This story is our story; it belongs to all of us who live in the watershed or have responsibility for what it has become under our stewardship. But the Anacostia also belongs to the wider world, and its history belongs within the context of a much broader narrative of ecological failure and, hopefully someday, redemption.

Seventy years ago, just before he died, Aldo Leopold finished a collection of essays titled *A Sand County Almanac*, which detailed the seasons of life in Sand County, Wisconsin. These essays, as Leopold described them, told of the "delights and dilemmas" of one who could not live with-

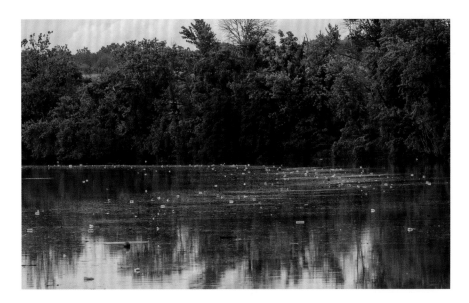

out the wild. They spoke of need, of beauty, of connection and discord. They offered a lament for the loss of wild places and creatures and formed a platform for the land ethic that Leopold proposed, which has become a cornerstone of our environmental understanding, of our place in the story of Earth.

As Leopold was writing his prophetic essays in Wisconsin, here in the nation's capital the culmination of all his fears was unfolding on the banks of the Anacostia. The river's ecological fabric had already been torn from every possible angle. It had been channeled, walled, deforested, and dumped on. While Leopold was writing about the meadow mice, rough-legged hawks, and oak trees of Sand County, the National Park Service was lending out the banks of the Anacostia as a dumping ground for the refuse of the nation's capital. That garbage, the waste of one of the world's wealthiest nations, was burned every afternoon in a national park surrounded by one of the city's most impoverished neighborhoods. On the banks of the Anacostia came the violent collision of colossal failures in ecology and justice—all brought to a painful nadir in 1968 with the death of a small boy in the Kenilworth dump.

Just four hundred years earlier the Anacostia had been a living, breathing artery of life for the Nacotchtank people. At the time, seventeenth-century English trader Henry Fleet described the Anacostia as "the most

pleasant and healthful place in all this country." But in a wink of time we transformed it into a toxic channel and dumping ground maligned by the federal government's engineers and land stewards and ignored by the capital city of the world's self-proclaimed greatest democracy.

You could point to a thousand moments in those four hundred years that led to this tragic outcome, but ultimately the profaning of the Anacostia was made possible by one factor: forgetfulness. In our Anacostia amnesia we forgot many important things that should not have been forgotten: the beauty of an old-growth forest, the joy of jumping in a clean river on a hot summer day, the thrill of seeing a bald eagle soaring high above the earth, and a kingfisher speeding along just inches above the water; we forgot the satisfaction of struggling to haul a healthy fish out of the water and preparing it for a family dinner; and we forgot the simple pleasure of sitting on the riverside and gazing down into a clear water-sky to watch turtles fly with perfect, impossible grace. We forgot what these things mean to us as humans. But most of all we forgot that we are a part of a community of land, water, air, bird, mammal, fish, amphibian, and insect. We forgot that this river watershed is our home, our ecosystem, our own community in which every single resident has both rights and responsibilities for the common good.

This book in essence is about community. The Anacostia community's bonds were broken when forests were clear-cut, roads thoughtlessly built, the land burned, scraped, divided; when justice was ignored and children lost; when the bond of trust between government and people was shredded by a culture of indifference. Through centuries of disregard for the health of those with the quietest voices and least power, this community was severed, with pieces of ecological and cultural fabric cut and scattered in the gale-force winds of national progress. Some may say that was a necessary sacrifice, but that progress has starved every watershed resident of basic natural joys and divided us from each other, leaving jagged-edged fissures at the foundation of this city. Whether and how we knit those pieces back together will determine the future of Washington, DC, whose health, peace, true prosperity, and sustainability have always been tied to this river. A community that desecrates its home and disavows its most vulnerable residents can never fully thrive.

Fortunately, here on the Anacostia, we have luminaries to guide our path forward, from Frederick Douglass, John Burroughs, and Rachel Carson, to more modern and numerous river heroes who have worked for justice and restoration of the Anacostia. This book is written as a meditation of gratitude to all of them for their part in opening eyes, taking hands, and leading this community toward a new day.

I myself have borrowed wisdom of the ages to find words that might bandage the wounds of this battered watershed and to add my efforts to those of many thousands who over the past decades have given their hands, heads, hearts, and lives to this river.

The *River of Redemption* is a love story for our river, told through the seasons of heat and cold, spare and plenty, past, present, and future. The story's aim is understanding, connection, and a plea to *remember this hallowed river*.

A Note on the Text

Aldo Leopold's graceful ode to the wild community has echoed through the decades, providing a framework for healing our own broken watershed as well as landscapes nationwide. This book has been written as an homage to Leopold's work and borrows the almanac structure he employed. The narrative flows along the seasons of our year, documenting how the land and all the life upon it responds to the nearness or distance of the sun. In each chapter I offer readers a glimpse of what I have seen here and what I have learned—of my own "delights and dilemmas" on the Anacostia earth. Each chapter is titled according to the custom of many native North American cultures, to name a month for the defining quality of its days. *River of Redemption* months are defined by two temporal threads—our present days within particular seasons and the days throughout time that have led to this moment in our watershed.

The historical threads woven through the book serve to offer a context for where we are now so that we might see more clearly what possible futures lie before us and better understand our ability and responsibility to determine that future.

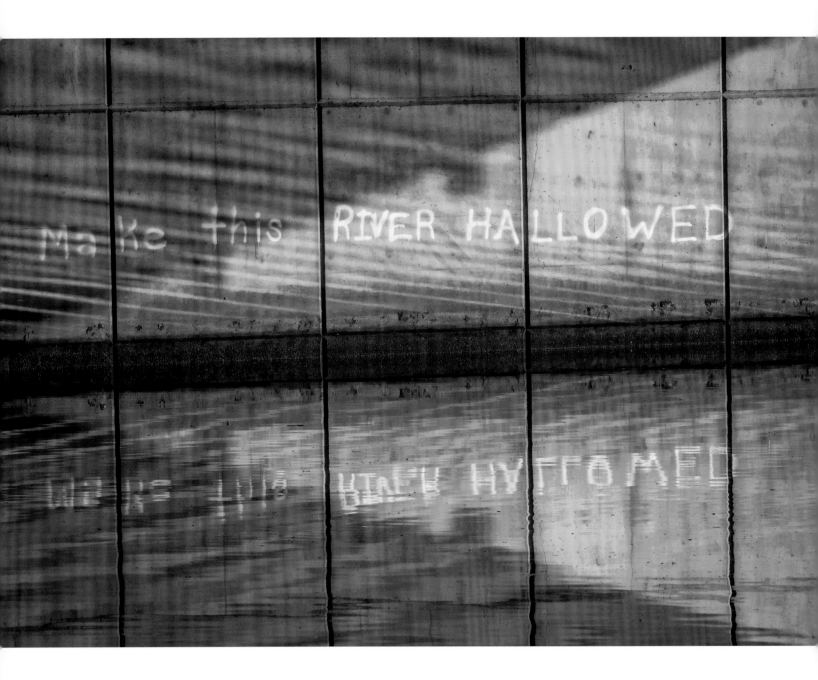

The Deprivation Moon

At icy dawn, the city remains gentled in night's deepest repose. I depart from my warm home in Mount Rainier, Maryland, and walk past slumbering bungalows and a shuttered gas station, through deserted streets, across railroad tracks, and along the edge of a sleepy forest—traversing a dark, noiseless mile to the frosted footbridge at Bladensburg Waterfront Park.

Upriver, near the confluence of the Anacostia's Northwest and Northeast Branches, hundreds of Canada geese huddle together, raising a dark feathered shield against winter's white knife and its unusually sharp edge this January morning. Last night an angry north wind descended on the watershed, driving temperatures to a low of minus eleven degrees Fahrenheit, more than twenty degrees below normal.

Today's river landscape testifies to the hard hand of that north wind. At low tide a rigid silt sandbar covers the west side of the riverbed, and a half inch of ice caps most of the remaining water surface. Downstream, the river departs to the southwest through a luminous white forest, gleaming toward the heart of Washington, DC.

I stand at river's edge in Bladensburg, Maryland, once one of the busiest shipping ports in North America, a nucleus for transatlantic trade in tobacco cultivated by the hands of enslaved Africans. This soul-weighty cargo succored a fledgling British colony and fueled an American revolution, all while sending a webwork of moral and ecological fissures spidering through the foundation of a young nation.

The thought sends a tremulous chill through my bones, though the Bladensburg waterfront before me bears little witness to this tortuous historical fault line. A few memorials to the War of 1812 are all that's left as direct physical reference to what happened here, and day-to-day this humble space exists as a much-loved nexus for people and the Anacostia

River. But in the silted shallow riverbed and bare-turf landscape, the river remembers.

On a slow stroll along the park's riverside walk, I step out onto a floating pier, where I encounter a single Canada goose asleep on the cold wooden platform. I stop, wondering why he is separated from the larger flock and surprised that he has not been roused by my presence. Inching a few feet closer, I observe that the morning frost, which has settled on the river landscape, has also laid a glittering glaze over the goose himself, whose head is locked tightly in the thick down of his back. When I approach within a few feet of the bird, he still does not stir. I reach out, tentatively, and lightly touch a tail feather, preparing myself mentally to be scared witless when the goose awakens. The feather crunches beneath my finger—the goose remains utterly still. Here is a sleep my winged friend will not be waking from.

Leaving the bird to his eternal rest, I make my way to the bank on the opposite side of the river. Ring-billed gulls have gathered on the western shore, tapping their beaks softly against the thin crust of ice covering the mudflats, searching for soft-bodied creatures in the warmer earth

below. Gulls are argumentative, pushy birds by nature, but today they are solemn and respectful of each other and barely bother to look up when I approach. In this deep cold, there exists a momentary truce. We are all too busy surviving the deficit of light and warmth to meddle in each other's affairs. There is too much to lose in January.

We all, each Anacostia and Earth resident in our own way, have strategies for surviving the deprivation moon. And in this month of scarcity and dark vulnerability, we each harden our creaturely resolve and lean, as ever, toward a universal prime directive—what Aldo Leopold called "freedom from want and fear." It is a desire never attained in life, not really, but ever sought after for all who move about on this planet, whether they are rooted to the earth and reaching toward the sun or walking, flying, or swimming in search of life's next pressing need. This elusive prize fuels our action and existence, from humble subsistence to greedy conquest. How a creature or community pursues this fundamental freedom will ultimately define it.

Leopold's anxious ambassador for this universal endeavor was a meadow mouse, gleefully building his snow tunnels and food storage rooms, gathering his brittle brown grasses, all in the safe obscurity of winter's white cloak on the Sand County land. "The mouse is a sober citizen who knows that grass grows in order that mice may store it as underground haystacks, and that snow falls in order that mice may build subways from stack to stack," Leopold wrote.

For mouse, unlike goose and gull, a long, harsh winter offers rest, a relative reprieve from the ever-keen eyes of winged predators. It is here, under the deprivation moon, that he has a frosty window on a world free from fear and want. For this clever mouse, snow is a building material and shroud for protected transportation pathways out of the eyesight of raptors, and for storage rooms to house a larder of grass for a well-fed winter mouse. The hawk, whose great advantage of speed and vision is stymied by the snow, will hold on over hungry months, awaiting a warm spell or the spring thaw, when mouse pathways are generously revealed and another winter has passed into spring—a season of increasing freedom from fear and want.

My Anacostia gulls, if they live through this trying winter, will surely

experience a similar spring euphoria and will undoubtedly squawk and caw about their spring fortune loudly and often. I anticipate shaking my head and rolling my eyes at their brash boasterisms sometime in a near warmer future, but in truth, they will then have earned bragging rights. Though they themselves are not modest, gull, like hawk and mouse, seeks a modest fortune, nothing more than freedom from hunger and a sheltering space insulated from the icy grasp of death. Gulls harbor no desires for superfluous luxury; their pursuit is simple—they want only a chance at life. Today, that pursuit demands determination, discomfort, and an efficient stillness. They keep their wings tucked tight, voices quiet, and heads down. I do the same, substituting arms for wings, and leave them to their winter misery.

<p style="text-align:center">〜〢〜</p>

On normal days, even in winter, attempting to walk onto the silted shallows of the Anacostia would be treacherous. Many have died in the urban sludge that has accumulated on the Anacostia bottom over the past four centuries of America's pursuit of freedom from fear and want. Our proclivity to hound every manner of superfluity led to the felling of ancient forests, silting of the river, and elevation of the historic riverbed some forty feet—bringing an end to the bustling port of Bladensburg. It is now almost beyond imagining that oceangoing ships once docked at this spot on the river.

I test the earth of the river bottom and find it icy-firm, a rare opportunity to experience a moment within the arterial wall of the Anacostia. We are all, always, within the body of a river. Every upland and lowland inch of the watershed plays a part in the river system, from my own backyard, to the headwaters at Sandy Spring in Olney, Maryland, to the smallest trickling capillary entering into the Watts Branch. But here, upon this artery at river-heart is where it all comes together.

On any given day, the Anacostia, like all rivers, is ever new. It is the same watercourse, but eternally changing, reinvented by moods of wind and weather, the magnetic pull of the moon on its waters, the restless angle of sun's illumination, and the wingbeats, splashes, and songs of its wild inhabitants. I stand in the middle of a unique moment flowing

together with an infinity of distinct river moments—there is a timeless surge of power here that jolts the senses and urges me forward.

Cautiously I test each step before I take it, and when the river begins to give beneath my weight, I go no farther. I am standing nearly in the middle of the Anacostia and can view the sculpted work that winter wind and restless tides have made of the river. The deep freeze that came in the night during a higher tide capped the river in thick ice, but when the tide began to go out and the air began to warm, rigid sheets of Anacostia began to buckle and break apart, like a river-puzzle—each piece now set aglow at the edges by the subdued light of a far-distant sun.

The fractured ice gives new voice to the Anacostia, a grumbling, groaning resentment as tide and current jostle the river's assemblage of broken ice sheets. But the real river drama must have happened some-time in the dark early-morning hours, when shifting tide and climbing temperatures pried the largest pieces apart. This thunderous cracking of a massive volume of water must have be something to hear—a sound track echoing the epic ecological dynamism that over so many eons of fire, ice, water, and wind, of continents colliding and seas ever rising, ever falling, created and continues to re-create this river watershed.

Somewhere in the earth beneath my feet there lies a record of the grand incomprehensible ages of river life. Somewhere, running deep beneath the riverbed, it leads down to a primal era where river life radiates in its purest form from some ancient infernal source, through a billion years of rock, clay, sand, and silt. Down fifty feet, one hundred, five hun-dred, one thousand—there lie the hallowed earthen halls of river memory.

The memory begins in the Precambrian era, 4.6 billion to 540 million years ago, when Earth was forming as a collection of molten starstuff jet-tisoned during the Big Bang. This molten matter was ground zero, quite literally the cornerstone of everything that has ever been in the world we know. As the fiery matter cooled, it transformed into the rocky founda-tion beneath my feet that through so many interactions with billions of years of water, sun, and wind became the Anacostia body. Down, down, down, deep beneath this icy landscape may rest a billion-year-old boulder comprising cosmic debris from the formation of our glittering Milky Way galaxy.

This thought expands in my head, neurons sparking out in their relay race toward consciousness, pressing against the outer space of understanding. My feet, with a direct physical conduit to this unfathomably aged earth, feel a tingle of their own sensory imaginings. My heart skips a beat.

During the span of time known as the Precambrian, Earth transformed from a bubbling cauldron of heat and creative energy to a blue planet covered with water and shifting continents of land, ever altered by heat energy erupting from below and sun energy beaming from above. The contours of the land carved by upheavals epic and unseen created spaces for water to flow and pool, evaporate and precipitate. Watersheds took shape, creating the framework for the intricacies of the land and habitats for all the living forms that would follow.

Life began in the Precambrian. A tiny mysterious spark grew into microscopic green hairlike bacteria that multiplied and began to exhale oxygen from their undulating green beds upon the ocean. Over many millions of years the collective breath of these cyanobacteria gave rise to an oxygenated atmosphere that animated Earth. We owe these little ancients everything. All we are, including the air we breathe today, remains entwined inextricably with their Precambrian exhalations.

Rock, sun, water, air, and hairy green spaghetti—deep beneath my feet lie these primordial membranes of river memory, shrouded in a few billion years of mystery that scientists are only beginning to unravel. The Precambrian covers almost 90 percent of the known geologic time line, more than *four billion years*, yet it is nearly as coherent as a bumblebee nightmare about an asteroid collision on the dark side of a Jupiter moon.

Exactly what the region now defined as the Anacostia watershed looked like during that immense span of time is speculation. There were certainly rock, water, and toward the end of the era some foundational lifeforms, but it would probably have looked to our eyes like a bombed-out moonscape bereft of trees, plants, or any visible life on land. By the end of the Precambrian, sea life included sponges, jellyfish, and worms. But they had the world to themselves.

At the dawn of the Cambrian period, 540 million years ago, a sharp rise in global sea level inundated our Mid-Atlantic region, and something epic began to unfold. Scientists call this time period the Cambrian *explo-*

sion, and though the explosion spanned twenty to twenty-five million years, this was a nuclear blast of biological events. For four billion years Earth had existed with almost no biological activity, a.k.a. *life*. Then suddenly, in twenty million years, atmospheric and geologic changes sparked the rise of most of the major animal groups. Arthropoda. Mollusca. Chordata—the trunk of our own family tree and all of our distant relatives like the blue whale, bumblebee bat, marmot, and meadow mouse. Based on what we *Homo sapiens* can read in the ossified Earth memory, the Cambrian explosion represents a geologic split second when all of these creatures' ancestors opened their eyes for the very first time.

These early animal pioneers inhabited an Earth unrecognizable to our eyes, and as they evolved, massive transformations were ongoing. About sixty to eighty million years after the Cambrian explosion, North America collided with a volcanic island, crushing what we now call Maryland. This collision—the Taconic orogeny—smashed the landscape of our Anacostia and the Mid-Atlantic, but it happened over millions of years, so slowly that even the longest-lived creatures of that time would never have noticed it. Yet so colossal was this battle of giant landmasses that it crushed the eastern edge of North America, smashing flat earth into a mountain chain. This mountain range was the beginning of the Appalachian Mountains and, in a way, the beginning of our Anacostia.

Though the mountains are so far away from where I stand on this winter river I can't begin to see them, I am currently standing within the great drainage basin of the Appalachian foothills, or piedmont. This mountain range formed and re-formed over hundreds of millions of years as the restless land wandered and was weathered by flowing water, relentless wind, and grinding ice. Over the past 450 million years the Appalachians have gone on some grand geologic adventures. During the 125 million years spanning the Paleozoic and Mesozoic eras, the Appalachians and all of North America joined with Earth's other landmasses into a single enormous continent we call Pangea. During that period, our mountains were just one section of a vast range called the Central Pangean Mountains, which spanned Pangea from the northeast to the southwest. As part of that range, the Appalachians were contiguous with both the modern-day Scottish Highlands and the Little

Atlas Mountains in Africa. Thus, while Pangea was intact, and if human beings had existed at the time, we could have taken an easy stroll from the Anacostia region to Africa!

On this frigid morning, a stroll to Morocco has a certain appeal. I consider for a moment the cultural ties that connect this landscape at the foot of the ancient Appalachians to both Africa and Scotland—from the rocky roots of our mountains, to the roots of mountain music, to the cultural and geographic roots of the people who have long inhabited the Anacostia watershed. Sparks of connection swirl in the air, mingling with my frozen breath. The temperature is beginning to rise, and the frosted river is beginning to fade to a colorless corridor of brown mud, water, and bare bark. I make a judicious choice and leave my frozen midriver musings while the ground is still good and solid. I trek across the river, back to the western shore, and along a path of brown grasses to the lowland forest that follows the river's every bend to the south.

Here winter's deprivations are joined with the deprivations we as a society have visited on land and river. This forest is young, a pale reflection of the aged trees that sheltered the first human inhabitants of this landscape. It is quieter than an ancient forest would have been, even in winter.

I stroll slowly through the stark naked beauty of the winter riverside. On the ground lies a matted bed of last-year's life: a memory of a thousand green leaves reaching toward the nearest ray of solar energy, bringing life to a forest that will, by their work, outlive them. Mingled with fallen leaves are insect bodies who, in summer, consumed leaf energy and gave song to the forest in return. Their song has died, their bodies joined with the silent soil. All around the dark bones of the forest slumber. Even in sleep they seem to reach for the far-off sun. I walk on, quiet and content beside the river, within the restive community of bramble, maple, ash, and birch.

Suddenly my winter eyes are arrested by a brilliant blue-and-orange beacon, a chromatic incongruity that floats on the air for a moment, then comes to rest on a bare limb outstretched over the water. My heart skips another beat at the sight of this beauty, this unexpected, colorful company, an eastern bluebird. The surrounding landscape gives no hint of

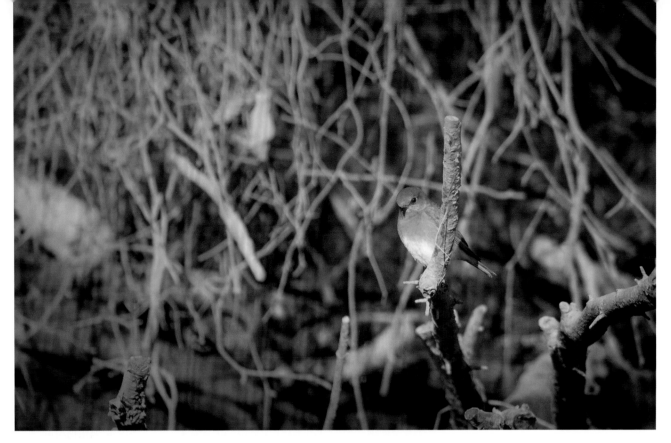

how he survives the winter: barren branches, not an insect in sight, bitter cold. But somewhere nearby there is a bright red berry on a holly tree with his name on it. The bluebird, like many other birds who share this winter landscape, adapted its habits and geographic range as plants like the holly tree made berries and evergreen foliage available through the frozen months. His presence is a testament to the strange, seemingly infinite series of events that over time brought about the landscape we are sharing at this moment.

I sit down on the frozen riverbank and look across the river, which now moves through its channel as a sluggish frozen gravy. On the opposite side, a red fox moves quietly along the shore, which is littered with an old tire, plastic bottles, a soccer ball. Foxes are adaptable; they have learned to quietly keep their place in an ecosystem too broken for most of their canid relatives. The red fox arrived in the Anacostia thousands of years ago, around the same time as my forebears, using the same land bridge across the Bering Sea during the Wisconsin glaciation. They have survived this long by virtue of their extreme cunning—a trait that has memorialized them in human mythology spanning global cultures, from those of Chinese, Japanese, and North American native peoples, to the Celts—who I think have the best myths about witches who can turn themselves into foxes in order to steal butter.

Beyond mythological powers, foxes have real-life staying power. In part they remain here because humans dispatched most of their larger rivals—wolves, coyotes, and mountain lions—whom we viewed as rivals to ourselves. But their prey species remain steady, including reptiles, birds, rabbits, and of course, the modest mouse. Mice in their snow tunnels may have an advantage over hawks, but not so much over foxes, whose ears are so sharp they can hear a mouse squeak three hundred yards away and accurately pinpoint the creature's location.

The red fox's dexterous adaptability has made him a survivor. Not an easy feat. Just ask the dinosaur. When Pangea began to break apart in the middle of the Jurassic period, 175 million years ago, the life-forms wandering the planet, and our Anacostia, were as mythical in stature as were the landmasses they evolved on. The landscape during this period varied from a warm shallow sea, rich with marine creatures, to a humid tropical lowland, lush with magnolia, cypress, and redwood trees, dynamic with volcanic activity and alive with a menagerie of Jurassic creatures. The dinosaurs were gone forever before we even existed. They seem almost as distant and unfathomable as the mythical kraken and Loch Ness monster. Yet they were real, and the Anacostia land remembers these giants and the watershed they inhabited millions of years ago.

At the southern end of Laurel, Maryland, tucked behind strip malls, parking lots, office complexes, and warehouses, there hides a curious patch of land near the meeting point of the Anacostia and Patuxent watersheds. An aerial view reveals a bare spot of earth with asphalt, rooftops, and roads on three sides and a small tract of forest to the southeast. This site was an open-pit iron mine in the mid-1800s. One day, in 1858, workers came across some odd bones, which turned out to be remnants of an enormous plant-eating dinosaur, or sauropod, the *Astrodon*. The miners' discovery, right here in our Anacostia watershed, was the first sauropod fossil found in North America and the second dinosaur fossil of any kind found on this continent. Since then, over the past 150 years, thousands of animal and plant fossils dating from the Cretaceous period have been found here and are still being discovered. I visited the site one day and, alongside a group of excited children, helped archeologists search for new discoveries. I found a petrified seed cone from an ancient redwood tree.

This site, one of the most important archeological deposits in the United States, has helped scientists form a snapshot of what this landscape looked like 110 million years ago. It was a wild watershed, where the first great expansion of flowering plants was occurring, making way for the evolution of the first pollinating insects. On this flat coastal plain, winding rivers flowed and within them swam crocodiles, turtles, a tiny shark called the hybodont, gars, lungfish, and bowfin. On land, beneath towering redwood forests, large predators like the *Acrocanthosaurus* stalked the *Astrodon*, who walked the warm, wet, bayou landscape with *Priconodon*, an armored, spiny plant eater; ornithomimids, like a modern ostrich; and dromaeosaurs, a feathered velociraptor. These creatures ruled Earth, their presence ensuring that mammals remained modest, small, and secretive. The dominion of the dinosaurs was well beyond our reckoning.

But then, just like that, a Mesozoic river dream came to a sharp Pliocene end. The dinosaurs were gone. In a thin line of earthen rock deep beneath my boots may lie evidence of the utter end for a whole suite of species whose like Earth will never see again—and the beginning point for my own species. At the end of the Cretaceous period three-quarters of the plant and animal species on Earth disappeared in a mass extinction marking the end of the Mesozoic era.

Within the genetic code of every species lies a richness of time and remembrance of those creatures who came before it. In the Cretaceous extinction, innumerable volumes of evolutionary memory, reaching back billions of years, simply disappeared. All that remains is an earthen memory—bits of bone, prints of an enormous foot—buried deep beneath this Anacostia landscape. And alongside them may be trace evidence of their capricious fate in the form of an enormous asteroid believed to have struck Earth some sixty-six million years ago. This asteroid left a crater one hundred miles wide in the Gulf of Mexico and ignited a domino effect of cascading atmospheric and climatic chaos—the assumed cause of the Cretaceous extinction.

It took Earth ten million years to recover, but eventually conditions developed that gave rise to much of the animal kingdom we know today—from birds and whales to bats and eventually a many-branched family tree

of primates. Somewhere above the bones or other evidence of the foot-falls of dinosaurs within this Anacostia riverbed may linger some evidence of the beginning of the Age of Mammals, when giant sloths, cave bears, saber-toothed cats, and camels roamed North America.

Just under two million years ago, glaciers gouged the continent, advancing and retreating throughout the oscillating cold of the Pleistocene epoch. Those ice sheets never reached the Anacostia, but that era of deep freezes and recurring thaws made its mark on our river landscape. Epic floods and shifting sea levels carved the topography and rainwater path-ways of this watershed, creating the modern architecture of the Anacostia, the bones of the river body. And somewhere down there, mingled with pollen of spruce and pine forests that shaded this land at the end of the last major ice age, is a river memory and earthen record of storybook fore-bears that predated human existence in the watershed. Here, beneath my bipedal primate feet, the river remembers footfalls of mastodons roam-ing its moist wooded landscape, showering river hillsides with seeds for a modest mouse and his vole and chipmunk cousins. The Anacostia earth remembers crisp mornings of quiet fog hanging on crystal-clear river waters; the sound of a noisy river crossing by bold, restless musk oxen; the soft lapping of river water by a secretive wolverine: these echoes of life live somewhere in deep sandy soils, within the bones of tapir, peccary, badger, and bear, lemming, mink, and tiny shrew that once roamed this water-shed in search of freedom from fear and want. The Anacostia's memories of clean waters, healthy forests, and innumerable fish splashing through her streams lie hidden deep beneath this city, in some core place where river resilience lives.

And from that time ten thousand years ago there is perhaps a record of the footfalls of the first *Homo sapiens*. Their numbers were few, and their reliance on hunting and fishing required them to revere the river and forest. Perhaps fifty feet below my boots lie arrows and knives made of stone, shards of pottery, pollen from a hemlock forest, and the bones of sturgeon, shad, and elk. They lived in balance within and as members of a healthy Anacostia community. And the river remembers.

But this is where the Anacostia memory changes, after 4.6 billon years of becoming, to a story of undoing. The river story of Washington,

DC, is suspended, for the most part, in the topmost forty feet of riverbed. The story's surface can be seen on this cold winter morning and continues back in time to the late 1700s, when European conquest of this region was complete, the United States was forming as a nation, and human population in the watershed was rapidly increasing.

The topmost layer, which crunches beneath my boots, consists of the salt that road crews, businesses, and homeowners have over the past weeks shoveled onto sidewalks and streets, to be carried by snowmelt through storm drains to the riverbed. Below that, within the first foot of earth, the river remembers last summer's stormwater runoff, a slurry of silt, oil, pesticides, plastic, cigarette butts, and a million particles of polystyrene like a poison snow that never melts. Farther on down in this modern layer, running through most of our forty feet, we find deeper, older chemicals, the legacy of a city dump, energy production, and the manufacture of weapons of war. Alongside these toxins swirl the sewage of centuries and the silt pollution that has run off the land during every construction project—from recently clear-cut forests for Whole Foods, Costco, and Lowe's, back to the building of the Navy Yard—and agricultural development since the 1600s, when the land was scraped bare and planted in tobacco. Here, in this exact spot where I stand, deep within the river earth is a memory from the land that echoes the iron shackles around the feet of Africans who survived the horrors of the Middle Passage and disembarked at the docks of Bladensburg, where endless bales of tobacco were being loaded for transport to England. Just beneath my feet lies our signature on the land, a crushing legacy beneath a proud city that broke a river community. And the river remembers.

Our earth record is deep for the time it represents, only a few hundred years, because the scope of changes that have occurred during this period is unprecedented in river memory. The Anacostia has weathered bigger transitions in its lifetime, inundations by great seas, volcanic explosions, mass extinctions. But never has so much devastation happened in such a short span of time. Geologists might one day label it the *Washington implosion*. Here we have an utter transformation of watershed dynamics in less than four hundred years.

But there is something else, a shift that has happened so recently that

as yet it leaves little trace, even in the topmost millimeters of river memory. Perhaps some subtle evidence exists, a slight increase in tree pollens, a growing concentration of seeds of wild rice and aquatic celery, the shell of an eastern elliptio mussel, fragments of shell from the natal home of a bald eagle chick, a slight lessening in the toxic content of the sediment— in short, the physical evidence of a new human consciousness and action to heal the Anacostia. Our role here is changing, and someday, someday, the river will remember.

A flash of blue stirs on the branch above me, then darts into the winter forest. Fifty years ago bluebirds were in decline due to habitat loss and invasive species like starlings and house sparrows, introduced from Europe by humans without thought to the ecological ripples they would cause. But then humans noticed the disappearance of this beauty; we realized that its scarcity on Earth impoverished our community in some important way. We began putting up nesting boxes and planting trees, trying to replace some of the habitat we had destroyed. Since 1966, bluebird numbers have been increasing to an estimated global breeding population of twenty-two million birds. It was also in the late 1960s that the consciousness of the dire plight of the Anacostia began to shift—because it was at that moment that the Anacostia River was plunged into its darkest hour.

DEPRIVATION

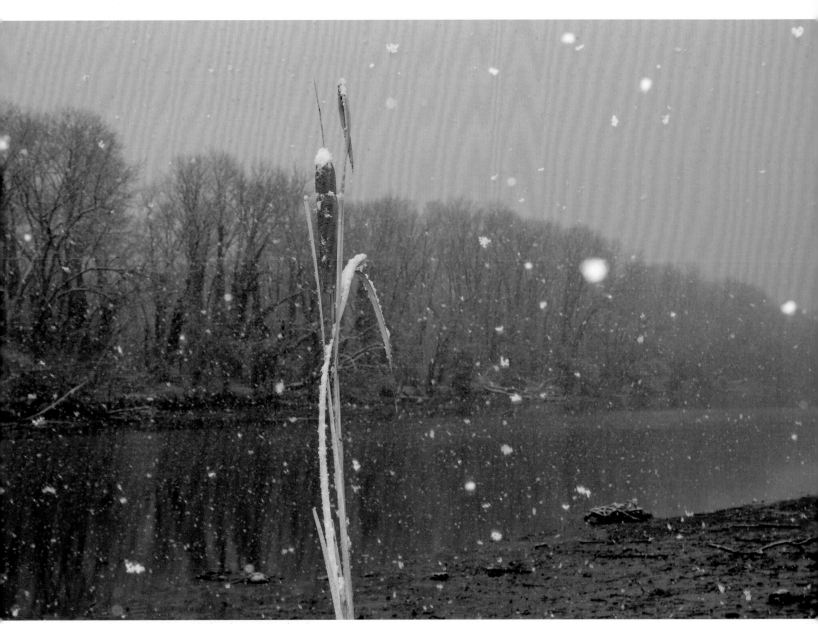

Anacostia River, Bladensburg, Maryland

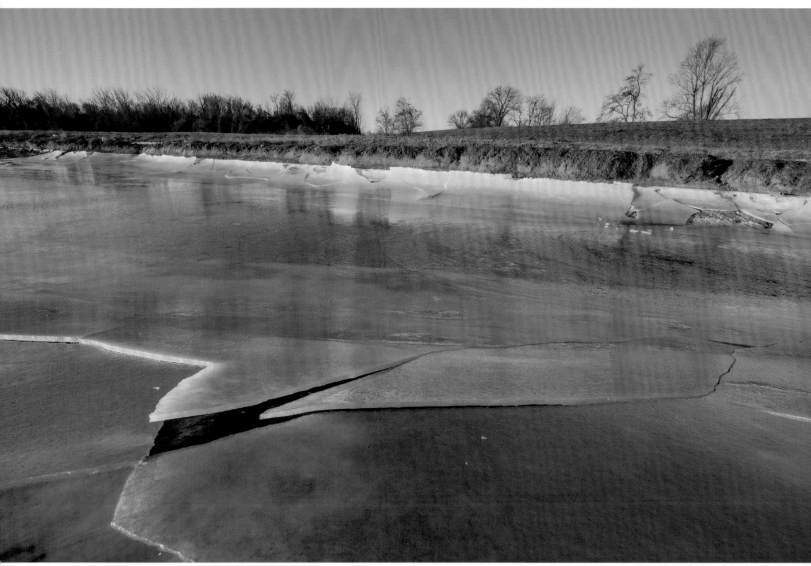

River ice breaking apart, Bladensburg, Maryland

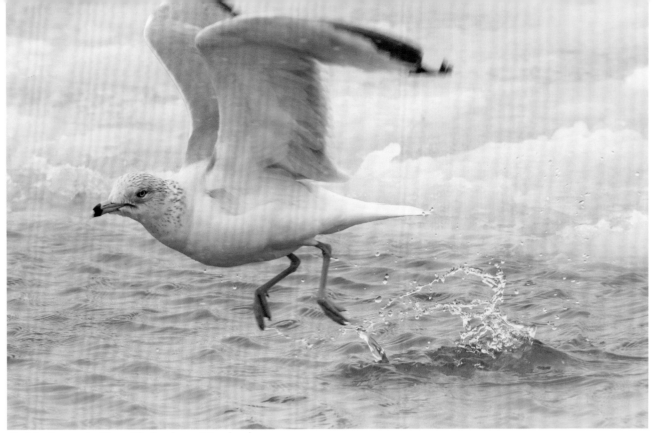

Gull in Anacostia River, Bladensburg, Maryland

Northwest Branch, Hyattsville, Maryland

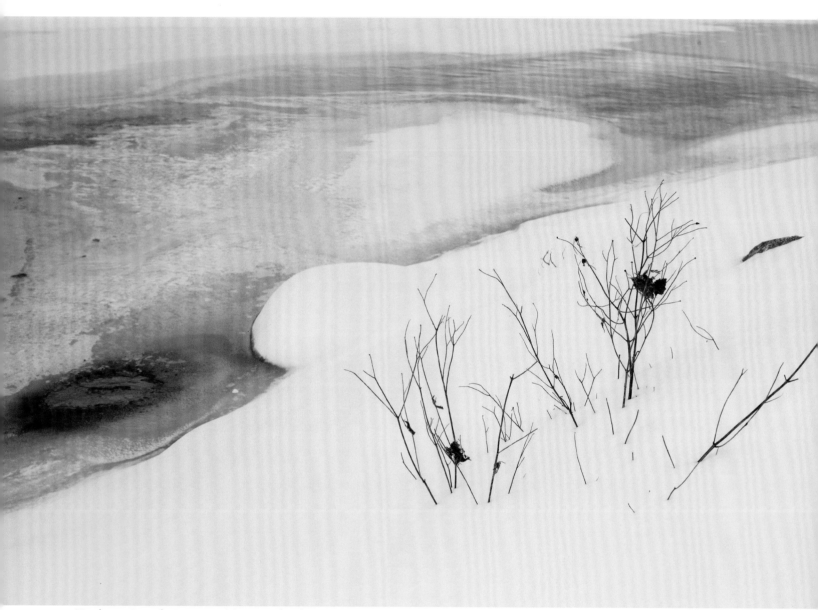

Northwest Branch, Mount Rainier, Maryland

(AT RIGHT) *Goose tracks in snow along Northwest Branch*

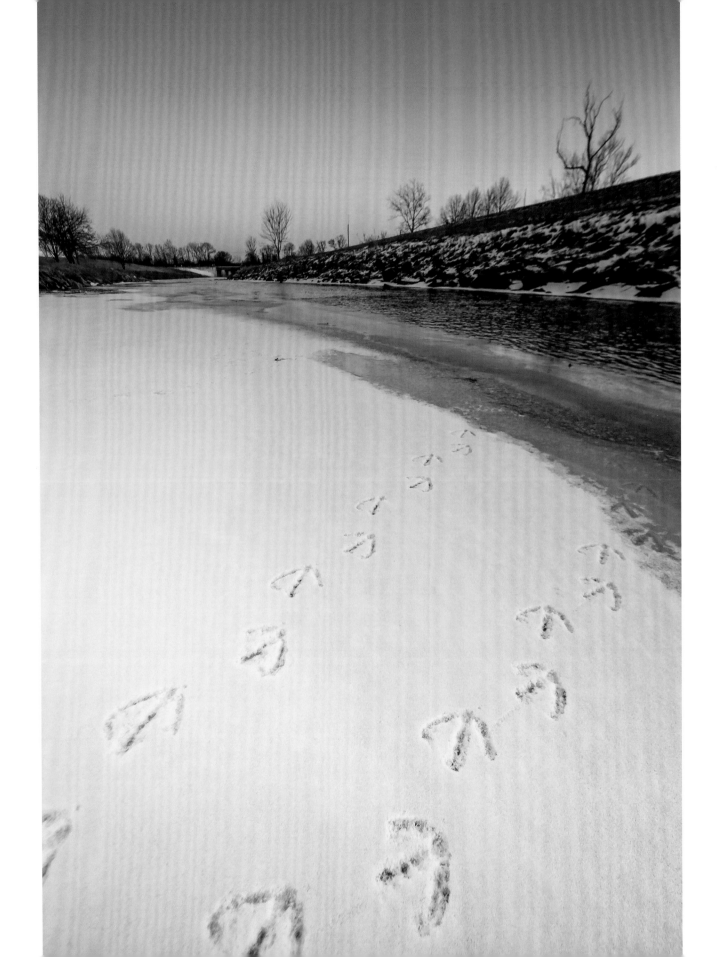

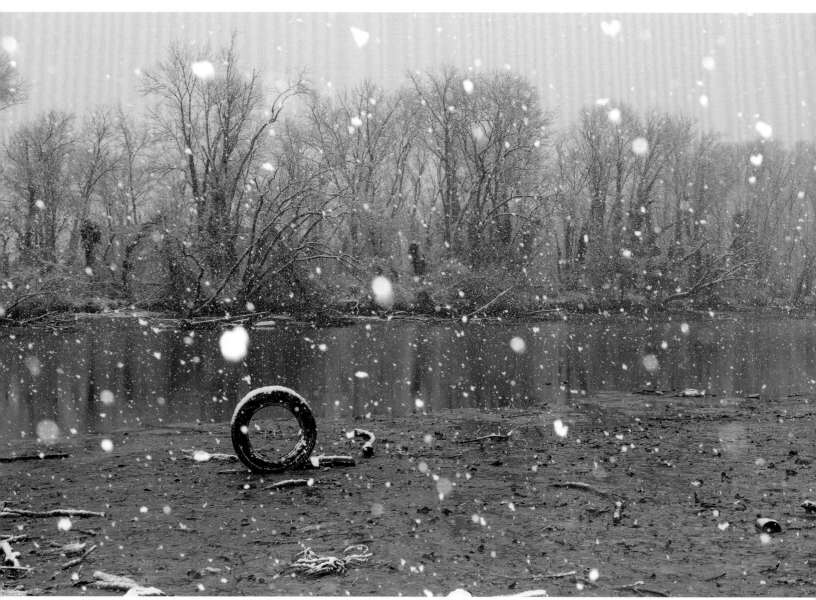

Anacostia River, Bladensburg, Maryland

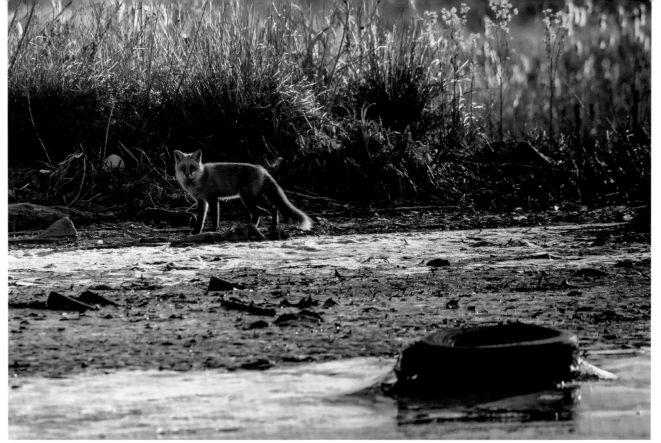

Red fox

Tire and ice, Anacostia River, Bladensburg, Maryland

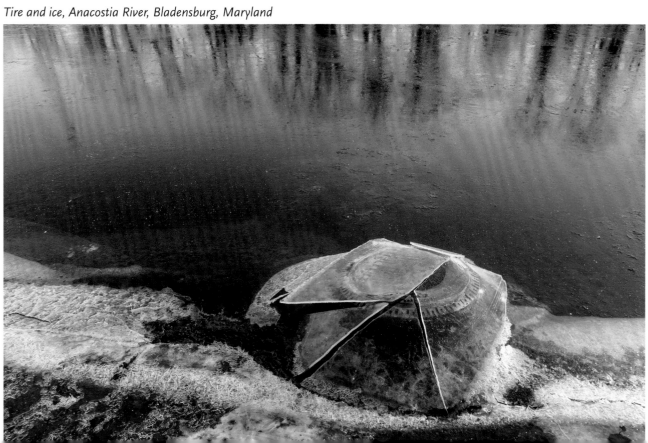

The Fire and Ice Moon

An ashen cloud shrouds Kenilworth Park in cold, gray shadow this morning, casting an especially bleak pall on the asphalt moonscape that sprawls across the southern end of the park. Winter wind strikes my face as I gaze westward across a field of pocked gravel and bare turf, toward the sliver of remnant forest that lines the river. The voice of a distant Carolina wren, perched across the river, rings out from the forested bluffs of the National Arboretum. His loud, sweet song lofts along the Anacostia, an optimistic note challenging the drear of the day. I stop, gazing for one wistful moment in the direction of the quixotic bird. Would that I could go to the river and sit in quiet audience until the little crooner has tired, that I could linger as cloud, sun, and shadow dance to the tune of a jaunty north wind.

Instead, I force my feet to walk in the opposite direction, obligated by the singular reason I have come here on this particular morning, February 15. The anniversary of bedrock bottom for the battered soul of the Anacostia. What happened here forty-nine years ago today, the river will always remember. I turn my eyes to a blank, recently plowed expanse of bare earth to the southeast, stretching one hundred yards toward the mouth of the Watts Branch. This ocean of dirt, made heavy by the moist winter wind and made tidy by machinery over the past week, cannot hide what lies beneath—the last immortal remains of the Kenilworth dump. It will not be mourned.

For most, it is long forgotten.

But forgetting a hidden wound doesn't heal it. No matter how deep we bury this place in the crypt of collective memory, it shadows us, a toxic cultural and ecological undercurrent of our river community, one of those deep hairline fissures set in motion when English settlers followed John Smith up the Potomac, bringing with them the seeds of the Anacostia's destruction, quite literally.

Tobacco.

Introduced to Europe by Spanish explorers in the West Indies, tobacco had become a hallmark of social status within the ruling class. Demand for tobacco grew as renowned physicians began to lecture and publish articles about the health benefits of this new plant from the colonies—which, according to some, was a medical cure-all, a solution to every manner of malady from headaches, constipation, snakebites, and joint pain, to "rottenness of the mouth" and "windiness."

As news of its prowess spread, tobacco became the economic foundation of the struggling British colonies in the Chesapeake Bay watershed. So central was this plant to colonial success that setting a minimum price for the commodity was the first item on the agenda at the very first meeting of the first elected governing body in the North American colonies. That meeting of the Virginia House of Burgesses took place at the Jamestown Church in 1619. That same year, the first twenty African slaves were sold in Jamestown.

Up until this time, British colonies had proved themselves hapless in both the growing of food crops and the building of relationships with native peoples. For the floundering colonies, tobacco offered a way out and a way up—a means of transferring wealth and power from Europe to the New World. Wealth would buy weapons for conquest and expansion, food for sustenance, and slaves to produce more tobacco and keep the cycle of wealth and power flowing. With a growing demand and nat-

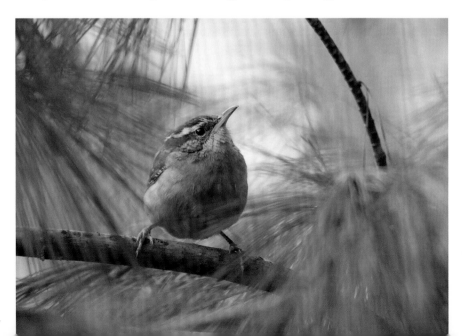

ural scarcity of tobacco in Europe, sales were assured; and the production opportunity in the colonies was bounded only by the supply of labor and land and a means of transport abroad. In the Anacostia watershed, these bounds could be removed by slavery, suppression of the Nacotchtank, and the river.

Tobacco production in the Chesapeake colonies exploded in the seventeenth century, from twenty thousand pounds in 1619 to thirty-eight million pounds at the turn of the eighteenth century, just eighty years later. In the same span of time, the number of African slaves tending the tobacco economy grew from twenty to seven hundred thousand.

By 1640, both Maryland and Virginia had made tobacco official legal tender—cash money. It's really no wonder then why forests were scraped clean off the land: they could be quickly transformed into money that literally sprouted from the ground. For 150 pounds of tobacco, a man might buy more land or a larder full of groceries, or he might purchase an English woman for a wife or five years of the life of an indentured servant, or put a down payment on the entire life of a slave—all of which would help the planter cut down more trees to grow more tobacco money to buy more land and people.

This tobacco cycle ripped like a cyclone over the Chesapeake Bay and into its sub-watersheds, including the Anacostia, leaving a waste of broken ecological and human communities in its wake. And like a cyclone, the ravaging of the tobacco economy could not be stopped until the forces that fueled it were spent: either demand for tobacco eased, or the supply chain was disrupted. Until then, the pursuit of tobacco riches would continue to scour the land and soil and soul of an embryonic nation, hardening the concrete of a European economic model in which wealth was defined by profits, land, and slaves.

How you define wealth defines you in turn.

Tobacco bled the land at its foundations, draining the soil of nutrients in three growing seasons. Rather than let profits lag while the earth recovered, forced labor was increased and new forests were stripped of native plants and animals and replaced with tobacco.

By the mid-1700s, half of the human population in Prince George's County—one of the primary tobacco-producing locations in the British

Empire—was enslaved. And by 1860, most of the Anacostia community—goldenrod, boneset, oak, bloodroot, blueberry, strawberry, cypress, walnut, bumblebee, bird, and Nacotchtank people—was gone. Of course, not every single plant and animal disappeared, and the Nacotchtank held on despite being scattered and displaced by the European subjugation; but the *community*, the infinitely complex intelligence that was the land community with all its immeasurable components and intricate connections, was dismantled, disambiguated, defiled. Ten thousand years of coexistence—from the Precambrian lava land, through the Cambrian explosion of life, the lush Jurassic land of dinosaurs, the great Cretaceous extinction, and birth of the Age of Mammals—everything that led up to the Anacostia landscape that existed when John Smith stumbled upon the ecological riches of an Eden on Earth was gone within a span of 250 years of the European commodity economy.

The tenure of this loss will endure for thousands of years, but the first practical consequences for the Anacostia appeared as soon as the first large-scale deforestation began. By 1762, the port of Bladensburg was beginning to clog from silt that ran off the scoured land. Stripped of the roots that had for thousands of years held her soil together, the Anacostia watershed lay naked and vulnerable to all manner of assault, from the winds that scattered her plowed earth, to the rain that flowed in torrents in spring and summer, carrying off the body of the watershed and dumping it in the riverbed, leaving a turbid wraith of water-land that smothered fish, aquatic plants, and invertebrates; blinded turtles and choked otters; and then settled to the bottom, raising the riverbed with every storm. In a matter of decades, the Anacostia River was transformed from a clear, deep river, flowing in a graceful meander to the Potomac, to a muddled, poisoned waterway that crawled over shallow, fetid mudflats, polluted by all manner of colonial detritus.

As I stand on the broken land of the former Kenilworth dump, I wonder, did anyone in colonial times mourn what they had done? The Anacostia found by the first Europeans was gone forever. Did anyone, aside from the Nacotchtank, birds, beavers, and fish lament this irreparable loss? Or

was it just another problem to be solved with all haste and expedience to ensure the tobacco would continue to move eastward across the Atlantic, money and slaves would continue moving westward, and colonial society would continue to stride forward unimpeded by grief and shame?

Had the establishment of the US capital been built on a sustainable model, the natural wealth of the region would have lasted indefinitely. Instead, those who were harvesting tobacco cash never thought further than the next hogshead of leaf, the next shipment to England, the next payment in gold, slaves, or land.

∿

The last large ship left Bladensburg in 1835; the once forty-foot-deep port had become a victim of its own crippling success. In 1850, the port was closed altogether—dredging could not keep pace with the destruction brought about by deforestation and agriculture. The river itself—choking on silt and spoiled with human waste—became a place no longer noted for its plentiful fish and clear water but only for floods and disease. Perhaps the worst indignity for the Anacostia was that our river was forced to become a servant of her own destruction, an indentured highway to the Chesapeake for the transport of tobacco; a shackled thruway from the Chesapeake for the transport of people stolen from their African homelands. No greater defilement could be visited on a river than to be transformed from an artery of life and community to one of destruction, disease, and enslavement.

In the 1880s, the US Army Corps of Engineers declared the upper portions of the river unworthy of improvement. *Improvement* had a very precise definition for the Corps—it meant *worthy of engineering*, the potential to be useful, profitable, once more an instrument in the machinery of commerce. *Unworthy of improvement* meant the river was now without value. Irredeemable. Washington, DC, had carved up the Anacostia's beautiful face, broken her body, then named her worthless.

But ironically, the Corps' dismissal of the upper Anacostia was a gift, the commutation of an environmental death sentence. The declaration was meant specifically for the Maryland portion of the river and the northernmost stretches within the District, those upriver of the Benning

Road Bridge. It meant the upper portion of the main river would not suffer the same fate that awaited the downstream portion. When the Corps of Engineers, the go-to agency of expedient solutions, stepped in, it was not to return the river to health. The major problems from the Corps' standpoint were declining navigability and human health. Silt pollution had made much of the river so shallow it was no longer passable even to small ships. Raw sewage was piped or dumped directly into the river, with the expectation that it would flow downstream and away from the capital. But given the natural slow meander of the Anacostia and its lush tidal wetlands and aquatic vegetation, sewage would often stay put and fester, fostering disease. The Corps could have devised a better sewage system and worked to reforest the landscape and improve agricultural and building practices to address the root causes of the problem. Instead, the agency opted to perform damage control and reengineering through dumping, dredging, seawalls, and levies—all of which further deformed the watershed in the name of progress.

By being unworthy of improvement, the upstream portion of the

Silt accumulation, Anacostia River

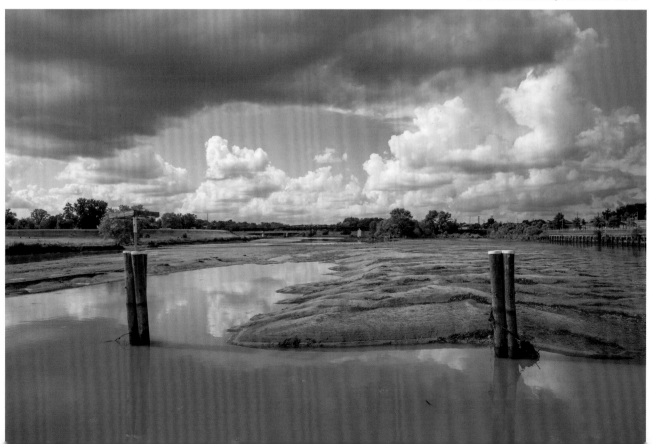

Anacostia would escape some of the Corps' improvement. But the stretch of the Anacostia from her mouth to the Navy Yard was too important to war and commerce to be left alone.

In 1891, Lt. Col. Peter C. Hains wrote in a Corps' report to Congress, "The Government has established at the navy-yard a magnificent work-shop for the fabrication of modern guns and other appliances of war." It was imperative, Hains noted, that the winding Anacostia be straightened, widened, and deepened so that ships could access the Navy Yard. He went on to state, "Besides the wants of the Navy Department, there are commercial reasons for improving the river between its mouth and the navy-yard bridge."

The problem of silting and sewage was noted in the chief's report, but there was little discussion of the root cause of these issues and how to solve them, only a plan to mitigate the inconvenience. Dredging silt would make the river passable for ships. Scraping away aquatic and wetland vegetation would cause the river to run faster and usher the sewage—and increasingly chemicals from the navy munitions factories—downstream to the Potomac and Chesapeake Bay. Hains suggested the expedient solution of dumping the dredge material onto the shallow marshlands to both smother the offending vegetation and create, or reclaim, usable land: "The reclamation of the flats must soon become a necessity, and how can this be done in any way that will be more satisfactory than by making the improvement of the channel and the filling of the flats a single job? Dredging is necessary. What will be done with the dredgings if they be not deposited on the flats?"

The psychology of reclamation was a curious one, which seemed rooted in the notion that marshlands were never meant to be—never meant to be homes for red-wing blackbirds, marsh wrens, and rails, never meant to be hiding places for muskrats or nurseries for fish and mussels. No, they were little more than a geographic placeholder until humanity got around to reclaiming them for their true purpose—real estate. I don't imagine there was a conversation within the Corps or Congress about the wildlife that would be displaced or smothered by the dumping of dredge. Did anyone note the silence that followed the machinery as the Corps swept over the land? I have found no note of it in the official record, but

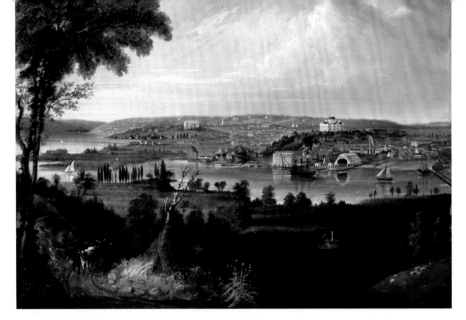

Painting by George Cooke depicting the Navy Yard on the Anacostia River in 1833. Photo: The White House Historical Association

without a doubt, the river recorded this loss and to this day remembers.

Perhaps there were others who made note of what was happening to the natural world of Washington. Naturalists like John Burroughs, scientists like Paul Bartsch, and even President Teddy Roosevelt decried the disappearing wealth of North American nature. Even as the Corps was proposing carving up the river and smothering its wetlands, the Audubon Society was gaining momentum and birders, hunters, and naturalists were beginning to speak up for the region's wildlife and quiet lands. Some of this spirit was contained, if in a confused form, within the 1902 McMillan Commission report. This report created a framework for Washington's federal park system and included ideas for a park along the upper stretches of the Anacostia. The McMillan Commission did not propose trying to restore or heal the broken Anacostia—these events predated the dawn of ecological science, and the McMillan commissioners were famous architects, sculptors, and landscape planners, not ecologists; they were largely focused on aesthetics and recreation. But inherent within their plan for the city was a recognition that access to healthy outdoor spaces was foundational to the success of the city and the well-being of its residents.

Unfortunately, the McMillan Commission echoed the Corps' insistence that the marshes of the river must be smothered in dredge material, but both entities agreed that the land created through this reclamation process should be converted into federal parkland. Over the early decades of the twentieth century, the Anacostia was deformed into a walled channel and depleted of most of its wetland habitat. But in return, in 1918 Congress set aside the riverside as Anacostia Park.

〰

Kenilworth Park—one portion of Anacostia Park—exists today because of that century-old Faustian Corps bargain: so devastating to river ecology but also, in a way, responsible for much of the natural space that now lines the river. Had Congress not designated Anacostia Park, all of the Anacostia might now be lined with factories, apartments, parking lots, and strip malls. Nothing is simple about this urban river, so steeped in a history of abuse but so filled with quiet promise.

Something unusual strikes me as I meander Kenilworth Park, where the ground, like a freshly dug grave, still bears the marks of the machinery that has recently plowed it flat: the chain-link fence that has long surrounded the last visual remnants of Kenilworth dump is now gone. This is the first time in six years that this park has not been covered with a bunch of machinery, a port-a-john, and piles of junk, dirt, and debris. All that remains is a construction dumpster, a pile of chain link, a dusty assortment of old silt fencing, and the port-a-john, lying on its side with sewage fumes fouling the air around it.

I watched workers in great groaning machines grade the bare ground

Army Corps of Engineers map of the Anacostia and plans for "improvement"

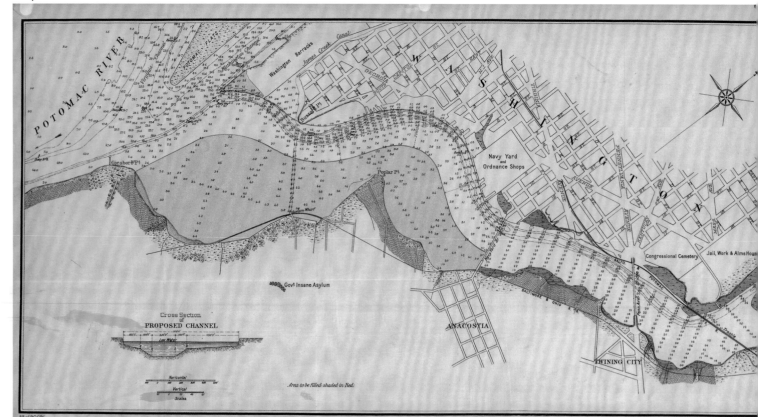

last week, and today I walk around the recently flattened fill dirt. It remains a dump, but it seems now to be a dump whose longtime owner, the National Park Service, feels a sudden stirring of discomfort with its existence.

ᴧᴜ

In 1933, the nascent National Park Service took over management of Anacostia Park and began working hand-in-hand with the Corps on many of its Anacostia activities. As Washington grew ever larger, waste began to inundate the city. Desperate for disposal options, the Corps began to add incinerator ash, construction debris, and other detritus to its dredge material for creating parkland. While the Corps piled Washington's waste on Anacostia wetlands, the Park Service shepherded the process, monitoring the height of the garbage until it was just right and could be covered with dirt.

Together, the Corps and the National Park Service molded the fetid dredge and ashen waste of the US capital into a neat channel, fortified by a stone seawall. In 1942, when the District's trash accumulation began to exceed the capacity of its incinerators, the role of the Anacostia as a dump-

ing ground expanded. World War II was far from over, and the construction of a new trash-burning facility was deemed infeasible during wartime. The Park Service agreed to allow additional trash to be dumped on its Anacostia land, but it remained firm that the height of trash along the river should not exceed the limit set by its regulations. So six days a week this riverside land was the repository of old bicycles and clothes, broken refrigerators, outdated food, unused paint and medical supplies, old paper and ink, motor oil, beer bottles, and light bulbs.

And six days a week the mess was set on fire, which would reduce the volume by some four-fifths. Historic photos of Washington, DC, during this era show plumes of dark smoke rising above the Anacostia as burning unleashed thick, ashy residue into the air. Depending on the weather, the black cloud either hovered above the dump or ambled about the neighborhood, pouring into the classrooms of the nearby Kenilworth School and Neval-Thomas Elementary, filling the lungs of children at their recess play, soiling the clothes that hung out to dry in backyards, settling on the dinner tables of nearby residents.

Often the dump smog rose above the city, traveling at the caprice of the wind, animating the city skyline as a landmark to rival the Washington Monument. "Everyone who lives, works or visits in the National Capital area has been made acutely aware of the Kenilworth Dump," wrote US Representative Charles Mathais, from the 6th District in Maryland. "The smoke smells and appalling vistas of the Dump have made it a landmark of sorts." An article in the *Albuquerque Tribune* noted, "The rats, roaches and flies always managed to survive. And at night, from the air, the glow of Kenilworth Dump's fires was visible through the perpetual pall which hung over the area." The dump was widely recognized as the single worst source of air pollution in the District of Columbia.

∿∿

In 1963, after more than twenty years of near-daily fires at the Kenilworth dump, the National Park Service pulled its temporary permit to burn, claiming the levels set for the height of the park had been reached. The topography of the cremated trash was at that point just right for a national park. But the District had not, during those two decades, made alternative

plans for the trash. The city collected thousands of tons of refuse every day—250,000 tons annually—and its facilities could incinerate only two-thirds of it. Continuing to burn the excess was the only option, according to the District, which was at the time controlled by the US Congress. There were plans for a new incinerator, someday, but incinerators and sanitary landfills were much more expensive than open-air burning. The District was considering a proposal to accelerate the denouement of the Kenilworth fires by trucking some trash to a property in Maryland. That plan would have cost $1.5 million in equipment and $500,000 per year. Congress failed to find the motivation.

And the fires continued.

The thick, billowing pollution coming off the Kenilworth dump was well known to be a serious health hazard, but the residents of communities neighboring the dump had little political power in a congressionally controlled city, and the District had ever-increasing amounts of waste and no other location willing to take it. Not that the residents of the Kenilworth community were willing participants in Washington's waste-disposal solution. For many years they protested the fires and the garbage being dumped on their neighborhood. In December 1966, twenty-five members of the Mayfair Parkside Civic Association, an organization of local residents, used their bodies to block the entrance to the Kenilworth dump. Trucks filled with Washington's waste sat idling as the residents demanded an end to the fires at Kenilworth and asserted their right to have a voice at any table where future landfills were being considered for their neighborhood. In the end the crowd dispersed, the trash was dumped, and the fires continued.

In July 1967, a national organization advocating a more modern approach to waste disposal offered DC a grant for two-thirds of the cost of a new sanitary landfill, if the city would halt the fires at Kenilworth. The city said, thank you but no: the Kenilworth fires cannot stop until a new system is built, due to the National Park Service regulations. The DC spokesperson for the dump, Col. William F. Henson, was quoted at the time saying, "We don't have a back-up area to go to when Kenilworth is filled." Under the Park Service specifications, without burning, the dump would exceed capacity in six months.

And the fires continued.

On October 1, 1967, it appeared the day had finally come to close an ugly chapter of the Anacostia story. A headline in the *Washington Post and Times Herald* that day read: "Dump Fires to Go Out Jan. 1." The story told of a joint announcement from DC and the US Department of the Interior that the Kenilworth fires would be doused permanently in sixty to ninety days. After intense pressure from journalists, District residents, politicians, and civic organizations the Park Service agreed to allow the height of the dump to increase and to permit landfill operations at Kenilworth to proceed for at least a year, while Congress agreed to help fund a new landfill. The plan hinged on a land transfer that would move dump operations to another nearby national park location in the Anacostia watershed, where trash would be unloaded into "gullies" to level the land for later conversion to parks. This was an era predating reduce-reuse-recycle; prior to the Clean Water Act and any significant protection for wetlands and waters; and prior to a scientific and social understanding of the importance of wetlands to river health and wildlife. And despite the unsavory nature of the Park Service plan, it appeared the lesser of two evils at the time.

In November 1968, a $733,333 grant was awarded to DC by the US Public Health Service to fund a new landfill. The burning would finally stop, as soon as the District could hire a contractor to convert its solid waste system to a sanitary landfill in the new neighborhoods, at the latest by January 1, 1968. But a bureaucratic error lodged a wrench in the sanitary landfill plan. The General Accounting Office announced that the contract the District had signed with an Illinois firm to convert Kenilworth into a sanitary landfill "lacked sufficient detail": specifically, how deep the landfill would be and what equipment would be used. Comptroller General Elmer B. Staats ordered DC to reissue the request for bids. In other words, to start over.

January 1, 1968, came and went. And the fires continued. Then on February 16, 1968, the Kenilworth fires ceased abruptly, forever, because of what happened exactly forty-nine years ago.

Standing atop the Kenilworth dump, perusing its assortment of dirt-caked ingredients, I find plastic bags, amorphous piles of rusty crushed

steel, candy wrappers, beer cans, water bottles, water bottles, water bottles. I find myself looking for something specific during my dump exploration. Spoons.

Longtime Anacostia resident and river advocate Dennis Chestnut told me a story one time about his youth along the Watts Branch. He and his friends would swim in the creek, which was in the 1960s a good deal deeper, and they would often explore the Kenilworth dump. During the heyday of the dump an ice-cream company would arrive on a regular schedule to unload the ice cream that had passed the sell-by date. Dennis and his friends would grab their spoons from home and tramp down the Watts Branch and then post a watch for the ice-cream truck. When it deposited its ice-creamy treasure, they would sneak into the dump for an ice-cream social.

Ice cream was not the only treasure to be found at the dump, which harbored an abundance of the discarded wealth of Washington, DC: a bicycle, radio, couch, box-spring mattress, engine parts—all manner of goods

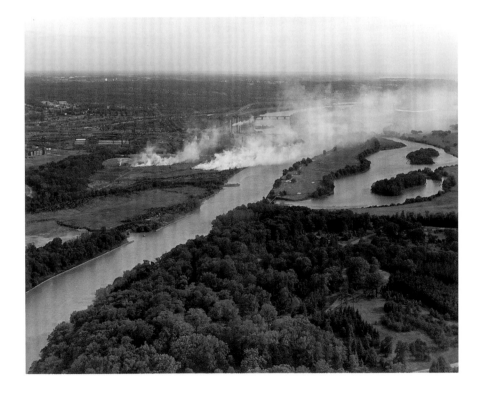

By the 1960s, smoke from the Kenilworth dump fires had become a landmark in Washington, DC. Photo: National Park Service

drew many to the Kenilworth hunt. In a society of superfluity, excess, and inequity, trash is a relative term. The trick was to get there late enough to have your choice of the day's deposits but before the fires took over.

On Thursday, February 15, 1968, Kelvin Tyrone Mock and three friends were following that Kenilworth formula, taking an after-school trip to the dump to reconnoiter what Washington had thrown away that day. The kids had perhaps been there many times before, but on this day, as the boys were exploring the dump near an active fire, the wind shifted, breathing life into the flames. Walls of fire leapt twenty feet into the air and surrounded Kelvin and his friends. The boys ran, and three of them escaped the encircling fires. But in the half-light of that late-winter afternoon, Kelvin fell and his clothes caught fire. Unable to reach him, two of the boys ran for Kelvin's house to find his mother; the third stayed with Kelvin, standing watch for when help arrived. That boy would ultimately stand by helplessly as darkness fell and his young friend was consumed by the Kenilworth fire.

According to the coroner's report, "It took four engine companies about a half-hour to reach the boy's charred body." The coroner ruled the death of Kelvin Tyrone Mock an accident. An accident. An accident that placed a burning dump a block from an elementary school that was predominantly African American and predominantly poor. An accident that would never have happened in Georgetown, Bethesda, or Capitol Hill; Bel Air, or Orange County; or certainly Yosemite, Yellowstone, or Mount Rushmore. Kelvin was seven years old, and he burned to death on a heap of garbage in his neighborhood national park.

∿

The icy morning wind burns my hands as I continue my exploration of the neatly graded garbage mélange. As I stroll past plastic bags covered in filth, candy wrappers, and lighters, I think about the kids at the dinosaur park in Laurel. They were so excited to find something of value, some mysterious clue to the past—a dino tooth, petrified wood, an *Astrodon* bone—some piece of the lives those great creatures lived. What would they find here? What puzzle pieces to the story of the human species would they discover by digging in the archeological heap of our civi-

lization? Needles, knives, motor oil, guns, pesticides, bleach, plastic toys, bags, and bottles. Spoons.

And what response would this Kenilworth dig trigger in them? Shame, over the failure of our species to protect the vulnerable? Sadness, over our inability to care for the land community? Estrangement and alienation from the land? Would they find motivation to do better for their river, their neighbors, and their children than their parents and grandparents did before them?

Kneeling in the Kenilworth dirt, I try to grasp hold of a belief that we are a species on a journey, that we have not reached the end, and there is still time to make amends for what we have done. I hear the little wren, still singing his heart out for the world, unleashing his beauty into the winter air. I imagine the tendrils of steam that must be rising into the cold sky with each phrase of his breathy song, tiny plumes of musical mist billowing into the Washington skyline, unseen by all. A monument to wren-kind.

The thought inspires me to rise. I walk east, toward the Watts Branch, and through the trees I see something strange and worrisome. The water in the creek is glowing, like antifreeze, like a neon green soup. I scramble down the bank to the creek, where an oil boom is draped across the stream. A brown filth hugs the absorbent boom. Upstream the water is clearer but tinted a strange hue of green, as if antifreeze has replaced water. I immediately text an inquiry and a photo of the creek to a friend at the DC Department of Energy and Environment: "What is happening in the Watts Branch?"

As I wait anxiously for his response, I walk along the creek to try to find the source of the disturbing color. In the shallows, schools of baby fish are darting about in the sickly green creek. Overhead a white-throated sparrow sings a phrase of his saddest winter song; cardinals chirp and blue jays bolt from tree to tree calling out an alarm. They are likely cautioning others about the presence of an American kestrel who has just landed on a nearby snag to assess his hunting prospects. But I can't help feeling an accusation or a plea: *Can't you do something about this?*

My mind recalls a phrase of Aldo Leopold's that often returns to me: "One of the penalties of an ecological education is that one lives alone in a world of wounds."

I am not alone; many grieve for this river and work to revive it, but it will still be many long years before we heal this wounded land. Mockingbird, cardinal, wren, sparrow, jay, and child of the Anacostia, forgive us.

I follow the sickly green water upstream and find where it enters the Watts Branch from a creek on the east side. A great blue heron is standing in the nuclear green water. Trash bobs on the surface and carpets the stream bank. Gulls fly overhead, crying. Crows make commentary. Geese honk. Otherwise, as I stand observing this ruin, all is strangely quiet.

Until my phone chimes with an incoming text. "Just finding out that our inspectors were out there yesterday investigating a possible spill. The green is from their dye—used to track the source. It should not be harmful." In the space of reading this text my perception of the moment and this day shifts. Despite all appearances, the green color is a good sign. It is a symbol of pollution, yes, but unlike fifty years ago, it means that the city government—rather than being a main polluter—is trying to protect the river and track down those who would harm it.

~~~

As I walk away from the stream bank, I see that while I was in the forest, the National Park Service dumpster has been taken too. Only the port-a-john, chain link, and silt fencing remain visible atop the decades of buried garbage.

~~~

I can say that a dump should never have been placed here, that Kelvin should have grown up with a healthy forest, meadows full of wildflowers, lush wetlands, and vernal pools alive with frogs, as backdrop for his adventures; that on February 16, 1968, in the wake of his death, the Park Service, Congress, and the city should have immediately cleaned up the wreck they had made of this river land and made amends. None of that happened. But it doesn't mean nothing has happened, doesn't mean nothing will happen to heal our Anacostia.

Looking out over Kenilworth Park, I imagine a different future for this landscape, a different national park for seven-year-olds to play in. A

place as full of wonder as Yellowstone and Yosemite. A place the National
Park Service can be proud of rather than this blank, scarred remains of
a shameful failure for this proud lands agency. I see mature forests with
healthy trees for kids to climb, meadows buzzing with bee and butter-
fly life, wetlands filled with secret passageways for shy creatures, chil-
dren splashing and watching tadpoles in a glassy clear Watts Branch. And
on the sign at the entrance I see Kelvin Tyrone Mock Memorial National
Park.

FIRE AND ICE

Kenilworth Park, Washington, DC

The Watts Branch being tested for pollutants, 2017

Kenilworth Park, 2015, Washington, DC

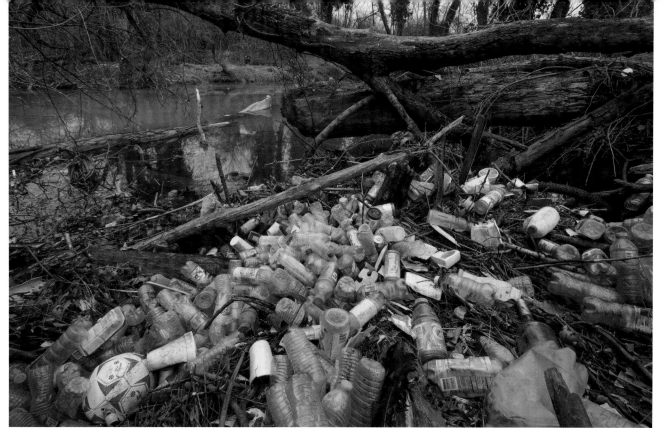

The Watts Branch in Kenilworth Park, 2017

Trash and feathers along the Watts Branch

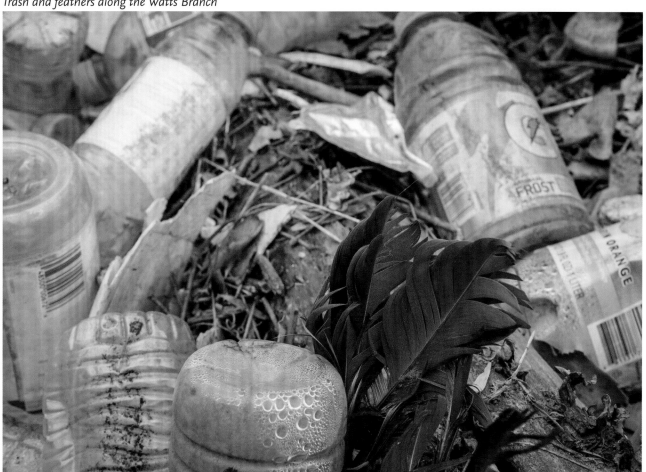

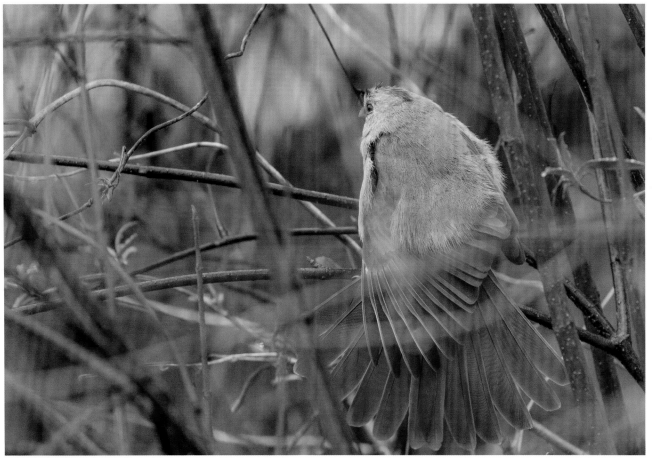

Female cardinal drying her wings

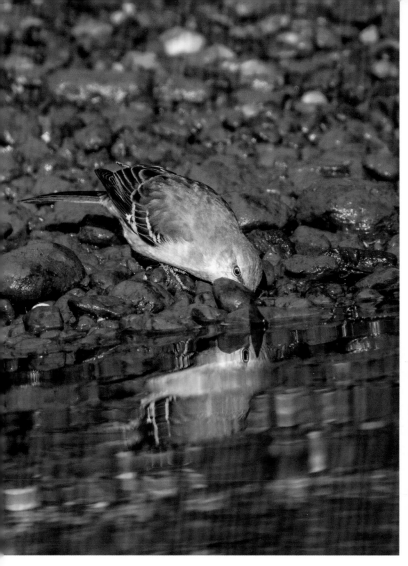

Oil pollution boom in the Watts Branch

Mockingbird drinking from the Anacostia River

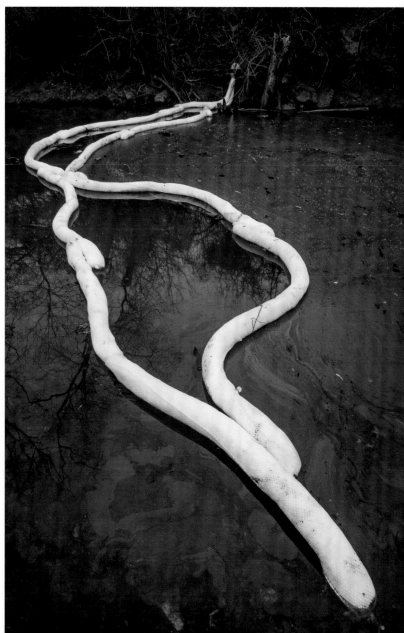

The Waking Moon

Fog envelops the upland forest of the US National Arboretum this morning, where a monochromatic quilt of chocolate, café-au-lait, pale beige, and khaki cloth blankets the woodland floor. Stitched in the shapes of oak, beech, poplar, black gum, and tupelo, they are the silent encore of November's final act at the end of last year's growing season. When the autumn curtain fell, it landed ever so softly here—and here it stayed to gentle the hand of winter, to give warmth to the roots and tiny creatures that slumber through snow and ice in the tired heart of the forest. These leaves are proof positive of things coming up before they fall, of what was and will be again. They blanket a promise the land is hiding under air alive with intrigue, under this watchful fog.

I crouch low to the ground and lift a corner of the leafy quilt. At first I find . . . soil. Just sleepy soil. The record of autumns past, of leaves rummaged by little bird feet, sorted and tossed by the busy hands of squirrels, chewed up by ant and worm and an eclectic assortment of insect oddities. These characters, alchemists all, transform the spent and fallen leaves, the discarded solar collectors of the forest, into growing-season gold. They transubstantiate sun and leaf into *life*.

But I find no busy little creatures. Not one. No tiny skink, or ant; no millipede or spider. Just soil—rich waiting, portentous, expectant earth. Soil is nothing. It is everything. As author John Burroughs wrote, "The soil is marrowy and full of innumerable forests. Standing in these fragrant aisles, I feel the strength of the vegetable kingdom, and am awed by the deep and inscrutable processes of life going on so silently about me."

It should be enough to find soil, to rejoice that the dirt is right here where I last saw it. But today I seek something else, soil in its next form, transformed by sun and seed. There is no visual evidence on the forest

floor of this hidden hope, but I know it is there buried in the brittle brown pages of forest history. I lift another hem of the leafy quilt and there it is, my quarry: a small, determined cylinder, the size of my pinky finger and the color of *alive*; a newborn green digit, pointing itself with unbreakable determination toward the sun. This coil of leaf is wound so tightly around itself that the only visible evidence that it is not a solid mass are tiny lines that spiral round the outside of the sprout. The coil protects the tender plantling from uncertainty above the warm earth, from the cruel clutches of winter's last grasp; leafy layers harbor heat at the heart of the matter. The coil also creates a rigid structure strong enough to part the soil from which it must emerge. Such effort! I can almost hear it groaning with the strain. This taut, perfect package pushed its way from root through compressed earth, through topsoil and into humus, adding girth to its green self along the journey. It began as a germ. Using the rich decay of millennia of forest life, it grew into a pregnant idea of a plant, a thought for a future life unfurled in the sun as a pretty little frog parasol planted in the forest floor. Mayapple.

I knew you would be there, little green soldier always standing on the front lines of winter's last stand. On the eve of the spring equinox, sunlight and darkness share the day in near-equal measures, yet neither is content and war rages in the Anacostia watershed this morning. Noiseless and nearly imperceptible, it is the battle of two epic forces meeting at the boundary of their temporal domains.

Winter has staked an early, decisive claim over this March day, holding an icy hand over the land, bidding tree, insect, and amphibian to sleep . . . sleeeep. But spring entrenched itself in the soil yesterday and now

rises up to meet the dawn, calling flower, bird, and fox to wake! Wake! For the moment, neither will give ground, and the clash spreads an enveloping fog over the land. I walk along this misty precipice between restive winter and frenetic spring, imagining I might pinpoint the exact moment when frost surrenders to fecundity.

A week ago we had our first snowstorm of the strangely mild winter, along with bitter gale-force winds raging through the watershed. Freezing rain formed icicles, dripping like glass from the first rosy buds of redbud trees. The entire river landscape seemed dipped in glimmering liquid crystal. Transitions in time and thought, like great battles between epic forces, do not come easily.

But now the sun lingers longer every day, melting ice from bud and coaxing the first blush of spring onto the fingertips of bare-armed maple trees. In the marshes, red-wing blackbirds and cattails grow bolder: the one flashes ever more fiery shoulder patches and ushers chattering challenges to rivals, while the other begins to push new green spikes through wetland earth. From within the lowland forest at the edge of the river, spring peepers have begun to chorus haltingly; their song charms water snakes, who begin to peek out of their cozy winter holes.

The robins are singing, the redbud has unfrozen, and the osprey has returned to the Anacostia sky. I spied him from my kayak a few days ago, and such joy I felt when I recognized his far-off form, to know that against unimaginable odds he has survived his grueling odyssey to South America and back. Anacostia born and bred, biology demanded he make a life-or-death gamble on a three-thousand-mile journey to find a safe winter haven. Several weeks ago, he gambled once again as he took flight for home, that spring would beat him back to the Anacostia. If by chance he had landed here on a city still covered with snow, a river whose fish were locked beneath a sheet of ice, death would have greeted him at the door of his life-long home. He could not go back to Brazil, weary as he would be. He would have to simply lie down upon the Anacostia earth and melt away. When the osprey arrives home in March, I know there is no going back to winter. As Aldo Leopold said of the Canada goose's spring return to Sand County, "His arrival carries the conviction of a prophet who has burned his bridges."

Every year, when the osprey returns and the hours of light and dark-

ness are poised in near-perfect equilibrium, winter's pale chill lingers despite spring's onrushing radiance. When the forest remains asleep but with eyes aflutter, I come to this forested bluff at the edge of the Anacostia, searching. Ostensibly, I am searching for a particular sign of the coming spring, a very small electric-green sign that signals the land has marked the approaching angle of the sun. But I am also looking for something less tangible, something entirely insubstantial but enormous: a pathway of memory to an elusive portal leading to the Anacostia of old.

∿

Beyond the hem of this forest, the columns of the first US Capitol rise out of a hilltop meadow, strange and incongruous. The Corinthian columns were originally erected in 1828 on the east portico of the Capitol, but as the building grew, they became obsolete and were later relocated atop this hill in the Arboretum. A monument can be a reminder of many things. These columns speak of history, of legacy, of the long making of a capital city. Today, in this fog, with the breath of land and river rising to cloak the columns, they also speak of a river landscape long subdued and erased into utter forgetfulness.

Over the past centuries, since before those columns were originally built out of sandstone quarried from Aquia Creek in Virginia, we removed all memory of what a watershed is. We scraped away, paved over, cut down, and carted away our watershed context: dumping dredge on wetlands, putting parking lots over former forests, even covering over the very streams that fed the river—turning gentle babbling waterways into pipes and culverts. We have no memory of what it means to live in a watershed because we can't see one anymore. Most residents have never considered this absence, because in effect we have imposed on ourselves an ecological dementia. How do we go forward wisely when we cannot summon what we left behind? How can we truly restore the Anacostia watershed if we can't remember it?

In the Arboretum, I look for a conduit to an ecological synapse that has not been fully severed, hoping to conjure the lush land that sprouted as the Pleistocene chill abated, a land that felt the feet of badgers, bison, and wolves, that greeted the eyes of the first humans who ever set foot here. It is nothing more than an intellectual exercise—that watershed is gone forever. But the practice offers something important. Here on the Fern Valley Trail, the US Department of Agriculture (USDA) has endeavored to re-create a piece of that native Anacostia in the upland woods, the forest floor, the bend of a clear creek rushing down the hillside toward the river. There is no other place like it in the Anacostia watershed for the density of land remembrance.

Tourists often come to the Arboretum to view exotic plants from Japan and China: bonsai, cherry trees, Japanese maple, and bamboo. I come to be transported not to a forest a continent away but to my own home, centuries distant and so much further beyond my reach. Here, in this re-created land, it is possible to breathe air that is an echo of an Anacostia unbroken. To find a germ of an idea of what may have been and thus a thought, a hope, a prayer for what could be again.

∿

I keep an eye out every March for the mayapple, a green umbrella beacon guiding the way toward the growing season. I know when I see it pressing upward that beneath this sea of fallen leaves the forest-world is already rising, just below the soil unseen: soon there will be fiddlehead, bloodroot, trillium, spring beauty, trout lily. Long ago these early risers, the first spring bloomers, were dubbed *wake-robins* because it was understood that when they appeared, the long quiet of winter was over; it was time to rise for bird, bee, and butterfly; it was time to wake, robin.

From every slumber there must be an awakening. Though the waking can be a very long time coming.

∿

By the 1850s, the Anacostia had suffered just about every insult a river can. Most of its old-growth forests were gone; silt and sewage had clogged its streams and main stem; the US Navy had built ships and weapons

on its banks and dumped their waste in the water; and the Army Corps of Engineers had begun to reengineer the river. The Corps would devote more than a century to dredging, dumping, and walling the Anacostia. When its work was done, the agency, by its own admission, had "destroyed some 2,600 acres of aquatic wetlands, 99,000 linear feet of aquatic habitat, and 700 acres of bottom hardwood trees in the forest buffer," reported John Wennersten in *Anacostia: The Death and Life of an American River*. Eventually the Corps would state that the Anacostia's worst problems "derived from 'urbanization and past Corps of Engineers activities.'"

You could say we as a society didn't know any better. But it's a bit more complicated than that. The great paradox of this chapter in the Anacostia story lies in the fact that at exactly the same time the Corps was gearing up to epically undo river ecology, devastate wild populations, and deform billions of years of Anacostia evolution, it was simultaneously responding to the growing demand from watershed residents for access to nature and wildlife. People were waking to a growing sense of connectedness to nature, and this kindling of ecological kinship led to the creation of Anacostia Park and the Arboretum. These parks, which may ultimately play keystone roles in the salvation of the Anacostia River community, were at the time of their creation the lipstick on the proverbial pig, if the pig were made of sewage, incinerator waste, and toxic dredge.

The contradictory and self-defeating role of the Corps would seem bizarre if it wasn't exemplary of the self-conflicted nature of human soci-

Bloodroot

ety throughout modern times. We clear-cut forests, pave over meadows, destroy vernal pools, and smother wetlands even as we are writing sonnets and painting masterpieces depicting the beauty of the natural world. As Leopold wrote of our conflicted inclinations, "We see repeated the same basic paradoxes: man the conqueror versus man the biotic citizen; science the sharpener of his sword versus science the searchlight on his universe."

This rending paradox shadows our relationship to the land. It is a dilemma long understood and articulated but as yet unresolved for society at large. Scientist Edward O. Wilson, in his book *Biophilia*, referenced this paradoxical problem by using historian Leo Marx's image of the "machine in the garden." Wilson wrote, "The natural world is the refuge of the spirit, remote, static, richer even than human imagination. But we cannot exist in this paradise without the machine that tears it apart. We are killing the thing we love, our Eden."

This wasn't an issue for 95 percent of our tenure on Earth as *Homo sapiens* for a simple, pragmatic reason. For most of the two hundred thousand years modern humans have existed, we were scrambling just to maintain small populations in the face of shifting climates, fierce predators and competitors, and bacteria and viruses that overpowered us at every turn. But at some point the balance shifted, and our machine began to dominate the garden in which we ceased to be threatened and became the threat.

"The inner voice murmurs *You went too far*, and disturbed the world, and gave away too much for your control of Nature," Wilson writes, and he suggests that our trouble may arise from the reality that "we do not know what we are and do not agree on what we want to become." Human society has for millennia distanced itself from a foundational reality— that we are but a single member of a complex Earth community. It wasn't until the nineteenth century, at the advent of evolutionary science, that we began to question long-held beliefs about *what we are*. In 1859, Charles Darwin published his *Origin of Species*, which gave proof positive that humans are fundamentally members of the land community and related to each and every other member. But Darwin's assertions were initially denied and then fiercely contested for more than a century. Evolution is no longer refuted by rational society—we know now that humans share

96 percent of our DNA with our closest relative, the chimpanzee—but what evolution means for us as creatures living in an Earth ecosystem eludes us. And *what we want to become* remains a matter of debate.

This tension was just beginning to simmer in the nineteenth century as naturalists like John James Audubon, John Muir, and Henry David Thoreau were recording their thoughts and observations of the natural world. The Anacostia watershed, and Washington, DC, at large, was a bubbling cauldron of conservation thinking and action by such people as influential ornithologist and bird advocate Florence Augusta Merriam, poet Walt Whitman, scientist Paul Bartsch, President Theodore Roosevelt, and naturalist John Burroughs.

Burroughs, who is credited with popularizing the concept of nature literature, was one of the most well-known writers of that century. Born in 1837 in New York, he moved to Washington, DC, in 1863, where he met and befriended his hero, Walt Whitman. While Whitman was nursing wounded Civil War soldiers, he and Burroughs began a lifelong friendship that shaped their literary work and the way they understood the natural world. In 1871, partly as a result of this friendship, Burroughs published his first book, *Wake-Robin*.

Wake-Robin was a collection of Burroughs's observations and impressions of the birds he encountered while exploring the forests and wetlands of Washington, DC, and his family home in rural New York. The book gives a rich recollection of the avian world that existed in the Civil War era of the District, with Burroughs's insights varying from academic natural history to deep admiration and petty insults for the bird community. Of the robin he wrote:

John Burroughs. Photo: J. Edward B. Greene

> From Robin's good looks and musical turn, we might reasonably predict a domicile of him as clean and handsome a nest as the kingbird's, whose harsh jingle, compared with Robin's evening melody, is as the clatter of pots and kettles beside the tone of a flute. I love his note and ways better even than those of the orchard starling or the Baltimore oriole; yet his nest, compared with theirs, is a half-subterranean hut contrasted with a Roman villa.

Ouch. But the robin got off easy. "The kingbird is the best dressed member of the family, but he is a braggart; and, though always snubbing his neighbors, is an arrant coward."

Touché kingbird.

But for the most part, *Wake-Robin*, which was inspired deeply by walks in the Anacostia watershed, was a celebration of the joy Burroughs felt among the sights and sounds of bird society and the natural world all around him. He spoke of hawk, swallow, finch, and sparrow, of the way their songs waxed and waned with the progression of seasons, of the privilege he felt to be in their audience. And no bird garnered more gratitude from Burroughs than the thrush. In this he was not alone. The wood thrush has been regarded by many, from presidents to poets, as possessing a singular beauty of song, a power to transport the listener with a melody that defies description and seems, impossibly, to be not one bird singing but a duet of birds. Many poets, advocates, and scientists have labored to describe it justly. Thoreau said, "Whenever a man hears it he is young, and Nature is in her spring; wherever he hears it, it is a new world and a free country, and the gates of Heaven are not shut against him." John James Audubon wrote: "Kind reader, you now see before you my greatest favourite of the feathered tribes of our woods. To it I owe much. How often has it revived my drooping spirits."

At the time Burroughs was writing *Wake-Robin*, the wood thrush was one of the most common birds in Washington, DC, yet it evoked a greater sense of wonder and love than almost any other. As Burroughs wrote, "The emotions excited by the songs of these thrushes belong to a higher order, springing as they do from our deepest sense of the beauty and harmony of the world."

Burroughs's admiration of the wood thrush was surpassed only by his love of the hermit thrush. So named for its shy, secretive habits, the hermit is a bird of deep, damp woods. Its favorite habitat, combined with its divine song, earned it the nickname "swamp angel."

I have encountered the hermit thrush once or twice in nearly a decade of time in the Anacostia watershed, but only in those places where secluded interior forest is uninterrupted by bike trails and roadways, notably on the southern end of Kingman Island and in the Arboretum forests

least visited by people. Only once have I heard him sing—today in fact—and I will never forget it. His voice rose through the silent fog, originating unseen from somewhere deep within the towering canopy, and almost seemed to me as the aged voice of the forest itself, eternal, transcendent, generous, and sad.

Burroughs wrote at some length of the hermit's song in *Wake-Robin*:

> This song appeals to the sentiment of the beautiful in me, and suggests a serene religious beatitude as no other sound in nature does. It is not a proud, gorgeous strain, like the tanager's or the grosbeak's; suggests no passion or emotion,—nothing personal,—but seems to be the voice of that calm, sweet solemnity one attains to in his best moments. . . . A few nights ago I ascended a mountain to see the world by moonlight, and when near the summit the hermit commenced his evening hymn a few rods from me. Listening to this strain on the lone mountain, with the full moon just rounded from the horizon, the pomp of your cities and the pride of your civilization seemed trivial and cheap.

The hermit thrush, wood thrush, robin, and the land of the Anacostia made their mark on Burroughs, and he made his mark on the world. Throughout his life he wrote hundreds of articles and twenty-seven books about the natural world. He also became friends with John Muir, Teddy Roosevelt, and Florence Augusta Merriam and in turn made his mark on them and helped shift the precarious balance between the garden and the machine. Burroughs met Merriam in 1886 when she was a student at Smith College. Merriam had invited the author of her favorite book, *Wake-Robin*, to visit Smith and speak to the students about birdlife. Burroughs accepted, and he and Merriam started a friendship that would last their lifetimes.

By this time, though only in her early twenties, Merriam had already become a fierce defender of birds. She began advocating for the uncommon practice of studying birds alive, in their natural surroundings, rather than dead birds killed for the purposes of science. Merriam also began writing articles denouncing the fashion industry and the killing of birds to decorate ladies' hats and dresses—an industry responsible for the death

of some five million birds annually in the late nineteenth century. A survey at the time found that in fifteen years bird populations across the country had dropped by nearly half. The commodification of nature has long had this devastating effect, and in Merriam's time, when so much of the natural world still existed intact, the results were heartstopping: four hundred thousand hummingbird skins sold in London in a single week; heron rookeries in the Florida Keys, which had been among the largest in the world, disappearing entirely. A bird hunter could make five hundred dollars in a single day selling herons, egrets, bluebirds, pelicans, and others—an unthinkable sum in the late 1800s.

After college, Merriam moved to Washington, DC, where she wrote what is widely regarded as the first modern field guide for birds, *Birds through an Opera Glass*. This accomplishment, and all those that followed, came at a time when women were largely relegated to domestic roles. Women would not gain the right to vote for another thirty years, and they were rarely taken seriously in professional society. Merriam helped change that, as well as the relationship of humans to the natural world.

She believed that if she could show people the grace and beauty of these birds in the wild that the practice of killing them for fashion would come to an end. She devoted her life to this idea and worked with colleagues like Jeanie Coyle Patten to launch the Audubon Society of the District of Columbia in 1897. Through her work in the DC Audubon Society, with friends and collaborators like Frank Chapman and Olive Thorne Miller, Merriam helped obtain the passage of the Lacey Act of 1900, the first federal law protecting wildlife. Many important safeguards for birds and other wildlife followed, including the Migratory Bird Treaty, signed in 1916, which made it unlawful to kill migratory bird species. The treaty has saved herons, pelicans, plovers, and countless other bird species from utter annihilation.

ᘯᙚ

Both Merriam and Burroughs were bright early sparks that fired an ever-expanding consciousness and constituency for conservation of the natural world. Burroughs was a friend to President Theodore Roosevelt, accompanying him on several camping expeditions in the still very wild West and

Florence Augusta Merriam.
Photo: Internet Archive Book Images

birding with him on the White House grounds. Roosevelt joined Merriam's nascent DC Audubon Society while president and even held meetings of the society in the White House. Roosevelt's connection to this community of naturalists, writers, and wildlife scientists helped him become the foremost conservation president in history, creating the US Forest Service, eighteen national monuments, and fifty-one federal reserves, which were the beginning of the National Wildlife Refuge System.

Paul Bartch, like Merriam, was rooted in the scientific community. He taught zoology at both Howard and George Washington Universities and held the position of curator of mollusks at the Smithsonian Institution. Bartch was also an innovator in the young field of ornithology and became the first North American naturalist to incorporate bird banding in scientific research. In the early 1800s, John James Audubon had tied string to the legs of eastern phoebes to more closely follow the movements of individual birds. But Bartch launched the first modern bird banding study when he attached small metal rings to juvenile night-herons in Washington, DC. The bands read: "Return to Smithsonian Institution." Through this study, and his time observing herons in the Anacostia and Potomac watersheds, Bartch published *Notes on the Herons of the District of Columbia*. The paper documented Bartch's observations of black-crowned night-herons in 1902 as they nested in their rookeries within dense pine groves and hunted on the extensive marshes of the Anacostia, then teeming with aquatic life and vegetation. This was the same vegetation that the Corps found so vexing and blamed for the river's inability to function as an effective shipping route and sewage system. But the Army Corps had not yet begun to *improve* this stretch of the river, so the tidal wetlands remained intact and wealthy with bird life.

Bartch's *Notes* gave intricate detail about the lives of these herons. He described their nests as "poor structures, mere platforms of dead twigs"; noted their nocturnal habits; and derided their nestlings as "about as ugly birdlings as can be imagined." He documented the pace of their development; makeup of their diet; and methods of self-defense. *Notes on the Herons* is part scientific study, part naturalist's fond observation of a unique species. "The feeding is all done at night and it is interesting to be in the colony after sunset—such clamoring, such calling, such din!"

Bartch examined two hundred black-crowned night-heron nests, which was only a portion of the nesting night-herons in DC at the time. His study recorded many new insights into this species and into birds in general. *Notes on the Herons* also described relatives of the black-crowned that spent time or nested in DC, including the yellow-crowned night-heron, green heron, little blue heron, great blue heron, and several species of egret and bittern. Many of these exquisitely arrayed species were targets for the feather trade that Merriam fought so hard to end.

Bartch's work was groundbreaking in many ways, and for the Anacostia, his record of heron life painted a portrait of a disappearing Anacostia already under the careless knife of the Corps of Engineers. His work preserved a critical piece of Anacostia memory.

> Anacostia River between Anacostia and Bennings in the latter part of August fairly teems with bird life. . . . This arm of the Potomac is at this season almost completely covered by wild rice and aquatic vegetation. The first covers completely the low mud flats and furnishes the thousands of sparrows, reed-birds, redwings, and ortolans with grain, while the latter forms a dense mat over all the water except the very narrow portion marking the channel. This green water-carpet is a favorite resort of the herons.

In the evening, many of the herons would retire to their remote rookeries farther upriver toward Bladensburg.

> I followed them one evening and found a secluded place on the bank where the tops of several dead trees were fairly well surrounded and hidden by green vegetation. Here the herons had assembled in numbers and were preening their beautiful dresses, preparing for the night which was fast approaching.

The Anacostia that Bartch documented so meticulously was one that members of Congress and the Corps little understood. The early twentieth century witnessed an awakening in our consciousness of the intrinsic value of the natural world, born of the work of Bartch, Merriam,

Burroughs, and many more. This would change the course of the world, and ultimately the Anacostia, but it would not stop the Corps. The expansive tidal wetlands where Bartch recorded the lives of the herons would soon be destroyed, and most of these exquisite residents would disappear. The machine would continue to dismantle the Anacostia garden, in large part because environmental science had not yet fully taken root and the concept of environmental law did not sprout for many decades. If the machine was a many-armed monster rampaging over the landscape, killing the thing we loved, environmental science was the brain that could guide it, and environmental law was the framework that could enforce the brain's dictates. But the brain, a century ago, had not fully developed, and the monster swept across the land.

I have observed at dusk and early dawn the great-great-great-grandchildren of Bartch's black-crowned night herons, who on rare occasion can be just made out in the half-light, standing silent as statues on the water's edge. Only a fraction have survived the past century of diminishment in the watershed. These herons are now rarely seen in the Anacostia, as are yellow-crowned and little blue herons and American bitterns—all are considered imperiled in the present-day watershed. The least bittern has disappeared almost entirely. The wood thrush, once one of the most numerous and beloved birds in the watershed, and DC's official state bird, is now

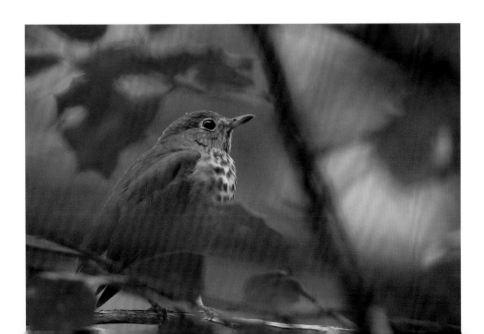

Hermit thrush

so rare that most DC residents will never see, or sadly hear, this District native. At least, not so long as the machine is in charge.

A few days after discovering the first of the mayapples pushing their way through the forest floor, the war of the seasons comes to an abrupt end. The sun has returned, spring is sprung, and the competition is on. In the sky above Bladensburg Waterfront Park a young osprey plunges over and over into the river while fish flee, and perhaps make mental note that their nemesis has returned from the tropics. When the osprey hauls out an unfortunate catfish in his talons, both fish and fish hawk are then harassed by gulls and crows, who shadow their every dip and dive for twenty minutes. Gull and crow have spent the winter here while osprey was off South America way; all need to recover from long travel or lean winter months, and the battle for food is on.

Farther upriver, at the confluence of the Northwest and Northeast Branches, I sit on the riverside spellbound by a group of twelve great blue herons who have gathered in the shallows of low tide. I have not seen a single heron since November, and here are twelve, gathered for the hunt. They posture and preen and pace along the current, occasionally stabbing their beak-spears into the water, occasionally giving their great blue wings a dramatic flourish, just to remind their colleagues how their exceeding loveliness gives them first dibs on the best fishing holes. How I have missed these arrogant blue beauties.

I encountered great blue herons on my first paddle on the river in 2010. I had seen hundreds in my life before that and have seen hundreds since, but each time I marvel at their effortless elegance. Aldo Leopold once remarked of the plover: "Whoever invented the word 'grace' must have seen the wing-folding of the plover." I would argue that the word might just as easily have been inspired by the wing flourish and gallant gait of the great blue heron.

I have watched them walking on the concrete, graffiti-marred channels we have constructed throughout the heron's home, elevating the ignominious hardscape with their very presence. I have seen them fishing in the wetlands we once routinely destroyed and have now begun to

Green heron

restore. I have seen them soaring high as an eagle above my kayak and gliding noiselessly inches above the river surface. I have been chastised by them for interrupting their work or disrupting their rest. And many, many times I have stared at them across the Northwest Branch, standing proudly at river's edge, as if they had been occupying that same ground for eons uninterrupted. And so they have. Herons are time embodied and timeless, a direct descendant of the Jurassic period, a survivor of climatic changes so severe that all of their distant ancestors were erased from Earth. If you take away their beautiful blue robes and the ribbons of royal filament that flow from their crowns, you are staring at a velociraptor standing in the Anacostia shallows, all scales and hungry eyes. I feel a visceral surge of gratitude every time I see them, this brutal beauty of the ages of earth, water, wind, and sky.

The same is not true for them of me. It is clear, they could take or leave me. Mostly leave.

Watching them today, I imagine a world where I never had the privilege of seeing them soar silently on great blue wings over the mirrored surface of my own river—a world that would certainly have come to pass had Burroughs, Merriam, Bartch, and Roosevelt not lived—an impoverished world where an understanding of *grace* would have been utterly incomplete.

WAKING

Great blue heron, Kenilworth Aquatic Gardens

(AT RIGHT) *Spring beauty blooming, Arboretum*

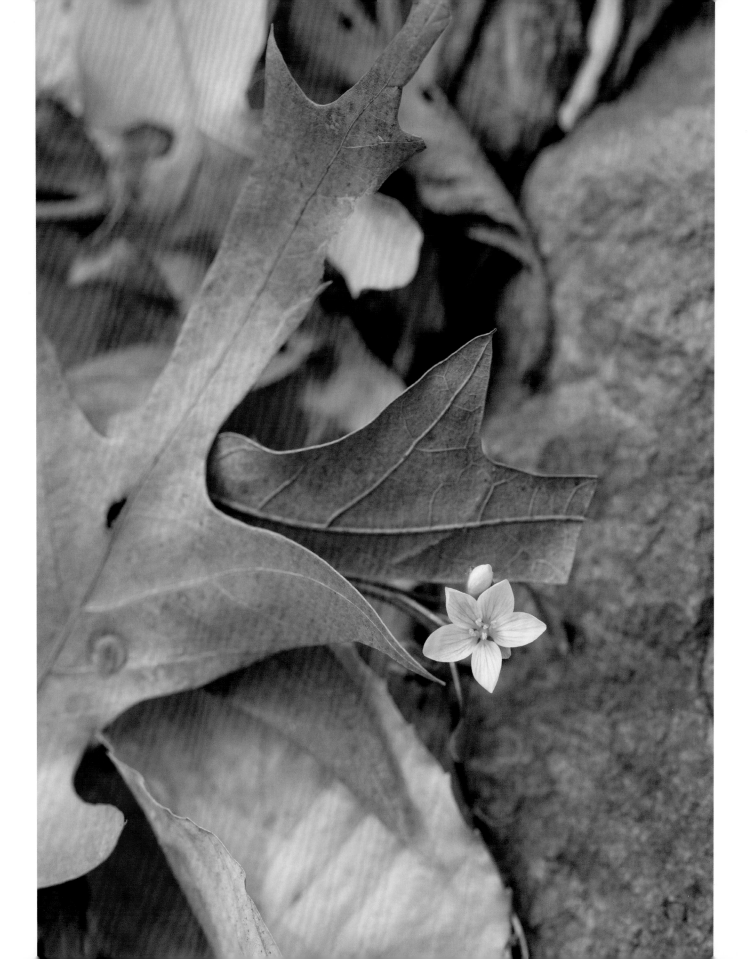

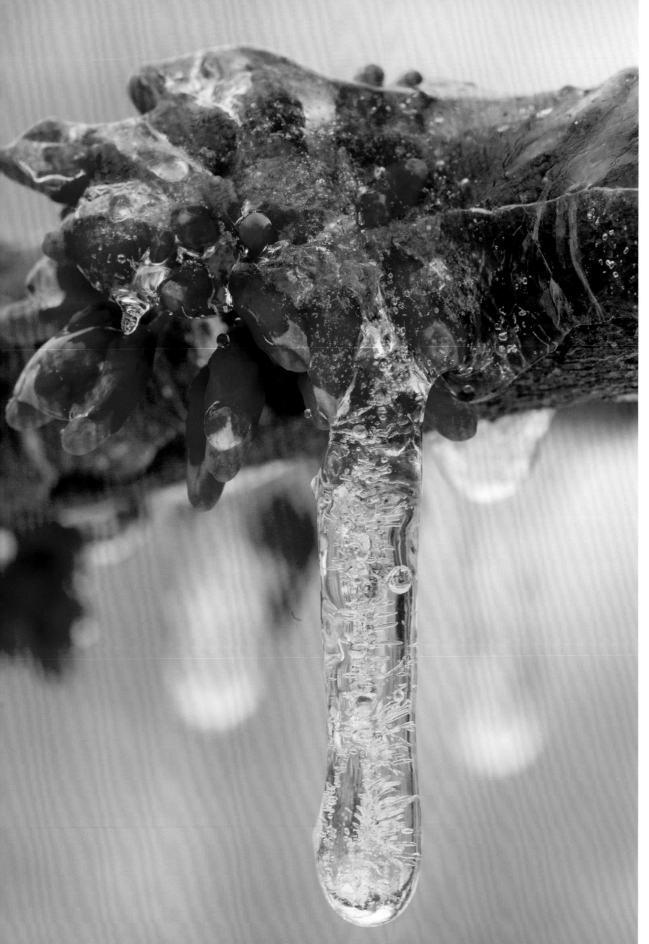

*Redbud in
ice storm*

Virginia bluebell sprouting, Arboretum

Mayapple, Arboretum

Spring peeper at the edge of vernal pool

Riverside pond, Washington DC

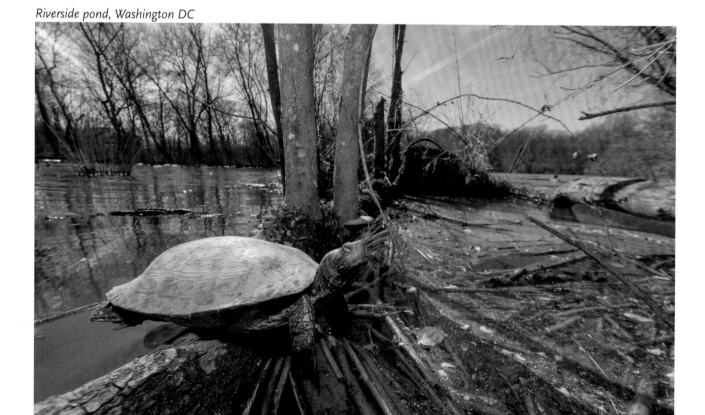

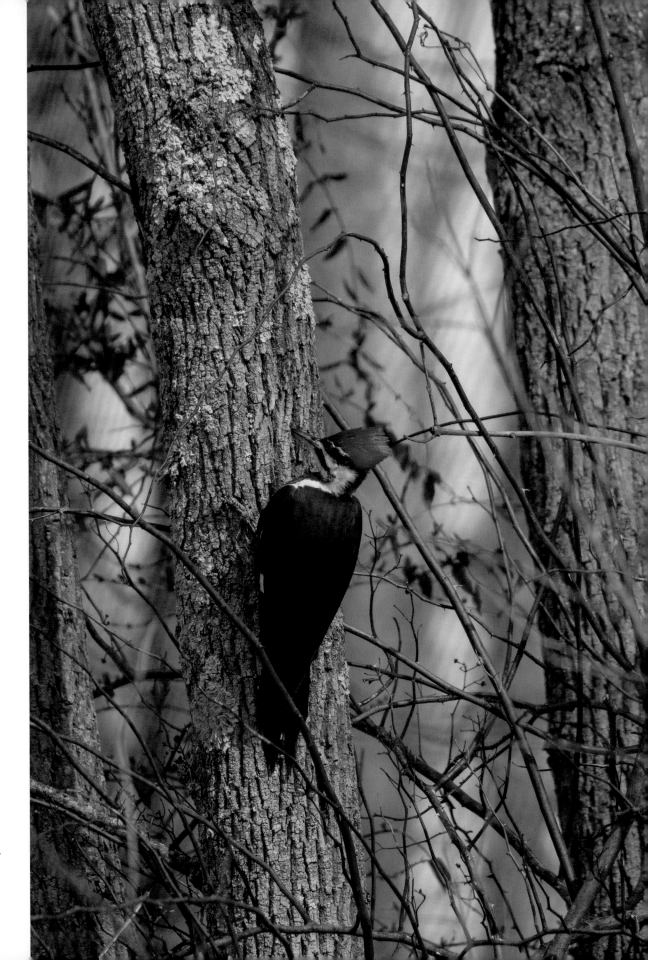

Pileated woodpecker

Bloodroot sprout

The Confluence Moon

April 4, 2017—Bright billowing cloud bodies make haste through a swift sky above the Kenilworth Aquatic Gardens. Hitched to a harried northwest wind, they barely have time to release an afterthought of rain before the wind drags them downriver, but in their wake a feather-light, luminous shower descends, each micro-droplet lit by the emerging sun. Like a falling mist of a million tiny comet tails. This golden vapor glistens on the curious face of a young white-tailed deer and shimmers upon the crimson cloak of a cardinal perched on the still-bare branches of a river birch. The fleeting sunlit spray mars the glassy surface of the water gardens with an impressionistic hand, painting a dreamy blur of anxious clouds departing a blue-sky pond. Here is a spring requiem befitting a king.

Under this celestial shower tiny droplets coalesce into larger beads when they alight on what's left of last year's lotus leaves, where they merge into mercurial pools. The deep red-brown lotus leaves, trailed underwater by shriveled umbilical stems that reach into the murky depths, appear as tethered islands lazing about on a pointillist dream of a pond. A heron flies in from the south and glides across the watery reflection to his hunting grounds, where a painted turtle basks in a restive float, his head just visible above the turbid water. The turtle appears to be poised in perfectly balanced buoyancy, but based on his canted angle, I imagine there is a single toenail staked in the mud below, anchoring him in place. His springtime satisfaction effervesces—a Mona Lisa smile curls upon his turtle mouth.

High above the turtle, two red-bellied woodpeckers dispute ownership of a prime perch atop a standing snag, eaten away thoroughly by several seasons of insect exploration and inhabitation. For woodpeckers, this is a choice location to rest, announce their dominion over this stretch of

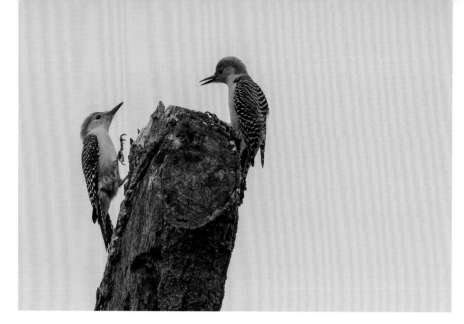

the riverland, and forage for insect snacks. Only one can claim this primo spot: it's worth at least an oral argument and a flash of red feathers. While woodpeckers discuss perching rights upon the towering snag, a sparrow sings sweetly from her more humble post on the matted brown mess of last year's cattails.

I walk around the ponds, observing what has changed in the past few days. Beaver trails between the ponds have grown more frequent and muddier. These industrious residents have work to do before the babies are born in May. They toil away gathering food, shoring up the homestead, and marking out their territory by depositing musk on mounds of wetland earth—the boundary monuments of the beaver world. The beavers work unseen beneath an increasingly complex symphony of birdsong, which has risen a decibel over the past week. A single frog adds his dissonant bark to the wetland music, managing only a few halting garbles. He will find his voice and be joined by many more when the night's lingering chill abates.

Though cypress, maple, and sycamore arms remain bare, this national parkland is coming alive and growing livelier by the day. Excitement, agitation, competition are escalating. My eyes, ears, and nose are on high alert for what wild surprise will appear next.

And there it is. As I round a final corner before heading out of the park, I spy a pale snake lounging in the warm light of the now cloudless sky. She looks to be a water snake, but her skin is a strange beige, lacking the beautiful dark sheen these snakes generally have. As I observe her for a few moments at some distance, she makes no perceptible movement, so I advance to get a closer look. Never have I seen such pallid, chalky skin on a snake; even her eyes are lifeless.

I inch closer and closer until I am crouching right above her. Still she makes no move. Certain she is dead, I pick up a stick and gently ease it under her belly, hoping to get a better view of what fate befell this pale beauty. Suddenly, her head moves . . . very . . . slowly. She gazes up at me. Hmmm, not dead. I lower the stick, ever so softly, grateful she was not threatened by my gesture. She proceeds to glide unhurriedly into a patch of tall grasses where she nearly disappears, wound in a twist of shadow.

It occurs to me that this girl was out sunning for a reason. Being uncovered, especially in her current coloring, puts her at risk: an easy target for a passing hawk or ground predator. The warm spring sun must have been too much to resist. She had to take a moment to bask in this radiance, to bring her body back to life after a winter's repose and prepare herself for the hunts ahead. I back off a few yards and kneel down on the marshy ground, giving her some space. Momentarily she peeks her head out of the grasses, flicking out her pink sliver of tongue, once, twice, trying to assess what manner of curiosity I am. I do the same, in my own way, and we observe each other for a while.

I speculate that she may be moving quite slowly and looking unkempt unto death because she is preparing to shed her skin and start anew for the growing season. Watching her on the threshold of this transformation, I marvel at the gentle way she considers the world before her, including my giant face staring down from the sky. What must she be thinking? She may have only a vague notion of me while her body remains preoccupied by its more pressing needs: hunger, a new skin, warmth—she may still be slowed by the torpor of a too-cold body. What vulnerability! I am no pred-

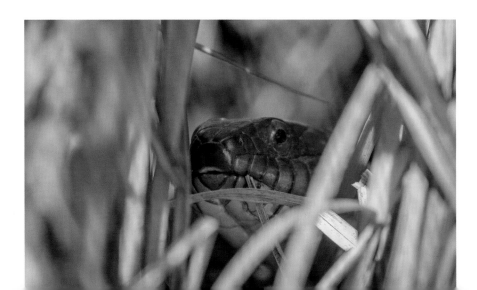

ator, and likely I am for the moment keeping predators at bay. But she can't know that. What a privilege to experience such wild wonder here in my city—in Kenilworth Aquatic Gardens, a park that for almost a century has been tended by the National Park Service: the US Solicitor General of Human Awe. I walk away, leaving this creature to her next slithers in life, and take my next steps downriver toward Kenilworth Park.

When I arrive, I am greeted not by birdsong, impressionistic marshes, turtles, beaver trails, and sleepy, shedding snakes but by the omnipresent port-a-john and the chain-link fence, which is still splayed out on the ground along with some other trash.

I often see people at Kenilworth Aquatic Gardens looking for birds and butterflies, strolling along the boardwalk through quiet marshlands, listening to a wild sonata conducted by blackbird, beaver, insect, and frog. I often see park rangers walking the grounds, taking people on tours, and tending the land.

I rarely see people at Kenilworth Park, neither rangers nor residents. I return now and then, just to see if the Park Service has made any move to care for this place as a national park should be cared for. As of today, not yet. Well, somebody turned the port-a-john upright. That's a start. But today, I wonder sadly, how many decades must pass, how much patience must be spent, how many children's childhoods will be gone before those responsible for the state of this river and its landscape stand up, apologize to the land, water, and people who live here, and say, "We are going to make this right." I understand all the rationalizations, the glacial pace of bureaucracy, the budget shortfalls, but where there is a will—a true will to do right—there is a way. And fifty years is more than sufficient time. Today of all days, standing alone on the sprawling toxic scar that is Kenilworth Park, I am unsatisfied.

On February 19, 1968, four days after Kelvin Tyrone Mock's death in Kenilworth Park, a *New York Times* article stated: "The city's festering, air-polluting Kenilworth dump, a landmark in the Negro northeast section since 1942, took the life last week of an exploring 7-year-old child, caught in a sudden, wind-whipped shift of flames."

This was one in a series of news articles that mentioned Kelvin's death—nine articles total that I have been able to find from papers nationwide. Only four mentioned him by name, one of which misspelled both his first and last names. Most referenced a seven-year-old boy, or a seven-year-old Negro boy, who had burned to death. Only one of the stories was actually about Kelvin and the tragedy of his death. None spoke of his life or family or of the injustice of siting a burning dump in a residential neighborhood—just blocks from two elementary schools. All but one of the stories concerned the ending of the Kenilworth dump fires, with Kelvin as a footnote.

How is this possible? His name, for the most part, has been lost to history. The forgotten child of a forgotten river. But in a long ripple of events Kelvin's brief life lives on. His legacy began the following day and continues even now, half a century later.

On February 16, 1968, the day after Kelvin's death, Mayor Walter Washington ordered a halt to the Kenilworth fires. *Washington Post and Times Herald* coverage of this news began, "In a very real sense, a 7-year-old boy gave his life to halt the burning of trash at the Kenilworth dump."

One could argue that Mayor Washington, had he come into power years earlier, may have prevented Kelvin's death. But Washington, the nation's first African American mayor—and the District's first mayor under home rule after nearly a century of congressional control—had just been appointed by President Lyndon Johnson three months before that fateful February day. Mayor Washington inherited an environmental ruin from the federal government, one that could not easily be set right.

The end to the Kenilworth fires was only a beginning. It took decades to shift the perception of this river landscape and poor northeastern neighborhood as a dumping ground. Trucks still thundered through the community to unload mountains of trash alongside the river. But instead of being burned, it was crushed by a powerful compactor, pressing a steady stream of waste into a thirty-foot-deep strata of metamorphic garbage. A story in the *Albuquerque Tribune* eighteen months after Kelvin's death said, "The Kenilworth Dump consists of 300 acres along the foul Anacostia River in the nation's capital." The riverside parkland remained a dump. But at least, a year and a half later, it wasn't on fire and there was a

plan: "When the land is used up, we'll be leaving the National Park Service a good stand of grass," commented a director of the landfill project. The Park Service planned to put in trees, hiking trails, a canoe center.

∿

I stand next to the port-a-john and think about the trees that were never planted, the hiking trails and canoe center that were never created; the garbage that clogs the Watts Branch; the nonnative turf carpet that capped the garbage decades ago—barren vegetation that blankets most of this national parkland. I wonder, if more people remembered Kelvin, if they knew the history of the Park Service's stewardship of this land, could we overcome the complacency that has allowed this to continue?

The seed of this forgetfulness is not hard to grasp. We are a forgetful species. But more than that, Kelvin's death came during a cyclone of cultural upheaval and unprecedented anguish, within Washington, DC, and nationwide. In the context of the 1960s, Kelvin's tragic death floated adrift upon a sea of tragedy.

In September 1967, when Mayor Washington assumed leadership of the city, Congress's near-complete control over the nation's capital came to an end. Finally, the residents of DC had a political voice, if a limited one. But in taking the mayoral post, Washington was stepping into a hornet's nest of a cultural battle between the most racist, segregationist members of Congress and the most militant voices in the civil rights movement, led in DC by Stokely Carmichael. These battles for long-deferred justice touched on nearly every angle of American society, from real estate to school equality to transportation. Congress was pressuring, some might say extorting, Mayor Washington to approve plans for massive expressways through poor and largely African American neighborhoods. Highway expansion had become a priority for segregationist factions in Congress when urban whites began fleeing to the suburbs after landmark Supreme Court cases like *Shelley v. Kraemer* (1948), and *Brown v. Board of Education* (1954). These court decisions, which undermined segregation, came during the Great Migration, when many African Americans were moving to northern cities to escape the racial oppression of the South.

In Washington, DC, along with many other cities nationwide, whites who were unwilling to accept the demographic and cultural trends toward

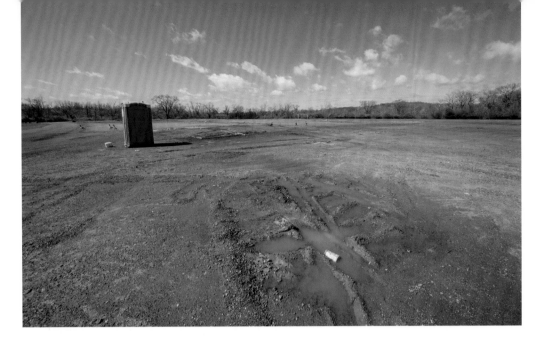

integration and diversity began moving to suburbs and demanding convenient high-speed roads to carry them back and forth from jobs in DC. In response, powerful members of Congress gave Mayor Washington an ultimatum: build the highways or forfeit funding for a new subway system.

Mayor Washington had his hands more than full, and meanwhile the national civil rights struggle was reaching a heartbreaking crescendo. It had been five years since Dr. Martin Luther King Jr. had delivered his "I Have a Dream" speech from the steps of the Lincoln Memorial, igniting the courage and resolve of 250,000 people who stood in attendance at the March on Washington, and millions more who were standing up for justice and equality nationwide. And they were not going to stand down, no matter the cost. The March on Washington came on the heels of the assassination of civil rights activist Medgar Evers and just months before the assassination of John F. Kennedy, who for years had been pressuring Congress for civil rights legislation.

Buoyed by a wave of national grief, anger, and activism, the Civil Rights Act of 1964 passed a sharply divided Congress. The legislation made unprecedented gains for social justice, but due to resistance by Southern Democrats, the bill lacked many important provisions. King, and those millions who stood with him, would not give up.

There are those who are asking the devotees of civil rights, "When will you be satisfied?" We can never be satisfied as long as the Negro is the victim of the unspeakable horrors of police brutality. We can never be satisfied as long as our bodies, heavy with the fatigue of travel, cannot gain lodging in the motels of the highways and the hotels of the cities.

∿

In the weeks preceding Kelvin Tyrone Mock's death, public attention was focused on the war in Vietnam and on civil rights protests, including the one King was planning in Washington, DC, in April 1968. President Johnson was pressuring Congress for a new Civil Rights Act to include protections that were left out of the 1964 legislation, but talks were breaking down every other week. King promised Congress that marchers in Washington would not be satisfied until their representatives passed a bill that would promote economic and social rights for the poor—black and white alike—including guaranteed jobs and guaranteed minimum income. He assured DC's leadership that the April action would be peaceful but warned that it could become disruptive if Congress did not act.

District and federal officials became increasingly anxious as the size of the planned march grew, and King's coalition broadened to include more militant leaders like Stokely Carmichael, who was educated at Howard University and had seen the worst of racist America. He had been spit on, gassed, beaten, and jailed during nonviolent protests for social equality. Over the years, the abuse marred Carmichael's faith in King's nonviolent process, and he had come to believe in a more militant strategy.

He wasn't alone. Anacostia watershed resident and leader of the Black United Front, Willie Hardy, spoke of her frustration over the pace of justice in an interview with the *Washington Post and Times Herald* published on March 10, 1968. "For hundreds of years you've taught me to be patient and wait," Hardy said. "But as soon as I say I won't wait any longer, you tell me I'm violent." Hardy worried that King's April action in DC would bring out what she called "ugly America," and she made it clear that this violent faction would not be met with passivity. "If those Maryland housewives come at us with guns, if the police issue threats and they call out the tanks—then we won't lie down and be nonviolent. No more."

Several weeks after Hardy's interview with the *Post*, King marched peacefully in Memphis for the rights of sanitation workers to safe, healthy conditions. But during the course of the march, a group of young people began looting, and police responded by gassing and clubbing King's peaceful protest. Riots erupted. The events that followed over the next

seven days changed the course of the nation, even as Kelvin's death changed the course of the Anacostia River watershed.

King had to leave Memphis for a few days after the riots. But he pledged to return and to continue working there until justice was firmly in place for the city's garbage workers. King returned April 4, 1968, to join marchers the next day. But the headlines on April 5 did not chronicle a march for justice. They did not detail a plan for fair treatment of those who toiled in one of society's most grueling jobs. They read instead, "Dr. King Is Slain in Memphis." And the world was never the same.

In the days and weeks that followed, instead of a peaceful march on Washington led by King, riots broke out in the District and in 130 cities nationwide. Dozens of people died when sixty-five thousand federal troops were dispatched to quell the violence. In the District, more than thirteen thousand troops were directed to subdue the city. The nation became a battle zone, with the largest deployment of federal troops on domestic soil since the Civil War. In many ways, it was just another battle in the same war, one waged since 1619, over who we are and who we want to become.

The assassination of King sent violent tremors through the bedrock of our community, widening the hairline fissures and subterranean fault lines buried in the deepest core of Anacostia and American history. Stratified centuries of slavery, lynch mobs, denial of citizenship and voting rights, segregation, police brutality, and the siting of chemical factories and burning dumps in poor, minority neighborhoods buckled our societal substrate. Without justice, there can be no peace.

It's impossible to say what alternative future would have unfolded if King had not returned to Memphis, if he had been able to lead his 1968 March on Washington, continue his own evolution as a thinker and leader, and amplify his irreplaceable voice for justice and connectedness. We will never know. What we do know is that his inspiration has never died. He is remembered, and the world is a different place because of it. Every year on King's birthday, thousands of residents come out to the Anacostia River to pick up trash, to do something good to honor his memory. An infinite number of other good works are done throughout the nation and world, many that are never noted or known but were inspired by the love and commitment that King gave the world. Memory matters.

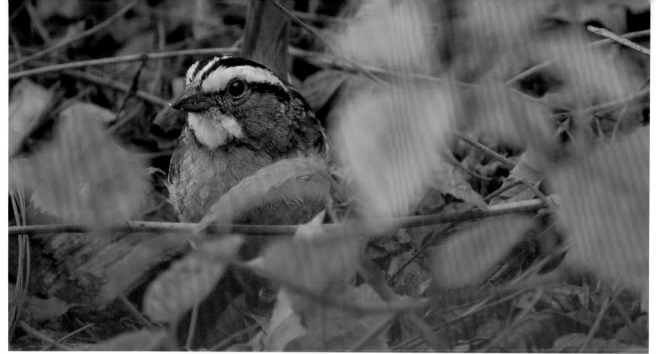

White-throated sparrow

If memory can inspire and inform, what then of forgetfulness and the void it leaves? What then of the forgotten child of a forgotten river?

∿

For the past week a young white-throated sparrow has been camping out in my yard. His song wakes me every morning, very, very early, before the sun has made the slightest hint of light on the eastern horizon. Before I have any intention of getting out of bed. So I just lie there, awake and listening in the darkness.

Bird reference books often translate the white-throated's song into the phrase *O sweet Canada, Canada,* an apt description of both the phonetics and the tone of these birds. Theirs is a wistful song constructed of minor notes, as if they are always preoccupied by thoughts of some other time and place, some melancholy memory or remembrance of a long-lost friend. My visitor sings throughout the day, distracting me from my work, as I would rather listen to him than do just about anything else. I've gathered he is a young bird because he seems to be practicing . . . and in need of practice. Sometimes he gets it right, but often he goes off key or loses pitch entirely or devolves into a whistle. He sounds like a gawky teenage boy whose voice is changing; every time he opens his mouth, what comes out may be a boy's treble, a man's baritone, or some crackling squawk that lies somewhere in between. His song lacks the grace and assurance of a mature songster, and he appears to be quite alone. I have seen no other white-throateds for a few days. I doubt his pitiful song has chased them

off. By now, many of my winter sparrows have begun to migrate north to Canada. Perhaps he is staying behind to practice before he journeys to the breeding grounds and attempts to woo a lady. That would be a good plan. He's not ready from what I can hear: *O sweet Canada, Cana-squawk-da*!

Yesterday I noticed the first buds on the walnut tree outside my back window. A few have already dropped into their bright green bloom, like clusters of tiny green grapes; but most are little more than bare twig with the slightest brown nubs just waiting to sprout. Within days the green thoughts percolating within these nubs will burst forth, attracting the attention of hungry squirrels, and very soon after that, my house wrens will return from points south and begin their seasonal governance of the walnut tree, where for years they have raised their young. They will scold squirrels, sparrows, and humans alike if we dare to enter their defense perimeter. I once saw a napping squirrel harangued for fifteen minutes by one of these feisty birds, which are the size of a ping-pong ball and about as heavy. If a squirrel were inclined, one punch of its paw in the wren's face would send the little ping-pong bouncing, bounce-bouncing. But squirrels rarely seem inclined toward violence, and wrens are quick and disarmingly cute. This particular squirrel ambled off and found another branch farther from the wren house where he could nap in peace.

Life seems to move so fast in these early weeks of April; everything becomes a battle for who will live the boldest and claim the best space for sun and food and shelter. Who will project the moxy that keeps interlopers away from their homes. Who can adapt to changing climates and conditions and still manage to thrive.

In search of some of this wild life I head out on my bike. On the bridge that spans the Northwest Branch on Rhode Island Avenue, I see a swallow emerge from one of the drains that empties into the river. He flies around for a spell, then returns to the hole, apparently having built a nest within. It's just a small hole, about the circumference of a baseball, about the size of a swallow, in the center of a thirty-foot-high concrete wall that channels the Northwest Branch toward its confluence with the Northeast Branch. I can imagine that to this little bird it resembles a cave in a high cliff wall, the kind of place his ancestors nested in, though a lot, lot noisier. And here, watching the swallows flying in and out of their concrete cave near

the merging point of the two main branches of the Anacostia, I consider the idea of confluence: two distinct arms, branches, ideas, coming together into one fluid stream. Throughout its modern history the Anacostia has been plagued with issues of injustice and environmental degradation: the felling of ancient forests, extermination of entire species, decimation of the native people, enslavement of Africans, dumping of sewage and garbage in the river, destruction of wetlands, dumping and burning in poor neighborhoods, decades of failure to do right by this river community.

In the 1960s, the struggle for civil rights paralleled the struggle for environmental protections. Both efforts sought to right wrongs, to end realities that were degrading to all involved, and both sought to compel the machine that had been ripping the garden to shreds—breaking the foundational bonds of community apart—to abide by the dictates of an increasingly more enlightened collective mind. Both were successful, to some extent, for out of this time came the legal framework that seeks to guide our river community on ethical environmental and social paths—the Clean Water Act and Civil Rights Act. But through the tumultuous 1960s these efforts generally followed their own separate trajectories. At the time of Kelvin's death, the ties between racism, poverty, and environmental degradation remained largely disconnected in the national consciousness.

Then in September 1982, the confluence of environment and justice struck the nation between the eyes when a poor, largely African American community lay down in the middle of a Warren County, North Carolina, road. The residents of Afton had protested the siting of a hazardous waste landfill in their community, but they were ignored. Industry and government made their plans to dump society's toxic waste on people they expected would have no recourse against them. As trucks filled with PCB-laden soil rolled into town, the residents, and their allies from the civil rights movement, blocked the opening to the new landfill. For six weeks they protested—marching, lying down, standing up, and sitting down, saying no, no, no, we won't be dumped on. In the end they lost, and toxic waste was unloaded on their rural town.

This wasn't the first instance of a community resisting an environmental insult. Cesar Chavez and Dolores Huerta organized farmworkers

in the early 1960s to protest exposure to pesticides and other workplace perils in California farm fields. In 1967, African Americans in Houston picketed a city garbage dump where two children had lost their lives. In New York City, 1968, residents of Harlem protested the siting of a sewage treatment plant in their community.

And of course, Kenilworth residents gathered to block the entrance to Kenilworth dump in 1966. But none of these efforts had garnered nation-wide attention as protests for environmental equality. Something different happened after Afton's failed protest. One of the protesters who joined that effort, Washington, DC, resident Walter E. Fauntroy, a longtime civil rights activist, took a decisive step. Fauntroy was by that time serving as the congressional representative for the District, and though the city had no voting rights in the House, Fauntroy did have the power to request a study from the Government Accountability Office about the siting of hazardous waste facilities. That study, published in 1983, found that three out of four hazardous waste landfills in the Southeast were located in poor and largely African American communities. More studies followed around the nation, and a trend became apparent—if you were economically disadvantaged and a racial minority, you were significantly more likely to have a waste facility in your backyard. Kenilworth dump was the rule, not the exception. There were thousands of Kelvins nationwide living, and sometimes dying, in the waste of an indifferent world.

I stand on the bridge watching swallows make do with their concrete cliff home as traffic on Rhode Island Avenue flies by and the Northwest Branch rolls ever onward toward its confluence. Near the water surface, another pipe enters into the stream, this one with a stain of grime left where polluted water has trickled out for decades. I notice someone has painted the figure of a peasant, holding his hands under the foul pipe, washing.

And out of nowhere, on an Anacostia breeze, the words of King return to me: "I have a dream that one day this nation will rise up and live out the true meaning of its creed: 'We hold these truths to be self-evident, that all men are created equal.'"

CONFLUENCE

Fiddleheads beginning to unfurl

Mayapple sprouting

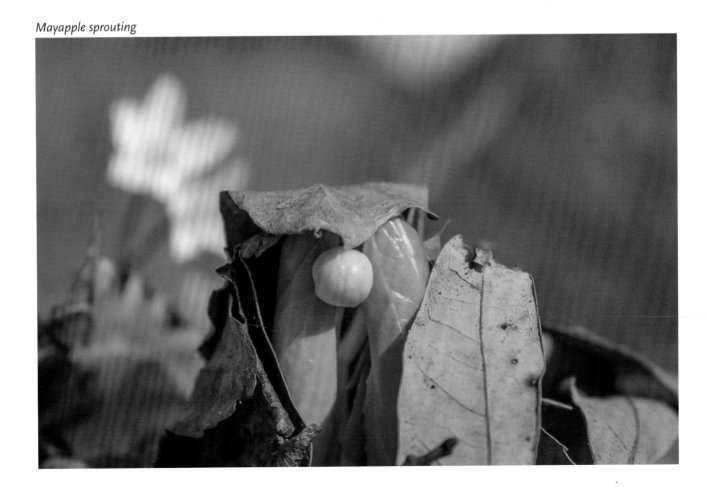

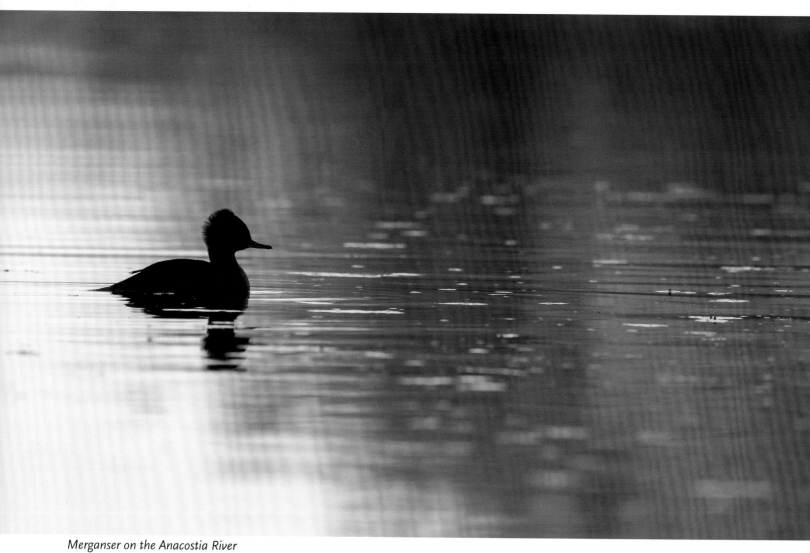

Merganser on the Anacostia River

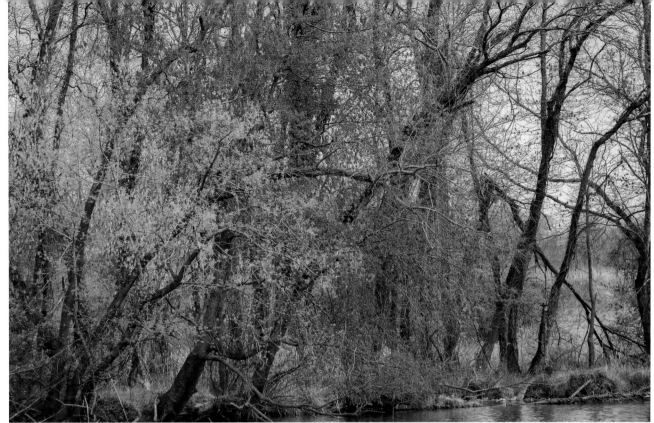

River forest budding, Bladensburg, Maryland

Red-wing blackbird flying through wetlands

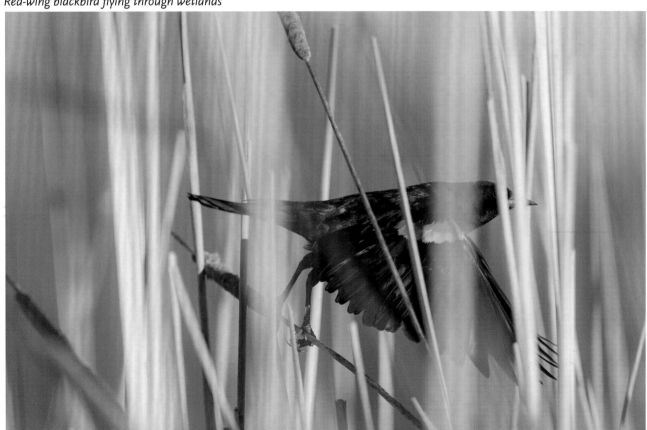

Sphinx moth

Spring forest, Arboretum

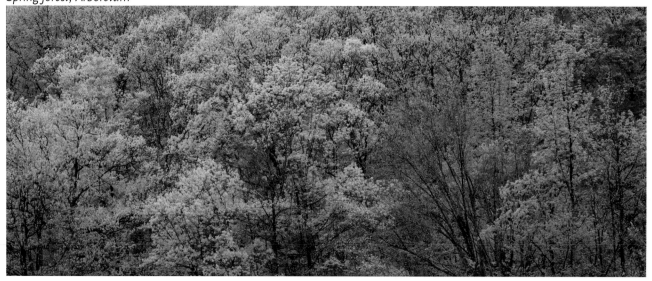

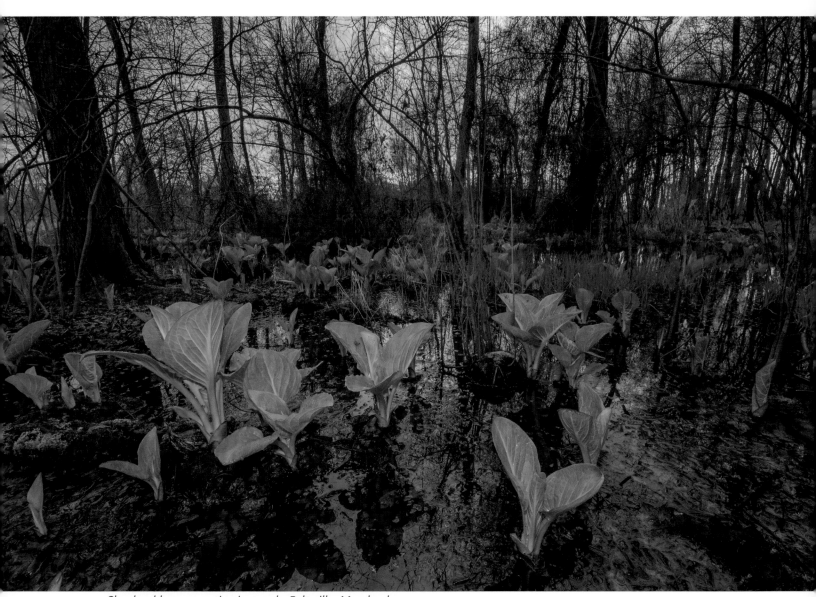

Skunk cabbage sprouting in marsh, Beltsville, Maryland

The Gilded Moon

By the first of May the watershed is lush and loud. Fiddleheads have uncoiled themselves into a sea of green feathers that sway upon the forest floor. Beside them, Jack in his pulpit has commenced preaching. Crayfish venture from muddy hideouts in the wet ground, and broad-headed skinks peek their flame-orange heads out of brown leaf litter—shy little embers whose brilliance could set the forest ablaze, if the world ever took notice of them. Certainly they prefer their anonymity. Freedom from fear and want in the skink world is a nice insect-ridden log for hiding, hunting, and—when no one's watching— basking in the glorious spring sun.

The last walk I took in the river forest, I could see seventy-five yards through a mostly bare community of trees and soil kept in the minimal- ist company of wake-robins. Today visibility has shrunk to ten yards or less because beech, gum, oak, and maple are now fully clothed, their raiment casting deep shadow on the forest landscape. Within the shaded folds of their dresses, red, lemon, orange, and cobalt-blue forms dash from branch to branch, like rainbow fractals cast from a swirling prism. The migrants are returned. And with them the full-spectrum color and forgotten song they carried away from forest, meadow, and wetland last fall.

These travelers have much to tell. They sing of tired wings that have borne them across oceans and over continents, forever following the roaming sun, guiding light of growing things. They speak of thirst and hunger; they sing of the hard work now at hand. Scarlet tanager, indigo bunting, redstart, and wren—they all have stories beyond imagining, each tale set to a sound track all its own.

The indigo bunting, like a mariner of old, followed the stars back from Central America, winging fifteen hundred miles on unseen cur- rents. I have been here waiting in the colorless winter world for the day

when I would walk along the edge of the Arboretum woods and hear his glad voice singing and see him dashing like a patch of sky fallen onto this verdant riverland. He threads his way through the ecotone, the border-lands of forest and meadow, of shaded fern and sun-drenched flower—his voice is as the coming of spring, a light and lilting opus for a time of ease and plenty, of freedom from fear and want.

Or so it seems to my human ears. In truth his song is more a tool for attaining that freedom than a celebration of a *fait accompli*. He will sing to woo his lady, or, when she is won, he sings to stay connected when work carries them apart; he sings to send assurance to his peeping nestlings that he is nearby and food is on the way; he sings to broadcast a claim over his space in the wild world. While his mate spends up to a week laboring alone to create their nest, the male indigo will sing almost non-stop. Buntings have been recorded singing two hundred songs an hour

American redstart

in the morning, and then one song a minute during the day. His phrasing, sometimes transcribed as *sweet-sweet-sweet-sweeter-sweeter-sweet-sweet*, describes a lovely sound but offers a poor translation. A closer interpretation may be *get-out, get-out, get-out-get-out*!

He sings ever so sweetly that this patch of ground belongs to him and his lady and their littles. Each *sweet-sweet* lays claim to every berry, seed, and insect in his song territory. Other birds may come in, but they must understand it is by his leave. It is not greed that drives him but survival, for him and for his family. He lays claim to little, just a small patch of Earth as far as his voice can carry. But what he needs, he cannot do without—such is the case for a life lacking superfluity, lived within nature's spare subsistence economy. Decadence in the natural world is death. The indigo is not laying claim to a cup of Starbucks coffee or craft beer, or Gucci purse, or Cuban cigar or tasting menu from a Top Chef—or coffee, beer, purse, or smokes of any kind. He claims what food he needs to feed his family and a safe branch to house his guileless babes.

Song can serve many purposes, but foundationally it is for many birds a boundary setter, a fence fabricated of musical phrases stitched together to delineate a bird's backyard. Song can be a threat to intruders and interlopers—for many birds song has taken the place of physical violence. Such a melodic apportioning of space prevents overpopulation of the land and

conflict over resources. A male indigo bunting with a strong voice can stake out food and space for his family without having to lift or ruffle a feather.

I have never seen an indigo bunting in a skirmish of song, where his home and family were truly at risk. But I have observed how serious song and defense of home can be for birds. On a recent paddle I saw an American redstart, recently returned from the tropics, defending a nest in the lowland forest on the edge of an Anacostia wetland. As soon as I noticed this gorgeous guy, a striking orange and black warbler, I stopped paddling and listened, having never heard his voice in the watershed. He wasn't singing, just piping out a single high, sonorous note at a constant slow tempo. I perceived an anxiety in his tone—which sounded more like an alarm than a song. Curious about the source of his distress, I looked around and noticed in the shadows below his tree a group of grackles had gathered and seemed to be loitering . . . just . . . milling around. The redstart measures perhaps one-sixth the size of a single grackle. He was facing down three, all expressing a keen interest in the tree. I couldn't see a nest, but grackles are known nest predators, and the diminutive redstart was on high alert. One by one the grackles started closing in, inch by inch, and each time they landed on his tree, the redstart swooped down furiously and chased them off, then returned to his singing perch and belted out his single notes. He was fierce, but after I watched this cycle repeat over and over again, I wondered how long it would take the redstart to tire. When would he even have time to eat? And if not, how could he keep up strength for the fight? He just finished a flight home from Central America!

Small birds can defend their keeps against much larger birds, and often I see these pipsqueaks chasing giant birds across the skies: blackbirds after eagles, orioles chasing crows. But everything depends on their health at the time of the attack. If they are already weary, if they are sick or the slightest bit off their game, they will have no choice but to watch while their eggs are plundered before their eyes or nestlings carried away in the talons or beak of another bird. If you've ever seen a newborn bird, it is not hard to imagine how vulnerable they are—often blind and bald and barely able to hold their heads up—and how vigilant their parents must be

Wren gathering nest material

Wren shack

if their chicks are to survive. Every moment is a struggle for a wild thing. Every hour a new chapter in a harrowing story of life, death, contentment, and anguish. I didn't have the heart to watch how the redstart's story would unfold, so I paddled on and hoped for his strength to hold.

Everywhere within the watershed these stories are forever unfolding. I catch mostly scenes and snippets, just enough to glean a respect for the

challenges my wild neighbors face. But there are certain characters I can follow more closely. I have for several days raptly observed my backyard wrens at work rehabbing the shoddy old house I put up for them in the walnut tree a few years back. It is a simple wood structure with a pitched roof—quite a handsome abode when I first brought it home. It has a small round door perfect for wren or warbler, but too small for invasive house sparrows or starlings. Through rain, snow, ice, and sun it has fallen into disrepair and is now held together in part by packing tape. When the wrens returned from their yearly trip south, they spent a full day inspecting and discussing the structure's merits, or lack thereof. At one point I saw the male standing on the taped part, pecking at it disapprovingly. It is hard to detect a frown on a beak, but male and female alike seemed displeased. Inwardly I shrank, ashamed at the state of my accommodations, though I have less to lose than the male wren. His success in wooing the female depends in large part on the home he presents to her—if she is displeased, he will remain a bachelor. Fortunately for him, this female has relatively low standards, and they agreed to move in. In my house's defense, it offers a hard structure with some protection from the rain and limited access for nest predators.

The pair has spent the past few days sprucing the shack up, gathering fresh twigs and leaf stems, grasses, hair, and other such things they can find in my yard to create a warm, soft, safe space for their nestlings. As they labor on the project, both birds sing and chatter, declaring to the world that they are back and this shitty excuse for a house belongs to them. The female often appears to be acting as foreman on the project, issuing a constant stream of instructions for the male, except when she has a twig in her mouth, and sometimes even then. I imagine she is either telling him to work faster, because she needs to lay, or micromanaging the manner of materials he is bringing home. He tends to gather items too large to fit in the entrance of the house—and wastes a fair amount of time trying to figure out how to fit them through the hole, turning them this way and that before losing control and dropping them to the ground. In truth he needs a good manager. I could watch her boss him around all day long, but as always the river awaits.

I head to Bladensburg Waterfront Park and hop in my kayak, easing

it into the river through a pale pink blanket of fog where swallows dart through the rosy river sunrise and crew boats line up for a morning glide. A great blue heron stands upriver in the shallows while a bald eagle lifts off from his perch upon a riverside tree. At the base of the eagle's tree, a beaver paddles by. I float downriver, taking in the life of the wild and taking my time in the tranquil fog. As always, osprey are soaring the sky above, peering hungrily into the silvery lives of fish.

High tide and a recent storm have carried an excessive amount of trash into the upper Anacostia. It flows downstream very slowly and collects in the river's sluggish areas, wetlands, and little bays, merging with sewage, silt, oil, and chemicals that have flowed from city streets through storm drains to the river. Beaver swim through the brown, sluggish slurry past plastic bottles; turtles poke their heads through flotillas of garbage; blackbirds forage on floating mats of detritus; sandpipers skitter along a littered riverbank.

I paddle through the refuse, under the Route 50 Bridge, and continue on past the Arboretum and Kenilworth Aquatic Gardens to the downstream side of Kenilworth Park, where the Watts Branch enters into a small cove on the river, at the foot of what was formerly the PEPCO electric plant. Starting in 1906, this facility burned coal and oil to create electricity for the District for more than a century. While we were running our lights, televisions, air conditioners, and hair dryers on PEPCO's electricity, the industrial fluids and fossil fuel by-products from the plant were poisoning our Anacostia community. There can never be a full accounting of the pollutants that entered air and water during PEPCO's long tenure on this land—many of these toxins entered the riverbed long before anyone understood the peril they posed. But since 1985 numerous poisons emanating from the PEPCO facility have been documented—everything from polychlorinated biphenyls (PCBs) to polycyclic aromatic hydrocarbons (PAHs) and heavy metals. For the Anacostia community, the burden of these poisons—linked to cancer, neurological disorders, and organ damage for wildlife and humans alike—cannot truly be measured. Degradation of river health, loss of wildlife resilience and diversity, diminishment of human health and happiness, and an economy hampered by industrial pollution—all of these are values without a known measure in

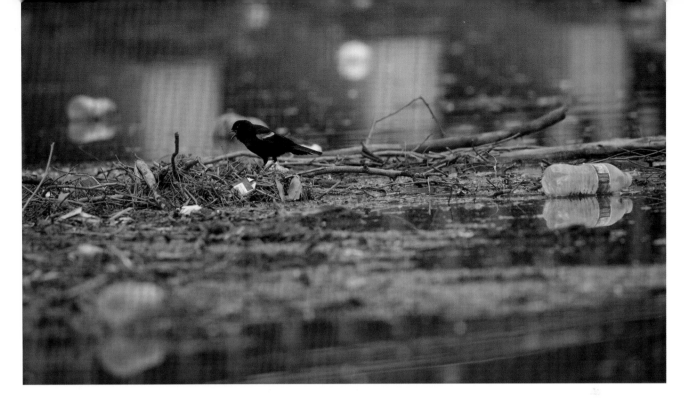

our society. They are *invaluable*, and thus there can never be a full reckoning. The land has never been restored, and pollution continues to stream into the river.

In 2011, the DC Department of Energy and Environment signed an agreement with PEPCO to guide cleanup of substances the company unleashed on the river community decades ago, which remain lodged in river sediment as an ongoing threat to river life. And as late as January 2017, the US Environmental Protection Agency (EPA), prompted by the Anacostia Riverkeeper and other advocates, sued PEPCO for ongoing hazardous discharges directly into the river from PEPCO land.

Undeniably, PEPCO has had a degrading presence on the Anacostia landscape. But the corporation's lands and actions represent only one of a heaping handful of toxic actors in our river community. Thirteen distinct locations were noted in a 2016 report commissioned by the District, which detailed the toxic chemicals that now reside in the riverbed: PCBs, PAHs, DDT, chlordane, and myriad heavy metals. Five of the thirteen sites—more than one thousand acres of land—belong to or were used at one time by the US Armed Services. The toxic residue of shipbuilding, weapons and ammunition manufacturing, fuel tanks, and air fields—those modern appliances of war that the Corps of Engineers' Lt. Col. Peter Hains gushed about a century ago—have infiltrated the soil and river sediment, where they are extremely difficult to remove without stirring up toxic ripples for the whole river and the larger Chesapeake Bay watershed.

The other main players whose toxic legacy remains lodged in river sediment include Washington Gas, the CSX railroad yard, and the National Park Service, stewards of the Kenilworth dump. The city bears some responsibility for all of this, but for much of the District's history it was controlled by the federal government and even now has no voting rights in Congress. Of course, we the people are ultimately where the buck stops—we *are* our government, and this is our legacy on the landscape, our civilization's reckless record in the Anacostia's aged memory.

So far.

I remember paddling just a few years ago under the long shadow of the PEPCO plant smokestack, which overwhelmed the river landscape with a towering grimy presence. Today that smokestack is gone. The plant was demolished in 2015, removing much of the riverside evidence of PEPCO's existence. The first moment I saw the riverbank without that industrial scar, it was as if a great weight had been lifted from the land. The psychology of that space had suddenly shifted. Trees and sky now dominate the river view.

But PEPCO is not truly gone. The bequest of this industry remains as a poison beneath my kayak, lodged in the toenails of turtles, in the bodies of tiny amphipods and insect larvae that make up the base of the river food chain, in the gills of eels and catfish, in the bellies of people who eat fish from the river.

In 2002, the US Fish and Wildlife Service published a study that found nearly two-thirds of the brown bullhead catfish in the Anacostia River had liver tumors and other malignancies tied to toxic sediment. A more recent study reported that much of the sediment remained toxic to the smallest aquatic residents and that the fish who consume them store PCBs, chlordane, and DDT in their tissues.

One wonders, surrounded by trash floating above a riverbed where poison is so widespread it has become a foundational part of the food chain—how did we get here, to this broken place so far down this crooked road?

Some might say greed lies at the crux of the matter. This inclination often drives society, though it tends to profit only a small proportion of people. But our predicament is also a result of the persistent misconception

that we exist in a system outside Earth's ecology and are not bound by natural laws that govern the land community. This belief gives rise to hubris unsupported by the Swiss cheese state of human knowledge; we are clever enough to forge the sword of science and technology but not yet wise enough to wield it with science as a searchlight on our fragile universe. We are capable as a species of creating the internal-combustion engine, atomic bomb, and chemical pesticides for the control of nature but not wise enough to understand their long-ranging implications or to use some restraint when long-term effects are unknown.

Never was this more apparent than during and after World War II, when the profit potential at the intersection of war, industry, and science became fully realized. A cornerstone of this intersection, the chemical industry, ascended in 1939 when Paul Hermann Müller, a Swiss chemist, discovered that a substance called dichloro-diphenyl-trichloroethane (DDT) could fatally impair an insect's motor coordination. DDT was the first major player in a new family of chlorine-based poisons, which were not obviously, visibly, or immediately toxic to people but were deadly to insects.

In the middle of World War II the US military rushed DDT to the war zone where insect-borne diseases like typhus and malaria were sickening soldiers and running rampant through refugee populations. This miracle killer was sprayed in billowing clouds over more than a million people. *Time* magazine hailed it as one of the greatest discoveries of World War II. And when the war ended, technology was credited with the win—in the forms of the atomic bomb and DDT.

Perhaps at no other time in human history had science as humanity's sword gained such ascendance, and that sword was leveled against every perceived US enemy, from Nazis and communists to the land itself. The problem was, as is always the case in our paradoxical world, the sword was double-edged, and we have been quietly bleeding from internal wounds ever since.

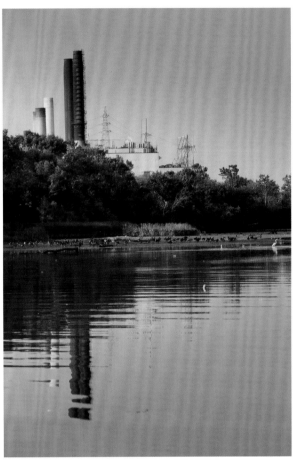

PEPCO plant, 2010

∿

After the war, an America full of postwar optimism embraced DDT like
a long-lost benevolent uncle, showering it from crop dusters over forests
and into farm fields, through hoses onto children in pools and school-
yards, from aerosol cans into cupboards in homes. You could buy DDT-
laced paper to line your kitchen shelves, DDT soap to lather onto your
body, furniture polish to shine up your dining room table, and even fog-
gers that created a cloud of DDT over your backyard before cookouts so
guests wouldn't suffer a single bug bite.

In the zeal for chemical control over our environment the government
even devised plans to rid the nation of whole species of creatures that
were inconvenient for humankind. The growing science of ecology offered
guidance against such reckless action. As Aldo Leopold wrote in 1948,

> The last word in ignorance is the man who says of an animal or
> plant: "What good is it?" If the land mechanism as a whole is good,
> then every part is good, whether we understand it or not. If the biota,
> in the course of aeons, has built something we like but do not under-
> stand, then who but a fool would discard seemingly useless parts?

But very few people questioned DDT and the growing number of miracle
pesticides and herbicides, or the wisdom of going to war against nature,
and it was assumed that government and industry would consider public
safety without being asked to do so. But chemists were largely concerned
with a pesticide's efficacy rather than its safety. The EPA did not yet exist,
and the USDA, the only agency with any real regulatory role, defined a
pesticide's appropriateness by the impact it had on crop yields. Chemical
companies—flush with the tobacco of the Cold War era—were swimming
in pesticide cash, and if they knew there was a problem, they were not
telling.

Birders and biologists began noticing steep declines in bird pop-
ulations and increasingly strange animal deaths. But in the optimistic
ticker-tape parade that eternally showered can-do confetti on the Greatest
Generation and toddling baby boom, there was little appetite for pub-

lic dissent. Until one day in 1962, when a quiet Anacostia watershed resident named Rachel Carson wrote a book that altered the orbital axis of the Anacostia community and the world at large. Carson's work was rooted in almost twenty years of study on the devastating impacts of DDT and other environmental poisons, which the government and industry had been quite content to ignore.

Beginning in 1945, research began revealing that DDT killed amphibians, reptiles, fish, mammals, and birds—in other words, just about every living thing—sometimes in alarming numbers. From scarlet tanagers and wood thrush to pumpkinseed, bluegill, crayfish, cottontail, and water snakes, the tests were conclusive—DDT was dangerous and cause for "grave concern," according to the US Fish and Wildlife Service. A press release was issued, but if any of the press or public saw it, there is little evidence. Carson, who worked for Fish and Wildlife at the time, proposed an article to the widely read *Reader's Digest*, but the magazine declined. The government's wildlife study remained relatively obscure, and in 1948 Paul Müller was awarded the Nobel Prize for his discovery of DDT.

Promotional poster for DDT. Photo: National Archives

Carson went on to other projects, including writing a series of best-selling books about the ocean. But she continued to follow reports of DDT's impacts, as well as the growing science surrounding the impacts of radioactive fallout from atomic testing. In the 1950s the US government was regularly conducting atmospheric tests of nuclear bombs and was simultaneously engaged in an attempt to chemically eradicate insects that undercut profits for the nation's agriculture industry. By-products of radiation and DDT started showing up in milk from cows that pastured on grass laced with radioactive fallout and pesticides. Research began to show that these contaminants were not only toxic in the immediate term but also capable of causing genes to mutate and damaging the cellular dynam-

ics of every living thing. Evidence was mounting that the government had not been telling the whole story or, as in the case of the Fish and Wildlife Service, telling it so quietly that no one heard.

Carson endeavored to change that. In the decade that had passed since she first proposed the DDT story to *Reader's Digest*, she had become a literary celebrity, with three best-selling books, a National Book Award, and a Burroughs Medal. She was financially stable and connected to a larger community of environmental leaders, many of whom, like Paul Bartch and Roger Tory Peterson, served with Carson as board members of the DC Audubon Society. In 1958, Carson learned that *Reader's Digest* planned a positive article about the government's use of DDT to exterminate the gypsy moth. Within months, she signed a contract with publisher Houghton Mifflin to write the book that would ultimately be named *Silent Spring*.

Carson wrote much of *Silent Spring* while in her home on the Northwest Branch of the Anacostia River, and though the book was not specifically about our river ecosystem, it told our story, along with the story of every watershed in America, and it would ultimately have profound effects on our river community. *Silent Spring*'s opening pages are an allegory of a fictional town filled with the riches of nature.

> The countryside was, in fact, famous for the abundance and variety of its bird life, and when the flood of migrants was pouring through in spring and fall people traveled from great distances to observe them. Others came to fish in the streams, which flowed clear and cold out of the hills and contained shady pools where trout lay.

But then something changed and the land fell into a toxic silence, where indigo buntings no longer proclaimed their territories to would-be rivals, wrens no longer chastised lazy squirrels, and robins no longer woke with the emergence of the spring wildflowers.

> There was a strange stillness. The birds, for example—where had they gone? Many people spoke of them, puzzled and disturbed. The feeding stations in the backyards were deserted. The few birds

seen anywhere were moribund; they trembled violently and could not fly. It was a spring without voices. On the mornings that had once throbbed with the dawn chorus of robins, catbirds, doves, jays, wrens and scores of other bird voices there was now no sound; only silence lay over the fields and woods and marsh.

In her fictional town, Carson alluded to a national obsession during the Cold War, the threat of an external communist enemy standing on the nation's doorstep, ready to invade. But, as she suggested, the clearest and most present danger lay within our own culture. "No witchcraft, no enemy action had silenced the rebirth of new life in this stricken world. The people had done it themselves."

It was an allegory for the American landscape at every time in US history since the dawn of the colonial era. No communist, terrorist, Tory, undocumented immigrant, alien, or robot had poisoned the water and silenced the land; we had.

From that opening story, Carson outlined the rigorous research she had done compiling the outcomes of the ongoing high-stakes science experiment on the American landscape—her work was in fact more rigorous and thorough than any that had been released by the supposedly responsible parties of government and industry. And she wrote it so that any American reader could understand. She detailed the composition of a dizzying array of new chemicals rushed to market every year—almost five hundred annually in the United States alone. More than two hundred of the chemicals created since the 1940s were designed especially for humankind's war against nature, for the killing of unwanted insects,

DDT wall hanging to kill flies in nursery. Photo: HistoryAnorak

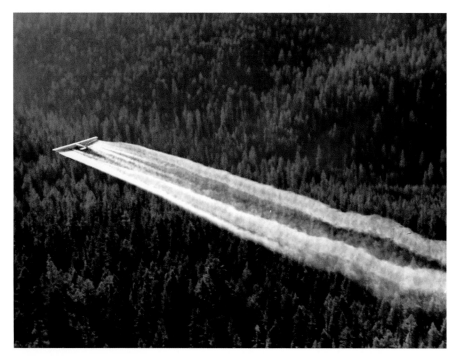

Aerial spraying of DDT, Oregon, 1955. Photo: R6, State & Private Forestry, Forest Health Protection

plants, rodents, and other *pests*. The problem was, what we called pests were in fact members of the ecological community with important roles: creating soil so that trees could grow, feeding birds and frogs, and providing pollen for bees that made all fruits possible. What we saw as unpleasant and inconvenient, and sometimes dangerous, were essential elements of ecology. And we were trying to extinguish them from the Earth with poisons we didn't understand.

DDT was one compound in a large and rapidly expanding family of chlorinated hydrocarbons, many of which, even in very small doses, could result in significant changes in the body: reduction in heart and liver function, sterility, cancers. The chemicals accumulated in body fat, and concentrations rose with each exposure, so that pesticides were routinely found throughout the human body, even in breast milk that fed newborn babies. The US Food and Drug Administration admitted in 1950 that the potential hazard of DDT had been underestimated, yet, as Carson reported in *Silent Spring*, many of these substances, including DDT, chlordane, and parathion, continued to be widely used by the public as well as government and industry. And many were even more dangerous than DDT, some by orders of

magnitude. Carson carefully documented the rising death toll for humans and wildlife alike: two children dead in Florida after playing with an empty bag that had once contained the insecticide parathion; farmworkers critically stricken in Riverside, California, after picking oranges treated with parathion; a child convulsing and going brain dead after exposure to a small amount of the pesticide endrin—in the same chemical family as chlordane. Pesticides were regularly sickening humans, and the chemicals were being absorbed in the body fat of every American, a hidden danger with unknown long-range implications.

But the death toll for wildlife was significantly higher, with chemicals not only threatening some members of species but hastening the utter extinction of entire species. When migrating American robins returned to Michigan State University in 1954 after the campus was sprayed with DDT, the birds began dying as if a plague had hit. "The campus is serving as a graveyard for most of the robins that attempt to take up residence in the spring," commented one of the campus researchers. The robins were not even present during the DDT application—they had no firsthand exposure. Rather, they were dying after eating earthworms that had stored DDT in their bodies for months after consuming contaminated leaves. Videos at the time showed robins lying on the grass violently convulsing after eating worms. One woman called the research team to report twelve robins lying dead on her lawn. Many robins who survived the poison were later found to be sterile. "We have one record of a robin that sat on its eggs faithfully for 21 days and they did not hatch." A full week she sat beyond the normal incubation period, not willing to give up on her nestlings.

Bald eagles were experiencing a similarly drastic decline in fertility after eating fish contaminated with DDT. The chemical caused the eagles' eggshells to be so thin that when the birds sat to incubate their clutch, the eggs were crushed. In some populations, the reduction in eagle fertility was 80–100 percent, with no young fledging from populations that had produced eaglets every year prior to widespread use of DDT. Whole generations were lost. And unlike robins, bald eagles were already imperiled as a species due to hunting, habitat loss, and declining water quality. In *Silent Spring*, Carson predicted that if something didn't change, the United States would exterminate its national emblem. When the bald

eagle was named the national symbol in the late 1700s, there were more than one hundred thousand of the birds; by 1963, a year after Carson's warning, there were fewer than five hundred breeding pairs and the species hovered on the brink of extinction. Many other birds were facing a similar peril, including osprey, falcons, and pelicans.

"Can anyone believe it is possible to lay down such a barrage of poisons on the surface of the earth without making it unfit for all life?" Carson asked. "They should not be called 'insecticides,' but 'biocides.'"

Silent Spring forecasted a bleak fate for a society that failed to show the slightest caution when introducing highly toxic substances into a fragile interconnected natural system. Despite its serious content and alarming conclusions, *Silent Spring* became an instant phenomenon, a clanging wake-up call for a slumbering nation. The USDA was overwhelmed with the public outcry. The chemical industry launched a smear campaign against the book and Carson herself, accusing her of being a communist and trying to destabilize the US economy. Opponents belittled her claims, saying, "What was the death of a songbird against ending world hunger?" This of course is a foolish, dishonest response: no pesticide is intended for or capable of ending world hunger. But more important, Carson wasn't writing about the death of a single songbird, and the industry's simplistic obfuscation missed Carson's point entirely: we ourselves are part of the natural ecology—there is no magical separation, no artificial barrier that protects us while the rest of the natural world suffers the consequences of our poisons.

Because she was a woman, critics called her hysterical and overly emotional—this about a person who had suffered metastatic cancer for years so silently and stoically that almost no one knew she was dying. By the time *Silent Spring* was published, Carson's body was so broken by the disease that she could barely walk. But the chemical industry was so threatened by this frail, dying writer, it asserted, hysterically one might say, that listening to Carson meant the "end of human progress."

People did listen to Carson. Her book became a center of national discussion and debate, prompting government inquiries, launching further investigations, and making the book a best seller. Carson became a reluctant celebrity, forcing herself to speak out on behalf of the birds and other

creatures whose very existence was at stake but who had no voice in our society. In 1963, she testified before a Senate committee, bearing witness to the enormous cost of our reckless actions and posing a question for the nation: Just how much are we willing to sacrifice to the grinding engines of economy and industry?

It was a question long in the making, the crux of Leopold's paradox between the sword and the searchlight, between Marx's garden and the machine. Having asked her question, Carson died in her home on the Northwest Branch. She was fifty-six and had been living in physical agony for years as she finished her final gift to the world.

∿∿

I recently took a pilgrimage to Carson's former home, a few miles upstream from my own home on the Northwest Branch. It seemed important to visit the place where she lived in order to understand her life as it was woven into the landscape of the Anacostia. Her house, a modest structure that she designed as a writing retreat in 1956, is now a National Historic Landmark. Mature trees and native plants still cover most of her yard, and a stream runs off the property, under a road, and then widens into a tributary of the Northwest Branch, shaded by tall trees and lively with bird voices. I walked along the stream while a soft spring rain fell and tufted titmice, robins, wrens, phoebes, jays, crows, doves, woodpeckers, and cardinals offered their voices to the watershed woods. I even heard a wood thrush in the distance along with cicadas and frogs; I found spiders and giant swallowtail butterflies and was bitten by a few mosquitoes—the price of admission to this Anacostia garden. Each resident I encountered on that visit, each voice, every wing on the wind seemed to me a living song of gratitude to the legacy of Rachel Carson. And as I listened to

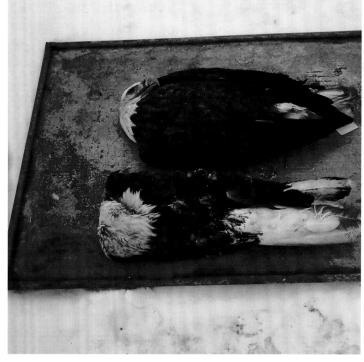

Bald eagles found dead after DDT spraying, Seney National Wildlife Refuge, Michigan. Photo: Seney Natural History Association

them, I thought of a quote from a letter she sent to her best friend after finishing the manuscript for *Silent Spring*:

> I could never again listen happily to a thrush song if I had not done all I could. And last night the thoughts of all the birds and other creatures and all the loveliness that is in nature came to me with such a surge of deep happiness that now I had done what I could.

Following Carson's death *Silent Spring* took on a life of its own in the ecology of human consciousness, and in the larger, more aged annals of Earth's ecology. The book sparked the creation of the Environmental Defense Fund, which launched a campaign focused on banning DDT. Carson's criticism of the USDA's cozy relationship with the chemical and agricultural industries led to the 1970 establishment of the EPA by President Richard M. Nixon. And in 1972, the passage of the Clean Water Act gave the nascent EPA legal standing to control pollutants entering US waterways and to hold polluters accountable. The new agency also had the authority to regulate products dangerous to the environment and human health. DDT was banned in 1972, PCBs in 1979, chlordane in 1988.

Silent Spring also sparked the 1962 protest led by Cesar Chavez and Dolores Huerta, who marched alongside California migrant workers demanding safe working conditions. This event is accounted by many as one of the earliest awakenings in the environmental justice movement.

When Carson cast *Silent Spring* onto the waters of human consciousness, she initiated ripples of action that to this day spread outward in perpetual motion. Her legacy has become infinite. But perhaps greater than any other accomplishment, Carson taught our society to take a critical look at technology, government, and industry; to consider the costs as well as the gains; to ask ourselves what our machine has done to the garden and whether it is truly worth it. In an interview with CBS Carson stated, "We still talk in terms of conquest. We still haven't become mature enough to think of ourselves as only a tiny part of a vast and incredible universe."

Carson spoke for science as the searchlight on our universe, science as a conduit to reconnect humanity to the community of land, water, plant, and animal. She spoke for gentle wisdom and humility versus aggression, arrogance, and hubris. Like Aldo Leopold, John Burroughs, and Florence Augusta Merriam, she helped us see that life is fragile, fragile as the trembling wing of a robin, as the delicate shell of a bald eagle egg, as the wing of a cicada or song of a thrush.

On the Anacostia River, in a single day's paddle, it's not hard to catalogue what we've sacrificed for what we call progress. *Silent Spring* afforded us a great leap in consciousness, but the conflict between the machine and the garden remains, as do the dangerous chemicals that have accumulated in the body of the Anacostia over the past century. Since 1972 federal law has stated that our rivers and lakes must be clean enough for people to swim in them and eat fish from them, but we are many years from achieving that dream.

On my paddle back to Bladensburg I encounter many who make up the Anacostia fishing community: eagle, osprey, cormorant, heron, and more than forty people scattered along the miles of riverbank, sitting in lawn chairs or standing along the shore, smiles on their faces and poles at the ready. Some of the oldest human civilizations were based on a subsistence fishing economy, and for so many of us the thrill of hauling a fish out of the water for dinner remains coded in our DNA.

When I arrive back at the kayak launch, I float for a while watching birds and humans hauling in their catch. None can compete with the osprey, many of whom soar overhead. When they see movement in the water below, they stop midair, hover for a moment, then plunge like a feathered spear into the Anacostia. Expert anglers, osprey have been known to haul seven fish for every ten dives, when they are on their game. Today, they are not on their game. I observe just one fish for every ten dives, just one. Often when they have taken flight with a fish, crows, gulls,

In addition to writing Silent Spring, *Carson wrote three best-selling books and was honored with a National Book Award and a Burroughs Medal, given in honor of the Anacostia's own John Burroughs. Photo: US Fish and Wildlife Service*

and even eagles chase them, hoping they will drop their hard-won prize. The bald fish thief shadows the osprey's every chaotic turn. He is a juvenile male striking out on his own very recently—one of the first fledglings of a bald eagle pair that began nesting in the Arboretum a few years ago. A huge moment for the Anacostia.

For almost seventy years while the species teetered on the edge of oblivion, bald eagles had been absent on the river, without a single recorded nest. After DDT was banned, eagles began to rebound. In 2015 they were estimated to number more than eleven thousand pairs nationwide. That same year, District wildlife biologist Dan Rauch noticed eagles soaring above Kingman Island in a mating flight. Another observer saw one of the eagles carrying a stick, suggesting nesting behavior. Shortly thereafter, National Arboretum staff found that the eagles had begun building a nest high up in an old poplar tree within the forest, with a view to the Anacostia. They had returned to exactly the same spot where they were last recorded nesting in Washington, DC, in 1947.

The eagles' return has captured the hearts of many in the nation's capital, and for good reason. These proud birds, crowned with brilliant white feathers, borne to improbable heights on powerful wings, endowed with their fierce and far-seeing eyes, suggest a nobility, an independence we have always aspired to as a nation. It was the reason the bald eagle was chosen as our national emblem. And when they began to disappear from the landscape, we lost something important of ourselves. Their return provides hard evidence that this lost something—and so much more—can return to us.

◠◡◠

As I watch eagle and osprey jousting in the Anacostia sky, I think about the hunger that drives these birds and try to imagine what true hunger feels like. I have felt hungry but never feared for my life or felt my continued existence hinge on whether I was successful at a hunt. When I think of hunger, I think of a feeling, an urge, not a need, because I have never been without. I may want a fish to eat, but if I see a river is full of pollution, I can leave, go to a restaurant, or grab something out of my full refrigerator at home. Osprey cannot, cormorants cannot, heron cannot— for them, what is in this river is what they have, all they have. It is life, or

it is death. Hunger brought their parents to this river before they were born, and hunger will bring them back every day until they die. They do not have the privilege of forgetting the Anacostia, if privilege it could be called.

A few years ago, a study of the human fishing community on the Anacostia found that a surprising number of people in the Anacostia watershed had a similar relationship to the river. Despite fishing advisories since the 1990s directing people not to eat certain fish from the river—especially catfish and other bottom feeders—approximately seventeen thousand people were regularly eating fish from the Anacostia. Most because they needed the food. Some were longtime Anacostia residents, often African American; some were new immigrants to the country, from Southeast Asia and Latin America, many without papers or mastery of English. I've met some of these residents while out kayaking and biking on the river. One family of recent immigrants from El Salvador had caught more than one hundred pounds of blue catfish when I paddled up. They spoke only Spanish and told me that they were out catching their dinner for the week. Another man who fished regularly from the CSX bridge was catching dinner for a friend who didn't have enough to eat. I sat with him as he hauled in one catfish after another, and one time snagged a plastic bag. A grandfather was standing with his granddaughter and grandson on one of the combined sewer outfalls in Anacostia Park, teaching them how to fish. They cast their lines into waters where plastic bottles and toys floated, where the sediment was more sewage than earth, but they were having a ball outside on a Saturday with their grandpa. And one man, in Bladensburg, was fishing to fill his freezer, as some measure of freedom from want in the coming months.

As I sit in my kayak watching the anglers, those with feathers and fishing poles alike, I recall a story told to me by former Anacostia Riverkeeper Mike Bolinder, about the surveys he took of the fishing community. He was interviewing a man who had recently emigrated from Central America and asked him if he was worried about eating the fish from the Anacostia. Mike's rough translation of the man's response was: "No, I ate fish from the rivers in my own country, and we don't have environmental laws. This is the United States; the waters must be safe."

We are the land of Muir, Thoreau, Carson, and Roosevelt. We passed

some of the first environmental laws in the world to protect water, air, land, and wildlife. It must be safe to eat fish here.

We are the land of Leopold. He spoke of fishing, one of his great loves, and the pitfalls common to human being and fish alike.

How like fish we are: ready, nay eager, to seize upon whatever new thing some wind of circumstance shakes down upon the river of time! And how we rue our haste, finding the gilded morsel to contain a hook.

When the Anacostia fishing study was released, the response of many in government and the nonprofit community was, "We have to get people to stop eating fish from this river!" There was talk of posting signs with skull and crossbones near the river, and Spanish-language signs linking the fish to cancer and death.

I thought, no, no, no . . . we have to clean up this river! We have to make those who profited or turned a blind eye pay to restore what they took from us—that essential piece of being a human creature living on a river, swimming and fishing and delighting in the perfect grace of a clean, clear stream—they stole that from us. They gulped down a gilded morsel and set the hook in our mouths.

We have a law saying that is not okay, and they must give back what they took. This is not a situation you adapt to by encouraging people to distance themselves even further from the river so that government and industry can continue to escape the hook. This has been the response of Americans to our poisoned waterways for fifty years. Every time it is discovered that someone has poisoned our food chain, the government tells us: Stop eating the fish. Fish advisories have become part of a culture of dysfunction, a fundamental reason why a half century after the Clean Water Act we still don't have clean waters.

DDT and other toxins have been banned in the United States, but many are still being sold internationally by US companies to countries that don't have legal protections. And many dangerous chemicals are still per-

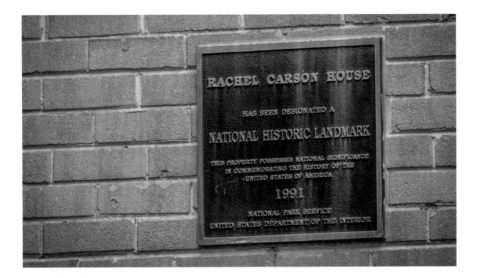

fectly legal to manufacture and use in the United States. Despite sickening 650 agricultural workers since 1966, and killing 100 of them, and being responsible for thousands of deaths worldwide, the chemical parathion has never been fully banned. The EPA has tried on several occasions to ban the substance, one of the most dangerous insecticides ever made. Each time it has been blocked by industry backlash, which claims that too much profit will be lost by its maker Bayer, and that it will cause an increase of food prices due to the higher cost of substitute pesticides. In 2015, the EPA effected a partial ban on the chemical, only for foods commonly eaten by children, which affords little protection to farm workers and none to the wildlife and waters imperiled by such a dangerous poison.

Parathion is one of countless, dangerous chemicals still being sprayed onto our lawns, fruits, forests, and vegetables—all of which ultimately end up in our food chain and waterways. Just about every toxic substance we can conceive of for a greener lawn, a more pleasing flower, a cleaner engine, a faster commute, a more colorful house will find its way into our Anacostia, into the bodies of its smaller creatures, and then into the mouths of fish, who will live sight unseen with the piercing consequences of our gilded hook.

Osprey, cormorants, and herons don't understand the skull and cross-bones, or Spanish, and even if they did, they have no other choice.

We have to clean up this river.

GILDED

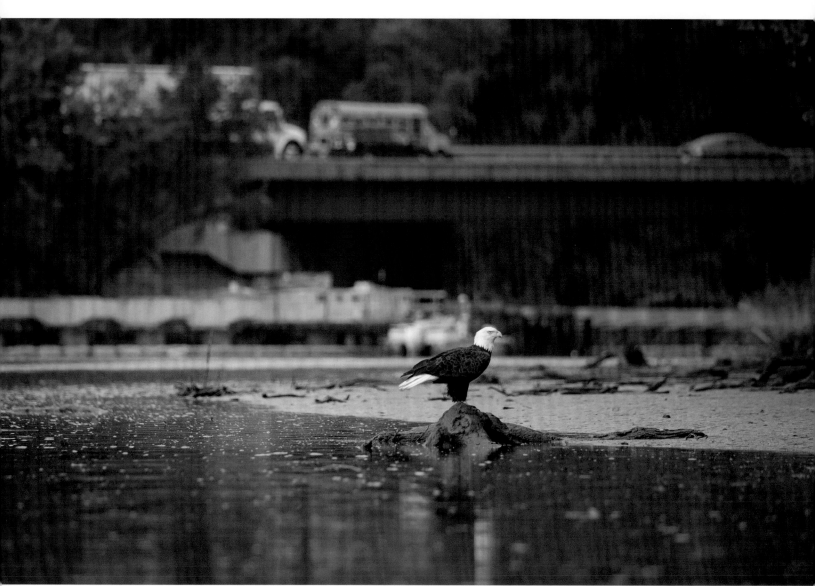

Bald eagle near the Route 50 Bridge, Washington, DC

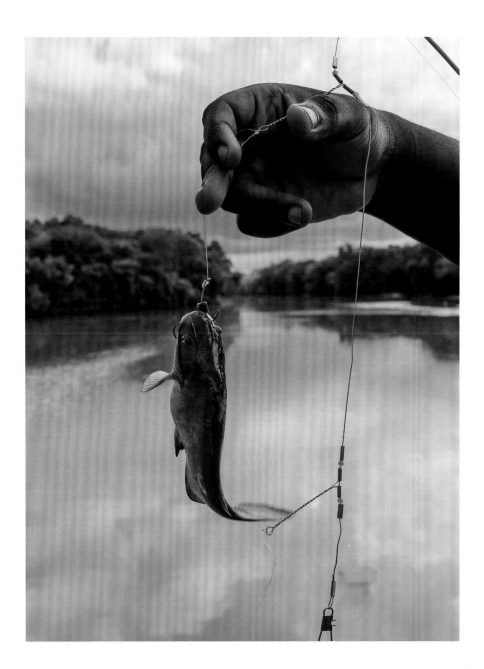

*Catfish caught in
Bladensburg, Maryland*

Turtle, Arboretum

Crayfish peeking out of his home

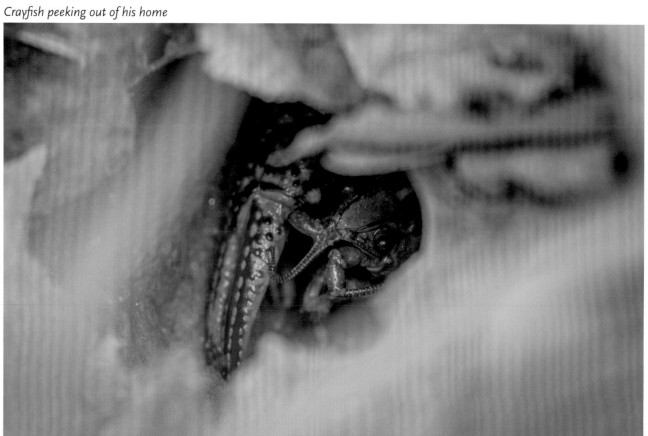

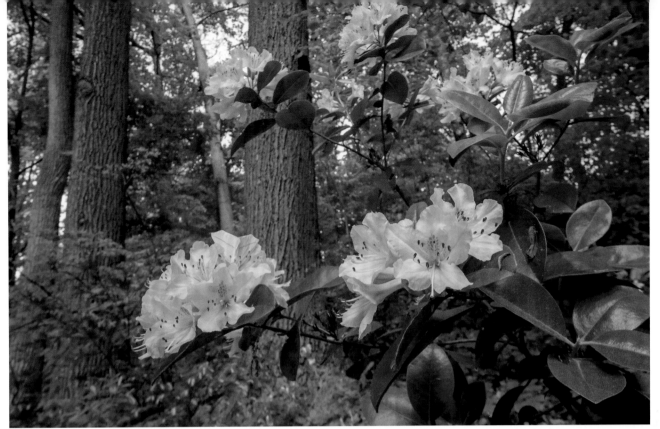

National Arboretum, Washington, DC

Phoebe near Rachel Carson home, Northwest Branch

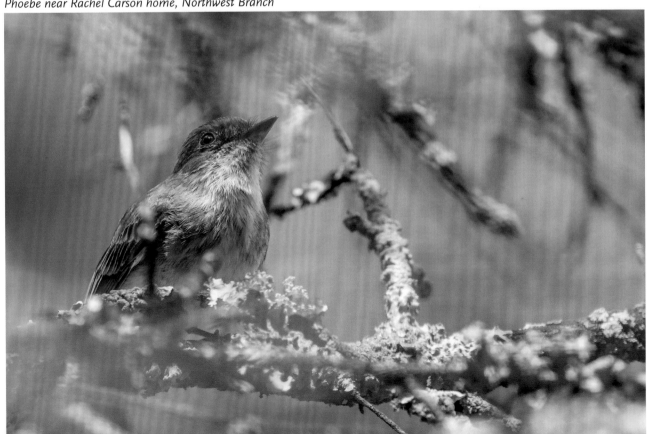

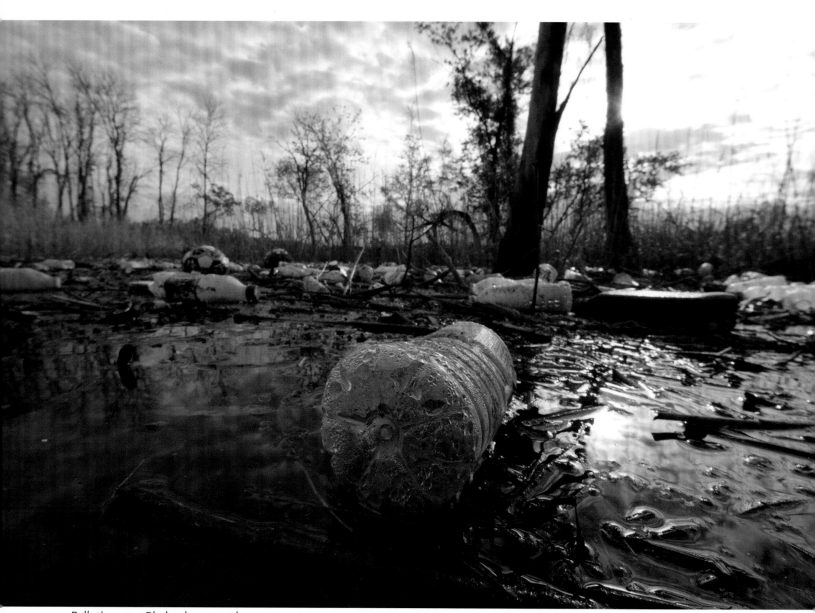

Pollution near Bladensburg marsh

Girl fishing with her family at Kenilworth Park

Brown bullhead catfish with lesion. Studies have found that two-thirds of catfish have some form of tumorous growth.

The Mallow Moon

The solstice sun shrieks through a cloudless sky onto the Robert F. Kennedy (RFK) Memorial Stadium parking lot, and asphalt begins to boil with that intense malevolence it has on blue-sky summer days. Yesterday the sun reached its closest annual angle above the Anacostia River, hovering for one bright moment above the Tropic of Cancer and showering us with nearly fifteen hours of daylight. Elsewhere in the watershed, the solstice is greeted by the eager outstretched leaves of summer's living world. Insects awake to its warmth, hopping, buzzing, and climbing busily over stem and stalk; crimson cardinal flowers, pink bee balm, and black-eyed Susans unfurl petals into a pollinator's paradise; frogs and turtles bask in the welcome radiance.

But here, upon one of the largest expanses of bare asphalt in Washington, DC—nearly one hundred acres of indifferent ashen pavement—the solstice is just another steamy summer day when the oppressive sun strikes an angry nothing, bouncing unbroken hostility back into the edgy urban world. This graceless meadow of petroleum tar mixed with gravel and sand was poured upon the Anacostia riverside decades ago. For those many years it has collected the oil, gas, smog, and other wastes of the urban environ and met the rain and snow with unforgiving hardness, offering no gentle quarter to any watershed resident and sheeting polluted runoff into the river. Sheet after sheet, storm after storm, decade after decade this asphalt slab has ushered an unending stream of grime into a defenseless Anacostia.

A Metro train roars by. The sun glares. A drop of sweat rolls down my cheek. I shrink to my smallest self, utter a curse upon the blistering inferno and all its children, and hurry across the lifeless wasted land, an incongruent monument to its passionate, thoughtful namesake. Kennedy

was killed forty-nine years ago this month, June 5, 1968; two months after Dr. King, four months after Kelvin. In 2018 a half century will have passed between them and this current Anacostia moment. This bleak landscape is no place to remember them. It invites no community, and, uninvited, I move on, homing toward the gentle shade of trees, toward a familiar voice chorusing from the forest on Kingman Lake. I spotted the Baltimore oriole the moment I arrived, a bright-winged ball of gentle sunfire dancing among the treetops singing to the hardscape world from a waving sea of green.

<p style="text-align:center">∿</p>

Without doubt, Kingman Island constitutes one of the strangest locations in the watershed. Unraveling its history, and all of the would-be futures that never came to pass, can be a brain-twisting exercise. Kingman was, in a very real sense, born of the Anacostia's undoing. But over a century this land has become one of the most natural spots in the downstream portion of the watershed, home to one of the most vibrant communities of wild animals and plants in the city, an odd island of birdsong, wild silence, and serenity in an ocean of urban haste.

In 1916, the Army Corps of Engineers built Kingman and Heritage Islands out of dredge spoils, and the devil only knows what else. The larger island was named after the head of the Corps at the time, Brig. Gen. Dan Christie Kingman, who for more than thirty years orchestrated some of the agency's most grandiose *improvements* nationwide.

Two years after their creation, the islands, along with most of the other land on the Anacostia riverside in the District, became part of Anacostia Park. One cannot overstate the importance of National Park Service authority over this land. It's true the land agency failed miserably to properly care for the Anacostia—allowing it to be dumped on, paved over, and polluted in many locations—including the RFK stadium parking lot. But one need only look at what *might have become* of Kingman to understand that in many places the Park Service saved the Anacostia from a much worse fate. Over the past century, Kingman has been the focal point of dozens of development schemes, ranging from a second city dump along the Anacostia, to a children's theme park, a prison, an airport,

and a massive parking lot for the Washington Redskins. Many of these ideas were blocked by the Park Service. Some were protested by local residents and nonprofits. Some were nixed by congressional oversight. Others dissolved during economic downturns. Had any one of them succeeded, I would not be listening to a Baltimore oriole while standing on a footbridge over Kingman Lake where beavers raise their young and nibble on wetland plants; where foxes den and shelter their kits; where frog eggs hatch into tadpoles that grow into funny creatures with four legs and long tails; where people walk in a kind of gentle, secluded space almost unknown in the rest of the city.

Within that gentle space, upon that bridge, I stand listening to the oriole while watching a great egret fastidiously tending its delicate lacework of white feathers. It has been doing this for some time after waking in the Kingman marsh with its cohort of fellow egrets, who compete by day for the best fishing spots but congregate each night for safety while they rest through the urban darkness.

While the egret preens, baby catfish—each about the size of an almond—cluster by the hundreds in the water below, seeking their own safety in an undulating amorphous catfish mass, as a bluegill hovers hungrily nearby. Blackbirds chatter, a catbird mews, the oriole sings, and the Metro rambles by carrying people to their daytime lives in conditioned air and artificial light behind four walls in the city.

The egret considers me for a moment, then flies away. I stay put and await Dan Rauch and Damien Ossi—both staff at the DC Division of

The East Capitol Street Bridge over Kingman Island

Baltimore oriole

Fisheries and Wildlife. These two know more about Anacostia flora and fauna than most, and I have asked them to accompany me on an urban adventure to one of the darkest but most hopeful spots in the watershed.

When Dan and Damien arrive, we walk east, across the bridge, but when we get to the middle of the span, Dan suddenly stops, grabs his binoculars, and trains them on a small white form darting above the water to the north. "That looks like . . . yes it is . . . a least tern," Dan says excitedly. "Well, that's a first for me in the District."

Dan has been meticulously surveying the birds of the District for seven years as the chief bird biologist for the city. He is out several days a week in every season, walking the land and keeping a careful ear and eye on who is singing, who is nesting or passing through, what habitat they are using, and what foods they are eating. If he hasn't seen a least tern here, it is because they are almost nonexistent in the watershed. Least terns have diminished nationwide due to the prevalence of cars, trucks, feral cats, and off-leash dogs on their nesting grounds upon sandy beaches and inland rivers. So much of their nesting habitat has been lost or degraded, they are considered an endangered species in the interior United States. I don't know when one was last sighted on the Anacostia.

We stand for a moment watching the bird as it flies off over the forest, then continue on. As we pass the second bridge onto Kingman Island, a vast stretch of bare earth sprawls across the landscape. Last fall this field

was planted as a native meadow in an effort to help struggling pollinators who have suffered a drastic decline in meadow habitat, both in DC and around the nation. But just as the meadow was starting to grow this spring, the Kingman Island Bluegrass Festival brought thousands of feet and vehicles that trampled the tender plants and compacted the soil.

This festival highlights a paradoxical problem facing the watershed. It began in 2009 with an idea that has become foundational for Anacostia advocates: for people to become engaged in river restoration, they need to be drawn to the river so that they can see its value, remember the forgotten river, and overcome the negative notions that have dogged the Anacostia for decades.

Tommy Wells, currently director of the DC Department of Energy and Environment, who was a cofounder of the event, described the intention: "The main point of it was to get people to the Anacostia River; to get people to the island to care about it." And it was a fast success. In its first year the festival drew a just few hundred people but in the second year doubled its numbers. Corporate sponsors came on board and the footprint of the festival expanded. "This last year there were fourteen thousand people for the second year in a row, and it's a signature event on the Eastern Seaboard for bluegrass," Wells says.

Many thousands have returned to the Anacostia because of the festival. I attended the bluegrass festival in its early years, excited by the prospect of an event that celebrated great music while engaging residents in the river landscape. But as festival crowds grew and the damage to the fragile island ecosystem expanded, my enthusiasm waned. This year I saw

Dan Rauch on a bird survey of Kingman Island

photos of friends on social media tromping happily through the muddy soup the festival had made of the meadow. One day of messing in the mud cost a year of sustenance for vulnerable pollinators and other insects, and a place to feed and rest for imperiled bird species. But very few people are aware how essential this spot has become for wild creatures. And had history gone even slightly differently, we would be walking on a steaming slab of pavement devoid of all life rather than a trampled meadow under the cool shade of trees beneath the gaze of soaring osprey.

I try to keep that in mind as we walk across the beleaguered meadow and turn south down a forested corridor along the eastern edge of Kingman. At the far southern end of the island, the trail opens out onto a broad grassland with sparse trees, and beyond that an older forest rises. "Maps from the World War II era show the northern end divided by small plots, which I think were Victory Gardens," Damien comments. "But here you can see the trees are taller, older."

The southern portion of Kingman may have been growing naturally since the island was created in 1916. Here, just a mile's walk from the sprawling RFK parking lot, the world of growing things maintains a rare remoteness right in the heart of the city—a space that offers something like home to shy birds and secretive small mammals, who for many decades have had this land largely to themselves. Occasionally, when visiting this spot, I have even chanced upon the hermit thrush, darting within the shadow of the older, deeper woods.

I follow Damien and Dan into the deeper shade, and we duck under branches along a rough trail where invisible webs cling to my face and their architects find themselves riding in my hair—an unhappy turn of events for both parties. A cool darkness pervades this space, unlike any other I have found in the District. Here at near midday, there are places where almost no light reaches the damp ground—it seems almost as though we have stumbled on some forgotten cave. It isn't the trees that block the sun but rather a dense aged thicket of invasive bush honeysuckle, covered with a thick roof of porcelain berry and other invasive species. They are European and Asian plants brought to an ecosystem unprepared to accept and tame them. Some were brought intentionally by gardeners who thought them pretty or useful; others may have stowed

away as unknown cargo on ocean tankers. But they are here now and reeking havoc. These plants have aggressively colonized the island and blocked all hope of life for most native plants. Conversely, they may have also helped save this place for wildlife by making it so hard for people to access. The vegetation towers above Damien, who is well over six feet tall. On the trail ahead of me, Dan disappears into a snarl of porcelain berry vines and Japanese knotweed that have consumed the path.

We finally emerge from the invasive forest in a meadow Damien, Dan, and others recently cleared of nonnative plants and is therefore now mostly bare ground. But growing happily within that cleared space, standing nine or ten feet tall and covered with eager buds, is the reason we trekked out here in the ninety-five-degree summer heat: the Virginia mallow.

Last year, while out exploring this isolated space and trying to assess how it fit into the overall Anacostia wildlife landscape, Damien spied amid the usual invasive suspects a leaf he didn't recognize. It seemed somehow familiar, and after some research and consultation with botanists, he confirmed something almost unthinkable: it was a cousin of the swamp mallow called the Virginia mallow—and it is a globally rare plant, endangered throughout much of its native range. This mallow offers something important to bees and other pollen-dependent species—it has a long flowering season, from midsummer through fall, so it provides food resources for a longer period than most plants. It grows only in sandy, damp soils along rivers and other wet places and is extremely vulnerable to a host of threats,

Restored meadow after Kingman Island Bluegrass Festival, 2017

from trampling, to competition with invasive species, to being mowed or otherwise disturbed in the wrong season.

No one will ever know just how or when the mallow got here or how it managed to survive within the invasive shamble. But, as we find so often in ecology, its precarious hold on survival is linked to many other things. The invasives that kept human feet from trampling the plant may have saved it, but they also threatened its long-term survival. And here it is rising from this wasted land, bearing witness to possibility.

Seizing on that possibility, Damien, Dan, and the Department of Energy and Environment have begun an effort to restore this stretch of the island, with the intention of providing sanctuary for the rare mallow and a start on recovering Kingman for native species. This effort included mounting an All Hands Day, when staff from every department in the agency came out to remove invasive species in an effort to save this plant. The department is also taking steps to have a special status afforded to Kingman due to the critical role it plays in the future of District wildlife.

Saving the Virginia mallow won't be easy. This plant, as with all native species, evolved over millennia, each into its own precise niche. Over those eons fire, ice, and floodwaters shaped their land and them in turn. We have disturbed this system in ways we don't even begin to understand. But the stakes for these species could not be higher, so we have to try. Nothing here is easy. But it is possible.

The plucky persistence of the Virginia mallow, along with the commitment and care exhibited by Dan, Damien, and so many others, sparks

Damien Ossi beneath a dark shamble of invasive plants on Kingman Island

a powerful hope that we have entered a new era for the Anacostia. It is a hope vulnerable to competing tensions casting shadows over a quivering wisp of chance, the most translucent shade of tenuous. The trembling heart of the Anacostia story stands on the precipice of our inescapable paradox: a forgotten river has no future, but a remembered river has infinite futures, and not all of them are born of wisdom; not all of them are preferable to simply being left alone.

The many futures of the Anacostia are laid bare as I walk back through the ruined meadow restoration. If the Department of Energy and Environment, which manages Kingman under a long-term lease from the National Park Service, can re-create a native meadow here, countless species will benefit, from pollinators and other insects; to the birds, reptiles, mammals, and amphibians that eat them; to the people who seek respite on this green land. One particular pollinator may need this restored space as much as the mallow. The rusty-patched bumblebee was declared a federally endangered species in 2016, the first bee species included on this list of the nation's disappearing wildlife. This bumblebee was once, not long ago, a common species throughout its range, including the Anacostia watershed. But pressure from pesticides, loss of habitat, and introduction of disease through commercial beekeeping has crashed its popula-

Virginia mallow bloom

tion in just decades. In the Anacostia, the rusty-patched has disappeared entirely. Meadow restoration on Kingman and anywhere else we can manage it could help save this bumblebee, right here in our backyard. But species like the rusty-patched and Virginia mallow are so near the edge of existence that any thoughtlessness will plummet them into the abyss, even the feet of excited bluegrass fans at an otherwise fantastic festival. Carelessness is exactly how we arrived here in the first place.

∿

After parting ways with Dan and Damien, I stand on the bridge that spans Heritage and Kingman, where a mulberry tree has recently ripened and is dropping fruit into the water below. Where the fruit falls, turtles and fish poke their heads above water to nibble sweet mulberries that float among the grime and trash that wash into the river during every rain. On the bridge railing between me and the water, I notice a gorgeous, orange-headed five-lined skink and then just ahead of him, the female. He shadows her a few steps, then climbs on top of her, and clamps his mouth onto her back, holding tight. Her skin stretches taut where he is attached. It looks painful, but then, love is never easy. They stay clutched tight, and for some time, I cannot turn away. For these two, nothing else exists in this Washington, DC, moment. Not the machinations of power on Capitol Hill, not the interest rates going up or down, not the strategy sessions of corporate lobbyists on K Street, not even the ongoing conversations about the future of this riverside land. For them there is only now and each other, their bond and the future they hope springs from it in the form of a tiny creature with electric-blue stripes and a shy demeanor and the ability to carry their species into the future. This is the wild. Since the Cambrian explosion this creative force has begotten the living world, species by species, leaf by

Skinks mating on the footbridge to Kingman Island

leaf, grasp by grasp—life clinging to life throughout time. Ever this wild creation moves forward, writing an incomprehensibly complex story, turning its pages, right here in the heart of Washington, DC.

This is our story, but not ours alone. I think of all the many hundreds of species I have seen here over the past decade, pursuing their purposes in the infinite pages of the Earth Chronicles: downy woodpecker, yellow-shafted flicker, mallard, merganser, sparrow, eagle, green frog and red fox, mummichog and dragonfly.

∿∿

They bring to mind a favorite poem by Wendell Berry, called "The Wild," where Berry writes of the life that clings to the land, singing, even in the places we have diminished to near desolation. He writes of warblers and tanagers, each one with a unique character in flight, color and song: "A man / couldn't make a habit / of such color, // such flight and singing. / But they're the habit of this / wasted place."

Berry could have been standing right here, on this footbridge between wild islands, alongside the immense asphalt slab of the stadium parking lot. Kingman was constructed by the Corps of Engineers out of the drowned residue of our careless history on the Anacostia land. But it was remolded and remade by oak, sycamore, cattail, and bramble into the Anacostia wild. Berry ends the poem with these lines: "In them / the ground is wise. They are / its remembrance of what is." He could have been singing his ode to this aged watershed, a landscape so steeped in forgetfulness but so rich with remembrance.

The remembrance of what is.

∿∿

One can never foretell what land memory may surface while walking in the watershed. On a stroll a few years back along the Anacostia River Trail near the confluence of the Northwest and Northeast Branches, I came across a gathering of some of the most unusual and magnificent creatures imaginable. They were clustered on the grass, just off the trail—ten to fifteen large black beetles with long antennae. Had there just been one, I would have missed it entirely, and perhaps even if I'd seen it, I would

have kept going. But in my experience a congregation of any sort of creature means something interesting is afoot. I stopped, kneeled down, and on close inspection saw that they were not all black. Some were iridescent green, and at their neck, knee, and shoulder joints, many oozed a bright yellow liquid. Most unusual. But even stranger, some of the beetles, which were perhaps an inch in length, had much smaller beetles riding on their backs. The smaller beetles did not resemble the larger ones, as they were red and black and had a different physical structure, but I took them for babies at first—a significant difference in structure and coloring isn't unusual for insect young. And what self-respecting beetle allows other beetles to filch a free ride on its back without putting up a fight? Turns out, the larger beetle *was* putting up a fight, in the form of the yellow substance pouring from its joints. And what's more, that was exactly what the smaller beetle was after.

I took some photos, taking care not to touch this unknown species, and moved on. Back home I did some research. The larger beetles were American oil beetles, also called "blister beetles" because any contact with them can result in painful skin irritation. The American oil beetle's blood (that yellow substance) contains cantharidin, one of the most poisonous substances found in nature. It was first described scientifically in the early 1800s by a French chemist, Pierre Robiquet, who compared its toxicity to that of strychnine. But historical references date back to the time of Augustus Caesar when it was said that his wife, Livia, dosed dinner guests with cantharidin to promote promiscuity and thereby gather blackmail material on her guests. Apparently throughout history it has been used as an aphrodisiac, by characters ranging from the king of France to the Marquis de Sade. (He was tried for murder on account of it.) The oil beetles' blood is that

American oil beetle with fire-colored beetle on its back

special mix of elements that can promote life and love, as well as take it. It can spark lust, cause painful burning and blistering, or even kill. And it may even be able to save lives. Cantharidin has been used for thousands of years in Chinese folk medicine to treat cancer and is now being tested in Western medicine for this purpose, with some promising results.

All this intrigue wrapped up in the body of the unassuming oil beetle, minding its own business on the Anacostia trail.

For the oil beetle, cantharidin serves many functions in the species' quest for freedom from fear and want. The toxin, produced only by the male, attracts females and is given as a sort of wedding gift during mating. She uses the chemical to coat her eggs for protection in their most vulnerable stage. She can also cloak herself in the poison to ward off predators.

For most animals, this toxic defense mechanism is reason enough to steer clear of the blister beetle, but one beetle has evolved a way to take advantage of the oil beetle's biological ingenuity. The small beetle atop the oil beetle's back turned out to be a fire-colored beetle, and he wasn't just hitching a ride on the beetle bus; he was stealing some of the oil beetle's blood. Instead of a bouquet of flowers or box of chocolates, lady fire-colored beetles are partial to a few drops of cantharidin, so the male beetle likes to have it on hand when courting a mate. He can woo her with this present and a promise that when they join, he will give her some of the stolen substance to protect their eggs. It is his unique way of pledging to his partner that he will provide some measure of freedom from fear.

The blood of the blister beetle has in this way become valuable currency in the fire-colored beetle's economy. By jumping on the oil beetle's back, the fire-colored beetle, a roughrider of the beetle world, was deliberately antagonizing the oil beetle to get him to secrete more of this valuable toxin. And it was working—the oil beetles were so angry they were exuding yellow liquid from every joint!

The actions of the fire-colored beetle, ingenious as they are, actually pale when compared to the mind-bending complexity of the oil beetle's own reproductive strategy. The female oil beetle deposits thousands of eggs in the ground, coated with cantharidin, and when they hatch, the

Question mark butterfly

tiny creatures congregate together on a plant leaf, assembling themselves such that they roughly resemble the body of a female bee. This theatrical ploy on its own would not likely fool a reasonably, or even marginally intelligent male bee, but the beetle larvae also emit a special pheromone that blinds male bees to their true form. This trickery, from a bee's perspective, transforms the larvae into a female bee who is keen on breeding. It is like something out of a fairy tale, where a sorceress blows a sparkling magic powder into a prince's eyes, so that he believes an ugly witch is really a beautiful princess. Only, in this case it is a glob of larvae masquerading as a beautiful bee-lady. The male bee tries to mate with the larvae lump, which I would imagine goes somewhat awkwardly. When the male bee flies away in frustration, the tiny oil beetle larvae have already climbed all over him and are off on the ride of their lives. Then, when the male bee finds his real bee princess and they begin to mate, the hitchhiker larvae get all over her, "like some six-legged venereal disease," as entomologist Piotr Naskrecki describes it. The female bee unwittingly carries the larvae back to her nest, where they feed on the pollen she is storing for her offspring, and eventually the larvae will dine on her growing baby bees.

I could have walked right by these amazing little creatures, but something caught my eye. Their unique strategy for living life, for surviving unseen by so many for so long despite everything we have done, has

stayed with me for years. I have not seen either beetle since then. I may never happen across them again, but I feel some strange contentment in knowing they go on, continuing their curious congregation of wonder, persisting in their peculiarity and obscurity.

And they are just two species of thousands waiting to be encountered, or hiding forever from our eyes. I don't have favorites, but some creatures I have become acquainted with in the Anacostia watershed have a special magic that takes hold. One of the plants that I look for on every walk in an Anacostia forest is the spicebush, specifically because one of my favorite Anacostia residents has an intimate relationship with this plant. The spicebush swallowtail butterfly in its larval form looks like a cross between a tasty, green-apple gummy worm and an alien that is trying to look terrifying, but badly, so it ends up being laughably cute.

This butterfly in adult form is black and blue with orange and white spots and moves with the silent grace that is typical of butterfly-kind. But its beginnings are quite a bit more pedestrian. The spicebush swallowtail female lays a tiny egg on the underside of a spicebush leaf—which, when it hatches into a caterpillar, looks exactly like a dollop of bird poop. I guess the evolutionary thinking here is that birds are going to be grossed out by the thought of eating their own poop. Alas, I think the swallowtail has overestimated the culinary sophistication of birds because the poop-caterpillars disappear all the time. Birds are the prime suspects.

The bird poop will feed on spicebush foliage at night, and then, when the sun rises, it will fold a piece of spicebush leaf over itself, as if covering with a blanket, and rest the day away in its little leaf burrito. As it matures, the caterpillar varies from bright orange or yellow to neon-green with sky-blue spots. And best of all, it has a fake "face" that is printed on the back of its head to make predators think it is a large scary monster.

Another watershed favorite is the broad-headed sharpshooter—a type of leafhopper. Leafhoppers generally are beautifully patterned insects, like fine-painted china detailed by the most delicate hand, as they are about the size of an infant's fingernail. Despite their diminutive dimensions, they have an unexpected charisma. I had seen the broad-headed sharpshooter many times before I understood the reason why it is so named. One day, while on a walk in the Arboretum, I was watching a group of

Spicebush swallowtail caterpillar

Spicebush swallowtail nesting in a spicebush leaf

green leafhoppers (of a different species, *Graphocephala versuta*) gathered on a leaf when I noticed that as I drew nearer, something would fly from their rears. It appeared as though they were shooting sparks from their butts. I watched them for a long while, not believing what I was seeing, and then walked away convinced that they could make fire and shoot it from their asses. But along the path I came across a larger orange and blue leafhopper, the broad-headed sharpshooter, and learned the true nature of this leafhopper defense system.

At first, the broad-headed tried to hide from me. These insects have an endearing habit of scooting sideways around a plant stem when you are looking at them. They can fly and dart like a bullet for some distance, so it would be easy to escape when a big-headed photoshooter takes notice. But instead they often just shimmy sideways so that they are on the oppo-

Broad-headed sharpshooter shooting wastewater

site side of the stem. It works, until I move my head to the other side of the plant. Then they shimmy the other way. This particular sharpshooter tried this defense for a while, but when it became clear I was not giving up, he decided to escalate. It was then I was able to capture a photo of the not-a-spark-from-ass phenomenon. In reality, the photograph shows, he was shooting liquid from his butt, small droplets of wastewater meant to ward off enemies.

∿

The stories hiding in the Anacostia wild have no apparent end. Given the number I've uncovered in the past six years, there must be thousands of plotlines and crazy characters I don't even know about. Every time I look out my back door, or down the trail, or into the water, I see somebody new. When I speak to others of these encounters—especially where insects are concerned—I am often met with suspicion, amusement, or sometimes revulsion, initially. But kinship grows easily from looking closely at our natural neighbors. We evolved from this community and are predisposed toward connection to the natural world, a concept referred to as "biophilia." Biophilia, a term made from the Greek roots for *life* and *love*, was originally conceived by social psychologist Erich Fromm. In essence, Fromm expressed the idea that we, as a species, are hard-wired to find broad-headed sharpshooters and oil beetles fascinating, if we can get past the fear responses we learn from a young age.

In the 1980s Edward O. Wilson popularized the term "biophilia" to describe the innate relationship human beings have to other living things, a connection that has since been scientifically proven to impact our health and well-being. Interaction with nature has been shown to stimulate brain activity that reduces stress and fatigue and increases the ability to concentrate and engage peacefully with others. Neuroscientific studies have shown that fractal patterns found in nature trigger the opioid receptors in the visual cortex—in other words, our eyes and brains are biochemically

predisposed to love and need nature. Walking through a forest, as opposed to an urban area, lowers stress hormones, pulse rates, and blood pressure, thereby lessening risk of heart disease and mental health disorders.

Some cultures have known the health benefits of nature for a long time. An ancient Japanese practice called Shinrin-yoku, which translates to "forest bathing," can be a simple walk in the woods, but it has been proven to positively affect human health. Studies have also shown that children have greater success in school when they have access to nature, with some studies showing a nearly 20 percent increase in test scores when students were given even the barest exposure to the natural world. Faster recovery times in hospitals, reductions in the incidence of violence, and lower crime rates have all been linked to interactions with nature.

It is clear, the more we safeguard the land community, the healthier, happier, and more successful we will be. Our long-term health is fundamentally linked to the health of the natural world and our daily connection to natural places. Conversely, the absence of nature in our lives can be seen as an invisible disease that we suffer unknowingly almost every day in the urban environment.

John Burroughs spoke throughout his life about the disease of vanity in American industrial pursuits, but he was, for the most part, not waging a battle for birds, he was simply expressing the elemental beauty they brought to the world. He was professing our biophilic nature decades before anyone had thought up a term for it. Burroughs once wrote to Lucy Warner Maynard, who wrote *Birds of Washington* in 1898, that "the happiest years of my life were spent in Washington and the fields and woods about it. I hope the birds there have brought you as pure a joy as they did me."

He was linking the fragile human capacity for pure, deep, giddy joy to our ability to observe, see, and understand the genius of the Earth community. I can sense this biophilic nature of ours instinctively, standing on the bridge over Kingman Lake, watching people who would scowl or avoid eye contact while walking along a city sidewalk, smile at me and point to the sky when an eagle passes over. Here they are released, at ease, content.

On the last day of June, I returned to Kingman Island to revisit the Virginia mallow. In a little over a week, many of its buds had turned into small white flowers, around which bees, wasps, aphids, leafhoppers, and other insects were pursuing their freedom from fear and want. Some of them I had never before seen in the watershed. This community of insects upon an imperiled plant exists here because of Kingman's cushioned isolation from the urban world. And as I watch these Kingman creatures about their business, a cold anxiety creeps into my consciousness. The future of this mallow and the varied lives being lived upon it is now threatened by the latest scheme for improving Kingman and the RFK complex.

This forgotten watershed gem has recently been discovered by individuals, organizations, and corporations, and currently plans are being drawn up to add bridges, trails, festivals, and developments that will trample the mallow and nascent meadows and displace the last of the hermit thrushes, mergansers, and waxwings that have for decades found a safe harbor here. It makes every kind of sense, in human culture. The beauty of this place has begun to draw people, and people, with every kindness intended, become motivated to share the beauty they have found. So now a process is under way that will decide the future of this precious spot on the Anacostia. The moment offers some promise, as part of the planning centers around removing and naturalizing the pavement of the RFK parking lot. But the plans have also suggested adding as many as eight bridges to ease the passage of people onto quiet Kingman and Heritage Islands and trails that would take an exponentially larger number of people through the most isolated parts of the island, where the Virginia mallow has a tender start on a sanctuary, the locally extinct rusty-patched bumblebee could have a meadow to come home to, and the hermit thrush can find some peace and quiet where he can trill his haunting ode to the heavens. In our excitement over what nature has made of this land in our absence, most fail to realize that by making these important wild places more accessible, we destroy the very thing that makes them special.

Kingman and a few other tracts of land like Poplar Point and Kenilworth Park, are ground zero for the Anacostia paradox: as we remember the river and absorb the wisdom that has seeped into the

ground during our absence, if we are not extremely careful, we will shatter this fragile newborn ecology and estrange ourselves forever from its growing memory of what is.

As I leave the islands, I stop on the bridge and gaze down at hundreds of mummichogs swimming in the water below. These iridescent little fish are some of the toughest alive and a potent symbol of the resilience of nature. They have survived some of the most toxic rivers humanity has created, waters filled with PCBs, pesticides, and dioxin. This land can and is beginning to restore itself, and every choice we make to aid it offers a new hope. But the strands of ecology are not all as hardy as the mummichog, and some of the most fragile strands may be the most essential. I think of the oil beetle, which cannot reproduce without bees, and bees who are so completely dependent on flowering plants, which are so terminally vulnerable to our actions on the land.

As I leave the park, I look inside a metal container meant to hold bags for humans to clean up after their dogs. When I was here with Dan and Damien, Dan pointed out that a Carolina wren had built a nest in the box and a single egg was sitting quietly inside. Dan believed the mother wren

Leafhopper on Virginia mallow

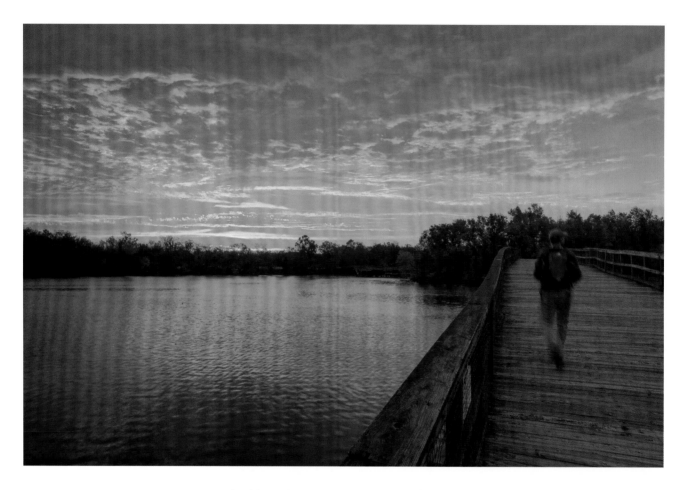

had been killed, because the egg was alone, with no adult wren spotted for days. I looked again inside the box, where the egg still lay, so fragile and unprotected, a seed of song invisible and untended.

I walked away thinking of the Carolina wren I heard while standing on the dump in Kenilworth Park, of the wisps of wren-mist I imagined rising with his song.

So much depends on this moment. If we are going to remember the Anacostia, we need to remember everything, everyone, or else leave it alone. The spicebush caterpillars and five-lined skinks, the Virginia mallows and the Kelvin Mocks. The Nacotchtank. The besieged waters of the Watts Branch. Our own silently yearning songbirds waiting to be born inside our biophilic blood.

Graphocephala versuta, versute
sharpshooters

MALLOW

Great egret

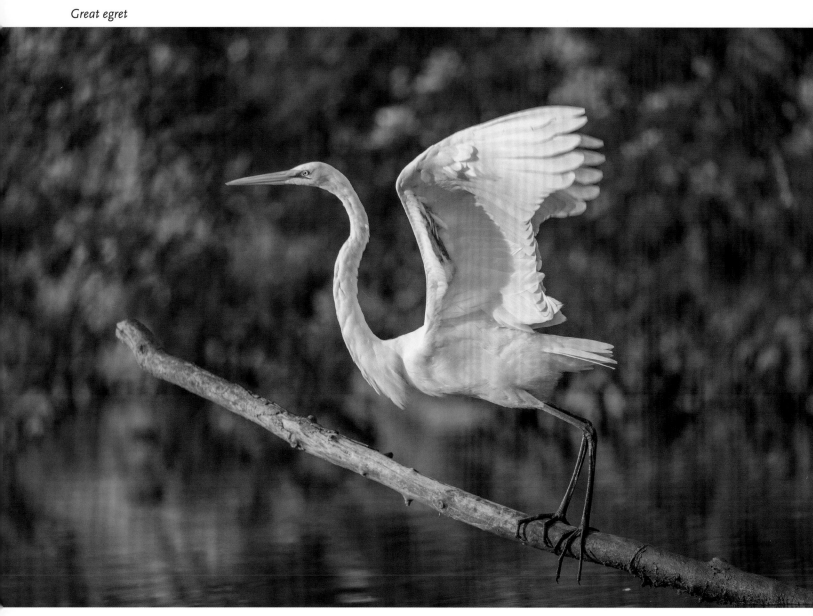

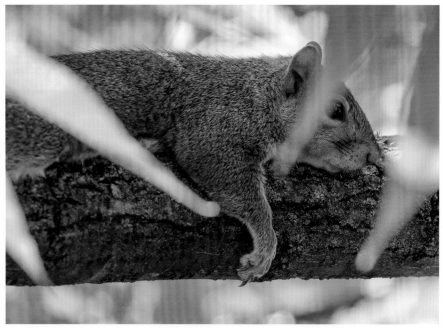

Squirrel heat dumping on a hot day

Red fox on Kingman Island

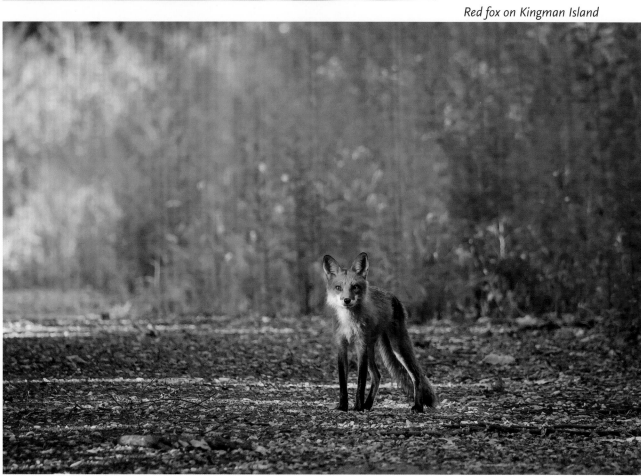

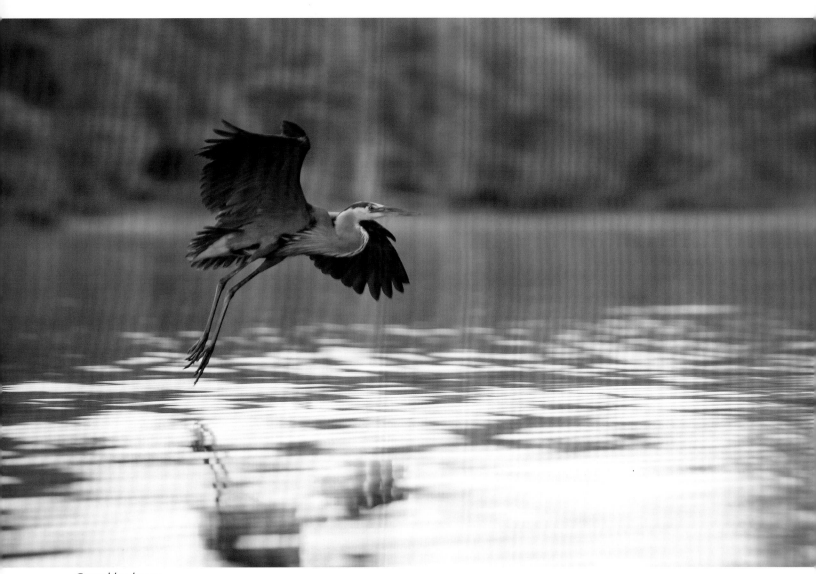

Great blue heron

Dragonfly

Phantom craneflies mating

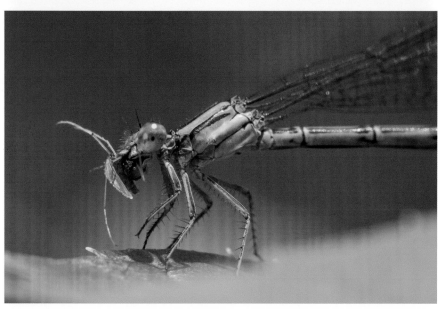

Damselfly with prey

Anacostia River sunset

(AT RIGHT) *Barn swallow in Kingman marsh*

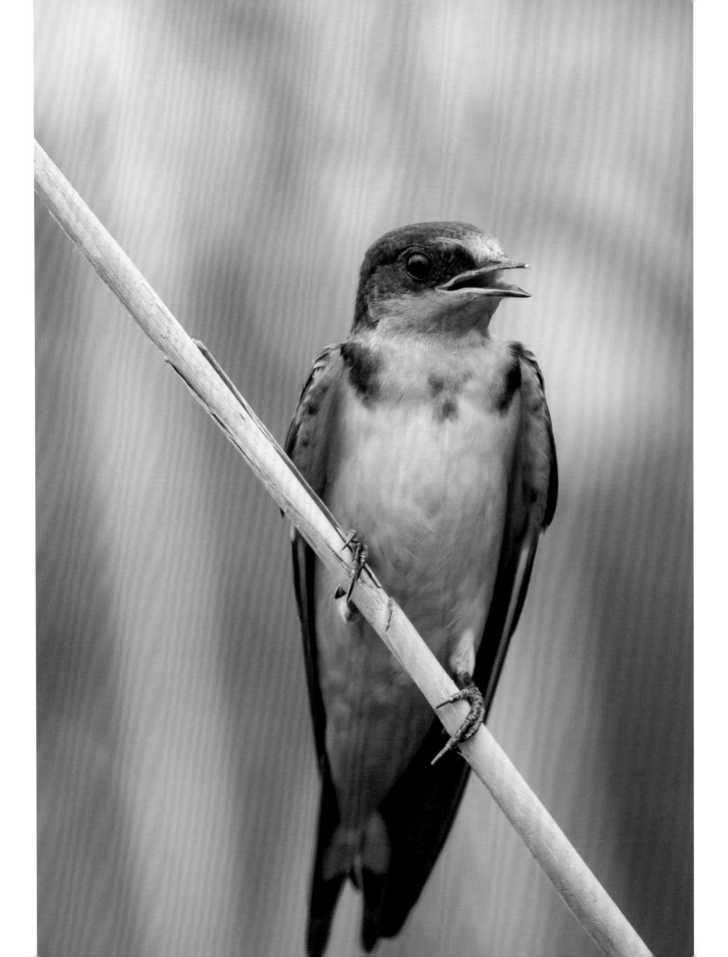

The Sacred Moon

On the second floor of the Smithsonian American Art Museum in downtown Washington, DC, the Yellowstone River cascades over painted canvas through luminous cloud mist into the Grand Canyon of the Yellowstone, a corridor of golden ochre and red volcanic rock carved by a mighty river over millennia. The painting glows softly like fog gilt by a glance of the morning sun, like something out of a dream. I stand for a considerable time, motionless, staring into this dream of an untrammeled North American past, suspended in pigment and presage, a prodigal daughter disconsolate at the locked gates of paradise lost.

The Grand Canyon of the Yellowstone, painted by Thomas Moran in 1893, was one of a series of renderings Moran made from sketches and memories gleaned during an 1871 expedition to Yellowstone country with the United States Geological Survey (USGS). Its director, Ferdinand Hayden, had invited Moran and photographer William Henry Jackson on the expedition so they might help Congress see for themselves the grandeur of this wild landscape.

When the expedition was over, Hayden submitted his report to Congress—with Moran and Jackson's imagery—and recommended that Yellowstone gain federal protection. In March 1872, Yellowstone became the world's first national park.

Moran was one of a school of artists and writers whose work set in amber an image of a disappearing paradise. Just down the hall from Moran's *Grand Canyon*, tucked into its own private alcove, resides *Among the Sierra Nevada, California*, painted by German immigrant Albert Bierstadt. The painting depicts a river plunging into a misty valley beneath a majestic wall of jagged mountains. A herd of deer stands at the edge of the lake where the water pools, reflecting the waterfall and inscru-

Thomas Moran's Grand Canyon of the Yellowstone. Photo: US Department of the Interior

table splendor of the mountains. Bierstadt unveiled the painting in Europe in 1868, where it toured the continent, fueling a wave of migration to this "Garden of Eden" in the West.

Just down the hall from Bierstadt and Moran's masterpieces dwells another famous portrayal of the American river landscape by Thomas Hart Benton, *Achelous and Hercules*. The painting depicts the Missouri River with imagery borrowed from a Greek myth concerning Achelous, the god of rivers, who provided life to all who lived on the land. During the rainy season Achelous, who sometimes appeared as a bull, would plow through the land with his horns, making new pathways for the river's swollen flow.

In *Achelous and Hercules*, Benton depicts the river god being violently subjugated by Hercules, who tears one of the bull's horns from his head and turns it into a cornucopia filled with a superfluity of fruits of the land—the horn of never-ending plenty. The Missouri River itself is almost

invisible in Benton's painting. The foreground is dominated by a dramatic depiction of well-muscled men immobilizing the bull, chopping down trees, and preparing to plant corn, while Deianira levitates luxuriously atop the cornucopia. This painting—which measures twenty-two feet across and dominates much of a large gallery with its bold, dramatic lines and vibrant hues—draws me in every time I visit the American Art Museum. But I had seen it a dozen times before I even noticed the Missouri River running placidly in the background, a brown sluggish channel, on which a steamboat purposefully chugs along, belching plumes of black smoke into the sky.

When Benton was painting *Achelous and Hercules* in the 1940s, the Army Corps of Engineers was just gearing up to *improve* the Missouri. Benton thought it grand to envision a future where the river no longer had any power of its own, where the Corps had conquered the very nature of the watershed. And indeed that future came to pass—for almost every river across the nation—though perhaps not quite so romantically as Benton had envisioned. By the end of the twentieth century, the Missouri had been channelized and subdued by hundreds of dams and thoroughly polluted by the runoff from the Midwest's vast agricultural machine. Hercules had indeed vanquished the river god and filled that horn of never-ending plenty—and in the process transformed North America's longest river into a severed, silty soup that flowed into an ecological dead zone in the Gulf of Mexico at the Mississippi River Delta.

In a single stroll through the second floor of the American Art collection one could understand how deeply Leopold's paradox of searchlight and sword cut through the culture and psychology of America. The brushstrokes and artistic eye of some of the nation's greatest painters give testament to our deep, abiding love and connection to the venerable natural world; these brushstrokes also illustrate the industrial axe that cleaved our connection to the American wild, to the Anacostia, to the rivers and natural riches all across this continent. Any gaps in understanding could be filled by the doctrine of *manifest destiny*, which gained a foothold in the early 1800s. This doctrine held that European peoples had a preordained mission, handed down from God, to conquer North America from sea to shining sea, to subdue, suppress, or supplant every nation, tribe, forest,

In Achelous and Hercules, *Thomas Hart Benton depicts the river god being defeated by Hercules, while men clear the land for farming. The whole scene is presided over by a Greek goddess Deianira, who often symbolizes fecundity. Photo: Smithsonian American Art Museum*

mountain, or river that got in the way—replacing them with what proponents declared was a more enlightened way of living. This idea had traveled across the Atlantic, firmly rooted in the minds of many of the first explorers, settlers, and surveyors from the European continent. But the earliest use of the phrase *manifest destiny* is often credited to a newspaper column published in 1845 by John O'Sullivan, which argued for the annexation of Texas against the objections of Mexico, saying it was "our manifest destiny to overspread the continent allotted by Providence for the free development of our yearly multiplying millions."

Our divine enlightenment would, over a century, take the unspoiled natural wealth of much of a continent—a natural richness that those who came from the long-despoiled European continent could not even imagine outside Bierstadt's paintings—and trade it for lumber, plowed earth, fashionable hats, guns, automobiles, parking lots, superhighways, and DDT, all in service of an ever-expanding population and ever-increasing standard of living.

Merriam-Webster's online dictionary defines *manifest destiny* as "a future event accepted as inevitable; an ostensibly benevolent or necessary policy of imperialistic expansion." *Benevolent* and *inevitable* are words subject to some interpretation.

One floor up from Benton, Moran, and Bierstadt, Alexis Rockman explores the concept of preordination in *Manifest Destiny*, an expansive panorama he painted in 2004. Rockman's work depicts, in gorgeous golden-orange hues, an apocalyptic destiny for a human civilization driven

by our Herculean machine. The *inevitable* Rockman imagines not as an industrious Earth glorified by humanity's boundless expansion but as an Earth emptied of humans, where birds glide peacefully through the ruins of a Brooklyn sky, where swollen seas have inundated the city and teem with sea creatures and microscopic forms—the basic building blocks of life at work—an Earth starting anew without us.

∿∿

Benton, Bierstadt, and Rockman swim in my mind as I stand on the Route 1 Bridge overlooking the Northwest Branch and watch a brown water snake *esssss* through the water below. The river today flows in near-perfect clarity. It's been so long since rain has washed pollution off the impermeable urban land that, as an unexpected gift of a summer drought, you can actually see life beneath the water's surface. This temporary lucidity reveals a world often occluded, a swimming, glimmering vision of grace in adaptive aquatic perfection. Turtles soar silently, dancing on water currents; small fish flutter about, minding their business, studying in their schools, sorting through particulate matter that may or may not be food, all while keeping a keen, jittery eye out for predators. And this snake, this organic winding beauty clothed in liquid geometry, has captured every bit of attention I possess. I believe actual physical strings have anchored me to him, tying every muscle in my body—brain, heart, belly, toes—to whatever movement he makes next. I'm a puppet going nowhere. At least, not until I find out what he is up to.

I watch him at the base of the fish ladder, which has been built here to help creatures travel over the low dam, or weir, which impedes the river's flow. He declines to navigate the ladder, whose channeled current is perhaps too strong for him. Instead, he swims to the left toward the concrete shore, where the water is so shallow his smooth chin must scrape against the rough concrete below. This shore slopes upward toward a towering earthen levee that dominates his horizon. From the snake's perspective, there is not a plant in sight or any other shelter from the hot sun and hungry predators. That will not do. He swims up the concrete shoreline toward the weir wall that runs perpendicular to the stream. When he reaches it, he seems perplexed, bumps against it lightly a few times,

then raises his head out of the water to determine if he can scale it. No, not feasible. He swims alongside the base of the concrete structure. It is clear now; he is looking for a way upstream, and like every aquatic creature at every one of the tens of thousands of dams we have put on streams throughout the nation, he is stuck. But he continues to explore his options and finds a small gap where water spills through the weir. Due to the low water level, the force of the water pouring through the gap is relatively light. Afforded this drought gift, the water snake takes his chance. He disappears into the shadowy gap, which I can see from above is clogged with trash. I wait for him to emerge upstream. And I wait. When he doesn't appear, I fear he is stuck in the trash, and I prepare a water snake exit strategy (namely, to pull the trash from his pathway). I stare intently at the spot where I last saw him and am all set to climb down onto the weir when, finally, he emerges from the garbage clutter, just upstream of the dam, and I watch him jauntily winding his way against the gentle current of the wide, shallow Northwest Branch.

With a happy ending to that watershed story, I continue on up the trail and head east, then south toward the confluence. Here the noise of traffic subsides, buffered by the green ribbon that girdles the river. I listen to the Anacostia, whose voice today is dominated by a chorus of dog-day cicadas. They just began to sing last week and are rising to crescendo as choir members wake and climb out of the soil and into the trees, from whence they will serenade each other and the wide world for the next few weeks.

Most of the year, cicadas are absent from our daily life, but for these summer weeks they are the sound track of red-hot radiant summer, of tomatoes ripening, fireworks exploding, corn roasting, families picnicking, beavers building, spiders spinning, and birds nesting. Our dogday cicadas rise each year when the clock strikes *wake*! They are one of more than one thousand cicada species worldwide, each set to its own earthen clockwork—some of whom appear only every decade or more. Relatives of leafhoppers, cicadas have

been waking and sleeping with sun, moon, rain, and drought for more than 250 million years. Over that time, they have evolved some fascinating physical attributes and abilities. Most of the cicada song we hear is produced by the males, but unlike many vocalizing insects, they don't create sound through friction of their body parts; rather, they have a sort of built-in drum in their bellies that we call a tymbal. It is in some ways akin to an eardrum, but they can use it both to produce sound and to perceive it. The sound of the tymbal is amplified by the cicada's largely hollow abdomen, making this species capable of producing some of the loudest of all insect vocalizations.

I once had a cicada land on my shoulder while I was riding a bike. He landed so softly I didn't know he was there stealing a ride until he decided he had found the perfect spot from which to broadcast his shrieking serenade. All of a sudden I heard this screech like a red-tailed hawk screaming in my ear, and I almost fell off my bike. I've read that cicada song is loud enough to cause permanent hearing loss in humans should the cicada sing just outside the listener's ear. I believe this. In fact, cicadas themselves have to be careful to disable their own tymbal when calling so they don't damage their own hearing.

Cicadas generally have more than one type of vocalization. The one we often hear in summer is a mating call to attract females, but many species also have a distress call, like a scream when they feel threatened. Some types of cicadas also have special courtship songs, which are softer than their blaring mating call. This seems to me a good idea. The last thing a lady wants during lovemaking is a Romeo screaming his devotion so loudly she has to disable her tymbal. Makes a man seem desperate.

In truth, these guys all sound the same to me, which works well for the cicada. Chorusing makes it very hard for an untrained ear to pinpoint exactly where a cicada is located, thus earning him some protection from predators who might otherwise find him based on sound alone. This leaves cicadas some peace to live their short aboveground lives in trees, where they dine on sap, love while they can, and stash their eggs safely away in bark until the young are ready to hatch.

I walk through the cicada convocation and try to decipher their invocations, invitations, and propositions ricocheting through the summer

steam. It's no use. I have no ear for it on a good day, and today I'm no more than a biscuit in a steam oven set to broil. The temperature hovers in the mid-90s, but with the stifling humidity it reads as more than 107 degrees Fahrenheit on the heat index. Today, an airborne slurry of car exhaust, humidity, and heat makes breathing a chore. I hasten through the open spaces where trees are scarce, where the sun hits asphalt pavement and explodes back up into my skin and lungs. When I reach the shade alongside the river downstream from Bladensburg, I stop and step out onto a flat muddy stretch alongside the river where I stand panting in the shade. Just downstream a bald eagle standing on a bare treetop is doing exactly the same thing. His mouth is open, tongue out, and wings lifted: he's doing his best to get whatever meager breeze there is to move through his toastiest parts. These are days turtles decline opportunities to bask. Squirrels flatten their bellies against the coolest branch in the deepest shade and park for hours. Foxes keep still in their burrows, shaded by the earth. These are the days when my kind, had history been different, had our ancestors made wiser choices and valued our river community above tobacco, furs, gold, and eventually green paper, well we would all be right here, our feet in coastal plain sand, beneath water so clear we could see tiny fishes nibbling our toes. We would be jumping, splashing, crawling, and floating upon the cool Anacostia, peering into depths where river otters pirouetted and sturgeon swam.

Instead, I stand here swimming in my own sweat, baking and basking in the deprivations of our time.

I have seen a handful of people swimming in the Anacostia over the past seven years, few enough that I remember each time. My first Anacostia swimmer sighting was shortly after I began this project. I was out on a paddle, and as I floated past Kenilworth Park, one of the most toxic shorelines on the river, two Latino men stripped to their underwear, grabbed a bottle of shampoo, and waded up to their waists in the river to wash. It was shortly after a rain, and the Anacostia that day consisted of about as much sewage and toxic runoff as it did rainwater.

The second time was a gathering of Anacostia advocates doing a protest swim, and most of them had donned protective Tyvek suits to guard their skin and make a point. The third time was just a couple of years ago

Bald eagle, panting

when I saw a mother, also Latino, guarding her children as they swam in the Northwest Branch. The kids were so very happy, I can see their joy in my mind's eye even now.

The last time I saw someone swimming in the Anacostia I was standing in this exact spot on river's edge downstream from Bladensburg. I was sitting on a low tree branch on a late-summer afternoon, watching the river roll by, when a young Latino man arrived, nodded hello, walked down the beach a bit, and disrobed down to his tighty-whities. He looked to be about twenty years old, but as he waded into the water, he turned around and looked at me with a grin that belonged to a six-year-old. He then fell into the water with a bigger splash than I thought possible, sending a procession of waves rolling across the river. When he emerged, laughing, he yelled to me, "It's so warm!" That was a year ago, but I remember feeling successive waves of comingled joy and sadness, joy and sadness, joy and sadness roll over me as I watched him. I can feel them even now, rolling and rolling along.

People who continue to swim in the river, aside from protest swimmers, are often recent immigrants who have not yet heard the stories about the Anacostia and who believe a nation with a Clean Water Act must, of course, have clean rivers. They have not heard about bacterial infections and hospitalizations, rashes, cancers, and poisons or about laws that prohibit swimming in either the Anacostia or Potomac. Prohibitions on swimming were established shortly after the Clean Water Act, when

water-quality monitoring raised consciousness about the dangerous pol-
lutants entering the river. As a result, gradually most people drifted farther
and farther from the Anacostia. We built pools of concrete and filled them
with chlorine to make sure nothing living could survive; we forgot that
there were once living places where we could swim. This I think was not
the spirit or intent of the legislation, but it has been one of the outcomes.

Of course, wildlife never stopped swimming in the Anacostia. They
have no other choice. I have shuddered watching birds drink at riverside;
beavers swim through brown sewage, oil, and garbage; fish nibbling at
unidentified detritus washed through pipes into the river.

I myself have never been swimming in the Anacostia. I have waded
thigh deep through marshlands and river shallows but only with my body
protected by impermeable plastic waders. Several times, despite this protec-
tive barrier, I have come away with itchy rashes that have lasted for weeks.
I can't be certain it was the river—it's hard to say sometimes how many of
the poisons we've spilled are physical toxins residing in the water and how
many are poisoned perceptions that live in our minds.

One day a few years back I was out for a walk on the river with my
friend Valerie and her young son, Sayid. We stopped at this same beach,
and Sayid kneeled down and started playing with pebbles and searching
for shells in the shallow water. I fought with myself about whether or not
to suggest that he should not touch the river. I didn't want to be the cause
of one more person being estranged from our Anacostia, but I also didn't
want him to get sick. Instead, I told Valerie that Sayid should be careful
to keep his hands out of his mouth, and we should go to the bathroom to
wash up when we left. He did not get sick, and each time Sayid found a
shell or lovely little pebble, he would hold it up and grin, as if the river had
set this special treasure aside just for him.

As human creatures, one of the primary ways we understand our
world is through touch. Making physical contact with another body is
essential to knowing that body. We shake hands, hug, kiss, pat on the
back, feel the texture of surfaces to understand them, caress a cheek to
show love. What then has it done to us, to our ability to have a relation-
ship with the Anacostia, if we cannot or will not touch it? I want so badly
to walk into the Anacostia, to wash the grime and discomfort of this city's

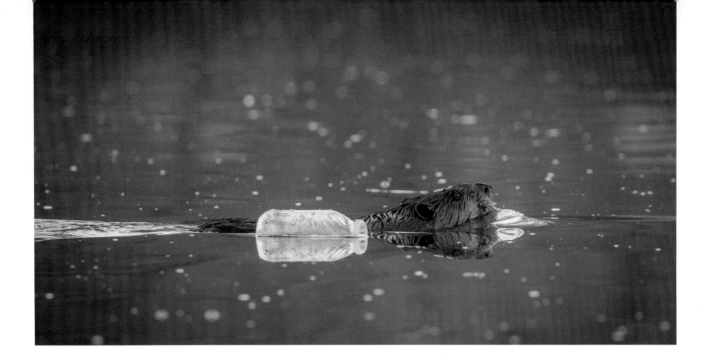

heat and haste from my skin, hair, and mind, but more important, to come to know this river as it should be known, feeling it cover my skin while I float for a while in the gentle arms of Achelous.

I will go on wanting from some deep wounded place of shame, helplessness, and guilt. We are all responsible. We have taken too much; profaned this river garden and locked ourselves out of paradise.

Standing on the Anacostia in this dog-day heat haze, I recall another piece of art at the American Art Museum—a sculpture called *Eve Tempted*, crafted by Hiram Powers. All in pristine white marble, Eve holds the apple of fecundity, that cornucopia of never-ending plenty that our Herculean machine secured for the human species. But one does not take such a lusty prize without paying a price or suffering some punishment.

Isn't it odd that we have accepted and over many generations *normalized* this punishment? I remember being warned as a child not to go into the St. Joe River near my home in northern Indiana. I accepted, obeyed, and internalized this information: rivers are polluted and dangerous. I spent my summers in swimming pools, where chemicals burned my eyes and turned my hair gray, but this also was accepted. I didn't think to question a reality that forbade contact with a river yet affirmed submersion in a chemical bath. Why would I? I had no knowledge that there were once rivers unbroken. And how can you miss something you can't even remember having?

As I stand on river's edge, the sky begins to darken and thunder rolls across the sky. Rain is finally coming. All the living land will welcome it,

but turtle, fish, and muskrat will soon vanish behind a brown shroud flowing downriver, drawing a dark curtain over the Anacostia. I'll watch them fade from view and know it wasn't always like this. I am no longer a child living without memory of what has come to pass. I know now the price we paid and the punishment we wrought.

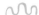

Less than four hundred years ago the people of the Anacostia River were born, lived, and died by the gifts of this living land and its waters. Within their first breaths of life, infants were dipped in the river, no matter the season. This foundational sensory memory bonded them for life to the Anacostia. Think of it: every child of this river community, depending on the season they were born, felt an icy immersive bite, a cool spring spank, or a soothing summer kiss of the river's clear waters.

The Nacotchtank, as they became known to early English travelers, lived in daily communion with the river, making their homes within a stone's throw of the water, catching fish, bathing, and drinking from its welcoming depths. For these descendants of ten thousand years of river life, the Anacostia answered thirst with drink, hunger with food, fatigue with energy, and illness with health. When life neared its end, the river offered some of the last moments of ease the Nacotchtank would ever feel. It was part of their first breaths of life and witness to their very last.

In contrast, today there are many people who live in the watershed who have never seen the Anacostia and know almost nothing about it, aside perhaps from warnings to stay away. Most have never paddled on it or hauled a fish from it; only a handful have ever swum within it. How could so much be lost so quickly? I puzzle over this answer as summer raindrops pock the river surface and lightning flashes across the sky. My mind returns to Benton and his cultural predecessors. My thoughts turn to John Smith.

As Smith voyaged up the Potomac, he kept a journal of his encounters with the land and native people, most of whom were kin to the Algonquin culture. This community, because they lived on the land and of the land, abided by nature's dictates. Dictate number one: Honor the bounds of natural scarcity. Native population densities were low, often not more than four hundred people per one hundred square miles, because that was

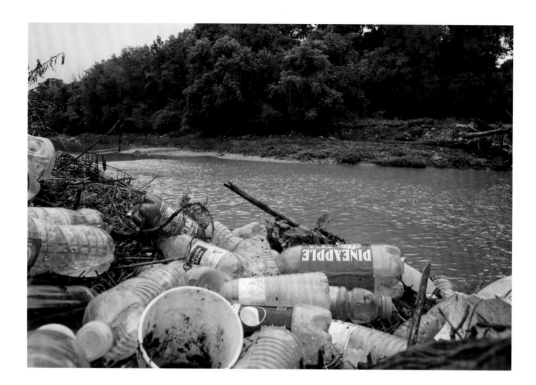

what the land could support. All members of the land community must abide by laws of scarcity or threaten despoiling the land they depend on. The larger a creature and the higher on the food chain, the more food and water resources that creature needs to survive and the lower the density of its population that can be supported over a given area. Jaguars, the largest cat in the Western Hemisphere, defend territories up to fifty square miles for themselves and a few females. All top predators have similar space requirements, humans too.

As populations grow larger, conflicts arise between neighbors over who has claim to resources. Limiting population to maintain a peaceful equilibrium went hand in hand with natural law number two: Don't take more than you need. Native cultures were subsistence economies with people growing and gathering what food, shelter, and clothing they and their families needed to survive. There were luxury items, like copper jewelry and beads, as well as ceremonial paints and clothing, but the greatest value historically was placed on items of necessity. It would be fantasy to imagine that they had no negative impact on the land, but with low popu-

lation and a subsistence standard of living the native people who greeted
Smith in 1608 were living a truly sustainable way of life—a fact that the
land bore witness to and Smith recorded. "Within is a country that may
have the prerogative over the most pleasant places known, for large and
pleasant navigable rivers, heaven and earth never agreed better." To the
eyes of a European, it was "a plain wilderness as God first made it."

In the 1620s, fur trader Henry Fleet echoed Smith's sentiment:

> This place without all question is the most pleasant and healthful
> place in all this country, and most convenient for habitation, the air
> temperate in summer and not violent in winter. It aboundeth with
> all manner of fish. The Indians in one night commonly will catch
> thirty sturgeons in a place where the river is not above twelve fathom
> broad. And as for deer, bufaloes, bears, turkeys, the woods do swarm
> with them, and the soil is exceedingly fertile.

Both Smith and Fleet encountered the Nacotchtank living just upstream
from where the Anacostia meets the Potomac. The community—believed
to number about three hundred individuals—lived all along the river in
small housing groups, with a larger trading village called Anaquash posi-
tioned near the river's mouth at the Potomac.

In his journals, Smith described the landscape around what is now
the District of Columbia as "a low pleasant valley overshadowed in many
places with high rocky mountains; from whence distill innumerable sweet
and pleasant springs." Smith was observing the geologic borderlands in
which we live, the fall line between the piedmont and the coastal plain.
In Smith's time, the boundary between the ancient Appalachian chain
and the Atlantic Ocean was thick with towering forests of oak, walnut,
ash, elm, cypress, chestnut, poplar, and native cherry. These trees and the
woodland understory and meadows provided the Nacotchtank, and other
nearby Algonquin communities, with staple food resources that sustained
them through much of the year: walnut, acorn, chestnut, cherry, straw-
berry, grape, and mulberry.

Smith noted with wonder how the waxing and waning of abundance
through the seasons was written on the bodies of the native people: "It is

strange to see how their bodies alter with their diet, even as the deer and wild beasts they seem fat and lean, strong and weak." As the sun returned from its yearly winter estrangement, solar energy transferred to land and leaf and thence to those who lived by their fruits. Following the thin winter months, the Nacotchtank would begin to grow and strengthen in March and April when the shad began to run. Each year, from back beyond the memory of any human, ocean-dwelling shad, herring, and other anadromous fish have followed their biological dictate to swim upstream to the fresh waters of their birth. Once home, cradled in the scent of their natal Anacostia waters, these fish have brought their own children into the world and immediately thereafter died from the effort.

For the Nacotchtank, the spawning runs provided easy food in otherwise spare months before crops began to ripen. Smith commented that he had "never seen fish in such profusion" and that during the spawn the fish were so numerous it appeared one could dip a frying pan in and haul out dinner ready to cook.

In May and June the people would plant fields of corn, beans, peas, and squash and live on fruits, nuts, and fish while their crops matured. If they could not find enough to eat near their villages, they would disperse in small bands during this season to hunt and gather what they could from stream, meadow, and forest. In summer, spare diets of roots, fish, and early wheat would expand as the land responded to long days of light and warmth.

The growing season came to fruition in fall, and for the Nacotchtank this was the feasting time, when all of their efforts and the ripening watershed would provide the year's greatest abundance of harvest and hunt. It was a time to give thanks and grow plump in celebration of another year on the Anacostia earth and in preparation against winter's deprivations.

Such a life, dependent on the unpredictable generosity of natural abundance, had its brutal side—drought, flood, hunger, cold, heat—these were integral to a way of life on wild land. If you couldn't catch a fish or find a nut, like osprey and squirrel you went hungry, your body shrunk to bone-hard angles, shackled by want. In the hardest of times you died or watched your loved ones die.

But there was also a gentle lavishness to life in a natural system

beyond anything we might imagine in a postsubsistence culture. Today we take a week or two out of our year to visit national parks and wilderness, places where the world is relatively unbroken; the Nacotchtank lived within and from the riches of a healthy land community beside pristine rivers flowing toward an ocean unsullied by an industrial world, in forests alive with the song of birds, the howl of wolves, the noiseless footsteps of mink and marten. They walked the Earth unburdened by ecological deprivation and shame. Some riches cannot be measured. There was a quiet sustenance in a life metered by the interplay between Earth and sun, focused on family and day-to-day work geared toward a simple goal: survival for yourself and those you loved.

Smith alluded to this simple beauty in his journals: "Their women (they say) are easily delivered of childe, yet doe they love children very dearely. To make them hardie, in the coldest mornings they them wash in the rivers." What an image. It reminds me of stories I've heard of baptisms that used to regularly occur in the Anacostia River.

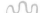

As the rain falls ever harder, the river begins to run faster, and the clarity of just a few moments ago disappears. A distant dream-memory of a Nacotchtank baby washed clean in the Anacostia is now obscured beneath the brown muddled haze that rushes downriver. We owe much to John Smith, but not all of it is cause for gratitude. Smith's purpose was in part one of discovery and exploration. But he had ulterior motives as well, including sizing up the landscape and its inhabitants for colonization by the English, according to their presumed divine destiny.

He wrote, "So then here is a place, a nurse for soldiers, a practice for mariners, a trade for merchants, a reward for the good, and that which is most of all, a business—most acceptable to God—to bring such poor infidels to the knowledge of God and his holy Gospel." In his journals, Smith noted where native civilization existed and the degree to which each village was capable of defending itself, including how many warriors, women, and children and what sorts of weapons they possessed.

The English, with Smith on the vanguard in the Chesapeake Bay watershed, represented one of many efforts throughout the world over time to

supplant hunter-gatherers and subsistence farmers with commodity economies. The decline of subsistence civilizations may have occurred eventually, as disparate indigenous cultures moved through time, but the pace of transformation was expedited wantonly by European cultural and economic expansion. As a result, natural laws of scarcity that governed the equilibrium of subsistence life were replaced by entrepreneurial endeavors to increase individual wealth and standards of living—for which there was neither natural governance nor equilibrium.

The European model could be summed up: take more than you need and transform that surplus into profit and an ever-growing cushion against freedom from fear and want. This model—unlike the egalitarian natural model driven by the sustainability of the entire community—set the individual above the community and established a society of big winners and big losers in a stratified social order. The losers in colonial America were the land, waters, and all those who depended on them to survive, as well as those forced into labor in service of someone else's insatiable pursuits.

Freedom from fear and want is a tricky concept for a species such as ours, capable of forestalling nature's laws and perforating the delicate boundaries of ecological doctrine. Under our system, which measures abundance by the malleable concept of a *standard of living*, the closer you get to achieving freedom from fear and want, the more this freedom recedes to the near horizon. The more you possess, the more you fear someone will take from you. The more your neighbor has, the more you are inclined to want. Freedom from fear and want becomes a logical impossibility when profit, competition, and growth constitute the central economic drivers.

The Nacotchtank and broader Algonquin way of life could not be sustained under such a system. Too much was being taken by too many, too quickly for the landscape to recover. Even before tobacco gained ascendance in the Anacostia, consumer demand in sixteenth-century Europe had begun to drive an intensifying fur trade in North America. Henry Fleet, along with other traders, tied their entire fortunes to the number of beaver skins they could ship from the Anacostia and Potomac back to England.

"I conceived all my hopes and future fortunes depended upon the trade and traffic that was to be had out of this river," Fleet wrote.

Fleet offered unprecedented riches to native people raised on a subsis-

tence lifestyle. For some, the allure of luxury and European power systems spread like an infection, and, according to Fleet's reports, tribes began competing for who would supply this unquenchable demand.

> I found that all the Indians . . . which are in number five thousand persons in the river of Patomack, will take pains this winter in the killing of beavers, and preserve the furs for me now that they begin to find what benefit may accrue to them thereby. By this means I shall have in readiness at least five or six thousand weight against my next coming to trade there.

Fleet and his fellow traders effected the extinction of beavers in the Anacostia watershed, yet still their thirst for profit was not quenched. The English upper class had seemingly endless appetites for status symbols like beaver fur hats, so as beavers were erased from the East, fur traders moved westward until the species hovered on the brink of extinction nationwide. With them went their keystone role in watershed communities—creating wetland habitat that provided homes for wildlife and helped remove pollution from the water. Thus, as rising human populations were pouring more and more pollutants into the river, they were also removing the keystone species that could help the land renew itself.

It is impossible to imagine what would have happened if European culture and military aggression had not displaced the native systems. Perhaps the depth of loss to the land community would never have reached the nadir that it has under our reality. Perhaps it eventually would have. All we know is what did happen.

Within a generation of John Smith's arrival, the fragile balance native people had maintained for millennia was shattered. The European population exploded with more than twenty thousand Europeans descending on the Maryland region by the late 1600s, bringing with them the diseases that would decimate native communities. As forest after forest was felled to plant tobacco, the Nacotchtank and the very basis of their way of life, so intimately tied to the land and river, imploded.

Ad for a beaver fur coat, 1921

One of the last official documents referring to the Nacotchtank came in 1666, when a young man appealed to a local court for relief from white settlers cheating him in trade deals. Even then, official documents had begun describing the Nacotchtank in the past tense, with land descriptions like "the Old Indian Fields." Within sixty years of Smith's arrival, the Nacotchtank had become a dream of the past, like clean and pleasant springs, fish you could scoop up with a frying pan, ancient forests, and healthy air. Those who survived colonization either assimilated, joined the larger Piscataway community, or fled north.

Out on the river their story seems almost a fable to me. But fables have endings, and this story is not over. As the rain falls, my mind flows with the river, and presently a young beaver swims by. Once exterminated from the watershed, beavers have returned, and with them their role in restoring and maintaining ecological functions of the watershed. As I watch him paddling along, I recall stories from friends who have loved the Anacostia much longer than I have; tales of a time before this time, when the river was much worse than it is now, before trickles of love began to etch hairline rivulets in the wetland soil, streams of affection and devotion heading toward the Anacostia.

No, this is not the end.

The past is a foundation we walk upon, but whether or not we become mired in it forever is our choice. We have already begun to pull ourselves out and crawl the first few miles on a long, winding, wetland road to redemption. And while our forebears created this hard road for us by favoring expedience and short-term profit, some of them also crafted stepping-stones and guideposts to lead us toward a better horizon.

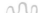

Now drenched by the summer downpour, nerves frayed by the frenzied electrical storm, I walk with some haste to the shelter of the Route 50 Bridge before another barrage of lightning strikes. The runoff from the highway pours from pipes under the bridge into the river. I gaze past it, along the downstream edge of the bridge, where I can see the graffiti on the westernmost bridge supports: "Make this river hallowed." As I have so many times over the years since I first noticed this graffiti, I puz-

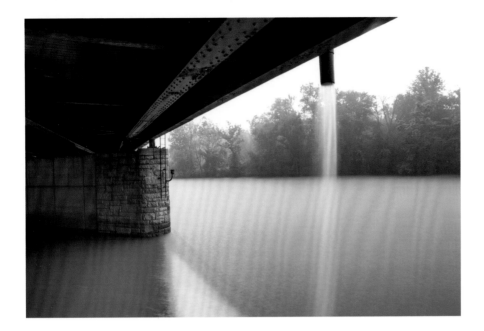

Polluted water running off the Route 50 Bridge

zled over the phrase. How do you make something sacred that already is? And how did we ever lose the belief that a river is inherently sacred? The Nacotchtank knew, as did the Algonquin. The ancient Greeks understood; Achelous is proof of that.

In this secular era we have grown wary of espousing morality for fear of being mocked by intellectuals or rebuked by conflicting religious beliefs. But can't we all agree that the source of all life on Earth, of everything we know, love, and hold dear, that fresh water and the fierce protection thereof, constitute a human moral imperative?

The river is life flowing through the landscape, creating more life. If ever there was a body sacred, the river is it. Human civilization has always, for reasons essential to our physiological and psychological makeup, orbited around rivers. We owe our existence to water. We *are* water. On this fact our very lives—and the existence of everything we understand as life—depend. We inhabit the only planet in a universe of billions where we know rain falls, flows across the land to the sea, and rises back into the sky to fall again. And because of this cycle, *life*.

In such a universe, what sort of creature wantonly destroys a river eco-

system? I think Aldo Leopold might answer: one who has lost its moral compass and no longer feels an urge in its bones to locate the North Star and find its way home.

∿

As the short-lived July storm abruptly ends, I turn toward home, dripping with rain. A few days later, I retrace my steps in a sweltering heat and hot mess of humidity. At the Route 1 Bridge, I stop to take advantage of a slight breeze channeling down the Northwest Branch, which brushes softly against my cheeks. The gentle current of these airy caresses waylays me, and as I look down on the fish ladder, instead of my snake I find a man and his two young children, a son and daughter, splashing around in the water. It has not rained since my last walk, and the water is again clear and welcoming. The toxins and sewage that flow with urban stormwater have by now largely settled or traveled downstream to the Potomac.

The little girl, giddy and squealing, cannot be more than five. Her father holds her small hand protectively while she reaches with her other hand into the water rushing over the fish ladder. Her brother clutches a prized basketball and cautiously walks along the slippery algae that grows on the concrete bottom of the weir.

Historically many people swam in the Anacostia, even long after the Nacotchtank were gone, even after military and industrial toxins and sewage began to pour into river waters. As our river became sicker and sicker, those who had the means began to drift away. They moved farther north and west. They got their drinking water from the upper Potomac, which we had not yet poisoned; they traveled to places where they could swim safely. Later they built pools of concrete bleached by chlorine chemicals—the same chemicals used to create weapons for war against man and nature. They made rules that people of color could not cool themselves in those antiseptic pools, so black people stayed with the river, bathed and baptized in its sacred waters, which did not, and never would, discriminate. Within the Anacostia children played, the faithful were baptized, families picnicked, and songs were sung. What greater homage could there be for hallowed waters than the divine voice of Marvin Gaye—who

grew up near the river—singing a cappella with his friends in the Watts Branch sub-watershed.

Marvin's voice and those of the African American community also drifted away from the river eventually, for this reason and that, as laws were passed to prohibit segregation; as word of DDT, chlordane, and PCBs spread; as more laws were passed to prohibit swimming in the Anacostia; as a whole civilization gravitated to an electronic world inside the walls of offices and homes where the air was cool in summer and warm in winter.

Today, the only human residents embracing or embraced by the river's waters are those who don't understand the language that tells them to stay away or who believe they have immigrated to a nation of laws protecting a sacred source of life. I watch the father and his children putting on their shoes and gathering their things and heading off home.

Something in me shifts, and I determine that this is the day I will be christened in waters of the Anacostia. I'm surprised it has taken so long. This moment was inevitable because the fact is, I can never really know the Anacostia if I fear to touch her and allow myself to feel her wounded touch on my skin. Now is the time for reconsecration, not of the river, which does not need my blessing, or any affirmation of the holy place it has always held at the center of life on Earth. No, this is for me, to return to this river fully and assert with my actions that I am not satisfied and will never be satisfied with a system that pays lip service to the foundational value of clean waters yet allows polluters to poison our rivers with relative impunity.

I have been told to stay out of this river. I will no longer do so. I climb down the levee wall, pull off my shoes, walk across the bare concrete that scrapes and burns the soles of my feet, and wade into the Northwest Branch, where water extinguishes the concrete fire, algae squishes beneath my feet, and little fishes begin to nibble at my toes.

SACRED

Route 50 Bridge

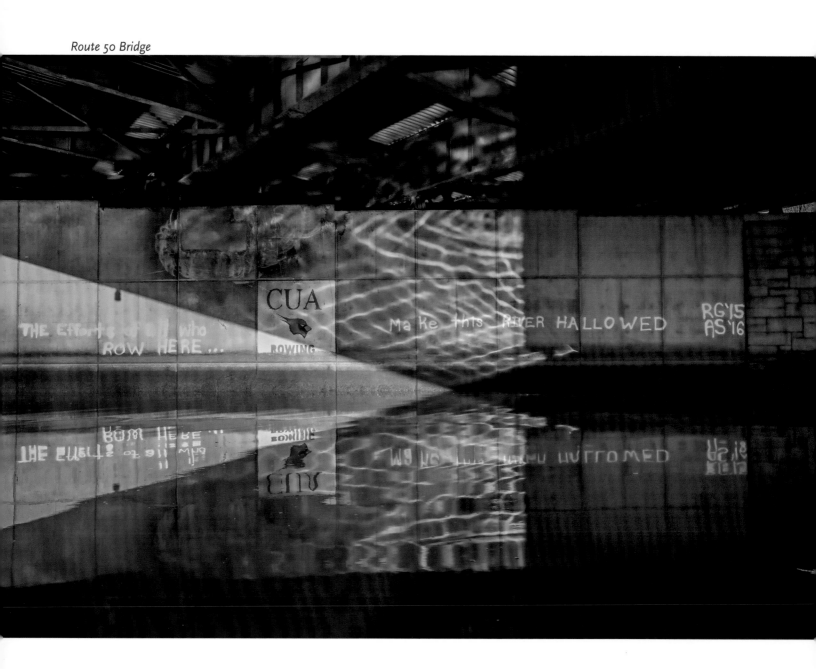

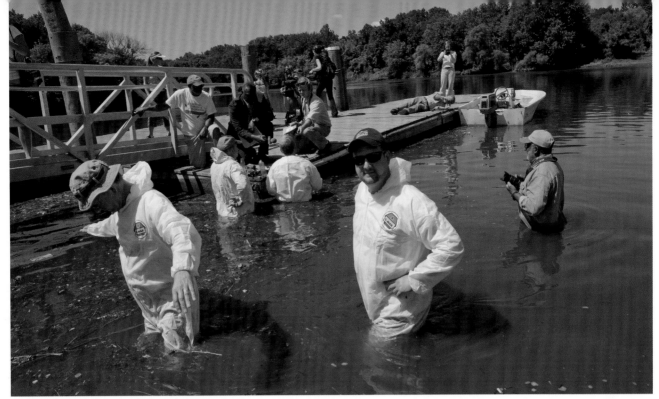

Anacostia advocates wading in the river

Great blue heron

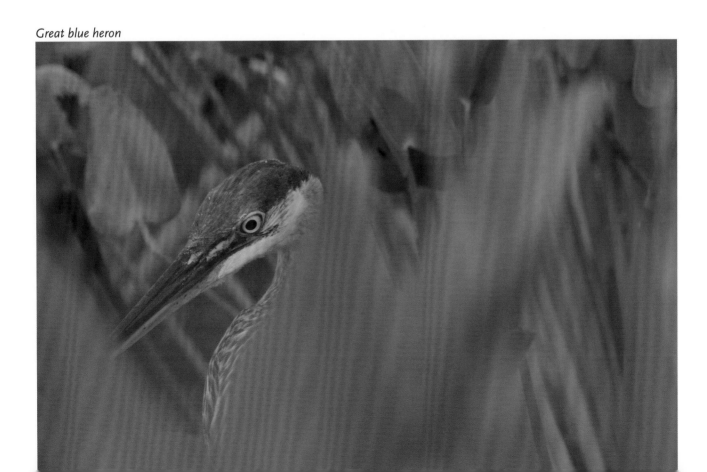

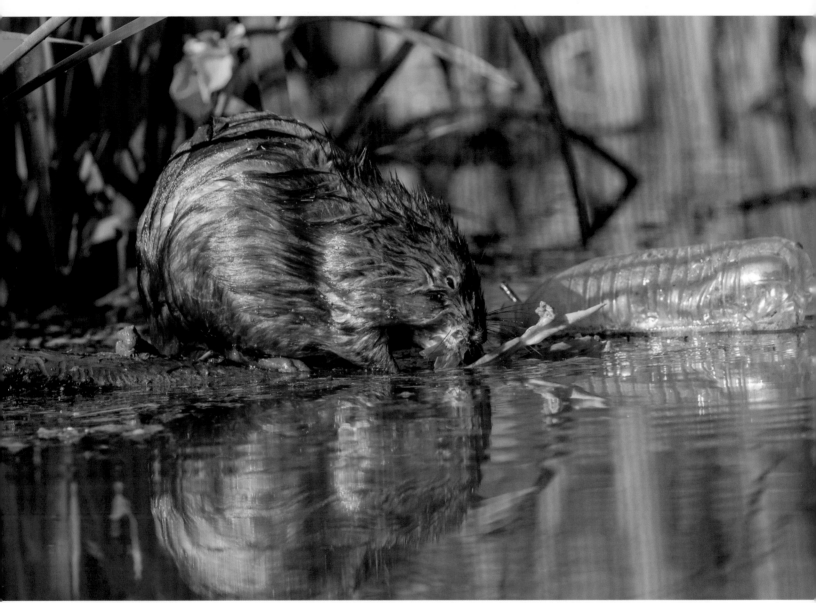

Muskrat with trash

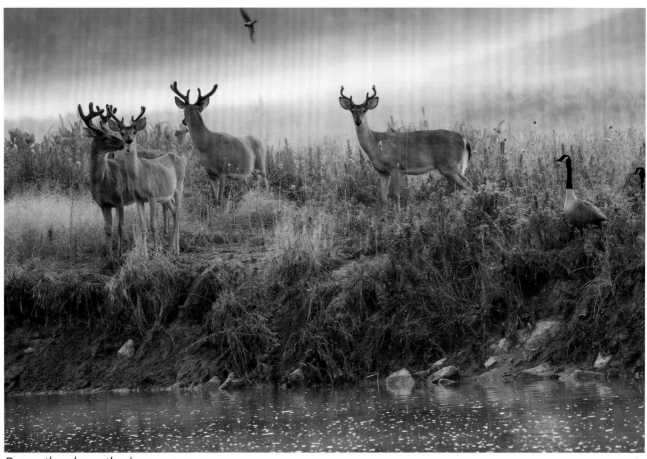

Deer gathered near the river

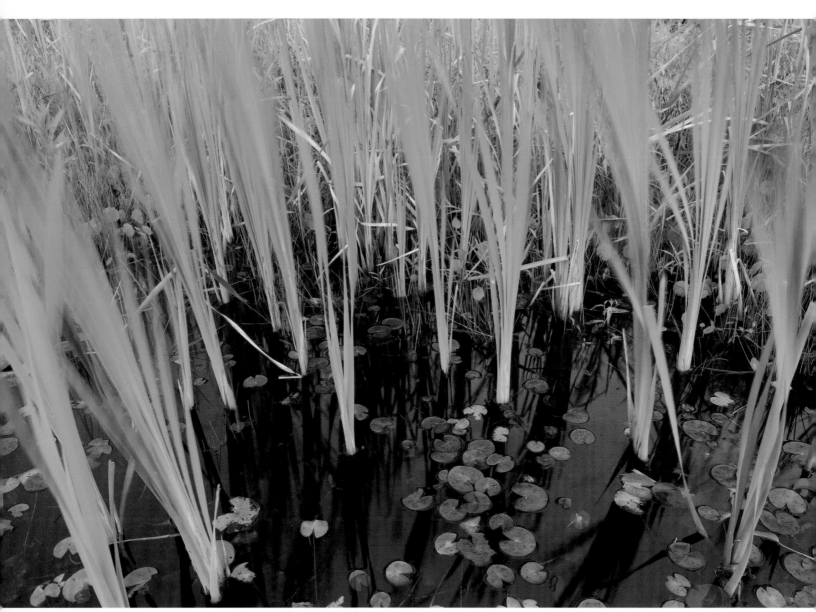

Wetland

Swallowtail butterfly on milkweed

Man and his son walking across Bladensburg footbridge

The Elliptio Moon

Ten inches underwater, in the shallows at Buzzard Point on a bed of pebbles and broken glass, a foot appears out of nowhere. I have been waiting some time for the foot, yet it takes me by surprise. Toeless, boneless, and alabaster white, it materializes from within a charcoal-gray shell, juts out a few inches from its hidey-hole, grasps on to the sandy riverbed, and drags its shell forward. Decidedly ungraceful and yet hypnotic.

I have never before seen a freshwater mussel walk, if it can be called that when the walker has only one foot and no legs. To be honest, I haven't until now put much effort into it, and this display of ambulatory prowess is uncommon. Adult mussels generally park for long periods of time

if conditions are right for their peculiar lifestyle. But they can amble along by thrusting their foot in front of them and pulling themselves through sand and mud. They have been clocked moving as fast as two feet per hour when they are particularly motivated.

I check my watch and find that I have been crouching over this spot at the far downstream end of the Anacostia for thirty minutes, still as a statue, waiting for this mussel to move a muscle. In that time—apparently lacking sufficient motivation—it covered roughly half an inch. But no matter, this foot feat impresses and I am feeling fortunate. As of this moment, I am one of only a handful of people alive today who have seen an eastern elliptio on a stroll within the Anacostia River.

Four hundred years ago many thousands of mussels—representing perhaps a dozen species—strolled all throughout the river, including this spot, which in those days would have looked out on the trading village Anaquash. Today, as I crouch on the pebbly riverbed, the view of Anaquash has been replaced by the hard angles of Bolling military base, a combined air force and navy facility and one of the most toxic sites on the river. To the west, beyond a thin tree-lined embankment at the edge of the shoreline, a perpetual cloud of dust hovers over a massive construction site for the new DC United soccer stadium. And right in front of me, under a searing, sapphire sky, Jorge Bogantes Montero—wearing the full-length khaki waders that are standard-issue dress for staff of the Anacostia

Industry has drastically altered the Anacostia River at Buzzard Point

Watershed Society—peers into a glass-bottomed bucket half-submerged in the Anacostia shallows.

Presently Jorge looks up from his bucket and says excitedly, "Found one!" He reaches into the water and produces a small mussel whose dark shell is adorned with a yellow pattern—like light rays radiating from a clouded sun. "Eastern lampmussel," Jorge says admiringly to the mussel and me. Indeed. *Lampsilis radiata* is a beauty of a mollusk.

"This is my new favorite place on the Anacostia," Jorge adds with a grin, then sticks his head back into the bucket.

Jorge has worked for the watershed society for eight years as a natural resource specialist, assessing the various locations that show promise for restoring the wild diversity of the watershed and then taking steps to help those landscapes thrive. He has an uncommon understanding of what lives in the wild places of the Anacostia and also what *could* live here. But occasionally the river throws him a curveball.

In a healthy river, my wandering alabaster foot and Jorge's radiant find would be commonplace. Freshwater mussels are widespread species of aquatic habitats all across the continent. But this is the Anacostia. Until just a few years ago, it was assumed that mussels could not survive because of high levels of silt and other pollutants. Then in 2013 the Anacostia Watershed Society happened upon a single mussel, an eastern floater, in Bladensburg Waterfront Park. After that, Jorge embarked on a project with the Maryland Department of Natural Resources to determine if the floater was a fluke, or if mussels had been quietly reestablishing themselves in the Anacostia. Since then, on survey after survey in spots all along the river, Jorge has found eight different mussel species, with the highest diversity found here at Buzzard Point on a rare natural shoreline along the most unnatural stretch of the river.

For those who advocate for the Anacostia, the mussels' return heralds a monumental ecological milestone. Mussels cannot live in water that is too polluted, so the fact that they are here at all suggests a healthy trend for water quality. That's good news for all of us, especially for mussels and those wild species who eat them and for those who have worked tirelessly to restore water quality in the river. It's also a bright harbinger of better days to come. Mussels are filter feeders—they take water into their

bodies to find food, then expel the excess water, which exits cleaner than it entered.

"One mussel can filter up to ten gallons of water in a day," Jorge notes.

For fun, on one mussel survey, Jorge and I did a side-by-side comparison of polluted water with and without mussels. Using identical clear containers, we scooped up equal amounts of sediment and water per container; then to one of the containers we added several mussels. Within an hour, the container with mussels had near-perfect water clarity, while the water in the container without mussels remained murky.

As mussels return to the Anacostia, its waters will heal more quickly because the river will have these mighty mollusks working on her side, as she did of old. One glance into the water here offers evidence of the gift these mollusks offer—water so clear you can see the texture of clam shells a foot down. The credit for this cannot be entirely claimed by the mussels. They are just one part of a fairy-tale ecological story unfolding on Buzzard Point, Jorge's new favorite place on the Anacostia.

In 2013, another important discovery was made near Buzzard Point—

Comparison of water clarity with mussels (left) and without (right)

an aquatic plant was found growing just downstream in the Washington Channel, near the confluence of the Anacostia and Potomac. Submerged aquatic vegetation has been absent on the river for many decades because, like mussels, these plants cannot survive in water that is too polluted—turbid water blocks the sunlight photosynthesizers need to manufacture energy. Many of these plants were originally lost when the Army Corps scraped the bottom of the river and smothered the Anacostia's shallow shoreline with dredge. Many more died as the water became too polluted to support their solar needs. This reality has long crippled the restoration of water quality throughout the Chesapeake Bay watershed. But sometime in the last decade or so, aquatic vegetation has been returning to the bay and migrating into its sub-watersheds. At the same time, stormwater policies requiring silt fencing and incentivizing permeable paving, rain gardens, and other green infrastructure must have healed the water to the extent that it met some threshold required by the aquatic plants. Consequently, one took root in the Washington Channel.

Buoyed by this discovery, in 2015 the Anacostia Watershed Society and DC Department of Energy and Environment gathered wild celery plants from the much healthier Mattawoman Creek in Maryland and transferred them to test plots on Buzzard Point. And then they waited to see if these first fragile plants could survive the Anacostia environment. The results exceeded all expectations.

"We found a total of seven species," Jorge says. "We only propagated one, and all these seeds showed up—which shows the capacity of the habitat to really expand when you give it a little helping hand."

Today Jorge and I wade through an underwater forest where aquatic plants sway with the gentle pulse of current, tide, and the waves we make. Within the clear water of that undulating aquatic forest tiny fish can be seen going about their little fish business. Here and there the tips of plants break through the water surface, and on their green leaves sit damselflies the color of liquid sky alongside their translucent alien babies. Less than a year after Jorge seeded wild celery, a whole aquatic community has taken hold at Buzzard Point, and the plants have naturally migrated miles upriver to Kingman Island and beyond. Hydrilla, an aggressive nonnative, has become the dominant plant, forming dense carpets where it grows—

Big bluet damselfly on aquatic vegetation at Buzzard Point

but hydrilla is one of the few invasive species accepted by some river ecologists because of its efficiency at cleaning polluted rivers. And along with hydrilla are patches of six other varieties, all native species that once made a home on the Anacostia through the ages of river life.

Jorge has been coming here on a regular basis to monitor the plants and assess their impact on water clarity, which has risen steadily as the plants have expanded. Near the established plant beds, clarity has already reached a record forty inches in depth, better than any other site documented on the river to date.

Submerged aquatic vegetation and mussels work in tandem to clean river water, and as they do, these underdogs assist each other in their perspective recoveries. Aquatic plants also provide underwater habitat that plays a critical role in the life cycle of many species, including mussels, some of the most unique and endangered organisms on Earth.

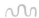

Mussels spend their lives in self-imposed isolation. They construct hardshell homes to shelter their soft bodies and pass their time pulling in water, gleaning its nutrients, and pushing it back out into the wider world. Enclosed as they are within their island fortresses, mussels are not well built for intimate encounters. Thus, in order to reproduce, male mussels release sperm directly into the water upstream from females. When the sperm encounter a female mussel, they swim inside, locate her eggs, and voila! . . . embryos develop—sometimes up to a million. These youngsters tuck inside a marsupial pouch in the mother's gills where they will

remain for months or even a year before they are launched on their next stage in life.

Then it's showtime.

Mussel larvae, once they are released from their mum, must find a host—generally a narrow group of fish species—within a matter of days. If they don't find a fish to parasitize, they will die. If they find the wrong kind of fish, the fish's immune system will attack, and they will die. Some 99 percent of mussel young will perish before they reach adulthood, with many simply not finding the right species and others not finding them in time before predators like catfish and pumpkinseed happen upon them.

Releasing thousands of young ones into the world with these odds of survival may not seem like responsible parenting. But many mussel moms have special tricks to give their babes the best shot at life. Some will dangle and twitch parts of their bodies outside their shells so that they look like a swimming fish. This "lure" draws predator fish in near proximity before the mussel releases her vulnerable younglings. Other species of mussel release their larvae encased in a sac that resembles the fish's prey. When the fish takes the bait, the larvae glom on to the fish's gills.

If a young mussel finds and attaches to the right species of fish, the fish's skin will envelop and feed the larva until it develops into a physically mature mussel. Fish hosts are generally not harmed by the hitchhiker, but I imagine they are somewhat relieved when the mussel drops off into the river sediment and leaves them the hell alone.

Once embedded in the sediment, the juvenile mussel constructs a home around its body and will add to this abode annually as it grows larger. At this point, young mussels enter into the solitary monastic order of mussel-kind. They can live ten to fifteen years, but for most of that life, they are on their own, almost entirely hidden within the river bottom.

In the Anacostia, mussels are most likely to be drawn out of their solitary cloister by muskrats, who find mussels especially tasty and like to pile up their shells in middens on good foraging grounds. I have also seen raccoons come down from the trees along the riverside and sort through the river sediment with their tiny human hands, perhaps looking for mussels, clams, and snails.

As filter feeders, mussels play an important ecosystem role, clean-

ing the water by removing excess populations of bacteria and other microscopic organisms. But they are also one of the most endangered wild families in the world. In the United States, nearly seventy mussel species are endangered or threatened according to the US Fish and Wildlife Service. Their initial decline came in the early twentieth century when industry began harvesting the mussels far faster than they could reproduce, in this case to make buttons.

Buttons.

More recently mussels have been threatened with water pollution, everything from silt, pesticides, fertilizers, and heavy metals, to the excessive salt that runs off city streets in winter.

Many mussel species, because of their reliance on just a few host animals, are highly vulnerable to any threats posed to those animals. Take my fleet-footed eastern elliptio, for example. This mussel relies almost exclusively on the American eel as a larval host within the Chesapeake Bay watershed. Mother elliptios release their larvae in a long, strandlike sac, which the eels swim through. As they pass, the mussel larvae spill out of the sac and swim into the eel's gills, where they are succored to adulthood. But American eels are a globally endangered species. Over the past centuries threats mounted against them as dams blocked their passage to historic waterways, and the fishing industry hauled out far more than could be sustained by the eels' reproductive processes. As the eel disappeared in the bay watershed, so did the elliptio.

The intertwined relationship of eel to elliptio can be observed in countless other life-forms throughout Earth's ecology, binding together the fates of seemingly disparate plants and animals. This universal entanglement can be seen as a foundational natural law: We are all connected to everything around us, most often in ways we cannot see or predict, and if we remove, wound, or endanger any one thing, it will send reverberations throughout and eventually come back around to wound us. One need only look at the story of our Anacostia for irrefutable proof.

∿∿

When John Smith sailed up the Potomac in 1608, he found bear, wolf, bison, elk, mink, otter, and marten walking the landscape and swimming

the river waters. By the time the first permanent English settlements were established, bison were gone. Wolves were hunted to extinction by 1728, their massacre hastened by a bounty of two hundred pounds of tobacco for each wolf scalp. The bounty was put in place to remove hunting competition for elk as the human population rose, but even after the wolves were gone, our appetites were far too lusty for land and meat, and elk were extinct in the watershed by 1844.

Within the historic river, shark swam with menhaden, anchovy and sole, striped bass, sturgeon, and salmon. In wetland and forest dwelled wood tortoise, mud eel, Jefferson salamander, Allegheny blacksnake, and diamondback terrapin, along with at least thirteen other species of salamander, ten frog species, twenty-one snakes, and eleven different types of turtle. In the late 1800s dolphins were seen in the Potomac near Georgetown so surely ventured into the Anacostia when it was clean and deep and by all accounts abounding with a wealth of fish. Canvasback ducks blanketed the river waters; flocks of wild turkey thirty to forty strong would fly through the city; petrels, shearwaters, ruffed grouse, and sandhill cranes were common, along with wood ducks and pileated woodpeckers. Carnivorous plants and exquisite orchids grew in bogs, including purple pitcher plants, sundew, and the snakemouth orchid.

This abbreviated accounting of the historic biological diversity of the watershed is taken from *A Sketch of the Natural History of the District of Columbia* by W. L. McAtee, published in May 1918, the same year Anacostia Park was established. McAtee looked into historical accounts of the wildlife and plants of the region, back to the early 1600s. It is by no means a full record of the wild community that Europeans stumbled upon, much of which was destroyed before it could even be recorded.

When Europeans arrived in North America, the passenger pigeon was by far the most abundant bird on the continent, numbering between three and five *billion* birds. They traveled together by the millions, a mass of grace and perfect coordination that would darken the sky and fill the land with a thunderous clamor. Such wonder! Within three hundred years of John Smith's voyages, we had killed every last one, save a lone female held in the Cincinnati Zoo. She was a fading ghost of hope for her species, which had been one of the world's most numerous birds. Her name was

Martha, and she died at 1:00 p.m. on September 1, 1914. With her died a piece of Earth, and us.

Martha was followed four years later by Incas, the last Carolina parakeet, in February 1918. A brilliant green parakeet with a yellow head and red face, the Carolina was the only parrot species native to the eastern United States. But this winged gem depended on old-growth forests along rivers, and we had cut all the forest down along the Anacostia, James, Potomac, and most other rivers of the East. At the same time, the parakeet was being slaughtered wholesale for its beautiful feathers and exterminated by farmers who considered them pests. Under this maelstrom of threats, the battered Carolina parakeet could not survive in this world. Today the parakeet exists only as stuffed specimens with lifeless eyes displayed on shelves in museums and in the drawings of John James Audubon, where within the confines of two dimensions it can be remembered as wild and free.

Many more species have been exterminated from the Anacostia community, either because we found them inconvenient or because we just didn't think about them at all. Yet many have managed to survive our precarious world. Wood thrush, once the District's most numerous bird, still live among us, though they have grown rare. Every year they make two trips across the Gulf of Mexico to their wintering grounds and back home, where their tired wings seek tall trees in deep aged forests to brood and raise their young. Very few old forests remain to them in the watershed.

Wild creatures, no matter how numerous, no matter how fierce, can be pushed only so far, and many even now teeter on the edge of extinction in the watershed, where their fate is entirely in our hands. There is perhaps no better symbol of this wild vulnerability than the marbled salamander. These small amphibians spend most of their lives in isolation under logs and leaf litter or in burrows in the ground. They emerge in late summer and fall to find mates and lay eggs in dry depressions in the ground. There the female curls herself protectively around her eggs until the rain comes to fill her ephemeral pool and her eggs begin their turn at life on Earth. The marbled salamander's existence is intricately intertwined with this precise spot on the Anacostia land—there can be no substitutes. Without these pools, there can be no marbled salamander.

Marbled salamander

Carolina parakeet museum specimen. Photo: Huub Veldhuijzen van Zanten/Naturalis Biodiversity Center

Several years ago, I accompanied Jorge on another survey of Anacostia wildlife, this one concerning the vernal pool biodiversity near the boundary of Washington, DC, and Maryland. Because so much of the watershed landscape has been covered with pavement, vernal pools have become exceedingly rare. And despite our knowledge of the importance of these places to wildlife, they continue to disappear. A decade ago, one of the few remaining vernal complexes in the District's portion of the Anacostia was lost when forests were cut and land paved over to build a Costco. Jorge was documenting what remained of this precious vernal community.

We pulled on our waders and eased through the marshy land, bypassing basking turtles and dabbling ducks, to one of the deeper pools, which measured about three feet in depth that day. Jorge sampled different sections of the pools, noting the size of salamander egg masses, the number and type of fish he found, and the various invertebrate life we encountered. Because it was spring, we found only spotted salamander eggs, but under a log near the pools, Jorge uncovered a single marbled salamander, resting in his safe hideaway. Jorge and I may be the only two humans ever to lay eyes on this soft-bodied little creature living alongside this pool, where his entire life and future are held in trust. For many decades the salamanders of these riverside pools thrived in their forgottenness amid the ever-developing urban landscape. But then Costco and the Fort Lincoln development came along. Forty acres of their forest home were cut down, the land graded, and vernal pools filled with concrete. Who knows how many of their kind were unearthed in one violent rush of machinery, torn

from their shelters on the Anacostia ground, tossed among piles of earth, flattened and forever buried beneath the lifeless parking lot. There is great peril in being forgotten.

Many marbled salamanders, turtles, fish, and frogs died in those days, but for those who were left behind, bereft of their greater community, the loss endures. The marbled salamander Jorge and I found was suffering a biological bereavement. Even before the Costco came, these salamanders had few options for mates within their fragmented islands of urban habitat. When the Costco destroyed their pools and killed their kindred, the community of marbled salamanders lost a millennia of genetic blueprints for the making of a marbled salamander. Genes for resistance to disease, skin patterning, and adaptation were lost, genetic instructions that could help the salamanders map out a route to survival in a changing world.

In a world as dynamic as our Earth, survival depends on the ability to adapt. None of us are just bodies. We are blueprints, codes for the survival of our species through time. And when too many of the blueprints are lost, the structure will collapse, either through inbreeding and the introduction of disease or an inability to adapt to changing conditions. Who knows what point that will be for the marbled salamanders of the vernal pools Jorge and I visited. It is possible that the genetic poverty inflicted by the Costco may already have sealed their fate and disease and physiological abnormalities will diminish each new generation until none are left. It is possible that the Costco may be the final cause for the extinction of the marbled salamander in Washington, DCs, Anacostia watershed.

Without doubt, marbled salamanders are approaching this point in the District, where they are officially a Species of Greatest Conservation Need according to the Department of Energy and Environment's Wildlife Action Plan, which Damien Ossi, Dan Rauch, and others drafted in 2015. The plan identifies roughly two hundred species that we as a society could help save from extinction in our watershed community. They include the northern long-eared bat, meadow vole, and eastern cottontail; spotted turtle, spotted salamander, and queen snake; woodcock, wood thrush, and black-crowned night-heron; monarch butterfly, rusty-patched bumblebee, and American eel. My marbled salamander is included on the list of species in greatest need of our help, but the report notes that chances

of recovering the marbled are grim. Less than three acres of vernal pools remain in the entire District, and very few marbled salamanders have been found in recent years.

The threats looming over Anacostia wildlife range from disease and invasive species—like feral cats, phragmites, bush honeysuckle, and house sparrows—to loss of their forest habitat, vernal pools, and native meadows. Despite our understanding of these threats, the machine moves ever onward and we are continually making decisions that challenge the existence of the urban wild.

In Prince George's County, near where I live, one of the last sizable mature forests in the Northeast Branch sub-watershed was razed a few years ago. I stood watching helplessly as they hewed aged oak, poplar, and maple; I watched as machines tore at the roots that still clung to the earth even after their trunks were severed.

Jorge Bogantes Montero holding a marbled salamander

On my local Listserv many people applauded the clear-cut and the construction that followed, saying, "What a great use for this empty land!"

Empty.

When I read this, I thought of that old saying, "If a tree falls in the forest and no one is there to hear it, does it make a sound?"

The answer is easy: yes, because there is always someone there to hear it.

One of my favorite descriptions of the rich life lived beyond our eyes came from scientist Edward O. Wilson, who wrote of a small patch of ground he examined in the tropical rain forest. Describing this space, which could have fit within the circle of his outstretched arms, he said:

> The woods were a biological maelstrom of which only the surface could be scanned by the naked eye. Within my circle of vision, millions of unseen organisms died each second. Their destruction was swift and silent; no bodies thrashed about, no blood leaked into the ground. The microscopic bodies were broken apart in clean bio-

Costco parking lot

chemical chops by predators and scavengers, then assimilated to create millions of new organisms, each second.

∿∿

The forest and indeed all healthy land communities teem in a frenzy of life and death and life again. And when a tree falls in a forest, there is always someone to hear it.

When they tore the forest from the watershed land, I watched cardinals and tufted titmice flee to the last standing trees, where they were the last forgotten residents of a wild community. I watched as concrete was poured and steel rose and a shiny new Whole Foods with its branded green label supplanted the wild.

Many of my friends and neighbors celebrated the Whole Foods grand opening earlier this year; I can barely drive by it without becoming morose, in part because I don't know where to begin explaining the hole in my heart that was left when that forest came down. I knew that forest was not empty. I knew that if a tree fell, there would be many to hear it. I had looked in their faces, taken their portraits, watched them struggle to find food and build their homes, and raise their young in trees and tunnels in the ground; I had flown with them to Central America and back again in my imagination. I had heard and experienced firsthand the words of John Burroughs: "We little suspect, when we walk in the woods, whose privacy we are intruding upon—what rare and elegant visitants from Mexico, from central and South America, and from the islands of the sea, are holding their reunions in the branches over our heads, or pursuing their pleasure on the ground before us."

For the past decade my job has been to chronicle the global picture of

Spotted salamander egg mass

Whole Foods, Costco, National Harbor, superhighways, coffee and palm plantations, and border conflicts, which all over Earth are supplanting the planetary wild. In the course of this work, while pursuing my displeasure in late 2016, I came across an article headlined "Rabbs' Tree Frog Declared Extinct." The article, which ran alongside a photo of the small reddish tree frog with large, fearful eyes, read: "Known as 'Toughie,' the tiny male frog, originally from Panama, spent the past few years living by himself at Atlanta Botanical Garden." It went on to note that the species had been unknown to science just two years before Toughie's death marked the end of the tree frog's existence on Earth.

This was in September, less than a year ago, but Toughie was just one of the latest in a long time line of escalating extinctions that have been ongoing since the dawn of modern human culture. Over the past century, since the Carolina parakeet was declared extinct, the rate of extinctions has been accelerating. The current rate, which is roughly one hundred times what scientists consider normal, has risen in direct proportion to human population and our standard of living. If the extinction rate continues unabated, scientists project that three-quarters of all life on Earth will disappear. The African elephant may be extinct in twenty years. More than 25 percent of the world's bumblebees are near the point of no return. Coral reefs are vanishing, and when they do, so will scores of fish spe-

cies who rely on them for nurseries and feeding grounds, and then scores of others who eat those fish. Our unprecedented success as a species has thrown Earth so far off balance that it teeters on the brink of biological collapse. We may be one of the last species to suffer the ultimate consequence of this cascade of undoing, but we are hitched to this Earth wagon and suffer it we will.

But we need not. As Leopold wrote, we have a capacity beyond all other inhabitants of Earth to alter our behaviors to achieve just about anything. He was writing specifically about the loss of the passenger pigeon, which humanity never knew it loved until it was gone. "To love what *was* is a new thing under the sun, unknown to most people and to all pigeons. To see America as history, to conceive of destiny as a becoming, to smell a hickory tree through the still lapse of ages—all these things are possible for us, and to achieve them takes only the free sky, and the will to ply our wings."

We can ply our wings right here, in our backyards, down the trail and up the stream. The District's wildlife plan did not give a full accounting of biological diversity in the watershed, and it falls short of a concrete strategy and plan of action, but it offers a good start. The plan identifies what it calls "conservation opportunity areas," those places in the watershed that offer the best chance for conservation of vulnerable wildlife species. Many lands of critical significance for wildlife—DC's biodiversity hotspots—are located in the Anacostia watershed within the bounds of the original outlines of Anacostia Park—which included most of the lands adjacent to the river. The plan asserts that priority lands should be protected from development and other actions that would degrade the habitat—lands that include Kingman and Heritage Islands, Poplar Point, and Kenilworth Park.

The top threats to these habitats are identified as invasive species, recreational activities, and development. The Wildlife Action Plan highlights specific current threats, like the Anacostia River Trail, which degraded marsh, lowland forest, and meadow habitats critical to wildlife. The document also outlines threats that loom on the horizon, from an expected increase in people visiting Anacostia natural spaces, to the disruptions that can come with toxin remediation, to major development planned along the Anacostia corridor. Kingman Island, Poplar Point, Kenilworth Park, and Buzzard Point are all essential to the health and res-

Trees being cut for Whole Foods development, Prince George's County

toration of the Anacostia—and all face development in the coming years. Development ideas range from thoughtful designs that integrate natural-ized shorelines, expanded forests and wetlands, to hardscapes, clear-cuts, and seawalls that would decimate any hope of restoration. The future of the eastern elliptio, wood thrush, Virginia mallow, and woodcock will be determined by the decisions we make next.

Consider the woodcock, a singularly strange and wondrous bird that historically bred in the District. Just over the past few years, woodcock have been observed carrying out their breeding rituals in the short grasses and forbs that have sprouted in an unmowed meadow in Kenilworth Park. I went to see them once with Dan Rauch, or I should say, to hear them. They display only at dusk and dawn, and only for a very precise and lim-ited time, usually about an hour and most of that in darkness. Their show consists of a series of death-defying aerial dives accompanied by an odd, rather indescribable noise the woodcock makes by vibrating his feath-ers together while doing a nose-dive to the ground. At that point he struts along the ground to show females how easily he has cheated death and will do it again whenever he wishes. Such a spectacle.

Aldo Leopold was riveted by the woodcock's aerobatics:

> The show begins on the first warm evening in April at exactly 6:50 p.m. The curtain goes up one minute later each day until 1 June, when the time is 7:50. This sliding scale is dictated by vanity, the dancer demanding a romantic light intensity of exactly 0.05 foot-candles. Do not be late, and sit quietly, lest he fly away in a huff.

The woodcock display depends entirely on the suitability of his stage—a very precise landscape is required.

> The stage must be an open amphitheater in woods or brush. . . . Why the male woodcock should be such a stickler for a bare dance floor puzzled me at first, but I now think it is a matter of legs. The woodcock's legs are short, and his struttings cannot be executed to advantage in dense grass or weeds, nor could his lady see them there.

The woodcock needs a grassy meadow, with some essentially bare spots, and trees or other cover nearby where he can find shelter. Only 1 percent of the land in the District now fits the description of grassland, and an even smaller percentage of that provides the stage essential to the woodcock's annual aerial breeding dance—and all of that is in Kenilworth Park. This national parkland has long been awaiting remediation, but when that happens, the pressure will increase for recreational and housing development, and if that development is not carried out with extreme care, the woodcock and many others will disappear from our midst. Already the Anacostia River Trail has been constructed directly through the meadow where I saw the woodcocks displaying. They will not carry out their struttings or put on their aerial show with bikes racing through. They will flee their home in the District. But if we secure and protect a suitable space for them, they will very likely continue their romantic spring performances and raise their fragile young on the Anacostia.

The woodcock is just one of hundreds of species whose future hangs in the Anacostia balance. The river wild, and all who seek to preserve it, faces complex challenges known and unknown. One of the greatest unknowns, climate change, is already throwing invisible wrenches toward the workings of this urban ecosystem, and indeed the greater Mid-Atlantic ecoregion. Wildlife scientists have mapped where they expect migrants to travel as climate chaos unfolds. In these forecasts the Anacostia and Potomac watersheds are predicted to be major thoroughfares for wild species—birds, mammals, and amphibians alike—trying to reach cooler northern and mountain climates. Our watershed—if we protect and enhance healthy habitat connected by travel corridors—could play a critical role in the survival of species all along the East Coast. But rising sea level could inundate the Anacostia riverside, eating away at an already small amount of habitat for local wildlife and migration pathways for the climate refugees of the wild world.

For wildlife to weather the coming challenges we have set in motion, we must have the will and wisdom to help them. Ultimately the fate of our watershed, the answer to the extinction crisis, climate change, and the other great ecological challenges of our time lies not in some new *green* technology or *green* corporation or a technology or corporation of any sort, though

all of those may play an important role. Rather, our future depends on answering Edward O. Wilson's questions about who we are, who we want to become, and what our role is in the larger land ecology. If we can agree on who we, as a society, as a species, want to become, then we can craft a structure, an ethical system, to guide our actions.

It was for this system of guidance that Leopold advocated seventy years ago: "All ethics rest upon a single premise: that the individual is a member of a community of different independent parts." But for Leopold, the important thing was how we defined the bounds of that community. We don't often think consciously about how we formulate our idea of community, but how we define it matters. If we limit our community to blood relations, our ethnic circle, our race, gender, religion, or sexual orientation, then we consequently limit our ethical framework to those who are perceived to be inside that community. For those who are outside, ethics have little bearing. If you do not see women as an integral part of your community, you can ignore a system that values her work as 75 percent as worthy as a man's. If you do not consider a person with dark skin to be included in your community, you can look the other way when he is beaten and killed and incarcerated far more easily and often than his light-skinned counterpart. If you do not understand a salamander, thrush, dolphin, and eagle to be a part of your community, you can feel no remorse when they are killed or displaced by human activity. But everything changes when we widen our community circle to encompass more of our neighbors on the landscape.

Sometimes looking into the eyes of the "other" is all it takes to expand our community boundaries. I have a friend, Clay Bolt, who cofounded a global organization called Meet Your Neighbours (Scottish spelling) geared toward widening the boundaries of community to include wild things. The organization provides photographers with tools to create intimate portraits of small wild species, the insects, tiny reptiles and amphibians, and small mammals that are often overlooked. But these neighbors are all around us all the time, sharing this land. I have taken a few of these Meet Your Neighbours portraits over the years in the Anacostia watershed and, by getting to know beetles, skinks, wasps, and snakes, have grown closer to an understanding of Leopold's *land community*. Many of these

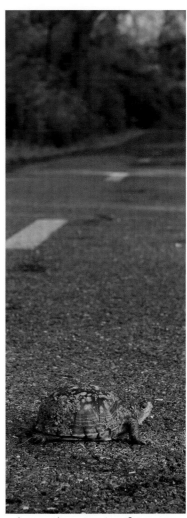

A box turtle, a Species of Greatest Conservation Need in the District, crossing the Anacostia River Trail

Beaver crossing bike trail

A ground skink

neighbors are foundational members of our community, breaking down dead wood, leaves, and other organisms that have lived out their lifespans, into soil and minerals, the elements for making more and more life.

Our world is filled with these community keystones and cornerstones; perhaps the greatest of these is trees, or more specifically, tree communities. More than any other single loss, the loss of forest communities crippled the Anacostia River. We are only beginning to understand the depth of that loss.

A great deal of research into the biology and culture of trees has recently shown a previously unimagined level of complexity in tree communication and symbiosis. At the heart of these relationships is the understanding built into the very fibers of tree culture that the individual will do best when the forest as a whole is healthy. Like all creatures, there is competition among trees for the basic resources of light and water. Competition within and between all species is natural and healthy in a balanced system. But research has recently shown that healthier trees—those that have successfully outcompeted their peers—share the benefits of their prosperity by sharing resources through an underground system of roots and fungal networks. Trees have been shown to send life-saving moisture and sugars to other trees in order to keep the forest as a whole healthy. The bolstering of one's neighbors may seem counterintuitive, since they are the nearest competition for limited resources, but they are also, as members of the community, each important to the forest as a whole. If a single tree dies, there will be an alteration to the microclimate in the forest when more sunlight hits the forest floor and wind enters places that it could not previously reach. This can throw woodland temperature and moisture off balance, which can cause other trees to falter. On its own a single tree may get more light and water and may even grow faster without competition, but it is also likely to have a shorter, harder life without the support of a healthy community. So forest ethics dictate that even if an individual tree must sacrifice some resources to aid another, the benefits to the community in the long run will in turn benefit the individual. In this way there is no real altruism, only symbiosis, mutually beneficial community ethics.

At the foundation of symbiosis is an ethical framework: what is good

for the whole is good for the individual—rather than what is good for the individual is good *enough* for the whole. We can look to many "organisms" within our human culture to see this community ethic in action. The Anacostia Watershed Society was created by Robert Boone in 1989 to advocate for the health of our river. Since then, this organization has leveraged the support of a community network to nurse the river watershed back toward health. One of the watershed society's first actions was to pressure the Arboretum to clean up its portion of the riverfront, which had been used by Smithsonian National Zoo for dumping animal waste. In the 1990s Boone and his growing cadre of supporters helped protect Kingman Island from becoming a Redskins parking lot. Through the years the watershed society has played a role in wetland restoration, trash and toxic waste remediation, public education, and habitat conservation—elevating community well-being as paramount and inspiring others to do the same.

Honestly, if the only thing the Anacostia Watershed Society ever did was empower Jorge, they would have changed the world. Back on Buzzard Point I stand by as he sorts through the shells he has collected, noting the diversity of species. At one point he holds one out to me and says, "Look closely at the algae growing on the shell." When I do, I see a very small shrimplike character squirming around. Even the abandoned home of the mussel has an importance for the river, providing microhabitat for small aquatic invertebrates.

"They are an ecosystem in themselves," Jorge says admiringly before returning to his task sorting the shells.

Jorge's work, and the work of so many other keystones in this Anacostia land community—from mussel and aquatic celery to the many organizations now advocating for river health—are helping us all find our way back, plant by plant, animal by animal, retracing our steps backward toward health and sustainability. Every one of us has a role in this process, every single one a keystone in the Anacostia recovery.

Robert Boone, founder of the Anacostia Watershed Society

ELLIPTIO

*A baby turtle found trying to cross
the Anacostia River Trail*

Green frog

Painted turtle

Ducks trying to swim away from a rower

Joyce and Samantha Wilson on a paddle with the Anacostia Watershed Society

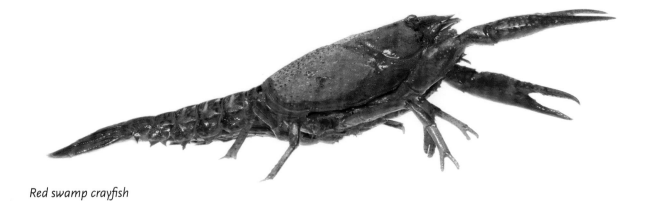

Red swamp crayfish

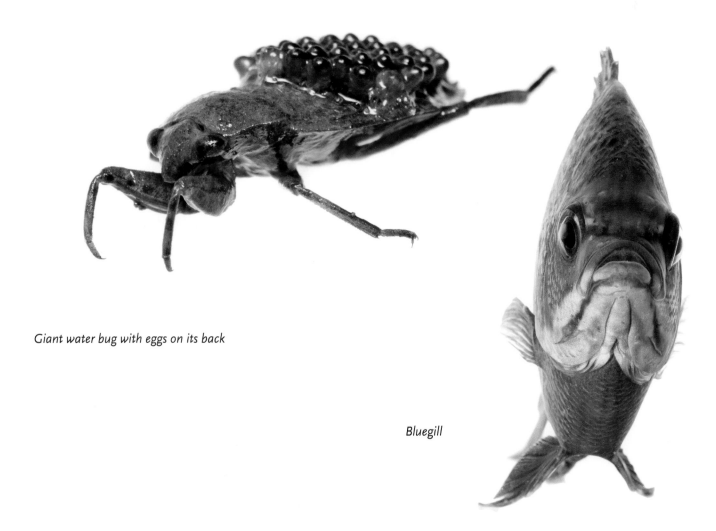

Giant water bug with eggs on its back

Bluegill

American eel

Big brown bat during a health exam performed by Lindsay Rohrbaugh of the Division of Fisheries and Wildlife

The Bombus *Moon*

The end of September is a fine time to catch bumblebees asleep on their feet. Goldenrod in full bloom is an excellent place to look. This morning at sunrise, with a thick gray veil cloaking the warming sun, I head into my backyard with a coffee cup in hand and make rounds on the goldenrod, an extravagant jewel of my modest domain.

Six years ago, this seven hundred–square-foot house in Mount Rainier, Maryland, and its quarter-acre yard became mine in the eyes of Prince George's County. The official county record lists me, and my spouse, as the sole owners. In reality though, this spot of land now belongs as well to an odd assemblage of perhaps ten thousand of the county's most eccentric residents. Some of these dress themselves as miniature dragons, others as fierce-eyed alien Lilliputians; some are fat and furry and occasionally ill-tempered. Others have crimson wings and wake me early in the morning with angel voices, or transparent ebony wings and keep me up at night with their *chit-chit-chit-chattering* love songs. They are as diverse and wondrous as a fairy-tale cast, and they make good neighbors, generally minding their own business while pursuing their particular paths toward freedom from fear and want. And almost without exception, they are new to this spot in the Anacostia watershed where I now live.

When we moved in, I don't recall seeing a single insect, though without doubt there were some spiders and crickets that subsisted in the bare turf and in the shadowed crevices around the house and shed. A few birds stopped by occasionally, but they didn't stay for long because in their eyes there was very little to recommend the location. No berries or insects to eat; no soft grasses to line their nests and cushion their helpless, hairless

hatchlings; no shrubbery to shelter them from the sharp talons of winged hunters. But what the suburban landscape lacked in existing wild riches, it made up for with potential—in sunlight and space aplenty where I could introduce seed and root to soil and watch leaves unfurl toward the warming spring sun.

Shortly after I took on stewardship of this land, I began the process of replacing the barren turf with native plants. These include plants that bloom in spring, summer, fall; those that thrive in shade and sun; those favored by birds, butterflies, bees, and squirrels. The names of these rooted beauties roll off the tongue as water cascades down the fall line from the Appalachian piedmont: beauty berry, hay-scented fern, Jack-in-the-pulpit, woodland poppy, *Viburnum dentatum*, little bluestem. I like to picture the botanists who first described and named these plants, women and men who prided themselves on their starched scientific detachment but who were apparently unable to hide their love, or at least deep fascination, for their discoveries. Virginia creeper, sweetspire, Jacob's ladder, redbud. Bee balm. Names describing the way they move along the ground, their fragrant flowers, picturesque physiques, or ecological mystique.

Who could withhold affection for these native Anacostia inhabitants? These plants are lifegivers, lifesavers, lovemakers, reaching for the sun, rewarding its attention with blooms bold and delicate. For the ecological health in my yard they are foundational, stretching from the soil toward

Ambush bug

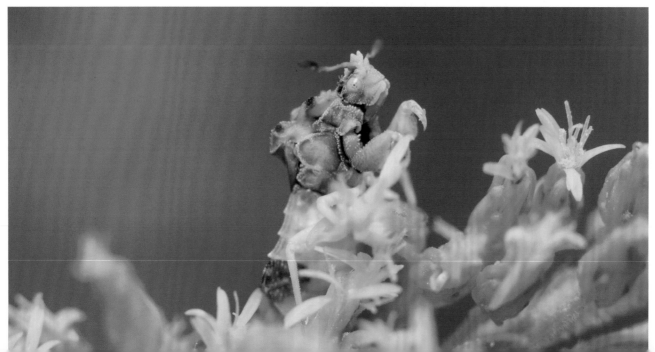

the sun, converting light into life, for themselves and a whole community of animals. And when these plants die back for the year, another community of animals converts their stems, leaves, and branches into resources for next season's plant growth, for the cycle of living to begin again. They are keystones laying a foundation for a watershed future.

For me, they offer something a bit less tangible but no less real. They are, along with each creature that lives upon or because of them, synapses of an ecological cortex—Wendell Berry's *remembrance of what is*, white-hot bursts of understanding about this system of Earth and my place within it.

In his book *Biophilia*, Edward O. Wilson describes the innate phenomenon of natural wonder:

> Now to the very heart of wonder. Because species diversity was created prior to humanity, and because we evolved within it, we have never fathomed its limits. As a consequence, the living world is the natural domain of the most restless and paradoxical part of the human spirit. Our sense of wonder grows exponentially: the greater the knowledge, the deeper the mystery and the more we seek knowledge to create new mystery.

Bursting-heart, a plant native to the eastern United States

As a species, we arrived on the scene several hundred thousand years ago when the ongoing story of the universe was already billions of years running. We didn't know the beginning, or any fragment of the story prior to our entrance. We arrived in the middle of a mystery. The grandest, deepest mystery that has ever been. And over our tenure as a species, we have been continuously uncovering infinite plotlines, marveling over each phrase in the as-yet-incomprehensible story of what and where we are. By observing, cataloguing, documenting what we see in the world around us, we are piecing together a narrative, a data center, a cerebellar cortex that holds the story of our quizzical context.

Over the past four hundred years, we have thoughtlessly discarded many of the watershed residents that contribute to this context. In my own yard, I endeavor to reestablish lost characters and then watch giddily as the wonders unfold. Over six years I have planted rain gardens, trees, shrubs, and meadow communities to increase my plant diversity, and thus

my own personal ecological cortex—going from about ten plant species (half of them nonnative) to well over sixty, not including the tomato, bean, kale, and spinach plants in my vegetable garden. All these wild plants in turn beckon to the creatures that grew up on this native landscape. With their alluring scents, colors, fruits, and flowers they gather them in— wren, wasp, moth, ant, and leafhopper. Many hundreds of species, surely more than ten thousand individuals—now co-own my yard with me.

Boneset and goldenrod rank foremost among these precious neighbors. It isn't because they are the most beautiful plants—in my view that honor goes to the woodland poppy, bloodroot, lady slipper, or maidenhair fern. Many view goldenrod and boneset as weeds, and in fact they are wild in their ways; sometimes swarthy and overbearing, sometimes scraggly and unkempt, they flaunt any attempts to keep them tidy, predictable, and contained. The boneset will grow into a sprawling beast of more than seven feet tall one year, and the next will disappear altogether or barely manage a foot of growth aboveground. The goldenrod pop up wherever they want, often in the least convenient places, blocking key pathways to the backyard and garage. Somehow they know full well that I will make every effort to indulge their capricious whims and yield to their plantly dictates—for the treasure they offer is unparalleled. And this is where they belong, right here, rising out of this ground at just the time when the winged and many-legged things need them most. They have flowers to produce and the bees will be waiting.

In nature, every inch of space is a battle and a bargain. The competition for light, nutrients, and space never quits, and every survivor must be strong, quick, or clever. Goldenrod and boneset are good competitors on their own, but I give them a hand in my little space in the watershed.

Over the past five years I have nurtured two patches of boneset and three patches of goldenrod scattered around my yard. This requires clearing away the invasive ground ivy, English ivy, porcelain berry, and other nonnative plants several times in spring and summer, which even then constantly threaten to smother these and other native plants. I fight back. But other than that, I occasionally toss some compost on goldenrod and boneset, water them during extended drought, and watch them grow, anxiously awaiting their late-summer magic show.

For the few weeks in September these plants are in bloom—first the boneset and then the goldenrod—there is little in the outside world that can compete for my attention. I am frequently called away on some business of human life (work, birthday parties, concerts, holidays), but it is a drudgery compared to the plotlines on the sun-kissed stage of boneset and goldenrod, and I'm always eager to get back and see what I've missed. Every single moment holds pregnant portent; each tick of time is a stepping-stone in the pathway to the future for these neighbors of mine. *Like sands through the hourglass, these are the Days of Their Lives.* And some small lives will last only days. Every move counts because life, death, and the battles waged between these worlds are what's at stake at every single second. The drama is enough to stop your heart with wonder.

Consider the tale of the aphid. Aphids set up colonies on many of my flowering plants, sipping sap and expelling a waste product known as honeydew.

Ants love honeydew.

Enter the hero.

At some point in the annals of ant history, some clever worker realized that the honeydew his kindred loved so much could be more easily obtained if the ants had some control over the fate of aphids. So hunter-gatherer ants transitioned into agrarians. And now, passed down from this ancient one, many ant colonies keep aphids as domesticated species so they can harvest—or milk—the honeydew that aphids secrete. In order

Obedient plant with bee

to keep their cash cow safe, ants will herd the aphids like shepherds and fiercely defend them from predators.

Enter the assassin.

Assassin bugs eat aphids in ghoulish style, by stabbing them repeatedly with sharp, strawlike beaks, and then sucking out their muddled juices. Ants are perhaps less concerned with the brutal style of killing than with the loss of their precious honeydew machines and will challenge the assassin bugs if they get anywhere near their aphid herds. I have seen a couple of ants attacking an assassin twenty times their size as it tried to sidle up slyly to a herd of little green cows with fat bellies and skinny insect legs. The assassin scurried off and skulked under a nearby leaf, most likely to try again later.

It is uncertain how the aphid feels about all this attention. Certainly protection from being suctioned up into an assassin beak has some merit. And assassins are not the only danger lurking for aphids, who are a favor-

(AT LEFT) *Ants farming aphids on a beebalm plant*

ite meal for lady beetles and wasps as well. But there is some science that suggests the aphids are not exactly living in domestic bliss with the ants. One study from the Imperial College London found that ants' chemical footprint—which they use to communicate with each other—may contain some component that tranquilizes aphids, so that even if they wanted to get away and start a new life, they couldn't because the ants have drugged them. I have observed aphids meandering away from the colony—not running, just sort of tottering away from the group—and being rounded up by ants and brought back into the fold. They do appear a sluggish, apathetic bunch compared with the keen-eyed and ever-vigilant ant. These characters are just two of a humming community outside my back door.

This year, my largest boneset plant grew to eight feet tall and has been the setting of incredible intrigue through the early weeks of September. I've watched it all play out on the boneset's billowing cornucopia of blossoms, as many hundreds of micro-citizens practice their particular art of survival. Many are here to harvest a luminous treasure, sunlight refined by boneset into powder. Tiny insect faces, legs, and hands are coated in the stuff, these bright bits of boneset pollen. Other creatures harvest the sap that flows through boneset limbs; and still others are here to harvest the harvesters. Ambush bugs stalk aphids; green metallic bees stalk blossoms; mosquitoes take a moment to rest on a flower, a short well-earned break from stalking me; and I've even spied a happy praying mantis who successfully stalked and captured a bumblebee in the vice-lock of his serrated forearms.

For a week, all insect life has seemed centered on the frosted green boneset with its profusion of elfin white flowers. But the universe of bee, bug, and butterfly now gravitates toward the goldenrod, drawn away from the fading flowers of the tired boneset by the beacon of bright lemony boughs, all gravid and aglow. These creatures follow the gilded nectar of sunlight distilled into pure energy by the chloroplasts of the plant world.

In my yard I have a front-row seat for the seasonal procession from energy to energy, from white to golden bloom. My closest friends know when I decline their offers this time of year, it is likely because I'm neck deep in the insect intrigue of early fall, holding my breath in anticipation of the next move in the slow-motion, microscopic dramas of the ambush

and assassin bugs; focusing my macro lens and filling my notebook with news of the predatory escapades of the praying mantis; the lilting aerobatics of buckeye, monarch, and swallowtail butterflies; and the miming movements of moth and fly. Endless surprise walks within these two plants as they burst into bloom on the eve of autumn.

I have photographed forty or more different insect species on these plants, have seen another twenty, and have probably completely missed twice that many. At least half are creatures entirely new to my eyes— all living right here outside my bedroom window. If I listen closely and attune my senses properly, I can positively feel the energy emanating from the life on these blooming universes; it is enough to keep me up at night. And often does. That and the cricket that sings to me all night long from the viburnum bush on the other side of my window screen.

But by far the greatest attraction in this cavalcade of backyard creatures comes in the last hours of summer, as we are standing on the cool easy precipice of fall. At this point, the seasons are poised in balance of near-perfect equilibrium—twelve hours each of light and darkness. Each day darkness gains and light withdraws. Summer appears to be backing slowly away, retreating to some far equatorial corner to nod off, but the days remain long and warm, and the epic work of the summer sun remains bright upon the land. The trees are beginning to whisper about their upcoming autumn pageantry, but they remain lush and green.

This September moment of seasonal transition has drawn me from my bed at dawn and into a clump of goldenrod nearest the house, where lemon-gold blooms beam in the diffuse light—their color so brilliant, I can almost hear its radiance pulsing, a luminous drumbeat heard with the eyes, a thrumming color seen by the ears, a moment of land life felt in the chest, a season brimming over into the yard like an upwelling memory of warm showers and the radiant summer sun.

Dreaming deep and content within that sweet golden memory is a plump little bumblebee, *Bombus impatiens*, the common eastern bumblebee. I sit down at eye level with the bee, set my coffee cup on the ground, and prepare myself for the business of watching him sleep. My first thought is to reach out a gentle finger and pet the motionless fellow. I am ashamed to say I've done this before, many times. The bee is incapable of

stinging me, in part because it is too cold to fully wake but more defini-
tively because it is a male and doesn't even own a stinger. I don't feel good
about taking such liberties, but restraint often eludes me. This morning
though, I look closely at his peacefully slumbering little self; his fur, illu-
minated by the palest light, looks sooo soft, soooo tempting. But I force
my petting hand to stay gripped on my coffee cup. I don't want to torture
this fellow. He knows I'm here and contemplating him, for good or ill. As
I lean in toward him, he begins stretching his limbs, with visible effort try-
ing to shake the sleep from them and raise his body temperature enough
to fully wake. In this state of torpor his movements are as slow as a sloth's
but with the coordination of a wet sleepwalking noodle. If bees had eye-
lids, his five eyes would be a quarter open, fluttering toward a third.

"It's too cold buddy," I say. "Go back to sleep." He settles back in, inca-
pable of doing otherwise. The sight of him in his somnambulic state
reminds me of a recurring dream I have about being asleep while know-
ing there is a murderer in the house. I try so hard to wake up and get
out of bed, but my neck appears not to work, and my head feels like a
lead bowling ball. Very slowly I rise from my pillow and just when I have
almost sat up I comprehend that my mind has tricked me, that I am still
lying down, fully asleep, in mortal danger. I wonder, was I a bumblebee in
another life?

Another fuzzy leg begins to wave in my general direction—I recog-
nize this as a warning in bumble lingo: he feels threatened. I back off a bit
to give the guy some space and discover another bee asleep to the left, and
then one to the right, as well as several above and below where the orig-
inal bee was perched. Scanning about, I spot at least thirty bees of sev-
eral different species. Some are perched on top of flowers; others cling to
the underside of blossoms or leaves; all are motionless aside from a few
slowly waving arms and legs, like little feathery fists shaking at me, prom-
ising that any intervention will be met with swift justice in the form of a
soft little punch on the face.

One bee has misjudged his readiness for flight; he lifts off clumsily
from the goldenrod, bumbling around from flower to flower like a sloppy
drunk, careening and crashing into other bees in their flower beds. They
rouse for a grumpy moment, so groggy they can barely lift their little

fists to shake them at the careless bee; then they drop back into their stupors. The drunk settles back in on a soft golden bough. I smile, feel a little extra-warm beat in my heart, an involuntary reflex sparked by this sublime scene within a hasty metropolis of horns and engines and hard-edged asphalt. These bumblebees rest in a precarious peace, forced by physiology to trust the world's intention to let them live until the sun shines bright enough to warm their bodies for wakefulness, while all manner of dangerous predators and harmless voyeurs may happen upon them at any moment. They cling by needs to a prayer for life's kindness, as the season's last lemony blooms sway in the morning breeze, cradling this gathering of black and golden dreamers in a sea of summer sun.

As I sit watching them, overcome with their quiet contentment, I can see clearly our opportunity in the Anacostia watershed. Bumblebees, emerald-green metallic bees, monarchs, and mantids—they offer riches of surprise and quiet connection, sending sparks of memory and understanding through the ecological cortex of our existence. But most of all they offer proof that what we have forsaken can return to us, that the mysterious garden we were born into is not lost or locked forever behind the rusty gates of our undoing. That ruination is *not* our manifest destiny.

These *Bombus* dreamers offer a poignant inversion of the prodigal son parable. Amazing grace. We can be good again.

I know this for certain because when I moved into my house and walked the yard, it was a landscape devoid of wild poetry, born of expediency and practicality—a direct descendant of the tobacco economy and commodity mentality. The land existed in a state of dire biological poverty, a graceless tableau representative of the greater part of the present-day Anacostia watershed, which can be described as a random selection of ill-matched biological components and a hardscape of ecological dysfunction. My yard contained few of the components of a healthy watershed community—nearly all native plants had been replaced by impermeable surfaces where rainwater ran off roof, driveway, and sidewalk to join polluted streams of water running down storm drains toward the river. My home contained all the components of a cage: steel, concrete, vinyl, and asphalt. It was as if someone had designed a quaint little kennel, and I had agreed to move in.

Deprivation, fear, and want come in many guises. For humans, the elemental creaturely desires have grown complicated, often driving us toward steel walls, deadly weapons, excesses of food and drink, every physical comfort and every manner of security—safety to the point of self-imprisonment, satisfaction of want to the point of compulsion and disease. But these and all other extravagances can never satiate a desire that was never intended to be satisfied. And the low threshold we of privileged societies have for fear and want—the compulsion to vanquish these unpleasant sensations and emotions entirely—has a tendency to deprive us of more subtle needs. But the subtly of a need never did measure its primacy, only the degree to which it would likely be met.

If you put a human child in a room with white walls, floor, and ceiling, ensured that no harm could ever come to her, and just gave her food and water to survive but deprived her of all else, what would she be? She would be safe, physically well, but broken inside, deprived of her context, of family, friends, world, landscape. We as a species have created a world that is a version of that. By building our great machine that bends the Earth to our will and removes almost every threat that challenged us as a species—predators, disease, competition for prey, hunger—we have also removed thread after thread of our ecological fabric, deprived ourselves of our natural context, torn at the portion of ourselves that is linked on a foundational level to the land. Our brains, to a large degree, were developed by the land itself, by our species' efforts to make a living from and within the landscape. If we are severed from that land context, from the

memory of what it means to be a human creature on Earth, what personal bewilderment results? Are we not then broken?

Imagine a sliding scale of deprivation: on one side you could place the Anacostia world as it was when Europeans arrived in the watershed; on the other side, the utter deprivation of a watershed without trees, plants, or animals of any kind, of putrid water unsafe to drink, swim in, or eat fish from. Currently the state of the river is somewhere on the utter deprivation side of the scale, but not nearly as much as one might imagine given its history. With every backyard, every square foot of watershed turf, asphalt, or concrete returned to native forest, meadow, or wetland, we heal ourselves even as we heal our Anacostia River and its natural residents.

Amazing grace. We can be good again.

Last night a steady rain fell, the first we've had in a long while. It came at a desperate time for plants, which have now noticeably perked up. This morning a soft, persistent drizzle falls in a mist on my yard. This poses a minor annoyance for my resident squirrel, who fusses over the rain on her coat and uses her tail as both umbrella and blanket. The bumblebees

suffer in stoic silence, but it appears a misery for them. As I walk the yard, I find many of my sleeping bumblebees with their golden hair plastered to their little bodies, droplets of water still clinging to their soft fur—they look like wet kittens after a bath. Still, they go on sleeping, as bumblebees are wont to do this time of year. Those now in the goldenrod, still thirty or more, are mostly males, and they are in need of rest after a wild ride over the past few weeks. Less than a month ago they awakened to a feast of bee loaf prepared by their queen to give them strength for the work ahead. Once fortified, they charged out in the full bloom of late summer to feast on pollen while they courted and bedded the newly emerged summer queens. That in a nutshell, is their life story. Now, with their life purposes fulfilled, they will perch on late summer's goldenrod and eat and sleep until they wake no more. Their job is done, their summer joys fulfilled—a gentle death awaits the slumbering boys of summer.

Squirrel in late summer rain shower

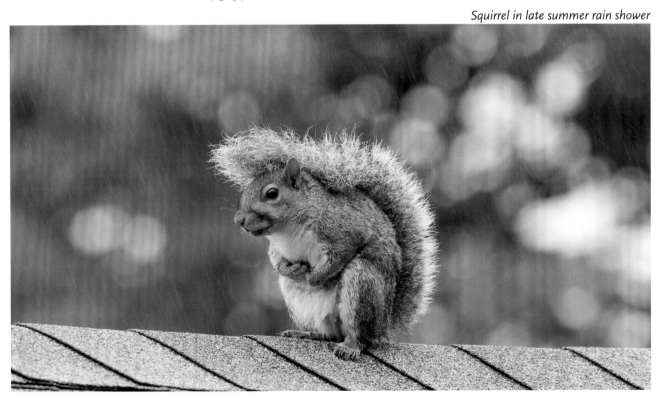

By the last days of the month, the goldenrod have begun to fade, but asters are just reaching their full bloom. Insect life again migrates, this time from golden petal to purple. Bumblebees cling to the last hours of a life that has already left them; the land charges forth toward winter and a new spring that waits beyond the icy horizon. These bees have no complaints I suspect, as they have lived much of their life in the luxurious embrace of the goldenrod. What more could one want from life?

By the beginning of October, my morning search for *Bombus* dreamers bears no furry black and yellow fruit. The boys of summer are gone, as if swept away with the morning's autumn wind. I find a single bee, a female carpenter, curled up in a forever dream beneath the swaying goldenrod. I feel a pang for her, but there is no time for grief. She joins the summer cicadas who have quieted their chorus entirely—their bodies lie lifeless on the ground or have become meals for so many others. They have lived their lives; now it's time for their children, already growing beneath the ground, waiting for their turn at life. Without their voices the world is changed. Every set of ears in the watershed will know—whether consciously or not—that cicada silence portends an imminent winter wind.

I will anticipate the return of cicada, bumblebee, goldenrod, and boneset for the next eleven months. But for now, a downy woodpecker is inspecting the dead branch on the walnut tree; nearby a russet spider is spinning her web from the tip of a low-hanging walnut leaf to the top of the mountain mint below. She catches a wasp and begins the careful process of wrapping him away in a blanket of gossamer thread—gently winding him in a luminous tomb.

The wren chatters from the walnut tree, and a blue jay screeches from the sky to all those who would heed his urgent autumn tones, "Ready yourselves!" Fall is come.

BOMBUS

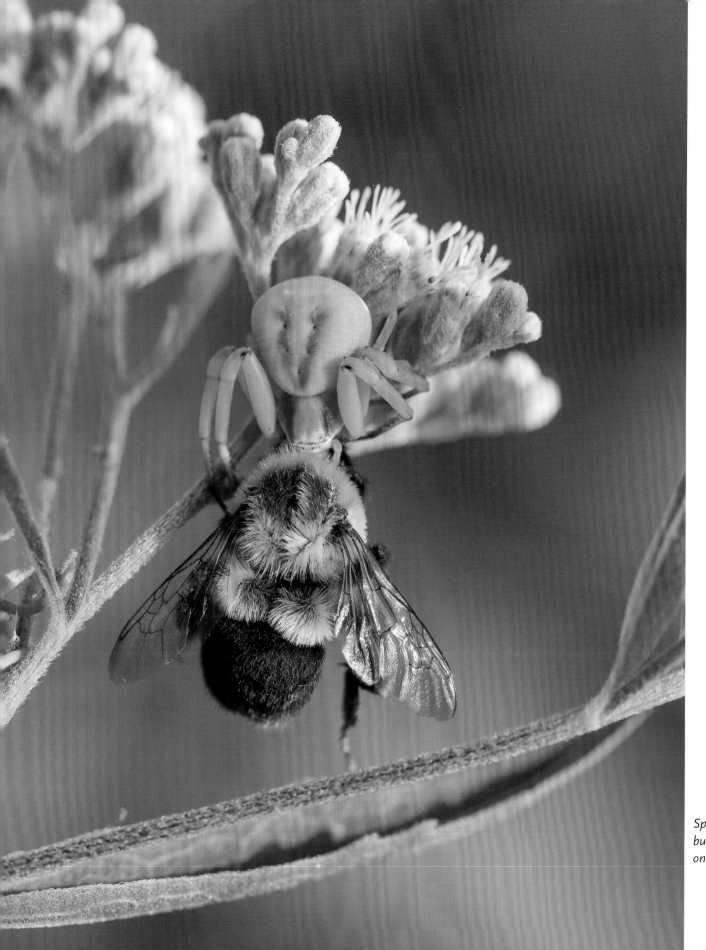

Spider with bumblebee prey on boneset

Fly on boneset plant

Green tree frogs are a Species of Greatest Conservation Need in the District

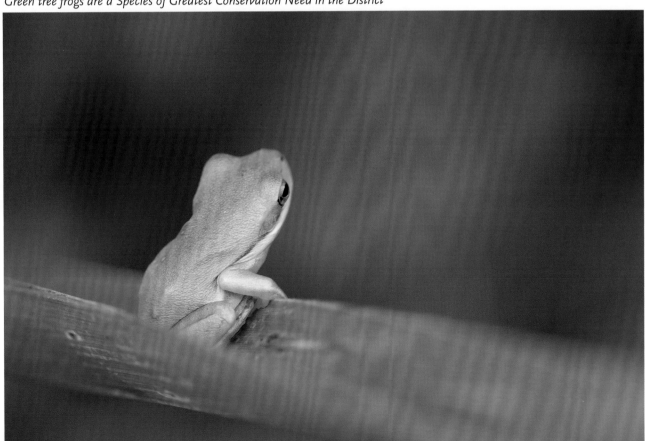

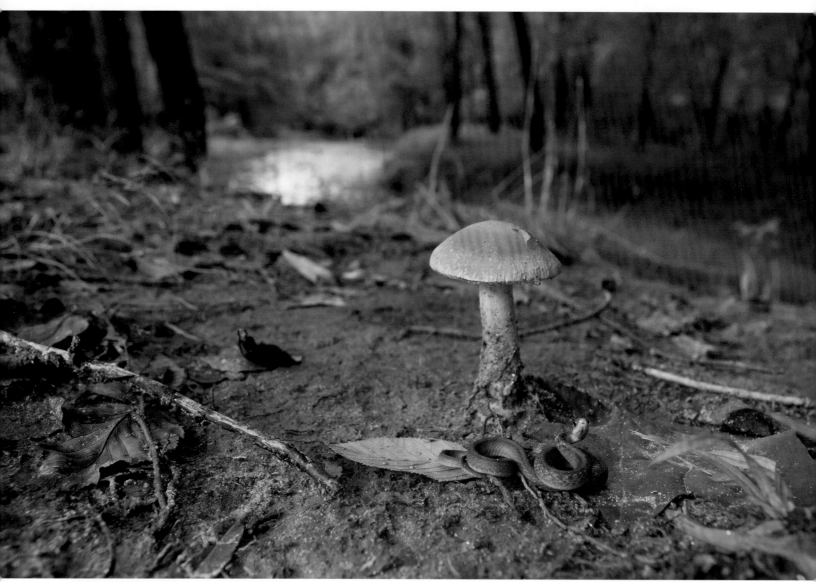

Northern brown snake on the Paint Branch

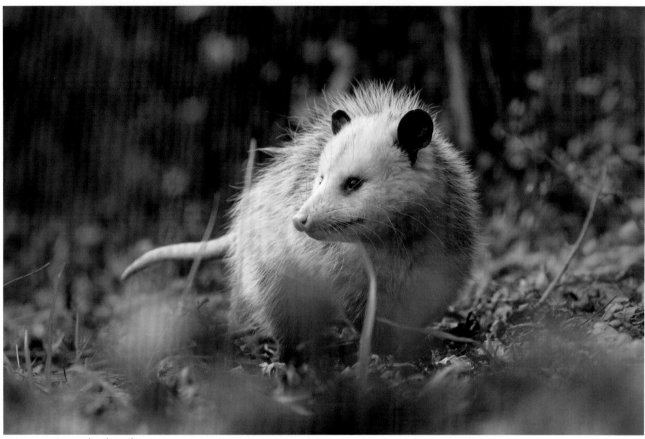

Opossum in my backyard

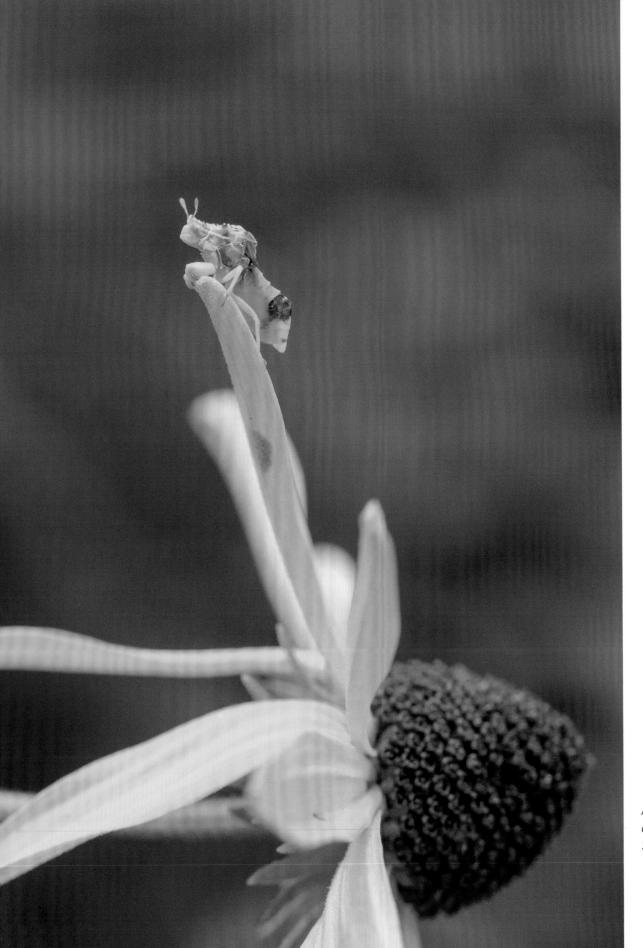

Ambush bug
on black-eyed
Susan

The Abundance Moon

Each year, when the preponderance of natural evidence points toward fall, I am visited by a seasonal terror that inserts an exclamation point on the languid prose of summer. While working in my kitchen, which looks out onto the walnut tree in its flattering autumn dress of lemon-gold, I am startled by a thundering *bang!* on the roof. This is followed by a series of quick repetitive clangs, a rapid rolling sound, then silence, and finally, a soft thud on the ground outside the window. Over the past five years this sequence of events has happened a hundred times, but the first time it occurs each October, an electric charge bolts through my heart muscle as I look quickly to the ceiling and a list of implausible invaders flashes instantaneously through my brain: bigfoot's clumsy revenant, wayward asteroid, flaming piece of an airplane, and eventually something far more plausible—a tree limb falling on my house. But then it dawns; no, this is just the squirrels finishing their seasonal work.

Several weeks ago the neighborhood gang of *Sciurus carolinensis* began making rounds on the tree, checking the status of each nut or, more likely, testing a random selection of the pungent green orbs, noting their physical characteristics and plugging the information into some squirrel extrapolating formula for determining the precise moment when the walnut tree is ripe for harvest. They have no abacus or calculator (that I can see), but squirrels by needs must have a complex ability to calculate and categorize. I occasionally observe them silently talking to themselves. From this it would be easy to assume they are simple or unstable, an assumption reinforced by the walnut-stain mustache that most squirrels sport this time of year. But I suspect in reality they are just running some numbers in their heads, perhaps dividing the number of walnuts collected by the number of deeply cold days in the average winter, sub-

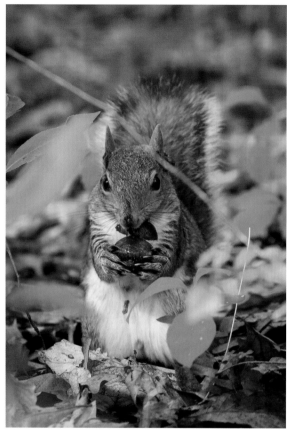

tracting the average number of stolen, spoiled, or forgotten nuts from their scattered caches, and adding the number they might be able to steal from neighbors (not as a guarantee, just a cushion). At the end of their whisperings, if there are still nuts hanging from the tree, they must often surmise, "I need more nuts."

It isn't gluttony that drives them. Squirrels, like all animals in their native niches, must live their lives in the balance imposed by a natural system, where abundance and prosperity are rooted in the concept of *enoughness*. My resident female squirrel provides a good example. I have observed her through several seasons, as she nests inside the eaves of my shed, chatters at me if I dare to enter my yard while she is about some sensitive squirrel business, or ignores me when she is hard at work on the autumn harvest. Her October work, though she goes about it in the characteristically comic style of squirrels, could easily be described as more deadly serious than any work I have ever performed.

Her calculus of walnut wealth provides her only insurance on survival. Greed and gluttony simply do not enter into her figurings—these quintessential modern human proclivities are nonsensical in a natural system. She takes what she needs; anything more could precipitate a fight with the other local squirrels, a fight she might lose. And she can't sit around eating herself sick in walnuts: there are only so many, and she needs to make them last the winter. For squirrels, and the rest of the animal world, there are three truly deadly sins: greed, gluttony, and sloth—unless you happen to be a sloth; then it's actually a virtue.

As far as I can tell, my resident squirrel is truly virtuous. During her autumn harvest, she carries out a critical component of her strategy for finding a measure of freedom from fear and want in the coming months. She searches, snatches, throws, gathers, and hides her harvest, just until she has enough. Enough to make it through the winter. The gravity of her deductions may be metered out in hours or days of hunger pain if she has

miscalculated; or perhaps malnourishment that impairs the health of her spring pups; or, quite possibly, the cost of a miscalculation could be her own life. Mistakes must not be made.

So this time of year, she travels each limb of the walnut tree, placing a small paw on top of each walnut she encounters or, when pressed for time, sniffing at nuts as she scampers past. When conditions seem right, she plucks a few nuts for a test-case snack and then, when well pleased, will begin to stash many treasures away somewhere in my garden or in the neighboring yards, and sometimes in my flower pots, which if they have flowers in them, she will yank out and toss onto the porch along with much of the soil.

She may well have hundreds of distinct hiding locations and can actually remember the precise location of most of them. Research by University of California neuroscientist Pierre Lavenex showed that squirrels remember and recover their caches, most of them single nuts, by using geography and topography. As Lavenex explained, "They use information from the environment—such as the relative position of trees and buildings—and they triangulate, relying on the angles and distances between these distant landmarks and their caches."

So, despite all appearances, they're not crazy.

Today, my squirrel is busy searching out the last of the walnuts, those in the topmost branches and other places hard to reach. This is tricky business, because those nuts that remain at this point are mostly the fruit of the thinnest, most far-flung, precarious limbs. I have seen squirrels fall from twenty feet, plummeting like large furry leaves to the ground, where they appear to bounce. Sometimes though they crash onto my porch. They still seem to bounce, but then they sit for a long moment in some confusion before staggering away. During this end of season harvest they are cautious, holding tight to the tree and prying the nuts free from their fastenings, throwing them to the ground for later collection. My roof happens to be the "ground" under about a third of the tree, and many dozens of walnuts are chucked onto it before they fall to the ground. Each time, after recovering from the initial shock of the *bang*, I make a mental note to go and check the state of the roof, but I never do. I just assume it is pocked all over with little walnut divots.

This is a small price to pay for the companionship and entertainment of squirrel neighbors. Their efforts, energy, and activities, along with those of bumblebees, beetles, and birds, are key measures of my own abundance. For this reason, my spouse, Bill, and I jealously guard food and shelter resources for our neighborhood squirrels. Several years ago, when our water main broke, a plumber recommended cutting down a mature Virginia white pine tree so that we could more easily—and inexpensively—replace the pipe. But within the boughs of this tree I had seen squirrels gathering pine nuts and titmice resting; had heard cicadas chorusing; felt the cool shade the pine provides and admired the grace of its green limbs swaying in summer rainstorms. So instead, we worked with friends to reroute the water main through our driveway and kept the pine and all of the goodness it brings to our lives.

We have been grateful for that decision ever since. Yet there has been an ongoing debate in our house about the walnut tree, which shades three-quarters of our roof much of the day and thereby blocks our ability to put solar panels on our house. There is talk of cutting it down. Bill, who works on climate and green building policy, has perfectly sound, altruistic reasons for wanting to remove it. We have a very small house and scant energy consumption that could be filled by the sun rather than coal or wind energy (which comes with its own environmental costs). But he works in a downtown office, not in our kitchen, which is in effect a window onto the world of the walnut tree. He doesn't experience the seasons of life for this tree and its inhabitants. He has never been held in thrall by the procession of small rulers that govern the tree during the seasons they need it most and has not seen the peaceful transition of power between the house wren, who, after spring hatchlings have fledged, gives over governance to the ruby-throated hummingbird, who, once he has fattened up for migration, abdicates to the squirrel. He can't know that by early October, two-thirds of the tree's leaves have turned to pale yellow or gold with green veins, and when the morning sun filters through them and the wind sets them dancing, they become a shimmering lemon-golden sylvan sprite in our backyard. He does not watch as the squirrels catalogue the walnuts and stash them away as indemnity against the deprivations of winter. He doesn't sit listening to the humming insects that hide on it, or the twitter-

ing cardinals and mewing catbirds that find shelter within its boughs, or the way the tree's own murmurings vary when the wind blows from the north rather than from the south.

But I tell him, and he loves these neighbors as I do, and we are at an uncomfortable impasse. Do we do them the most good by transitioning away from fossil fuels and renewables that disrupt wild land? Or do we best help secure their future by safeguarding this tree as a carbon sink, shade provider, and habitat? We cannot know for sure. So for now we turn up the thermostat in summer and down in winter, drive less, take shorter showers, eat vegetarian, and remain childless, all in an effort to minimize our human footprint and climate impact. Hard times, hard choices. All who care for the world at large must suss out the relative impacts of every choice we make, wading through life with a constant undercurrent of questioning: How can one be good within such a bad system?

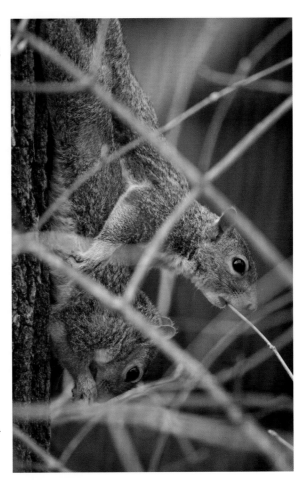

These dilemmas were born ten thousand years ago, when the laws that govern our behavior as creatures began to shift from natural law to human system. Instead of relying on the land and what the land community provided naturally to a limited population, we altered the land so we could expand our population beyond what Earth could provide. Eventually this advantage allowed us to create further technologies that prolonged our lives and made life more comfortable for an ever-growing, longer-lived population; it paved the way for written language and the complex intellectual and technological endeavors that sprouted from that revolutionary shift. But following this trajectory also destroyed the land community and displaced many who relied on it, from the smallest insect to the hunter-gatherer tribes that did not choose to live as natural outlaws.

It was a grave choice to value our new easier, more comfortable way of life over all others—one that we as a society have rarely second-guessed. Even today, knowing all we know, you hear seemingly wise individuals talking about "how we feed the world's ever-growing population" rather than "how we reverse the global population explosion."

Hummingbird lording over the walnut tree

But in the last few hundred years the consequences of our choices have clarified themselves and intensified. We have come to understand we have the power to break whole ecosystems and even Earth's atmosphere so that these natural systems no longer operate in the service of clean water, clean air, abundant biodiversity, and a stable climate—the riches we were born into as a species hundreds of thousands of years ago.

In the Anacostia watershed the first hairline cracks of that breaking are easy to pinpoint: John Smith sailed up the Potomac in 1608, followed by the commodity economy of England and the culture of colonial Jamestown, where tobacco was cash, and cash was the primary measure of abundance. But the value of cash is . . . nothing. It is just a physical manifestation of who has more—more power, more paper and ink, more precious metal.

But bees cannot sleep on cash or metal, no matter how precious we say it is. Where then can they rest their weary heads when death is near? Where can they find a last sweet sip of summer's nectar from a diminutive golden sun? We ourselves cannot drink cash to quench our thirst. Or jump in a cooling pool of gold to wash the grit of humid summer from our skin. Our lives would be better if we had a clean river, yet in our system there is no measure for its value. Understanding a land community as a commodity means that it can be carved up into little pieces and traded for other stuff, until it's gone. And then you have traded something of immeasurable value, something unique in the world, that brings life to creatures and joy to people, something that can *never* be replaced, with something that has only short-term value to those who sell it, or no real value at all.

In a natural system, wealth is a well-defined concept meaning you have safe shelter and enough food to survive, and perhaps a small cushion tucked away underground or in a hole in a tree, so that if the winter is especially harsh, you have a fighting chance. For the squirrel it is the cache of walnuts and other foodstuffs that will carry her through winter's scarcity; for the meadow mouse it is a thick blanket of snow to hide

his tunnels from predator eyes and his larder of grass from thieves; for the hawk it is strong wings, sharp eyes, and a clear sight line revealing scurrying prey and leading him to a full belly. For wild things in general, there is a measure of natural wealth that is simply enough. Enough to survive the winter, enough to feed one's offspring. Enough.

Four hundred years ago, just this time of year, the Nacotchtank would have been beginning their celebration of the abundance of the Anacostia earth. Feasts of corn, turkey, fish, squash, and beans would bring people together for a time of gratitude and contentment—a time for giving thanks that another year had passed and Earth, sun, and river had provided enough for them to survive as a community.

Contentment and gratitude are states of mind achieved when one has an abundance of wealth. But when the concept of wealth is tied to perpetual desire, to a thirst that can never be satisfied, there can never be true contentment.

Part of what it means to be a civilization is to collectively agree on what wealth *is*, what we as a group define as valuable. We did not consider the grave implications of this cultural exercise when the British colonies were developing, so we didn't realize what it meant to trade an ancient unbroken land for coins. What the beneficiaries of this exchange gained in the early years of the United States cost us all in the long term. But we are ever evolving in thought and action. The Civil War could be seen as an epic battle in our conflicted cultural identity, answering one of the foundational questions within that conflict: Is there an ethical line that defines how far is too far in the pursuit of profits? The outcome of the war stated clearly: *yes*, there is a line we will not cross, at least in regard to how we relate within the human community. We agreed as a nation that wealth obtained through the abuse and debasement of others stole more from our collective soul than it gave to a few individuals' bank accounts. We agreed that the health of the American community demanded that moral restraints be imposed on individuals who rejected *justice for all* as a core principle of the republic. This ethic of human justice is one we continue to pursue, even 150 years after the war. But for the land community there has been no such accounting or an assessment of how we devalue ourselves with our commodification and defilement of the land.

In the Anacostia, an economy arranged around the infinite accumulation of material wealth is the reason why we could debase and forget our own river, because little by little we removed all traces of natural wealth until all that was left was a deep nagging feeling that we once remembered butterflies floating by, and the curious stare of a fox pup, and the feel of cool, clean water on our skin as we plunged into our own river and swam with schools of bright sunfish. If wealth is measured in the square footage of a house, the label on my clothes or car, the ability to raise high walls to keep others out of my yard or nation, having more food than I could ever eat, a new phone every year and a vacation in France, well then, what matters the river, the goldenrod, or the walnut tree?

Within the Anacostia watershed lies our answer. I have seen it and heard others speak of it, both specifically and in the abstract. Author Herman Hesse, in his book *Siddhartha*, placed a river at the center of an existential understanding of abundance and contentment. Siddhartha, the main character, had spent his life chasing enlightenment throughout the villages and forests of India. He tried prayer, fasting, and self-deprivation; he tried overindulgence in wealth, food, and drink. He could not find fullness or contentment and instead found that his insatiable thirst and hunger had shackled him miserably. Then finally, one day late in life, he gave up the search and sat down by a river.

> Tenderly, he looked into the rushing water, into the transparent green, into the crystal lines of its drawing, so rich in secrets. Bright pearls he saw rising from the deep, quiet bubbles of air floating on the reflecting surface, the blue of the sky being depicted in it. With a thousand eyes, the river looked at him, with green ones, with white ones, with crystal ones, with sky-blue ones. How he did love this water, how it did delight him, how grateful he was to it!

In the river Siddhartha heard the voices of all the creatures of the earth, of the past, present, and future, all flowing together as one living community outside time. And in that voice he found a contentment that no other possession or endeavor had availed to him.

And so it is with the Anacostia, which speaks with the voice of the wood thrush, woolly mammoth, *Astrodon*, asteroid, and naked

Nacotchtank newborn; it sings of joy and grief and joy again with the voice of the grizzled, bearded John Burroughs and shy Rachel Carson, of young Kelvin Mock, the eastern elliptio, and marbled salamander.

Here in the waters of our Anacostia, unfathomable riches are flowing ever among us. You can see it in people's faces when they are spending time on the river. You can hear in their voices, that they too have heard the voice of the river. Some come to the Anacostia to find answers to questions or to find peace after a day of anxiety or conflict, others come to be alone, some to cry, some to laugh with their children or grandchildren. All when they leave are changed in some way.

On a recent visit to Anacostia Park, just downstream of the CSX railway bridge, I met two fishermen casting lines into waters blanketed with trash washed into the river by an exceptional summer rainstorm. I stood with them for some time, talking about fishing and our wounded river. Both men, cousins, had lived in the watershed their entire lives, in the same multigenerational home west of the river on Capitol Hill. Byron Coleman had been fishing on the river since he was a boy. His cousin, William Mitchener, had never before been fishing at all. Byron had the comfortable way of an outdoorsman, a fishing hat on his head and an ease in being right in the place that he loved, doing just exactly what he wanted to be doing at that moment. I asked him if he ate the fish he caught.

"Here, in the Anacostia, no. Would you eat a fish out of this?" He gestured to the undulating mat of garbage that spread across the brown river water. He ate fish from other locations; here he threw them back.

"Have you ever swum in the river," I asked. To which they both replied emphatically, no. "I've never even dipped my feet in," William said.

While we talked, they kept an eye on their lines, which occasionally would suggest a bite that was actually just a piece of garbage snagged on the line and carried by the current. But finally, a little bell—which both men had attached to their poles to alert them of action—started to jingle on William's line. He hesitated and looked doubtfully to his cousin, who said, "Get it! This is all you!"

William tugged on the pole and reeled in a near-foot-long brown bullhead catfish. Byron helped him unhook the fish, and I took William's picture with his first-ever catch. The smile on his face and the sound of his laughter have etched themselves deep in my Anacostia memories.

This moment now flows alongside infinite others within the river waters.

"I wasn't going to come today," William said after he threw the beautiful wriggling fish back to the Anacostia. "This is my cousin's world. But I was having a rough day, and he talked me into it. He said, 'Your troubles will be here when you get back,'" William recalled, then he looked out at the river smiling. "Now, I feel like dancing!" And dance he did.

We can define wealth in any number of ways that would have completely different consequences for us and our world. Maybe abundance is a day on the river with your cousin casting lines into clear waters you would not fear to eat from. Or maybe it is enough walnuts stored in just enough places you can remember where you put them—in which case you are on vacation till October. Or better yet, what if wealth is an occasional vision of a luminous emerald metallic bee, in which case, I pursue abundance by planting purple aster so that the bee has a reason to enter my world and stay awhile. Or maybe the greatest largesse of abundance is a river flowing so clear I can see the sandy bottom twenty feet down, and jump in on a hot summer day and listen to my heartbeat within my eardrums, and swim with turtles sparkling in river sunlight, and hear children squealing with delight as they splash around. I saw a river like that once, as a child, in a dream, somewhere in the wilderness of Texas.

<center>～‍～</center>

Just before sunrise, I pedal myself along the bike trail to Kenilworth Aquatic Gardens, where I sit down in the wetland mist and listen to the autumn land come alive. A white-throated sparrow sings a sad song for summer's end. A fish jumps, coaxing the water behind him to flow in a shimmery silver arc. Wind blows through crimson feathers and golden, orange, and russet leaves, whispering the world into a trance, a sunrise dance on the Anacostia. Across the wetlands I see a great blue heron alight on a bare limb that hangs over the water, giving its great blue-gray wings a flourish as it lands. Within a few minutes, on that same tree, a few branches closer to the water, a red-tailed hawk arrives and takes his rest, his reflection mirrored in the still water below. Above hawk and heron, at the top of a tree snag, sits a squirrel. Behind them all, shrouded almost completely by the tangled brush, a doe moves from

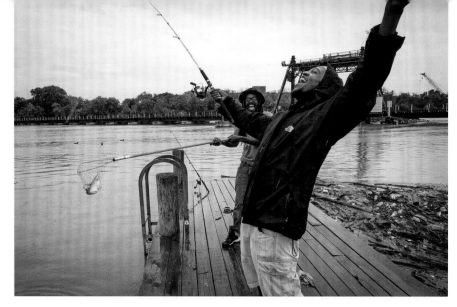

*William Mitchener catches his first
fish with cousin Byron Coleman*

plant to plant, snapping twigs, rustling leaves, and browsing as she goes.

And the wind blows.

And the sun warms.

And a fish jumps, sending rippled waves out in circles without end.

The first light of sun lays a veil of gold on the wetlands, illuminating the heron and hawk's gnarled tree and the autumn leaves all around. White-throated sparrow repeats his melancholy song, geese honk, a wren kvetches, while a mockingbird quietly cleans his wings. A bluebird perches prettily on a branch above my head, while a blue jay calls, and I, I am filled with abundance and awestruck by the gift of the Anacostia. After everything we have done—every assault, insult, and decade of indifference—this ecosystem yet lives, humming with life and all its bright yearnings. Singing its heart out in forest, meadow, and stream.

What courage and contentment we can learn from a wild thing in an urban world. To find a song within the spare fragments of forest and meadow, upon waves of oily brown waters, and to sing it loud enough that your family, your lover, your child can hear you above the din of train, truck, helicopter, and all the rest of the machinery at large in the garden. I sit as quietly as I possibly can, listening to their courage, grateful that they have not given up on this place and determined to follow their lead— to believe in this wounded land, to need it so much that I too will sing my heart out. I follow the yellow-rumped warbler, downy and red-bellied woodpecker, deer, robin, cormorant, nuthatch, sparrow; all have come today to this spot where the sun warms tree snags and acorn and hawthorn, where the city noise is far enough away we can hear ourselves singing and feel our hearts swelling inside our rib cages, full to bursting with the wealth of this Anacostia land.

ABUNDANCE

Muskrat

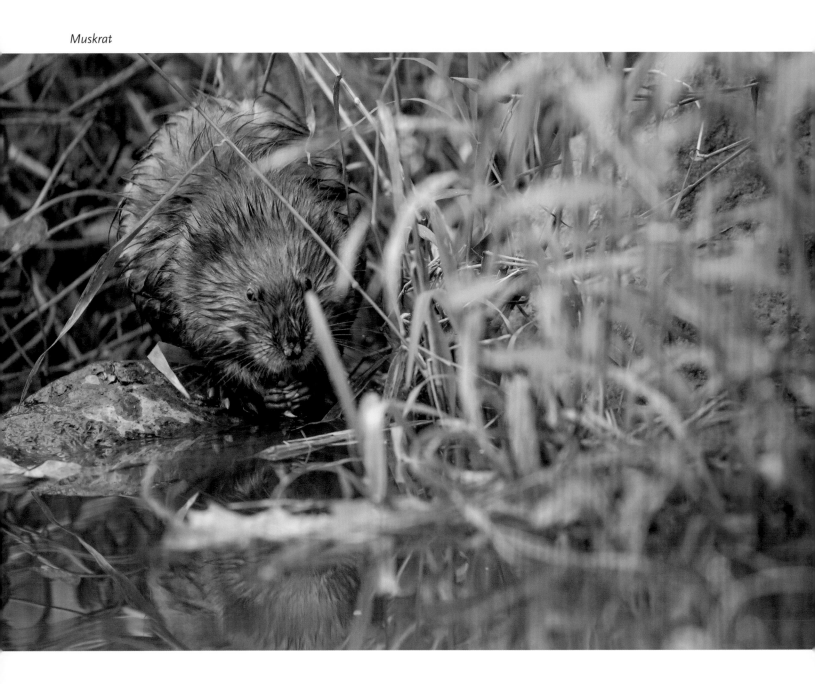

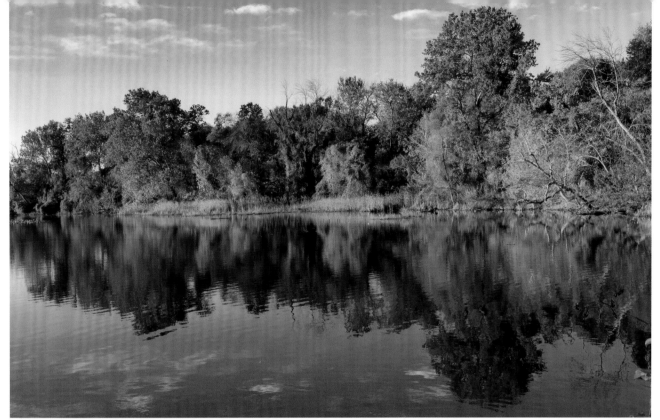

Anacostia River, near the Arboretum

Anacostia watershed resident Valerie Theberge kayaking

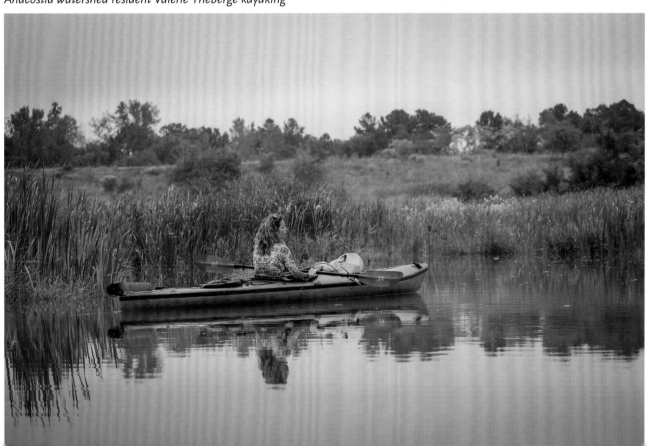

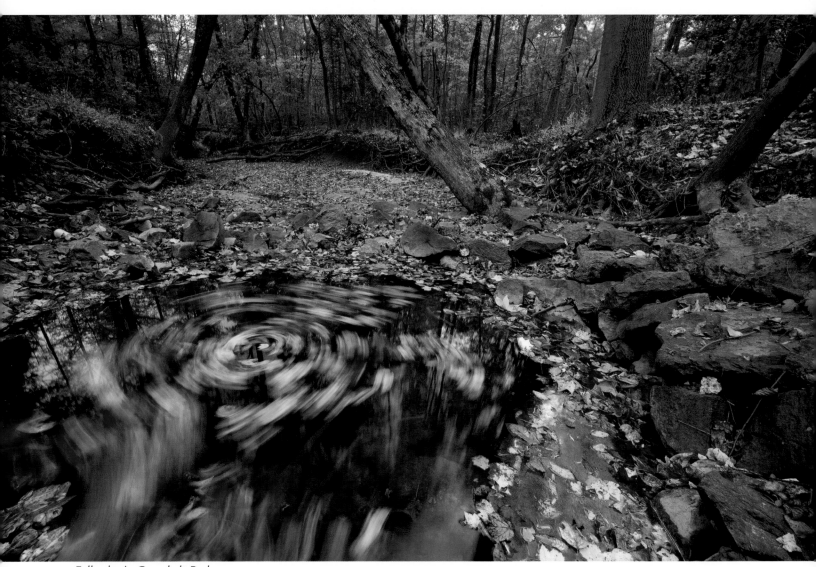

Fall color in Greenbelt Park

Anacostia Watershed Society river tour

Mallards flying through the river corridor

Leaves in the Northwest Branch

Dead bee in leaf litter

Cedar waxwing

The Zugunruhe Moon

By early November, the walnut tree wears only a few pale yellow leaves, silently quaking under the cool breath of autumn. I see less and less of my resident squirrel. She has other foodstuffs to collect, stash, and tabulate and a diminishing window of time in which to do so. Winter will soon be upon us. Occasionally I glance out my bedroom window to find her sitting at the peak of my shed roof, gazing out over the yard thoughtfully. I can only imagine what concerns may be preoccupying her; perhaps she is recalculating her cache of walnuts and acorns. Surely her musings bear more weight than my own. She evaluates a winter survival strategy; I take note of the color of the viburnum leaves, the arrival of the dark-eyed juncos from the north, maybe take a moment to consider the upcoming presidential election and how it could affect the Anacostia and other lands I love. We both have our anxieties. But my thoughts in these autumn days are not burdened with fears of my own imminent mortality, while hers must be.

Still, my squirrel and I are akin. Squirrels, like humans, do not migrate seasonally, only at great need. Even on the days I don't see my squirrel at all, I know she is near and will share the coming months of cold, dark quiet. Other neighbors have disappeared entirely from the watershed. Birds swirl in flocks of silhouette shapes far off in the bluest autumn sky. They are coming, going, agitated, restless. Amphibian voices are quiet. Bumblebees, vanished.

The indigo bunting has departed for the Caribbean, taking his electric-blue self and *sweet-sweet* murmurings with him. The wood thrush and his melodic *ee-oh-lay* have taken flight for the Central American tropics. The osprey too are gone. One day they were here on the river, soaring silently above the water; the next day, they were vanished without so much as a see-you-next-year. I feel no slight. It is ill luck to foretell a future that

may never come. These birds have thousands of arduous, hungry miles to journey before they alight on their winter safe havens; there is no guarantee they will reach the coast of Brazil or survive the return home. Osprey pack their perils and the summer sun and set off with them to South America, leaving me and my squirrel to contemplate the quality of their absence, the loss, for a few months or perhaps forever, of their soaring wings and fierce searching eyes.

I consider this seasonal absence while walking slowly along a pathway near the headwaters of the Anacostia at Sandy Spring, Maryland. The autumn wind is whispering, speaking through the raspy tongues of dry leaves still clinging to trees and through the lazy rustle of leaves lying in heaps on the dry ground. My softest footfalls crunch the fallen life of the summer forest. Rain has not come to us for weeks, and though the temperature remains mild, most of the winter travelers have taken flight and the insects have quieted, either gone underground or given their lifeless bodies over to the soil. This autumn quiet provides a boundless space for listening to the watershed, listening closely for a soft current that cannot be heard in other months when the din of life barks loud and bold.

Years of research, documentation, and introspection on the nature of this river community have led me here, time and again, to this particular path. Sometimes along this stretch of land, I can feel a pulse of river memory, a soft humming thread connecting decades, centuries, millennia of river experience to some essential seed at the heart of the watershed matter. This stretch of land sits, like Kenilworth Park, at a crossroads of meaning, a place where human history and natural history converge revealing the deepest truth—that there is but one history, one past, present, and future, and it belongs to us all, human, animal, and land alike.

My feet follow a trail through a long-standing Quaker community that developed in the 1700s around a sandy freshwater spring, in what is now a far northwestern suburb of metropolitan Washington, DC. This spring has for millennia uncounted trickled to the southeast, gathering momentum as it moves along with gravity, in that cheery, determined way that water has. It bubbles into brooks, creeks, streams, propelled down the fall line as a boisterous white and silver water to the languid flats of the coastal plain, where it widens into the Northwest Branch and converges

Osprey

with the Northeast Branch to become the Anacostia River. The town of Sandy Spring lies in the approximate location of the northwestern headwaters of the Anacostia. An interpretive pathway winds through its pastoral fields and wooded creeklands, which hold the memory of a history more poignant than most would imagine as they speed along the rural roads that gird this watershed heartland.

At the corner of Ednor and Norwood Roads in Montgomery County, a collection of county and Quaker properties make up the Underground Railroad Experience Trail. The trail begins at the Woodlawn Manor Cultural Park, a property that once belonged to William Palmer, a farmer and physician who was ostracized by the Quaker community for refusing to free his slaves. From there the trail imagines a pathway that may have carried fugitive slaves from Woodlawn Manor and points south, toward freedom along the Northwest Branch, past Sandy Spring, and on to the relative safety of Pennsylvania. The trail commemorates a hallowed journey that many refugees from slavery made along Underground Railroad routes through the Anacostia watershed in the eighteenth and nineteenth centuries. I walk this path, over and over, leaning in to absorb a spark of knowledge, to generate a current of connection to a source memory, a headwaters for the Anacostia story.

Twentieth-century British poet Edward Thomas once wrote that a path was "imprinted with the dreams of each traveler who had walked it." Author Robert McFarlane echoed Thomas's notion: "The paths' sediment comprised sentiment." A footfall on this path of memory and story can act as a conduit for absorption of a particularly defining river experience, a moment in time as integral to the Anacostia as the arrival of John Smith and the death of Kelvin Tyrone Mock.

Woodlawn Manor Cultural Park

This memory, though essential, remains ethereal. One can never know all the historical details of the Underground Railroad here, the name of every person who passed and what happened to them after they traveled on—that information is lost to us. The success of the pre–Civil War underground—and the very lives of the people who were involved with it—depended entirely on secrecy, so there are no lists of travelers or maps of routes and waystations. It is therefore impossible to say whether this stretch of the upper Anacostia was even on that route. But based on historical research about the work of Quakers, free black families, and churches in Sandy Spring, it seems very likely that this wooded path felt the anxious footfalls of escaping slaves. The presence of hidden staircases and secret tunnels in historic homes; family histories that recall aiding escaped slaves with food, clothing, and shelter; the strong Quaker ties throughout the community—all point to this pathway's role in the route to freedom. In the mid-1800s, Sandy Spring was so noted for its pro-emancipation sentiments that Dred Scott's lawyer sought the community out to house Scott while the Supreme Court was hearing his landmark case. Scott's case argued for his freedom on the grounds that he had lived for years in the free states of Wisconsin and Illinois and that his

enslavement when he returned to Missouri was unlawful. The Supreme Court, with five of its nine justices born of slaveholding families and seven appointed by pro-slavery presidents, ruled that Scott had no standing because he was not a citizen and never could be. Chief Justice Roger B. Taney stated that when the authors of the US Constitution wrote "all men are created equal," they didn't mean *all* men. Scott lost that case in 1857 and his chance at freedom. But sometimes a loss for an individual is in the long-term a win for the community, if those who fight for the cause do not lose faith, if their voices stay strong and their hearts resolute.

One Anacostia voice who never waivered, Frederick Douglass, had grown up a slave but had secured his own freedom and committed his life to a mission of universal emancipation. Though saddened by the Supreme Court's decision, Douglass saw the fight for freedom as it bent over the long arc of history and counseled courage in the face of defeat. He wrote about the cause of emancipation in the wake of the Dred Scott decision:

> Politicians who cursed it, now defend it; ministers, once dumb, now speak in its praise; and presses, which once flamed with hot denunciations against it, now surround the sacred cause as by a wall of living fire. Politicians go with it as a pillar of cloud by day, and the press as a pillar of fire by night. With these ancient tokens of success, I, for one, will not despair of our cause.

And Douglass was right. The court's decision likely precipitated the escape of many more slaves along the Underground Railroad, strengthened the resolve of antislavery activists, and hastened the dawn of the Civil War.

I walk along an open field reminiscent of some dream of the pastoral past. Horses graze behind a wooden fence; in the distance a picturesque old barn reflects morning sun off pale limestone. The peacefulness of the morning belies the bondage that built this well-ordered farm, as it built this nation. Standing on this ground, haunted by a lingering memory of its unmaking, the dream erodes in the reality of how its forests were felled, how the hard labor of plowing the land and caring for crops was done by a coercive system that robbed people of self-determination. I tuck

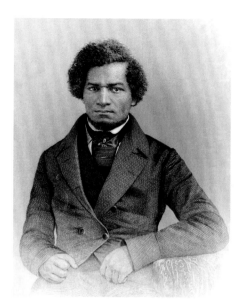

Frederick Augustus Washington Bailey was born into slavery on the eastern shore of the Chesapeake Bay in Maryland. He changed his name to Frederick Douglass when he escaped to freedom as a young man. Portrait engraved by J. C. Buttre.

this memory within the Anacostia story in my mind and move into the forest cover.

The air changes; the memory shifts. A landscape of bondage and oppression transitions into one of resilience, courage, and determined resistance. I listen to the wind moving through branches and the crunching of autumn leaves beneath my feet, mingled with the tittering of golden-crowned kinglets and bluebirds lightly dancing in blue shadows between the trees. The same sounds and sights may have accompanied the soft fleeing footfalls of an escaped slave two centuries ago. Such a beautiful music to accompany such an agony in time.

As author Fergus M. Bordewich described in *Bound for Canaan*, making the decision to escape slavery must be counted among life's cruelest dilemmas. Two almost equally intolerable options weighed on the scale of one's life. On the one hand, one could choose to accept bondage and all it entailed, to relinquish any hope of freedom from life's deepest fears and gnawing hungers, to accept abuse and oppression as the punishing price of keeping one's life intact. On the other hand, one could choose to say good-bye to spouse, children, and home.

Those who chose freedom would risk their lives on a gamble that they could outmaneuver plantation owners, overseers, slave hunters, and law enforcement over terrain they had no knowledge of, toward a freedom that lay somewhere out in an uncertain landscape—all while knowing they would most likely never see the faces of their loved ones again. Taking an entire family would almost ensure capture and risk the lives of everyone. There was no map guiding them to the North and no guarantee of liberty short of the Canadian border. Though Pennsylvania, Ohio, and Indiana marked the northern border of the divided United States, and there was a chance an escaped slave would find northerners friendly to their cause, federal law was against them. The US Constitution required that fugitive slaves in any state be returned to their owners, and the subsequent Fugitive Slave Act reinforced the rights of slave owners to recover—by almost any means necessary—the people that some piece of official paper said were their property.

Frederick Douglass knew from personal experience the agony of an attempted escape and the even greater agony of accepting one's life as a

slave. Born a slave in 1818 on the eastern shore of the Chesapeake Bay, Douglass was taken from his mother as an infant. This assault on the most basic unit of community—one's own family—was common practice at the time. Douglass was cared for by his grandmother, Betty Bailey, but was taken from her at age seven to labor on the Lloyd family plantation under a brutal overseer named Austin Gore, who regularly beat slaves to near death. A few years later Douglass was moved to Baltimore to work for the Auld family. He spent much of the rest of his childhood under the yoke of the Aulds and those they hired his young body out to. By the time he was a young man, he had endured the grief of separation from his family and serial abuse from masters and overseers and had attempted to escape, unsuccessfully. He wrote:

> Our notions of the geography of the country were very vague and indistinct. . . . Then, too we knew that merely reaching a free state did not free us, that wherever caught we could be returned to slavery. We knew of no spot this side of the ocean where we could be safe. We had heard of Canada, then the only real Canaan of the American bondman, simply as a country to which the wild goose and the swan repaired at the end of winter to escape the heat of summer, but not as the home of man.

To run from slavery was a choice between the sparest thread of hope and a home where you had a family and a life, but both family and life could be taken from you at any moment. A crueler bargain has never been struck. Tens of thousands of slaves every year chose to roll the dice and risk everything to find a better life, to achieve some measure of foundational joy, some hope for a future, some chance for a life of freedom from fear and want.

I arrive at a spot on the trail labeled by a small sign as "the brambles." This stretch of trail consists of a narrow path through thick, thorny brush, which today quivers with the activity of autumn birds. They are drawn by the shelter this snarl of vegetation provides and the berries that still cling

to dry branches. The location would have offered the same to the weary, wandering traveler of two centuries ago.

Many slaves made their escape in winter, around Christmas holidays, when they would have a good chance of not being missed for a few days. After they had endured days of running through the night, guided by the North Star and driven by fear and adrenaline, a tunnel through thick brambles would have offered a place to hide and rest, a safe haven from hunters, where they could wait out the day until the cloak of night returned.

The safety of the brambles draws sparrows today. I stand for a long while and listen to them singing their sorrowful song from within a sharp tangle of food and shelter. There could scarce be another tune that suits this space so well as the winter sparrow's, ever repeating its singular phrase: *O sweet Canada, Canada, Canada. . . .*

White-throated sparrows arrive in numbers by November, and through the winter I see them nearly every day. But Canada—where they settle in with their mates, gathering grasses, twigs, and leaves for their nests; where they lay and care for eggs, feed and fledge their young— Canada must for them hold the title of home. The Anacostia watershed provides a place to shelter while icy winds rage through sweet Canada. Our river is a safe space where they can abide until it's time for life to begin again. They pass the time singing their sad string of minor notes, their melancholy homage to Canada, refugees of winter, waiting out the long months that stand between them and their northern home.

I'm glad for their seasonal company and their solemn song. I stand for some time in the path, listening to the rustling of little bird legs hopping about within the tangled vegetation. Occasionally a male sparrow pops out onto the top of the mess of brambles, and I can get a good look at his white and yellow face singing earnestly of *sweet Canada, Canada, Canada* as leaves fall all around.

My eyes often mistake leaves for birds: red maple cardinals, brown birch sparrows, yellow poplar warblers, here and there spiraling toward the soil, lifted momentarily by wind, floating in stasis for a single second, then resuming their downward path. Some of the birds in turn mimic leaves, dropping in a flutter of shadow and fragile wing, as if they mean

to enter straight into the leafy duff and down deep into the soil to join the bumblebees and cicadas. One day they will. But for now these bird-leaves pivot just before they reach the leaf litter and rise to the nearest branch, red, yellow, and brown wings trembling, voices twittering with satisfaction upon their arrival.

The air within the forest canopy smells of leaves fallen, of sweet mint and bitter sage, dried by the sun and ground into a pungent loam of sycamore, oak, and maple leaf; of an eon of healthy decay, the future's soil and green things sprouting. The air tastes of a premonition of spring, of warm sunshine pulsing from the deep, cool shadow of a timeless forest; of a thousand yesterdays leading to today and on to infinite tomorrows. I walk along in this heady aroma, turning aside on a spur trail. Interpretive signage points to a tree a short distance down the path, which was at some point hollowed out at its base by a lightning strike, the inside coated with char. The interpretive map I picked up at the trailhead suggests that this hollow old tree may have been a place for a refugee to build a hidden fire and rest for a while before continuing on under the cover of darkness. Secreted locations like this were also used by conductors and supporters of the route to freedom, people who would leave baskets of food and other survival tools to aid those on the run.

I kneel beside the tree, peering into this arboreal shelter, and try to imagine the courage of the runaway slave. It is truly beyond my reckoning in the context of my own life. I have no personal reference for exactly what

White-throated sparrow

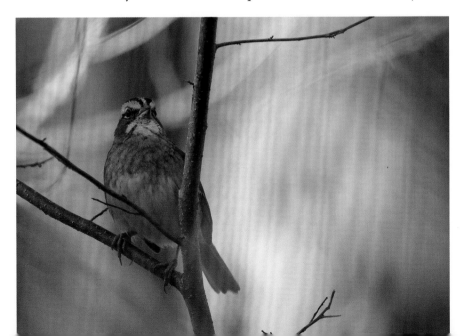

measure of grit, determination, and desperation it would take to make
this punishing journey hounded by barking dogs and slave hunters with
cruel hearts and itchy fingers on triggers. I have known hardship, and it
has sent me on odysseys of my own. But I have never needed to flee from
danger through pain and peril, with the cost of failure being my life or
freedom.

But this pathway recalls for me a previous memory from a dis-
tant landscape. Several years ago, while working on a book about the
US-Mexico borderlands, I visited a pauper's cemetery in Holtville,
California. This cemetery was one of many in the borderlands where
county coroners disposed of migrant bodies when identification could not
be ascertained and thus next of kin could not be notified. More than six
thousand migrants have met this cruel fate since the early 1990s, when
President Bill Clinton launched a policy of militarization on the US bor-
der with Mexico.

As I had with Sandy Spring, I had traveled there in search of a source
memory: to visit the graves of unidentified migrants whose remains had
been found in the searing summer desert, whose grueling odysseys in
search of freedom from fear and want had come to a grievous end. I can

recall that land experience with rare clarity: the look and feel of the grave-yard mud beneath my feet; the texture and contour of the land where graves were sunken in; the crumbling red bricks etched with a John Doe identification number; the incongruous cheeriness of an artificial sun-flower left at one of the graves. The sting of the desert sun on my skin. The acrid sickness in my stomach. The black wooden crosses planted throughout the graveyard, all inscribed with the same Spanish phrase: *No olvidados*, not forgotten.

Yes, I have seen this tragic courage before, felt it enter my bones through some unseen current in the land while walking the pathways of modern migrants, those driven by hunger, poverty, and violence to travel hundreds of harrowing miles across the harsh North American deserts to reach the United States. Some made that journey and lived to tell about it, to reunite with their spouses, to hold their newborn children. Others departed that path at an unmarked grave in a pauper's cemetery, where all their courage came to its final fruitless conclusion, where no one who once knew their name would ever find them.

Migration is ever driven by hunger in its broadest sense, though not

Hollow tree may have served as a shelter for escaped slaves

all those who migrate are ultimately fed. Nothing is guaranteed. But all who live will migrate when driven by hunger for home, that place where life becomes livable, fear impotent. We are all wired for homing toward opportunity and away from suffering and deprivation.

As Bordewich wrote, "Slaves ran because they had been beaten too often, because they were terrified of a sadistic overseer, because they couldn't bear to be sold away from family and friends one more time, because they had come to believe that their labor was worth a salary." And as news spread of the Underground Railroad and the rise of emancipation laws beyond the Mason-Dixon line, more and more slaves began homing north. "Once there was someplace to go where fugitives had some real hope of keeping the fruits of their own labor and enjoying the comfort of their family without fear of it being ripped apart, they would flee there, no matter how distant, no matter how low the odds of successful escape," Bordewich wrote.

Jermain Loguen ran after his master pounded a wooden wedge into his mouth, nearly killing him, and leaving him disfigured for life. Loguen found home in New York and became a fearless protector of escaped slaves and an orator who helped change the course of the nation.

Araminta Ross endured a childhood of dire poverty, hunger, and abuse in eastern Maryland and watched helplessly as two of her sisters were sold and forced to march off in chains. In 1849, Araminta learned that she and two of her brothers were also going to be sold. She fled north, found her way to Pennsylvania, and renamed herself Harriet Tubman. Rather than head farther north toward freedom, she turned around and traveled back into Maryland to rescue her family. Over her lifetime, Tubman made more than a dozen journeys back into slaveholding Maryland, risking her freedom, her very life, to help others find home.

Josiah Henson was also born into slavery on the coastal plain of Maryland. When he was just a small child, he and his whole family—three sisters, two brothers, and his mother—were auctioned off. Originally, Henson was sold away from his mother, but he was small and frightened and soon grew deathly ill without her. The man who bought Henson sold him at a reduced rate to Isaac Riley, who had bought Henson's mother. Reunited with his mother, Henson regained his health and spent the rest

Harriet Tubman (far left) with people she helped guide along the Underground Railroad

of his childhood on Riley's farm in Montgomery County, less than ten miles from Sandy Spring and the path I now walk along. Josiah Henson married and had children who were born into slavery. But when Riley planned to put his family on the auction block, Henson escaped. He ran away from Riley, all the way to Canada and into history. His memoir served as the basis for Harriet Beecher Stowe's *Uncle Tom's Cabin*.

Author and abolitionist William Still recorded the stories of many who fled slavery in the 1800s. Stories like that of Henry "Box" Brown, who mailed himself to freedom. Still reported that those who opened Henry's box in Philadelphia expected to find a corpse; instead, Henry came out singing with joy. Still also recounted the story of a woman named Mary, who escaped slavery and fled to Philadelphia, where she found her way to Still's office.

"She had been the mother of fifteen children," Still wrote, "four of whom had been sold away from her; one was still held in slavery in Petersburg; the others were all dead." In Still's care, Mary told him of her dream that she would one day "sit under her own vine and fig tree where none dared to molest or make her afraid." Mary spoke for all who are motivated to move across the landscape, propelled by the same desire that moves all creatures of Earth away from deprivation, pain, and fear and toward a path to survival. We all lean ever toward life.

Humans, like squirrels and many other species, generally migrate only at great need, such times when the climate—whether geophysical, emotional, cultural, or political—becomes antithetical to life. The Dust

Bowl sent thousands of Midwesterners to California to escape starvation and death; the Great Migration saw millions of African Americans migrate northward to escape the caging oppression of the Jim Crow South. Humans have made desperate journeys throughout our existence as a species because of ice ages, droughts, war, famine—and we will continue to do so.

Big cats like jaguars begin to move when their populations grow too large for the available land to support them or resources grow too thin or mates too few. Squirrels strike out for similar reasons. Though we have not seen this in my lifetime, gray squirrels have been known to migrate by the millions on an irregular basis when food resources bid them to move. In *The Rambler in North America*, Charles Latrobe wrote an account of a mass squirrel migration in the 1800s:

> A countless multitude of squirrels, obeying some great and universal impulse, which none can know but the Spirit that gave them being, left their reckless and gambolling life, and their ancient places of retreat in the north, and were seen pressing forward by tens of thousands in a deep and sober phalanx to the South.

According to Latrobe, these squirrels were so driven on their overland odyssey that they even marched straight into the swollen Ohio River and paddled across, an ordeal many did not survive. They were following the most unbending law of the natural world, adapt or die—and the myriad adaptations animals have made to facilitate migration are nothing short of astonishing.

Bernd Heinrich compiled stories of these amazing adaptations in his book *The Homing Instinct*, where he detailed studies of migration strategies throughout the animal world. Some of the most fascinating are those of insects. For instance, baby spiders, when pressed to move by a scarcity of resources, can travel through the air by *ballooning*. They climb to a high point on land, stand on their tiptoes, point their abdomen to the sky, and shoot strands of gossamer thread into the wind. Using these "balloons," they can travel hundreds of miles. Though they can survive for weeks without food, the death toll for ballooning is high, as spiderlings have lit-

tle control over where they are taken or for how long. But if home provides no hope of survival, away they must go. Ballooning spiders have been recorded thousands of feet in the air; they have even been encountered by sailors in the middle of the ocean. Charles Darwin, on his 1839 expedition on the HMS *Beagle,* was one of the first to observe and record this spiderling phenomenon. He wrote, while sixty miles off the coast of South America: "Vast numbers of a small spider, about one-tenth of an inch in length and of a dusky red color were attached to the webs. There must have been, I should think, some thousands on the ship." Darwin surmised that the spiders, each holding on to its own single thread, had, in the wind, gotten their threads tangled together so that they were floating by the thousands on one huge gossamer balloon.

In the annals of migration, ballooning spiders must find a place of honor. Their feats are deserving of an ode, and thankfully, Walt Whitman did oblige:

> A noiseless patient spider,
> I mark'd where on a little promontory it stood isolated,
> Mark'd how to explore the vacant vast surrounding,
> It launch'd forth filament, filament, filament, out of itself,
> Ever unreeling them, ever tirelessly speeding them.
>
> And you O my soul where you stand,
> Surrounded, detached, in measureless oceans of space,
> Ceaselessly musing, venturing, throwing, seeking the spheres to connect
> them,
> Till the bridge you will need be form'd, till the ductile anchor hold,
> Till the gossamer thread you fling catch somewhere, O my soul.

Just a few days ago, while paddling in my kayak, I saw a spider web spanning two-thirds of the Anacostia River. It came from high in the air on the western bank, and stretched at an angle some thirty feet or more to the surface of the river. At the end of the thread I found a spider standing in perfectly poised equilibrium on the surface of the water, his eight feet making tiny indentations where they met the mercurial river. When I

approached, he dove under. This spider, a fishing spider, had jumped out of a tree and floated to where the fishing was best, all the while holding on to his secure line of webbing.

When you don't have wings and you need to get somewhere, you adapt. But some species of insect can actually grow wings right when they need them. When summer comes to an end, plant resources become scarce, and aphids, who drink plant sap, often need to disperse. In response, these tiny insects can grow wings and move to a less crowded location. Up in the air, with the aid of the wind, they "float like the seed of a dandelion or poplar tree, or a baby spider on a thread of silk," Heinrich wrote. Their wings are relatively weak, but they do the trick, helping the aphids home toward the color light green, which has a good chance of being their main food source, new plant growth.

Migration in times of need is foundational for us all. Even plants migrate, though they have not legs. They catch a ride as seeds on the wind, in the fur, or in the feces of more ambulatory creatures. For some animals, migration is so central to survival, it is imprinted on their genes. Eels, sea turtles, and monarch butterflies all travel thousands of miles using navigation techniques that harness the power of ocean and air currents and even the magnetic forces of Earth.

As I walk this trail, I am aware again of the absence of indigo bunting, osprey, and wood thrush. They have left because some ancient force within them knows that their future, the future of their children, and their kind is tied to some warm southern forest or grassland. They use the stars, the magnetic force of Earth, and their inherited genetic wisdom to perform travel feats that have boggled the human mind for generations. Osprey travel as far as Argentina, and over the long winter they are separated from their mate, until they return home to their Anacostia nest. But a reunion is never guaranteed. Either bird may be blown off course during migration or

caught up in a storm, where exhaustion or disorientation can mean death. It happens all the time for all manner of winged migrants. In 2016, a flock of tens of thousands of snow geese was blown off its migration course by a winter storm in Montana. The only unfrozen water source where they could find rest was a toxic tailings pond. When the flock landed in desperation, many perished. A bitter end to a grueling journey. But it's a gamble they were born to take. Somewhere within their genetic instructions biology dictates that every October they must depart, and as a reminder each fall they are visited by a fierce agitation that physically alerts them—it's time to move.

The idea of migratory restlessness was first described by Charles Darwin, who noted the antsyness of birds before they took off. In the 1950s, German ornithologist Gustav Kramer called this phenomenon *Zugunruhe*, literally "migratory restlessness." And since then experiments have shown in great detail the agitation of birds and the inclination to physically orient their bodies toward their migratory pathway.

My dear sweet, sweet indigo bunting was one of the birds studied many decades ago. When caged within a planetarium prior to spring migration, the bunting would always agitate and orient itself toward the North Star. These birds travel to the Caribbean and Central America using the same tools that a historic mariner used to travel across the Atlantic. Only the bunting, like many other birds, has an internal clock and instinctual sense for celestial navigation that allows it to orient. It took humans many centuries to learn how to accomplish navigational feats the bunting is born with.

As I walk along the Underground Railroad path, I am aware especially of the absence of the thrush. This watershed woodland is defined for me by the song of the thrush, which I hear without fail when I visit this path in spring and summer. The silence where the thrush's beautiful voice should be leaves a hollow feeling in my heart. He is gone. Off to Central America, facing perils of flight and weather, fortune or misfortune, and I cannot know if he will return. But then again, I know if he stayed, he would not survive the coming winter.

The thrush flies nonstop over the Gulf of Mexico, which requires twenty-four straight hours of flight. But his is not the most grueling

migration, not by far. That distinction may go to bar-tailed godwits, which fly from Alaska to Australia, nonstop. They don't eat, they don't drink, and their body weight shrinks by half on this impossible flight. "To fly nonstop for eleven thousand kilometers over open ocean, though, without taking a bite of food, a swallow of water, or a minute of sleep, is a mind-boggling demonstration of the epic importance of home," wrote Heinrich.

Home. Is there anything more sacred? In the natural world this place, for mouse, squirrel, bee, and beaver, is the definition of sacrosanct. A place so central to survival and successful rearing of children—our foremost creaturely desires—that most will fight to their last ounce of hope to protect it from threat. A place so essential that creatures of all ilk may dance or weep for joy when they have found it for the first time or returned to it after a long absence.

Heinrich witnessed one of the most dramatic displays of the deep connection to home that we creatures of Earth have. He was visiting the Alaska nesting grounds of a long-studied and celebrated pair of sandhill cranes, Millie and Roy, just at the moment they were expected to return from their winter absence. They were late, and Heinrich and the others who awaited them were worried. Cranes, like geese and swans, do not have genetic imprinting that shows them the route home. They learn it from their parents on their first migration. Millie and Roy knew the way home well, but every year each crane has to make an important decision: *when* to leave. If they leave too early, their nesting grounds in the polar north may still be covered in ice, and there will be no food or water resources. The cranes will die. If they leave too late, their chicks will not have enough time to mature before fall migration, and their children will perish on the migration route.

Heinrich waited and waited for Millie and Roy. When Roy finally arrived, Heinrich recorded the male crane's reaction:

It bugled and sprang up half a meter or so, unfurling its long neck with beak held skyward and with extended wings at the apogee of its graceful leap as if to catch itself in the air to prolong this moment. It looked like a physical embodiment of joy and excitement. The crane kept leaping, all the while continuing its stirring bugling.

When I first read this passage of Heinrich's book, my mind immediately returned to Josiah Henson. In 1830, the moment his feet touched Canadian soil, he wept for joy with "a happiness so powerful it was indistinguishable from pain." Henson wrote in his memoir: "I threw myself on the ground, rolled in the sand, seized handfuls of it and kissed them and danced round til, in the eyes of several who were present, I passed for a madman."

In 1838, at the age of twenty, Frederick Douglass escaped from bondage with the help of his future wife, Anna Murray. Douglass wrote of the moment he arrived in New York: "If life is more than breath, and the 'quick round of blood,' I lived more in one day than in a year of my slave life."

Similarly, Harriet Tubman recalled of her arrival in Pennsylvania: "There was such a glory over everything; the sun came like gold through the trees and over the fields, and I felt like I was in Heaven." She also told of a migratory vision that returned to her throughout her life. As Bordewich recounted, "She dreamed of flying over fields and towns, rivers and mountains, and looking down upon them like a bird, until she reached at last a great fence, which she feared she hadn't the power to fly over. But just as she was sinking down, and losing her strength, ladies dressed in white would stretch out their arms and pull her across."

Home is the place where we all feel safe, where we have our greatest measure of freedom from fear and want—it is a concept that unites all living things under one desire, one need, though we define it in many different ways: a sheltered nest, a den, a cave, a burrow, a house, a nation, in the arms of a loved one we would trust with our very lives. Home is the place where dignity is afforded us for the ardors of being alive, where we can feel connected, safe, assured of a future that is worth living. It is a place most creatures will endure any hardship to find and which most of us are willing to die for.

I wonder, as I sit on a stone bench beside the Sandy Spring, if we all knew the Anacostia watershed as our home, what wouldn't we do to restore its health and to protect it from further harm?

ZUGUNRUHE

Anacostia River

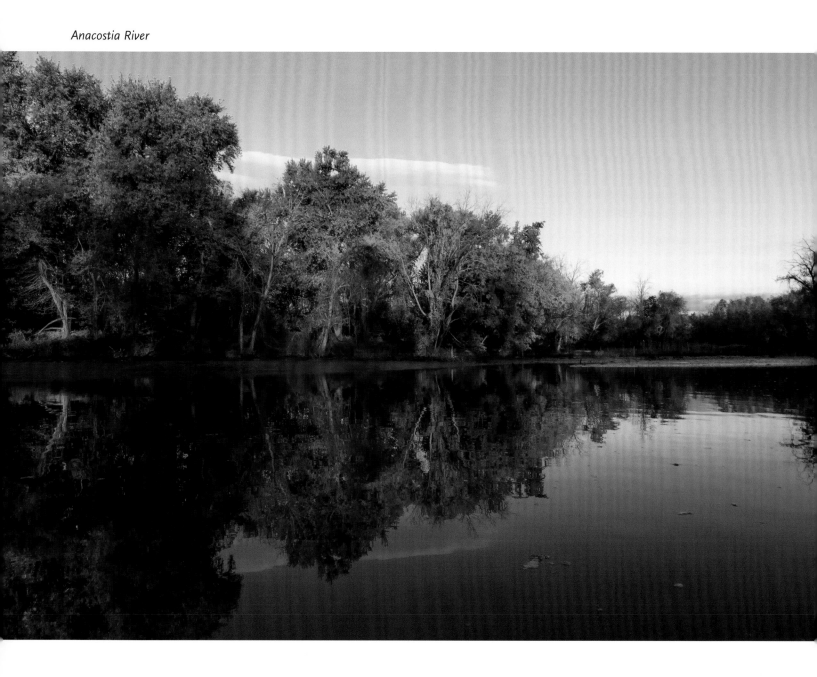

Trail on the Northwest Branch

Deer crossing Anacostia River

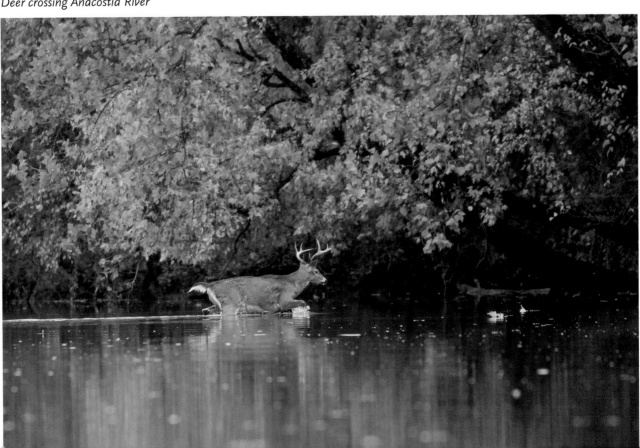

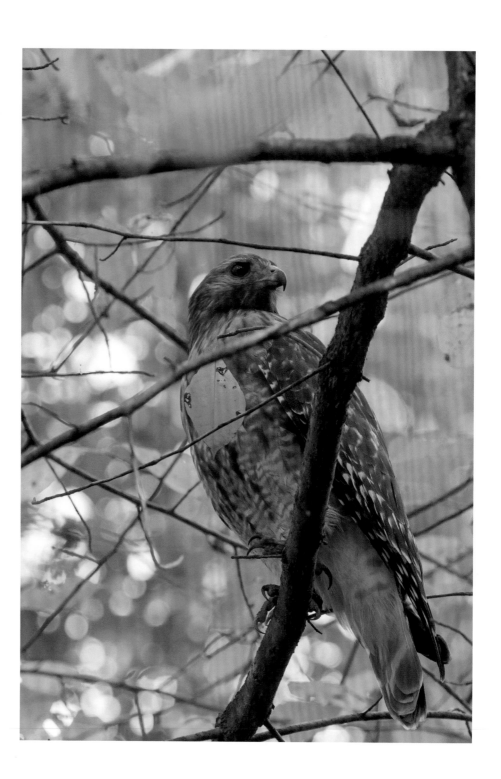

Hawk in the Arboretum

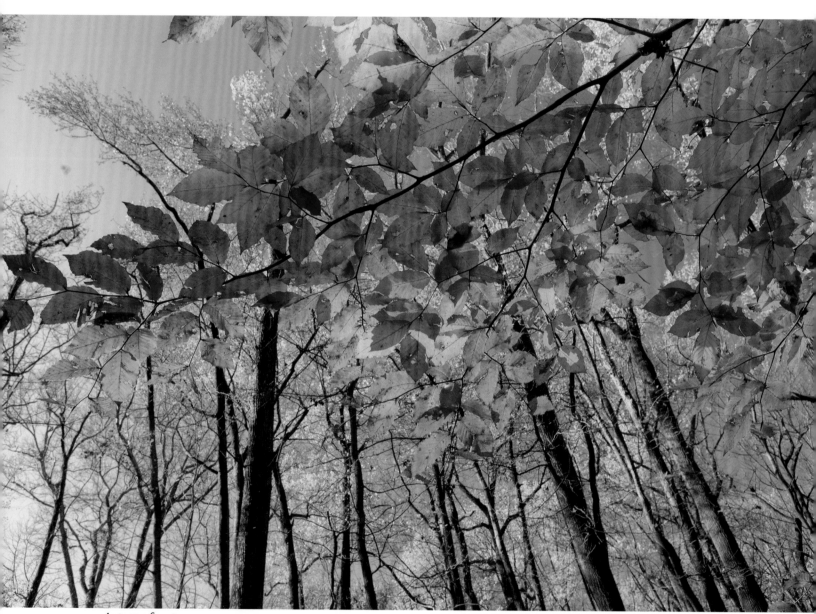

Autumn forest

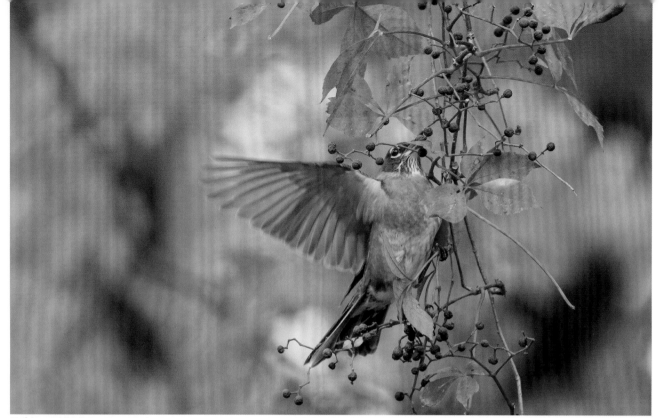

Robin on Virginia creeper vine

Autumn forest

*Sandy Spring, headwaters
of the Anacostia River*

The Prodigal Moon

Dawn comes to the December solstice arrayed in the palest shade of pink, blushing across the eastern sky with that wistful, muted beauty that winter so often has. I step out onto a grassy meadow in the Arboretum where warm air from my lungs rises in wisps of steam, and every blade, every pale leaf, every brown stem of a slumbering plant glows with a halo of frost. The temperature hovers around twenty-eight degrees, and the far-off sun, veiled by a thin shawl of cloud, will not likely warm this day much more.

Last night, fourteen hours and thirty-four minutes of cold darkness loitered in the watershed. At 5:44 a.m., instead of rising to disband the darkness and warm our watershed land, the sun lazed upon the Tropic of Capricorn, some four thousand miles southward, warming the tired wings of our itinerant Anacostia osprey.

Since June 21, our sun has been retreating from us. With each passing mile of separation the days have grown incrementally darker, the wind blown ever colder, and the land fallen ever quieter as our neotropical migrant neighbors followed their fiery pied piper to the tropics. Yesterday, we were left with roughly nine hours and twenty-six minutes of daylight on a lonesome land beneath an Anacostia sky pining for the distant sun. Darkness during these solstice days seems to close in like a roof and walls before the clock strikes 5:00.

But our restless sun has drifted as far away as he will go this year, or any other. Today at 5:45 a.m., while much of the watershed slept, our fortunes were wildly reversed—from this moment on, our sun will be returning to us. Joy to the world. Or at least the Northern Hemisphere.

The North Pole suffers twenty-four hours of darkness today; the South Pole, twenty-four hours of daylight. For us here in the Anacostia watershed this day marks the turn of a moment in time: from decreasing light

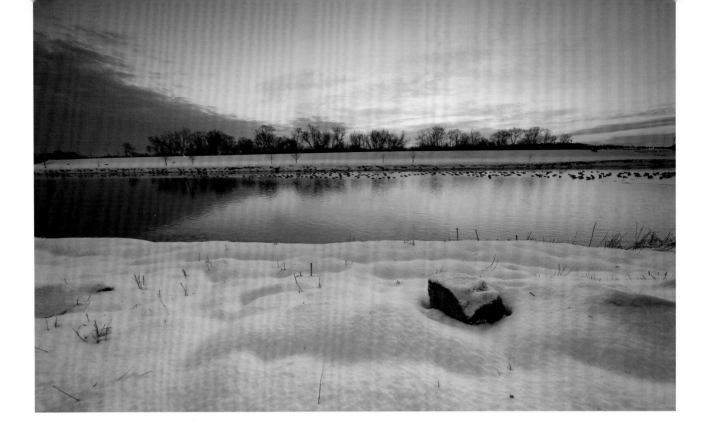

and onrushing darkness, to increasing light and retreating darkness. This transition, though many of us mark it not, plays a central role in our experience of life on Earth; it is the annual dawn of hope for all creatures.

For prescientific peoples, and especially subsistence cultures, the solstice was well marked. If they had a way of measuring the exact time of the solstice, and many did, ancient cultures could reliably predict the return of light and warmth and a growing world that would sustain them. The Nacotchtank would certainly have noted the moment when the days began to grow longer in light, knowing that each hour afterward brought them closer to a time when the shad would run and plump mulberries would again shake down from the trees, filling their children's bellies and staining their small hands and faces with bright purple life-giving juices. Knowing the arrival of the winter solstice helped them ration their winter reserves and offered assurance that when this day came, their community was that much closer to the easing of deprivation, to freedom from fear and want.

A ritual celebration of the solstice, or at least this particular time of year, is almost universal in the Northern Hemisphere and commonplace in the Southern. Five thousand years ago an ancient culture built Stonehenge at least in part to mark the solstices and equinoxes. On Machu Picchu in the Peruvian Andes the Inca arranged great stones to

point directly at the sun during the December solstice. Wiccans celebrate the rebirth of the sun god this time of year; in Pakistan a seven-day feast with ritual baths, music, and bonfires ends on the solstice; Mayans honored the sun god on this day; in December the Jewish people celebrate the festival of light, Hanukkah, and Christians commemorate the birth of Jesus, often referred to as "the light of the world." Ancient Rome's solstice celebration, Saturnalia, was organized around *a reversal of the usual order* when grudges were forgotten, schools closed, wars halted, slaves served by masters, and the rules of polite society overthrown for orgiastic pandemonium.

At this annual moment when light begins to overwhelm darkness, a promise is made that has ever been kept: that once again robins will wake and green things rise, that nuts and fruits will again fall from the trees, and roots will spread in the ground, and babies of all kind will be born, and life will continue, because the prodigal sun has set out on his long journey home.

In a scientific age we understand, even if vaguely, what is happening during the darkest days of the year when Earth is tilted so that the Southern Hemisphere feels the sun's fondest gaze. Yet there is for many an emotional and even physiological response to winter's shortest days. Some harbor a nebulous anxiety rooted in the thought: What if it just keeps getting darker and darker and darker? But then the solstice dispels all fears.

I wonder, does my squirrel mark this day? I doubt she indulges in all-out debauchery, but can she eat a few extra walnuts today in celebration? Or does she calculate her remaining caches, measure them against the meager light of the day, and feel a stab of concern?

I think of her as I pursue my own trivial intellectual musings on the frosted solstice ground of the Arboretum. How remarkable is it that the angle of the sun on Earth could define so fundamentally the characteristics of the place we call home? If Earth's angle on the sun was more like that of Uranus, we would spend several months of the year in total darkness and several months when the sun never set. If our planet leaned toward the sun like wacky Pluto, certain times of the year atmospheric pressure would be so extreme that liquid nitrogen and methane would

flow on Earth's surface. Most likely, with any significant shift in Earth's relationship to the sun, we, and all life as we know it, would not exist. This angle also determines the quality and quantity of life that can be lived in particular locations on Earth, from the frigid Arctic where the living world must grapple for every breath taken, to the tropics, where lavish fecundity showers over a crowded living land.

This is simple geometry, the shifting angles between two planetary bodies; but the ecology of the space on Earth where we live, breathe, eat, sleep, and love is driven in large part by this angle, by the relative hours of light and dark and how they change throughout the year. If we could look directly into the eyes of bunting, beaver, oil beetle, and *Bombus impatiens*, we could see reflected the spark of sun that shines so particularly from day to day in this exact spot in the universe—a spark reflected as well in our own eyes. This spot, under this angle of the giant star that makes all life possible in this Anacostia watershed, this, right here, is home. This warmth, this cold, this light and dark, this cicada who sleeps and wakes according to the unique rhythms of *right here*, this radiance of the solstice sun reflected on Anacostia waters rippled by the winter wind—this whole system of moving, breathing parts on the land, this is home.

The word *ecosystem* derives from Greek roots *oikos*, for home, and *systema*, meaning an "organized whole compounded of parts." So this word that we often think of as something outside ourselves refers to us, our own home, and how each component works together toward the fate of the whole—for better or worse. The origin of the word *system* is linked to the idea of a collection of independent components organized such that they have a cohesive strength beyond the capacity of their disparate parts. Like each tree in a forest, every bee in a hive, each person in a family— if any component steps out of the system's fundamental organizing principles, then the systemic whole will inch toward death. Cancerous cells in the human body offer a good example. Normal cells in the body have limits on their growth defined by genetic instructions, the body's organizing principles. But cancerous cells can go rogue and multiply unceasingly, without regard to what this will do to the body whole. The same is true for the ecosystem—the collection of tree, water, bee, flower, bird, cattail, and human that make *home*. If one component member of the land system ignores the

organizing principles, or simply forgets that the system and its organizing principles exist, the ecosystem as whole will begin to wither and die.

An ecosystem is a community. We are all, each one and together, components of a land system, which, when healthy comprises infinitely complex interrelations between diverse community members, each doing their part to maintain the integrity of the system. We are all members of an Anacostia *whole* that comprises *home*.

∿

Sometimes home is all around us, yet we recognize it not. We can drift away emotionally and psychologically from a connection to home, even while we inhabit the same space on land. Within this Washington, DC, landscape, more than four hundred years in the unmaking, we scraped away so many of the component parts of the Anacostia body that we could no longer recognize our hallowed home. Over the centuries we grew ever more estranged; ignored the Anacostia's organizing principles; disregarded the role of wetland, wolf, water, and forest; and gravely wounded the watershed body.

∿

At the National Arboretum, I step out onto the wooded pathway along the Fern Valley Trail, though today it might just as well be called the Valley Trail. The ferns and most other plants are all either disappeared under a litter of brown leaves or standing resolute in their solstice robes of winter brown. They make the land a sober, sleepy companion for the gurgling stream that runs through Fern Valley. This stream, wandering along the lowland forest contours, around the roots of towering oak, poplar, and sycamore, over rock and sand, is remarkable within this watershed. It is relatively clean, cared for, not a single article of trash or a pooling of oil or sewage. Here, many of the keystone components, those vital to the health of the watershed body, are intact—soil, root, leaf, stem. Many of these wear nametags, which I read as I pass: red oak, hickory, poplar, bloodroot, black gum, tupelo, ostrich fern, trillium . . . There is something powerful about knowing their names, at least, the names we have given them. To name something is to know it. When we meet people, we offer them

our name and ask theirs in return, and suddenly we are not strangers anymore. Red oak towering above me, you of the massive strong torso and dark silver skin, I know you. I recognize your work in the world, your role in providing home for feathered, furry, and many-footed things, your role giving oxygen to me and shade to the soil and absorbing rainwater, which keeps this stream healthy. I recognize the impact of your absence in the greater watershed.

The stream that runs through Fern Valley empties into Hickey Run, which also travels through the Arboretum but originates far beyond the sheltering boughs of this green land. The main stem of Hickey flows through an industrial gray hardscape bereft of the work of red oak and his kin. On this barren ground, Hickey Run gathers the grime off concrete and asphalt, then rushes through a pipe under New York Avenue before it surfaces in the Arboretum. If you look behind the public curtain of this USDA gem, you will find the stream running through this tended federal land is as broken as much of the rest of the watershed—littered with trash, its murky water smelling of chemicals, an invisible, forgotten shame hidden behind meticulously stewarded exotic bonsai, bamboo, and Japanese cherry groves.

One of my very first experiences photographing the Anacostia back in 2010 was here in the Arboretum at the place where Hickey Run daylights and begins its pathway through this parkland. I'll never forget the shock I felt as I gazed on Hickey Run, the sadness and shame for what we had made of this watershed. The pipe where Hickey Run emerges from under New York Avenue was covered by a metal grate, which had become a tapestry of dingy plastic bags, balloons, rope, clothing, and yards and yards of bright yellow plastic caution tape. The water flowed from the pipe in a sickly shade of green, and the streambed was littered with plastic cups and bottles, toys, diapers, tires, cans. It was hard to conceive at that moment that this was a river that could ever be saved from what we had made of it, that we could ever restart the ancient beat of the Anacostia heart, that we could find a way to hold our heads high and return home again. But I've seen much since then, and I know that home is just up around the bend along a path already being prepared by some of our watershed's most vital component bodies.

Hickey Run, Arboretum, 2010

I leave Fern Valley and walk across a meadow, past an enormous old willow oak, through a grove of trees where a red fox slinks into the shadows. All is quiet. But this winter quiet belies a revolution that is now unfolding—a reversal of the usual order at Springhouse Run, which flows along a winding path through the northeastern corner of the Arboretum toward its confluence with Hickey Run. For someone visiting Springhouse Run for the first time, this stream might seem unremarkable, though lovely. But a year ago this streambed was a mess of machinery poised at the ready, along with construction fencing, mountains of rock in various sizes, piles of sand, brush, and earth. It was a construction site. And an Anacostia revolution.

For more than one hundred years the prevailing belief surrounding the management of waterways has been that they need to be managed—contained, walled, straightened, channeled, dammed, and many times, for human convenience, covered over entirely lest they get in the way of our roads, buildings, or sidewalks. The notion was that water flowing over land was a nuisance to be dealt with efficiently, to be engineered and ushered expediently out of our midst. But we have come to realize that concrete and water do not go well together, that pollution from streets has poisoned our rivers and impoverished our lives, and that ecological dynamics work best when they are allowed to work just as they have for millennia.

Springhouse Run, like Hickey Run, flows over a waste of polluted concrete—six hundred acres of industrial, largely impermeable surface. The stream grows hot, harried, and polluted by the time it enters the Arboretum via a tunnel under New York Avenue. Over the past century Springhouse has been managed, remanaged, and managed again with masonry walls, earthen berms, culverts, and pipes. But a year ago the DC Department of Energy and Environment began working with the USDA

to unmanage the Arboretum stretch of the creek by removing walls and berms, digging out the channel carved over decades by raging stormwater, returning the graceful curves of a natural creek, and creating spaces for native flora and fauna to regenerate: in short, trying to set the clock back to when Springhouse Run determined its own pathway to Hickey Run.

By the end of 2017, the Springhouse project was complete and planning had begun on a project to restore the beleaguered main stem of Hickey Run. Similar projects to repair natural stream dynamics have been undertaken in a handful of locations across the watershed. In some places this has focused on restoring natural waterway contours and flows; in others it has included "daylighting" streams by breaking up the concrete that has for so long entombed our Anacostia tributaries in darkness. Restoring these streams will result in less erosion and therefore less silt pollution, provide better habitat for native wildlife, and effect a shift in watershed psychology as residents rebuild relationships with their renewed sub-watershed streams.

The power of this last benefit cannot be overestimated. Large portions of our watershed have disappeared entirely into pipes, so we never see streams that were once our companions—whose voices we heard babbling cheerfully and on whose surface we saw our sun and sky reflected. Daylighting these streams enables people to interact with a long-lost and

Springhouse Run prior to restoration

forgotten friend, helping us understand a very simple but crucial fact: we live in a watershed. We are members of this system. What is invisible cannot be known; what is not known cannot be cared for and is easily forgotten.

∿

I visited Springhouse Run several times as the restoration process moved forward over the past year, including several trips with Stephen Reiling and Josh Burch, vital watershed components who are heading the project for the DC Department of Energy and Environment. On one tour, when the project was near complete this past summer, we came across a streamside pool where American toads were breeding—hundreds of tiny baby toads were hopping around like popcorn on the sandy ground. Nearby a mallard with her young ducklings was hiding in the woody habitat along the stream, and killdeer were perusing the reconstruction site. This wildlife activity was especially good to see. Undertaking a stream restoration disrupts the lives of flora and fauna living in and around the stream. This is the challenge of trying to make things right after centuries of wrong. There will be missteps and stumbles and hard choices between divergent pathways as we endeavor to find our way home.

There is a chance that a few years from now, the Springhouse restoration may be undone by ongoing watershed dysfunction. The upstream portion of Springhouse Run remains largely a concrete ecological waste. Though the restoration project built in some protections against storm-

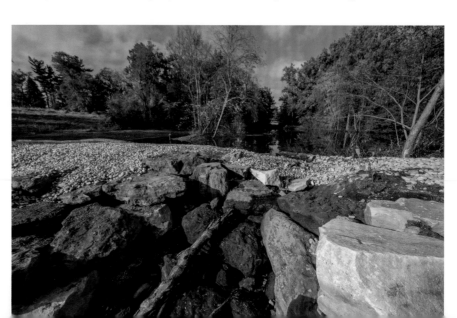

Springhouse Run after restoration

water surges, if naturalizing the land doesn't move forward at a rapid pace, the Springhouse restorations will be dismantled as polluted stormwater barrels again through the fragile stream, scouring and disfiguring it. And if waste reduction programs do not move forward—things like bottle bills and public education about single-use plastics—the streambeds will soon become clogged with trash.

Destroying a watershed, as it turns out, is much easier than restoring one. Over the past decades major government regulations and incentives throughout the watershed have helped ignite a process of naturalizing the landscape and reducing trash and toxins. Stormwater fees and a stormwater trading system have created a value economy around restoring the river; governments have offered financial support for rain gardens, green roofs, and tree plantings and introduced plastic bag fees and polystyrene bans. This and many other actions by Anacostia community members have revolutionized our concept of what is possible here in our home watershed.

But there is always pushback from those who do not yet consider themselves component members of this watershed community. Plastic bottle bans or fees have not yet been implemented, in large part because industry is pressuring governments to drag their feet. And while construction codes have established important expectations for developers to mitigate damage to the river community, our capacity to build wisely has greatly outpaced our political and economic will to do so. Over the past decades, building science has advanced considerably, providing innovative

Josh Burch holds an eyed click beetle found at the Pope Branch stream restoration site; Stephen Reiling stands in the background

ways to design the built environment such that it no longer detracts from our watershed health, and in some cases actually promotes ecosystem and human health. The LEED building standard, which sets some basic sustainability guidelines for developments, was a beginning, but it only incrementally decreased the negative impacts of construction. The Living Building Challenge goes far beyond LEED by requiring that buildings play a positive role in watershed health, air quality, human equity, climate resiliency, and biodiversity, all while mandating that any building should add beauty to the surrounding landscape. The *Living* standard is predicated on the idea that anything we build on the land should emulate the efficiency, value, and beauty of a natural structure. A tree, for example, can provide all of its own energy from the sun and gather its own water, while producing no pollutants and providing myriad benefits to the surrounding landscape, including habitat for wildlife, shade for the soil, oxygen for the air, and beauty for the world at large. Trees, and plants in general, are the quintessential vital component bodies of a land community—taking only what they need and giving back more in return. The Living Building Institute has challenged society to make buildings that "like a flower, give more than they take."

Only one building in the Washington, DC, region, has met this standard—the Cafritz Environmental Center, built by the Alice Ferguson Foundation in Prince George's County, Maryland, along the Potomac River. The building produces all of its own energy through solar panels;

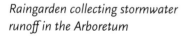

Raingarden collecting stormwater runoff in the Arboretum

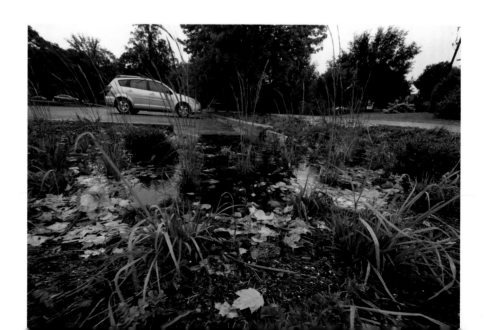

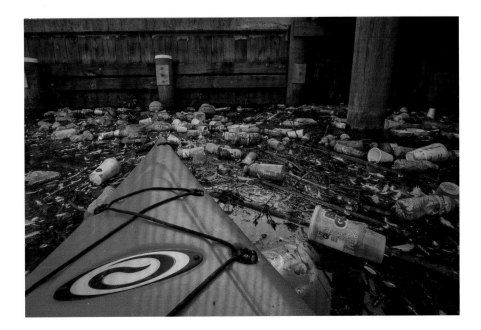

collects rainwater for use on the grounds; was made with all nontoxic, sustainably sourced building materials; incorporates native plant landscaping; and integrates natural light and healthy open spaces that have been proven to increase human health and well-being. The foundation, which has been working since the 1980s to help restore the Potomac and Anacostia Rivers, uses this innovative building to help educate young people about their role in the future of our rivers.

Living Buildings provide a standard that may bridge the yawning rift we have gouged between ourselves and a healthy Anacostia home. This approach to design of the built environment is essential to the restoration of the river community—transforming our role from a drain on the health of the watershed to a component member that contributes to the renewal of this system. But few developers have adopted this approach because these methods can reduce short-term profits. In some important ways, the culture of the colonial era has never changed, and in a world where short-term individual profits are primary, the fate of the broader community will always suffer.

A baseline expectation for those who would profit from our land community should be to replace what they took in kind. If a development

would displace a forest, it should offer as much as or more than the forest did in terms of clean water, clean air, protection of biodiversity, beauty, shade, climate resiliency, and carbon sequestration—all of which are invaluable to society as a whole. Yet forests are stripped to the ground routinely in the watershed, replaced by developments that provide none of these values to the community.

The fact is, within the current state of human intelligence, we cannot match the genius of the natural ecosystem; thus, if we seek restoration of our watershed community, we must favor forest, meadow, and wetland over human construction. In those places where we have already polluted or paved over the land to the point it seems useless, we must not assume that any development is better than the scar currently in place but see that wounded ground as a precious opportunity to heal the watershed. Thus, in places where we are redeveloping a hardscape within the river corridor, all construction must strive to restore native habitat and return natural integrity to the land, as the Living Building Challenge does.

We must—if we hope to find a pathway that leads us back to our Anacostia home.

Is this what we seek? As a community we have to define who we are, who we want to be, and what restoration of our river means. If we don't agree on a destination, we cannot create a pathway to travel together.

What does it mean to heal this river? I have asked many Anacostia advocates this question over the years, and most have repeated the mantra born of the Clean Water Act: restoration means swimmable and fishable. Is this enough? We can make the Anacostia swimmable and fishable without really restoring the Anacostia land community. We can engineer our way there with a better sewer system, permeable paving, and a remediation process for toxic sediments, while losing the thrush, eastern elliptio, and marbled salamander. Is this restoration?

A massive tunnel—12,500 feet long and 23 feet in diameter—is currently under construction by DC Water, expected to be complete in 2018. The tunnel will capture sewage that now routinely flows into the river during storm events and divert it to the Blue Plains treatment facility, dramatically reducing the amount of pollution entering the river. DC Water estimates that 80 percent of sewage discharges will be a thing of the past.

Another process is under way, led by the DC Department of Energy and Environment, to remediate the toxic sediment that has accumulated in the Anacostia over the past centuries—an enormous, expensive, and important undertaking. The tunnel and toxic remediation will be huge steps toward a cleaner river and will expedite the time line for making the Anacostia swimmable and fishable, but they must be seen as beginning points, not endings. Engineering the watershed is a bandage, not a cure.

Aldo Leopold said, "The practices we now call conservation are, to a large extent, local alleviations of biotic pain. They are necessary, but they must not be confused with cures." A doctor can treat a cancer patient by cutting out a tumor, but this will not return the patient to health unless the cancer is eradicated and the body as a whole made healthy and strong.

"Health is the capacity of the land for self-renewal," Leopold wrote.

Over the past thirty years a multijurisdictional effort has been under way, much of it shepherded by the Metropolitan Washington Council of Governments, to keep the many disparate pieces of the restoration puzzle working together toward the shared goal of restoration. This collective effort has achieved many successes project after project, year after year, and without any doubt progress is being made toward a swimmable and fishable Anacostia.

But if our goal goes beyond that, if we seek restoration writ large, if we want to heal the whole *systema* so that the watershed can again become a self-renewing body, we must look at this work in a different way. We must heal the river's vital organs—her forest, meadow, wetlands, and native

Clear-cut for Whole Foods development in Prince George's County

aquatic and land-based flora—and we must restore her animal communities, all those vital component bodies that have been lost over the years, ourselves foremost among them.

Our home remains a land divided into governmental jurisdictions and private plots—each one subject to its own set of economic expectations and pressures. No one has created a whole watershed vision that looks at the Anacostia as a single body of component parts, with every piece of land and each creature on it playing a part in the future of the community. We must learn to see the watershed as a whole of which we all are a part. We can add green infrastructure, tunnels for sewage, plant a tree or one thousand here and there, build one or two deep green Living Buildings, but unless we look at the whole body of the watershed, the land community will continue to suffer the dysfunctions that were born over the past centuries as we dismembered the watershed body.

Our return to the Anacostia community requires looking at each of the threads that weave the Anacostia ecology and knitting together, one by one, the strands we've severed. Re-creating a self-renewing system means considering not just how many trees to plant but how to re-create the forest, meadow, wetland, and aquatic plant *communities* we have lost. Each of these plays a different role in the health of the river and its residents. Restoration means naturalizing shorelines and protecting the river bottom for mussels and aquatic vegetation. It means aggressively reducing the threats posed by invasive cats, birds, and plants; fiercely guarding mature native plant communities and restoring them on degraded lands that linger as bare turf, parking lots, and abandoned brownfields. It means considering how the changing climate coupled with the unique ecology of the watershed will alter our world in the coming years. It means engaging the development community in a discussion of its significant role in the future of our watershed—a role that must become regenerative if we are going to achieve a self-renewing river system. And it means leveraging National Park Service land for the best possible outcome for the whole Anacostia landscape. The Park Service's role in the Anacostia has not lived up to the promise of *America's best idea*—but it must if this river community is ever to be healed of its history.

Restoration also entails examining how human culture is interwoven

in the Anacostia ecology of past, present, and future. There is a very fine line between restoration and gentrification. We could thoroughly clean the river until it is a healthy place for swimming and fishing; we could establish a one hundred–yard woodland buffer for all creeks and streams and another one thousand yards of green infrastructure to buffer the buffer; we could institute the highest green building standards in the world and have an urban national park that is the envy of every city on Earth. All of these would be great achievements. But restoration, if it displaces human or wild communities, is not really restoration at all; it's just the next phase in the colonial paradigm.

This is a recurrent topic of discussion for the Anacostia. We are on the precipice of peril as Washington, DC, remembers this river but has yet to remember many of her longtime residents. I am reminded of a conversation I once had with a friend who has worked for decades on restoring the Anacostia. She was speaking of the economic issues surrounding pollution and poverty, saying many people she had met in the long-standing African American communities along the Anacostia feared restoration of the river because they believed it meant that property values would go up

Only a small fraction of the Anacostia's historic wetlands have been restored

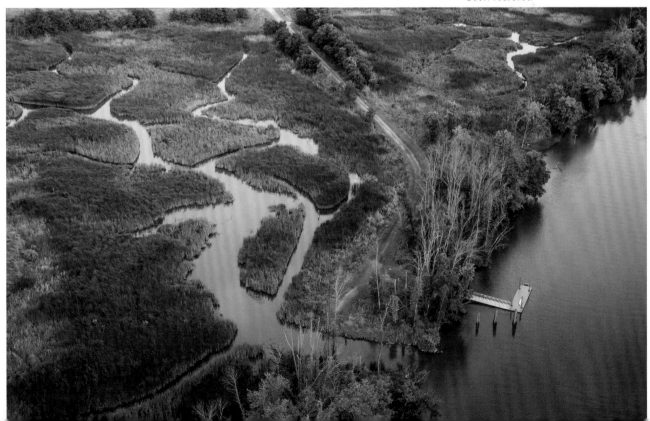

Rain garden at the DC Department of Energy and Environment built to prevent polluted runoff from entering the river system

and they would be displaced. "And they're right," she said. She had seen the dynamic too many times; she knew the trends and saw over and over that no one had a solution.

Displacement, whether for humans or wild creatures, can be viewed as a compulsory departure from one's home community. Exile. It can come all at once, with a forest being cut down and the land scraped clean of its forgotten life; or with a neighborhood being razed for "urban renewal" and its residents being forced to find new homes; or a meadow being mowed down, killing innumerable wild creatures and sending pollinators to search for new sources of food. But it can also happen in a slow trickle of subtractions to the home ecology, a building of losses that mounts against the odds of survival. Even one thing, one small thing can tip the scales—a new bike trail through quiet river forest; a small increase in property taxes; the loss of a corner store or increase in staple food prices.

My friend was not endorsing the idea of gentrification, just expressing a helplessness over a historic trend that seemed inescapable. A healthy land with access to nature is desirable to the human creature, and thus more valuable, so those with money will move in, and those without will find other places that our society has devalued with our ecological care-

lessness. This is just how it goes in a system rooted in the pursuit of individual wealth rather than community health.

I had, prior to talking with her, been deep in research about Kelvin Tyrone Mock's death and the long, toxic presence of the Kenilworth dump. Steeped in this historic injustice, I was unprepared to accept her statement, and I protested, "Where is it written that you have to be rich to live in a healthy landscape, to have a healthy river?"

This is not just. And justice is the root that feeds community, and without a strong community, we have not achieved restoration.

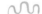

Environmental justice is often defined as "the fair distribution of environmental benefits and burdens," but generally we focus on the *burden* side of that definition. We think of *injustice* as dumping dangerous toxins on poor communities, and we think of *fighting for environmental justice* as working to keep those chemicals out. But if we seek to restore our Anacostia community, justice requires a higher standard. More and more evidence is coming to light that proximity to healthy forests, wildlife, and clean waters has a positive impact on a person's emotional, physical, and intellectual health and on one's ability to excel in school and work. Populations who are deprived of healthy ecological systems are then at a disadvantage in life, simply because they are poor, often because their skin is black or brown.

We failed Kelvin Tyrone Mock as a society not only because he died in a burning dump on national parkland a few blocks from his home but also because he, and thousands of other young people, were denied the health and emotional benefits of access to a proper park with forests, clean water and air, and vibrant natural spaces. True environmental justice entails not only protecting people from pollution but also ensuring that they have healthy natural spaces around them. It means reenvisioning a healthy home ecology as a fundamental right. It means elevating environmental justice to *ecological justice*, the opportunity for all to walk under the shade of a mature forest, to see a butterfly floating past, to wiggle one's toes in a healthy stream where green frogs sing their banjo songs. These are fundamental to life, liberty, and the pursuit of happiness and to the freedom from fear and want.

Thus, restoration demands an assurance that those who have called the Anacostia watershed their home through the worst years can continue to call it home if they choose. It requires hearing the voices of the river's longtime residents—those who speak in human dialects as well as the more musical voices of the wild world—and setting safeguards in motion that will protect home for all who have lived on, needed, and loved this land. It means that when developers and architects are at the drafting table, and politicians and policy makers are considering the future of this river community, those who make up the diverse Anacostia community have a seat or surrogate at the table and that ecological justice becomes a guiding organizing principle within the Anacostia ecosystem. Establishing that ecological organizing principle may be the greatest challenge ahead of us, but it is also the most essential task we face in defining the legacy we leave on the land.

∿

I stand on a bridge overlooking Springhouse Run, listening to the soft voices of the winter birds. I name them: white-throated sparrow, dark-eyed junco, bluebird, cardinal, song sparrow, blue jay, robin, crow, northern flicker, red-breasted woodpecker. I am among friends, connected through invisible filaments to each and every one and the trees they alight on and the stream from which they sip. As Martin Luther King Jr. said, "We are all caught in an inescapable network of mutuality, tied into a single garment of destiny. Whatever affects one destiny, affects all."

This is our solstice moment, our opportunity to reverse the usual order and usher light back into the world. We do so by making a promise to the children of the Anacostia—to every not-yet-born oil beetle, beaver, and rusty-patched bumblebee; every helpless human newborn; every ugly heron hatchling that will one day show us the meaning of grace with a simple flourish if its great blue wings—we make a promise that we are setting out, and we won't turn back no matter how hard the journey or how long it takes to return to our hallowed Anacostia home.

PRODIGAL

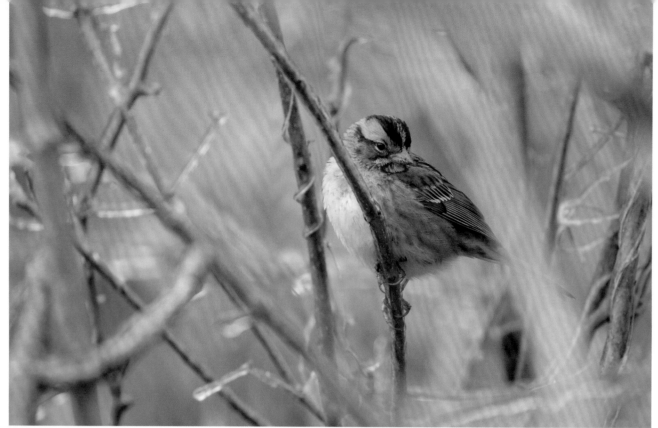

White-throated sparrow

Kenilworth Aquatic Gardens

Ice-covered berries

Anacostia River cleanup event

American robins and a discarded tire on the riverbank

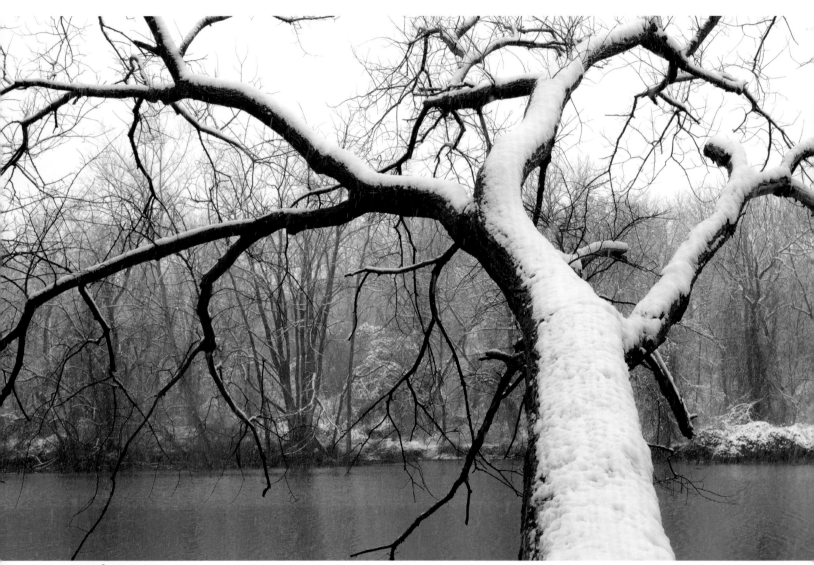

River forest in winter

Epilogue

The end is reconciliation, the end is redemption,
the end is the creation of the beloved community.

—Dr. Martin Luther King Jr.

On February 18, 2017, I packed a breakfast and a thermos of hot coffee and paddled out of Bladensburg Waterfront Park just before sunrise. The temperature was thirty-two degrees, but the sun would soon rise on a cloudless sky and a warm wind blew steadily from the south. My kayak eased noiselessly through the morning calm, casting ripples across dawn's perfect reflection, while geese honked indignantly at my arrival, gulls cried over some perceived slight, a Carolina wren sang a light lilting ode, and cardinals chirped to one another as they blazed like a summer fire through the brown winter forest. Each of these river voices rang out into the crisp morning air as instruments in an Anacostia serenade ongoing for eons. But on this particular day, the Anacostia concerto seemed as a birthday song for one of the most important residents ever to have etched an impression in river memory.

Frederick Douglass was born 199 years ago, several hours to the southeast in Talbot County, Maryland, but he spent much of his later life as a member of this watershed community, tirelessly fighting for justice and offering a model for faith and persistence in the face of overwhelming odds. His courage has been and will always be a critical component of our watershed ecology—like the river forest and wetlands, like the Sandy Spring and undulating green arms of aquatic celery—all cornerstones supporting every burden lifted in the effort to find our way home.

I followed the western bank downstream under the spare but warming glance of the prodigal sun, which bounced a pale reflection of itself, soft as shimmering moonlight, on the western shoreline. Radiant ripples of this river-sun danced over the tangled brush on the riverbank, and I found, as I

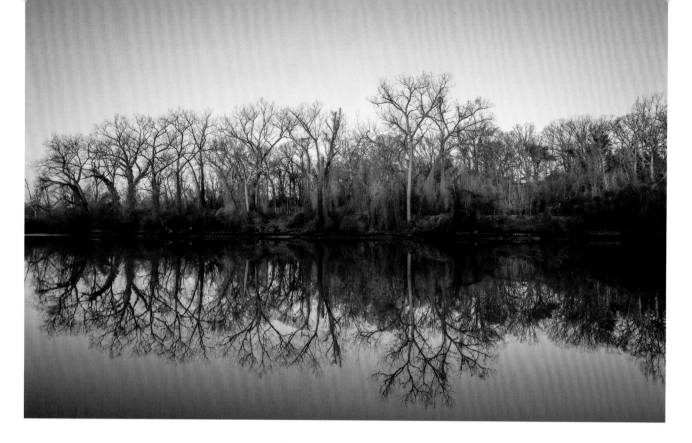

sat in audience, that the movement of my kayak stirred waves that altered the sun's rhythm. If I sat perfectly still, the waves rolled in a steady pattern choreographed by wind and water. When I rocked, the pattern disrupted, and I myself became choreographer of the moonbeam fractal ballet.

I snugged the bow of my kayak in the river bottom to prevent the current from carrying me downstream and to prolong this moment with the energy from our distant sun coursing in luminous confluence with water, wind, myself, and the cold winter land. My thoughts turned to Frederick Douglass. His life ended just over 120 years ago, but like a distant sun he continues to emit a radiance that ripples forever onward throughout history. One of the greatest gifts Douglass gave to America was a seemingly fathomless faith that we, as a people, would one day see our pathway to justice and an ethical relationship to community, and that we would in time put one foot before the other and step decisively upon that path. Over his lifetime Douglass saw us stumble and fall a thousand times; each time may have broken his heart anew, but he never broke faith.

Douglass chose a path in life that put his own personal freedom and his life at risk for the future of the community as a whole. In collaboration with the New England Anti-Slavery Society, Douglass traveled throughout the North, speaking to audiences about life as a slave, putting a personal face on a largely abstract problem in the minds of many Northerners.

Douglass said of the endeavor, "I never entered upon any work with more heart and hope. . . . All that the American people needed, I thought, was light. Could they know slavery as I knew it, they would hasten to the work of its extinction." He spent his life helping the American people know slavery and oppression as he knew it. In 1845, Douglass published his autobiography, *Narrative of the Life of Frederick Douglass, an American Slave*, and in 1847, he began publishing his newspaper, the *North Star*, under the motto, "Right is of no Sex—Truth is of no Color—God is the Father of us all, and we are all brethren."

His writing and speaking helped galvanize the abolitionist movement and would ultimately help bring about the end of slavery, but it would take almost twenty years and many bitter defeats before the Thirteenth Amendment to the US Constitution was ratified, abolishing slavery forever. Over those long years, Douglass himself was beaten by pro-slavery mobs and dragged off trains for refusing to submit to segregation, yet he continued to speak out for the rights of all Americans and maintained an unyielding faith that a more just world would someday come to pass.

As the sun's angle shifted, its dancing projection on the shore fell to shadow, and I continued on downstream. While paddling beneath the reaching arms of the river forest, I chanced upon a thin form hanging over a bare tree branch that hovered three feet above the water at low tide. I assumed at first that it was a piece of trash, possibly a bike inner tube— a good bet here. But as I approached, I realized that it was a dead water snake, which, based on its withered appearance and smell, must have been hanging for a day at least, draped over the branch like a long dark stocking hung out to dry. I tried to piece together a story of what happened to the snake. We have had no big rains, so getting hooked on the branch during a flood seemed implausible, and in any case, a live snake could easily have maneuvered itself out of such a predicament. It seemed therefore that the snake must have fallen dead from the sky. This also struck me as unlikely, but just then I heard two Cooper's hawks above, screaming at each other while engaged in a heated chase through the bare winter forest at river's edge. I could see that the hawk under pursuit car-

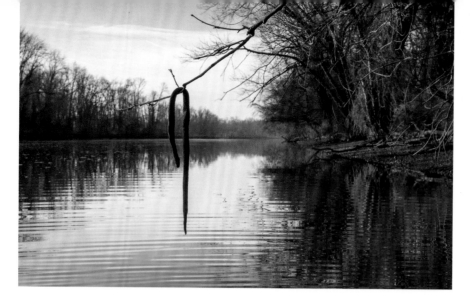

ried something long and thin in his talons but could not determine what it was before they flew off beyond sight—still crying out in their anguished raptor tones. Perhaps these two argue over food frequently around here, and perhaps this fallen snake was caught in the middle, killed, and then lost when the hawk loosened its grip.

I stayed with the snake for a few minutes, imagining the life he lived before this untimely end—wondering how his short, sweet Anacostia life played out. Did he feel comfort while sheltered in his safe underground hole; did he delight in traveling over the river's surface with smooth snakeful grace; did he find joy basking in the first rays of the spring sun?

I very much hoped so as I drifted farther downriver, as quietly as possible. Before long I came upon a mockingbird, standing at river's edge, beak in the water, taking a sip of the mud-brown winter river. After he finished, a procession of birds followed—first a crimson cardinal, then his buff-colored lady in her orange hat, and finally a white-throated sparrow, each hopping to river's edge to take a drink.

I watched each one take its turn and felt the fullness in my heart that I have felt so many times over the years as I experienced the great gift of the Anacostia. I can imagine a morning five centuries earlier when these same birds, or rather their ancestors, came to this spot for a sip of river water. Back then they saw their reflection in a deep river, crystal clear, rather than this shallow, murky soup. But cardinal, mockingbird, and sparrow have no memory of that time. For them everything is new here, every morning, without the sting of history's shame. And through them, with each rising sun at river's edge, there is a moment where we can decide to begin again as members of the Anacostia community.

Despair over what we have wrought has no purpose, though periodically I do despair. But then I rise again, buoyed by a faith I've heard

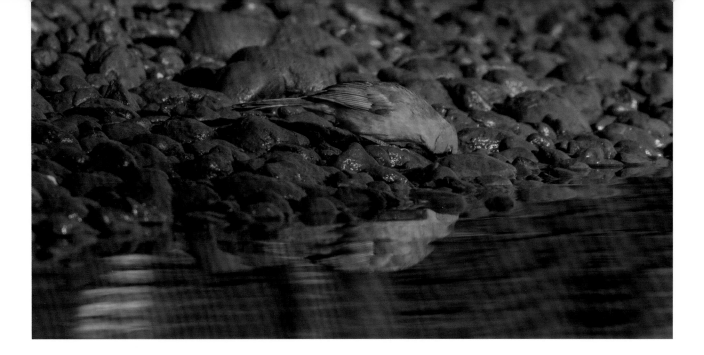

unshaken in echoes over centuries, from lives distant in time but occupying the same space in the timelessness of human consciousness. Douglass maintained his faith in the shaky pillar of American justice based on the belief that if only people knew, if only they could see the truth, they would abolish slavery and work toward realization of our nation's foundational self-evident truths. Following Douglass, so many who have walked on this watershed land have renewed that belief in justice and the future of our community—from Florence Augusta Merriam to Rachel Carson to Martin Luther King Jr. Each of them staked their lives on the idea that a great wrong could be righted and community healed if only people could understand and see what they had seen.

Earlier this year, while photographing one of the most encouraging projects in the watershed, I heard an echo of this timeless notion. It was mid-May, and the Anacostia Watershed Society had accompanied a class of fifth-graders from Mount Rainier Elementary School to plant arrow arum and wild rice in the wetlands on Kingman Lake. Under a Watershed Society program called the Rice Rangers the students had, over the winter, poked tiny seeds into soil and tended the resulting sprouts in their classroom. These young Rice Rangers studied the Anacostia inside the walls of their school and spent time with the river and its residents on boat rides with the Watershed Society. They heard how pollution, invasive species, and urban development have wounded the Anacostia, and they were given a chance to do something about it. On that May day, they dug holes with sticks in the wetland ground and settled their plantlings in their new home.

Over the course of the morning, the kids took their role seriously, for the most part. I heard one boy remark, "It's fun to play in the mud." A girl stated, "This is gross, but it feels nice in your hands." (They were all gloved and booted of course.) One boy threw some mud. I shook my head. Another boy tattled on him. But nobody fell, or cried, or got tooooo dirty, and when they were finished, hundreds of native wetland plants that the kids had raised from seed were sitting nicely in their new wetland home off Heritage Island, ready to filter river water and provide home for redwing blackbirds, marsh wrens, and muskrats and resume their long-standing role as one of the most vital components of the watershed.

The Rice Rangers' teacher had made this program part of his classroom curriculum for seven years. The collective hands of his students have made a real difference in the life of our river. Over the years I've seen this wetland expand from a small restoration covering a few acres, to an expansive wetland that now spans most of the water between Heritage and the mainland. From the bridge above the growing marsh, I've listened to the way the wind rushes through the wings of the Canada goose as a whistle and through the mallard's wings as a soft rattle; I've seen a beaver family gathering for dinner and munching on wetland plants; I've seen baby fish schooling for safety, egrets preening, and turtles basking, thanks to the work of these students and a cadre of other organizations and individuals who have given their time and talents to the Kingman marsh. It's one of those places where even in ten years' time you can watch the river healing, in front of your very eyes, and you know that there were hands—some

Mount Rainier Elementary School students helping the Anacostia Watershed Society to restore the Kingman marsh. The Army Corps of Engineers, the agency responsible for the sweeping historic destruction of the Anacostia's wetlands, began this Kingman marsh restoration in the 1990s.

young, some old, some black, some white, some brown, some small, some large, some male, some female, and *all* vital components of the Anacostia community—placing those plants one by one in the wetland earth.

When the kids finished their work and went off to have some sandwiches, I stayed behind to talk with Watershed Society staffer Chris Lemieux, who had led the project and was tidying up some of the not-quite-complete plantings abandoned by hungry children. We talked of the progress of wetland restoration over the years and of the endangered Virginia mallow found recently on the southern part of the island. Chris asked if I had gone to the Kingman Island Bluegrass Festival the previous weekend.

"No," I said. "I've been before, but to be honest, now it kind of breaks my heart to see what it does to the island."

"Yeah, I know just what you mean," Chris replied. We discussed the likelihood that it would be moved off island to protect this land so critical to urban wildlife and the looming plans for constructing buildings and bridges all over the island and other infrastructure projects that would degrade habitat and increase traffic to this quiet space. We both lamented the lack of general knowledge about the critical value of this island to the health of the watershed.

"I just wish people could see what I see," Chris said. If people could see the ecology at work here, the wild community coming alive—the hermit thrushes and tree frogs and cedar waxwings—along with the efforts of all those people who have helped restore it, they would guard this urban sanctuary against additional trails, buildings, and bridges and find another place for the festival, someplace compatible with crowds, where there wasn't so much to lose. The natural wealth of Kingman, Kenilworth, the Arboretum, Poplar and Buzzard Points, along with so many other spaces along the forgotten river, offer ecological riches incomparable to any other urban river nationwide. We can build on that wealth by enhancing and restoring the land community, and many people are trying to make that happen. But at the same time developers are fixing their gaze on these spaces and people are returning to the river, and if they don't understand what is happening here, and what has happened over the past centuries, they run the risk of trampling this ecological revival before they even have

a chance to experience its full riches, before they have a chance to see this community, to name its members and know their work, and to learn to be a part of it. There exists a very real risk that Washington, DC, residents will remember this river and rejoice in what it has to offer them yet fail to see the *river community* and what they—as component members—must *give* for it to survive.

It is a race for time, trying to help people see what Chris sees, what Jorge Bogantes Montero, Dennis Chestnut, and Dan Rauch see, what the hundreds of others who love this river have seen. The remembering of the forgotten river is our Anacostia Achilles, our greatest hope and most perilous weakness. The Virginia mallow offers the perfect symbol of the Anacostia at large: this rare flower hidden beneath a heap of indifference and thoughtlessness so thick it could obscure the sun, but once it is discovered, it becomes vulnerable to being trampled by all who come to admire it.

Safeguarding a future for this landscape requires a delicate, thoughtful, but determined hand. There are some in the Anacostia community who say we have adapted to the unacceptable for far too long and that we must begin to demand action. Others say we need to be wary of this urge toward change at all cost. Both are right.

For half a century we have been rising from rock bottom gradually. But we have adapted to realities that should not have been accepted, like the toxic, unstewarded land of Kenilworth Park, the legacy toxins in the river sediment, and constant stream of poisons that continue to run off roads into the river through the storm drain system. Adaptation can lead to the normalizing of unacceptable realities—a polluted river, a park as a dump, the idea that healthy natural spaces are the provenance of the rich. Sometimes you have to stand up and say no more. Sometimes you must be unsatisfied to create a different way of being. Martin Luther King Jr. cautioned against the dangers of adapting to the unacceptable: "This is no time to engage in the luxury of cooling off or to take the tranquilizing drug of gradualism." We need action, persistence, and an unwillingness to accept excuses from those who refuse to take responsibility for the past. But within this fragile urban ecosystem, action without memory, understanding, and caution, without love and ethics, may be the worst of all outcomes.

The government processes that have been so slow over the past century of apathy toward the Anacostia can spring into high gear when prompted by political pressures. But when this happens, they can be so preoccupied with dates and milestones that they do not take time to think carefully about how a bike trail displaces wildlife and breaks up forest, about how developments in silent places further reduce our rarest urban resource: stillness. If we do not have a plan in place to heal the watershed, to give back more than we take, we will lose the last holy relics of unbroken forest, native meadows, and urban solitude. And this time there will be no going back. We will lose the long memory and rich history of the African American and immigrant communities that have long lived on this river. We may lose the eagles, just as they are beginning to return to us. We may diminish the community of beaver, turtle, mussel, and fox. We will almost certainly lose the last of the thrushes, before most residents have ever even heard their song and been transported to a time before machines, when the world was young and we were without sin.

In *Silent Spring*, Rachel Carson wrote of the danger of proceeding without mindfulness, of rushing headlong toward change for change's sake: "The rapidity of change and the speed with which new situations are created follow the impetuous and heedless pace of man rather than the deliberate pace of nature."

A technological approach to river restoration may allow us to swim and fish in it and may allow some to profit as property values rise. But this will ignore the basic underlying inequity built into our relationship with the land and those who live on it. Big shiny developments that bring thousands of people back to the river at Buzzard and Poplar Points and the PEPCO property will usher economic activity to the river. But if those plans are not guided toward the good of the river *system*, we will displace the wild and human communities who have been quietly living their lives in this forgotten space, whose need of this river has always been more desperate and enduring than our own.

This loss, in my mind, would be the greatest tragedy the Anacostia has ever suffered—not because it is worse than what has come before but because now, without any doubt, we know better. We know the wrong we have done, and we know how to make it right.

∿

In *A Sand County Almanac*, Aldo Leopold referenced Edward Arlington Robinson's Pulitzer Prize–winning poem, *Tristram*: "Robinson's injunction to Tristram may well be applied, at this juncture, to *Homo sapiens* as a species in geological time:

> Whether you will or not
> You are a King, Tristram, for you are one
> Of the time-tested few that leave the world,
> When they are gone, not the same place it was.
> Mark what you leave."

Now is a time to think carefully about what our Anacostia legacy will be. Legacy is not some abstract concept but the gift or curse we leave to the children of the Anacostia—those who have yet to open their infant eyes, those with downy feathers and tawny fur, those with shimmering silver scales and soft carapaces, those encased in pearlescent shells lodged in the river sediment.

It is easy to curse the missteps of our predecessors when considering the current landscape of the Anacostia, but it is to the future we must look. How we conceive the future and shape our legacy will color the lives of all who follow. What is right? What is restoration? And how do we make it a reality?

∿

In Leopold's description of life on the Sand County land, one can see, hear, and feel the love he felt for this place, his home, a landscape he saw disappearing before his eyes, in a sense, dying in his arms. I have chronicled life on a homeland ravaged, broken, and barely breathing, gazing up at us with wide eyes, helplessly wondering if we will give of ourselves so that the community might live. We now have the opportunity to gather the broken body of the Anacostia in our arms, to tend her wounds, and in so doing to heal our own estrangement from a living land our society abandoned long ago. In love, anything can be accomplished.

To do so, we need a Tristram of the mind, a central dictate, an ethical organizing principle that above all else bases decisions on one demand: *Mark what you leave.*

Without a clear, conscious direction, human society moves as a many-armed thing lurching in random advances. In the Anacostia watershed, as in so many places, we have allowed this many-armed, confused monster to bumble around the land feeding its compulsion toward expedient, short-term profit, while the more thoughtful arms, the *better angels of our nature*, fret and scramble and try desperately to undo or avoid the damage.

We are motivated by thoughtful intentions for river restoration, but we continue to make choices that we should have learned a century ago were not compatible with a healthy watershed, like ripping down countless acres of mature forest to build National Harbor in Prince George's County; paving over some of the last vernal pools in the watershed to construct a Costco in the District; clear-cutting some of the last mature urban forest to build yet another Whole Foods; and felling thousands of acres of mature forest to build suburban developments and highways like the intercounty connector in Maryland, just to make it easier for people to drive more. We remain mired in conflict and paradox, a confusion that with every passing year darkens the future of the Anacostia community.

For more than a century the Corps of Engineers has been one of the driving forces behind our alterations of the land, and perhaps more than any other single entity the Corps represents our many-armed monster without a guiding principle. For much of its tenure the Corps has been our whetstone for sharpening science as a human sword, and that sword has too often been wielded inadvertently against our own best interests. A gradual process has led the Corps toward being more of a biotic citizen, at times learning to treat land as a collective organism. The Corps has led several efforts to restore wetlands in the watershed and to craft watershed restoration plans. Still, in other areas the Corps continues its strong-arming of nature all across the nation. There is no getting around it; the Corps is and has always been Hercules, and Hercules simply cannot serve the role of Tristram. We need an organizing principle whose role is to understand the ecological system, whose aim is to shine a searchlight on the vital component elements of our watershed home and to safeguard

them in their work to make a stronger, healthier whole. Leopold offered just such an organizing principle in one simple idea: "A thing is right when it tends to preserve the integrity, stability, and beauty of the biotic community. It is wrong when it tends otherwise."

Our many environmental agencies—federal Environmental Protection Agency and Department of Interior, as well as District, county, and state departments of environment—offer a start on this concept. But they are subject to political pressures and generally do not employ or give great authority to ecologists, people like Rachel Carson and Aldo Leopold, who see how things fit together, how one single component can either strengthen or gravely harm all the others within a system. We need a US Corps of Ecologists and District and county departments of urban ecology.

Ecologists think differently. They think of the *oiko systema* and its many component parts and how they all work together for the health of the community as a whole being. We need ecologists to represent the land community and help us see that with every action and inaction upon the land, *we leave the world not the same place it was.*

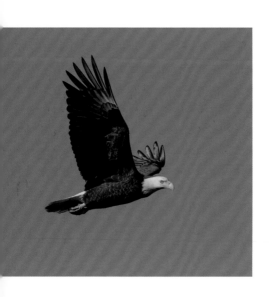

The *oikos systema* must be paramount as we walk our path toward the future. If we could remember the cyanobacteria that gave the world oxygen, the Cambrian explosion, the *Astrodon* and mastodon, the Nacotchtank, and all the long ages of this watershed home; if we could see the Anacostia as a single community, a being, a *gift* of which we all are a part, we would make careful choices that ensured our land community grew and thrived. If we could imagine the Anacostia's grief over Kelvin's death, and over the extinction of the rusty-patched bumblebee, bear, and Carolina parakeet, and the biological bereavement of the marbled sala-mander and silencing of the thrush; if we could come to know our own silent river of grief over our treatment of the Anacostia, then we could be sure that each step forward gave life, beauty, and health to the whole com-munity. We could hear our Tristram and never lose sight of our North Star; we could find our way home and once there could mark what we leave and know that our legacy on this land was of the healing kind.

This is a moment neither for despair, nor inaction, nor impetuous-ness, nor rest. This is a moment for a labor of love.

In the Anacostia watershed, these labors are not only for us but also

for the greater Potomac and Chesapeake Bay watersheds, whose health is inextricably tied to the health of the Anacostia. Our Anacostia work can also provide a model for the nation at large, for making good on the promises outlined under the Clean Water Act. For if we cannot do it here, in the very watershed where the Clean Water Act was passed, then what hope have we for the nation's countless urban rivers suffering the same history as our beloved Anacostia? Transforming our nation's relationship to land and water requires a commitment to honor the foundations of life and community and to consider more carefully what we hold dear.

"Do we not already sing our love for and obligation to the land of the free and the home of the brave?" Leopold asked. What exactly does this pledge of fealty mean? Whom, Leopold asked, do we love? "Certainly not the soil, which we are sending helter-skelter downriver. Certainly not the waters which we assume have no function except to turn turbines, float barges, and carry off sewage. Certainly not the plants, of which we exterminate whole communities without batting an eye."

Back to the time of Thomas Moran, Albert Bierstadt, and John Burroughs, Americans have known that the purple mountains majesty were as integral to our identity as was a flag we had hallowed as a symbol of our fellowship. Yet over so much of this land we desecrated mountain and stream while deifying the symbol of this land we once loved. Burning an American flag is a cultural incendiary, but polluting a river just requires filing some paperwork and fitting it into the waterway's *pollution diet*.

Whom then do we love?

Depending on how we answer that question, we may find that profaning our rivers, the carotid arteries of Earthly life, is a much graver sin than burning a piece of cloth with stars and stripes.

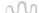

As the morning gave way to midday on Frederick Douglass's 199th birthday, I paddled into the Bladensburg wetlands, where a thin crust of ice still covered the surface of the shallowest water, crunching lightly as my kayak passed. At low tide much of the muddy ground beneath the wetlands was

Baby chickadee

exposed, and it wore a lacework of white frost. Redwing blackbirds chattered among the pale yellow stalks of last year's cattails, which reflected on the still water surface. And on the frost-powdered land, the pathways of muskrat, beaver, and rail were revealed, secret passages where likely no human feet have tread, at least not for a very long time. As I floated within these secret ways, listening to the life that is constantly carrying on throughout this watershed, I wondered: How is it possible that this ecosystem yet lives?

In the body of this river we can see the same eternal spark of resiliency that drove Douglass, Carson, and King. This spark, this energy, this is the remembrance of what *is* and *yet may be*. Fueled by this spark, the river wild has already begun to restore itself, to thrive again in its quiet forgottenness, to remember through skink and goldenrod, redbud and wild rice, what it was, is, and must always be. Seeds that were dormant through the most destructive years, sprouted; or they floated on the wind from remnant islands of wild forest and meadow. Winged things followed them back: those with wings of translucent paper, those with wings of delicate orange and yellow velvet, those with wings of red, white, and blue feather. They came back while many were still shunning this broken place, and they began to fix it. Need drew them, and they worked as a com-

munity to knit each newly returned piece of the ecological puzzle back into its niche.

Over the years I have had such joy watching them work, in song and strife, as predator and prey, toiling forever in conflicted balance to remake this landscape. The things I've seen on this Anacostia land! I've seen a Cooper's hawk in a life-or-death battle with a yellow-shafted flicker— twenty tense minutes of talon, tender flesh, and torn feather, from which both birds flew away. I've seen a monarch butterfly emerge from a chrysalis like a tiny glass vial filled with liquid butterfly; I've seen hummingbirds threaten wrens, cardinals dress down eagles, beavers chastise boaters; I've seen this whole living song of a river that refuses to die. There is so much, so very much. More than a mind can ever convey, hold, or carry away.

At the end of every morning I understand the Anacostia better than I did the day before. Perhaps better than anything I understand that I will never understand. On this resilient land I have seen the ground grow wiser and wiser and found remembrance while observing, documenting, and reassembling a vision of a timeless land filled with myth and memory, a world that, as John Burroughs wrote, surpasses all understanding.

"Go to the sea or climb the mountain, and with the ruggedest and the savagest you will find likewise the fairest and the most delicate. The greatness and the minuteness of nature pass all understanding."

I have gone to the sea and climbed the mountain, but I have never felt so humbled by the splendor of the land community as I have right here, at home, in the outstretched arms of the Anacostia, her body so broken but forever becoming.

Our Anacostia lives, which means we have a chance, a fleeting wisp of chance, as ephemeral as the wind stirred by a hummingbird's wings, to place a gentle hand on our watershed home and press the rhythm back into her still-beating heart.

US Capitol Building as seen from the Anacostia River

Selected Bibliography

Anacostia 2032: *Plan for a Fishable and Swimmable Anacostia River.*
 Washington, DC: Department of Energy and Environment, 2008.

Bartsch, Paul. *Notes on the Herons of the District of Columbia.* Washington,
 DC: Smithsonian Institution, 1903.

Bordewich, Fergus M. *Bound for Canaan: The Epic Story of the
 Underground Railroad, America's First Civil Rights Movement.* New
 York: Amistad, 2005.

Burroughs, John. *Wake-Robin.* New York: Hurd and Houghton, 1871.

Carson, Rachel. *Silent Spring.* Greenwich, CT: Fawcett Crest, 1962.

Daley, James, ed. *Great Speeches by Frederick Douglass.* Mineola, NY: Dover
 Publications, 2013.

The Economics of Biophilia: *Why Designing with Nature in Mind Makes
 Financial Sense.* New York: Terrapin Bright Green, 2012.

Heinrich, Bernd. *The Homing Instinct*: *Meaning and Mystery in Animal
 Migration.* Boston: Mariner, 2015.

Hyslop, Stephen G. "Life in America 400 Years Ago: When Algonquin
 Culture Ruled Our Region." *Washington Post,* June 14, 1995.

Kofalk, Harriet. *No Woman Tenderfoot.* College Station: Texas A&M
 University Press, 1989.

Leopold, Aldo. *A Sand County Almanac.* New York: Ballantine, 1966.

McAtee, Waldo Lee. *A Sketch of the Natural History of the District of
 Columbia.* Washington, DC: Biological Society of Washington, 1918.

Neill, Edward D. *The English Colonization of America during the Seventeenth
 Century.* London: Strahan, 1871.

Ossi, Damien, Dan Rauch, Lindsay Rohrbaugh, and Shellie Spencer.
 District of Columbia Wildlife Action Plan. Washington, DC: District
 Department of the Environment, 2015.

Smith, John. *The Generall Historie of Virginia, New-England, and the Summer Isles*. London: I. D. and I. H., 1624.

Souder, William. *On a Farther Shore: The Life and Legacy of Rachel Carson*. New York: Broadway, 2012.

Still, William. *The Underground Railroad: Authentic Narratives and First-Hand Accounts*. Mineola, NY: Dover Publications, 2007.

Wennersten, John R. *Anacostia: The Death and Life of an American River*. Baltimore: Chesapeake, 2008.

Williams, Brett. "A River Runs through Us." *American Anthropologist* 103, no. 2 (2001): 409–31.

Wilson, Edward O. *Biophilia: The Human Bond with Other Species*. Cambridge, MA: Harvard University Press, 1984.

Wohlleben, Peter. *The Hidden Life of Trees: What They Feel, How They Communicate—Discoveries from a Secret World*. Vancouver, BC: Greystone, 2016.

Brown bullhead catfish

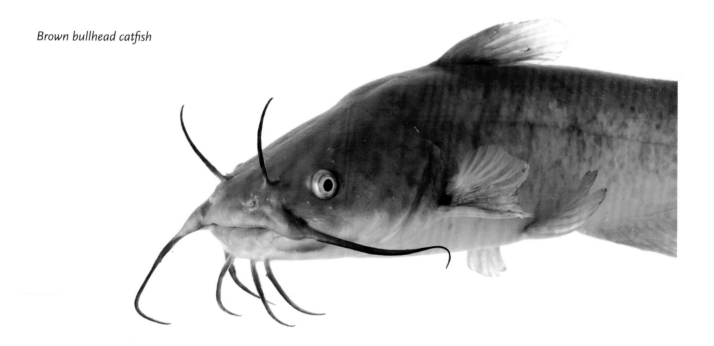

Index

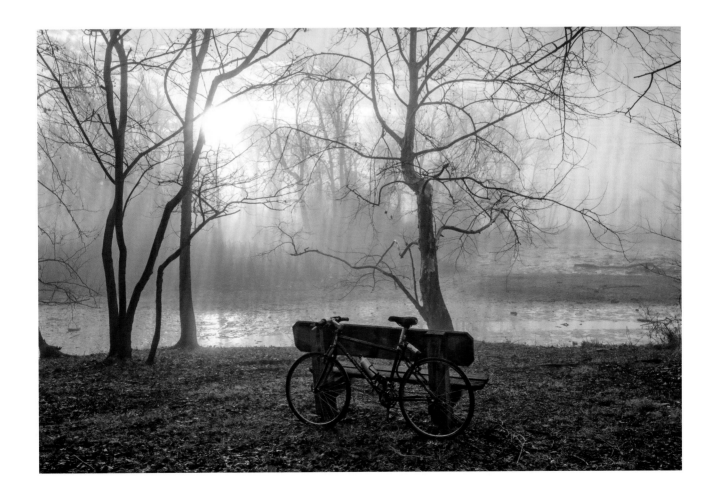

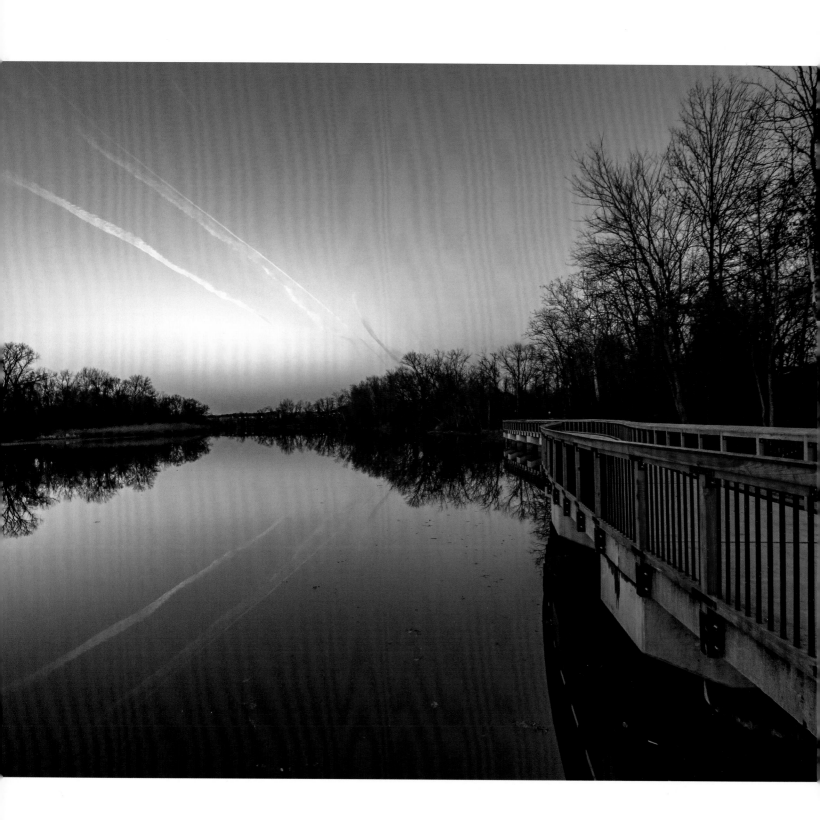

Other Books in the River Book Series

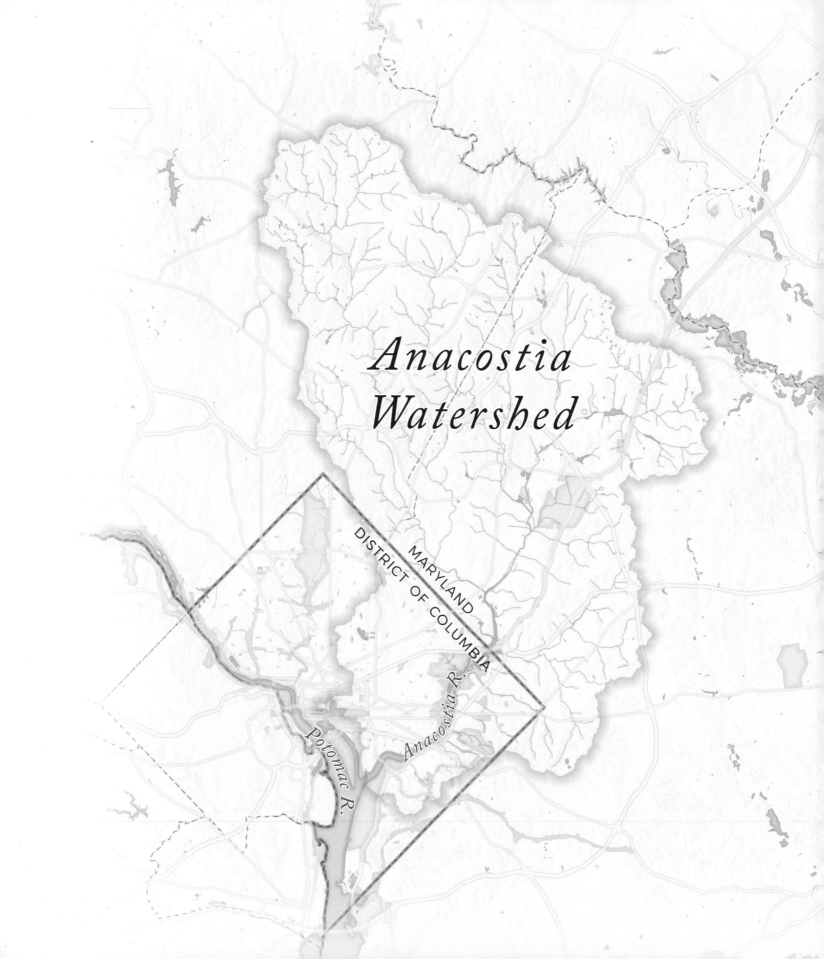

Anacostia
Watershed

MARYLAND

DISTRICT OF COLUMBIA

Anacostia R.

Potomac R.